GARDEN DESIGN REVIEW
Best Designed Gardens and Parks on the Planet

GARDEN DESIGN REVIEW
Best Designed Gardens and Parks on the Planet

EDITED BY

Ralf Knoflach

TEXTS BY

Gesa Loschwitz-Himmel

ADVISORY BOARD

Vicki Hinrichs

Rolf Sachs

Stephanie Gräfin Bruges-von Pfuel

Matteo Thun

teNeues

Contents

Preface

Every garden is unique, and also quite personal. A lot of character and personality goes into every garden at every stage from planning to care. Every garden is a personal creation: It is often associated with thoughts of the past, images from childhood, or a certain smell that evokes memories. I can still smell the sweet scent of a certain tree that I associate with the start of my professional life—a small that is completely characteristic of these plants. At the time, I was walking past a row of katsuras in a tree nursery and was completely entranced by the beguiling scent of this fascinating tree species. Of course, this is just one of many facets that make it so wonderful to spend one's time with living greenery. The interaction between the colors of flowers, crown forms, and trimmed shapes can turn a garden into a masterpiece. Each designed green oasis represents a precisely concerted ensemble of plants and other materials, inspired by personal experiences and ideas, and maybe even animated by travel to other cultures.

Travel has always been a source of inspiration for landscape architects. Peter Joseph Lenné, who designed the impressive landscape of the park surrounding Potsdam, as a student, he traveled to locations such as Southern Germany where he learned about the English Garden in Munich and other parks designed by Friedrich Ludwig von Sckell, and to France, where he became acquainted with exotic plants. Some landscape architects traveled further, even crossing oceans to further educate themselves. Frederick Law Olmsted, the designer of Central Park in New York, traveled from the US to Europe and studied the landscape gardens in England, Germany, and France.

Much like an educational journey, this book takes you to gardens and parks all over the world, both known and unknown. It offers you a glimpse behind the hedges and walls of gardens normally closed to the public and takes you to some special pearls of landscape architecture. When Hendrik teNeues asked me if I wanted to curate his first book about international gardens in the summer of 2017, it was immediately clear to me that this volume should not simply be a showcase of beautiful gardens. Instead, it should serve as an introduction to the diversity of garden culture and present a collection that acts as a source of inspiration and provides garden enthusiasts with useful and interesting information that can be applied to their own gardens. You are holding in your hands the essence of months of research that my longtime friend, Rosa von Fürstenberg, and I conducted: A diverse and multilayered GARDEN DESIGN REVIEW.

We have selected private and public gardens, each one representing a facet of landscape architecture, also taking a look at some of the special challenges of today. In metropolitan areas increasing in density, the space allotted for gardens and parks is limited. Botanist Patrick Blanc has been addressing this issue for many years now with his creation of vertical gardens, adding soft accents to the concrete city landscape and conjuring a green shimmer on building facades. We show you some of his masterpieces in Asia and Europe.

The grass and shrub compositions of Dutchman Piet Oudolf are always a feast for the eyes. We show you his design of the grounds of the Hauser & Wirth art gallery in Somerset, England. This garden with a classic layout features vast meadows with colorful, blossoming shrubbery and grass that blows in the wind, softly swaying around the building and continuously breaking the lines of the garden. Oudolf ultimately describes himself as someone who designs landscapes. His client in Somerset gave him free reign to do as he pleased, and there were very few guidelines for him to follow. You will see for yourself what an ideal landscape created by Piet Oudolf looks like.

Other examples of private arts foundations in this book illustrate that garden design often involves visual art. These include the Sculpture Park Waldfrieden in Wuppertal, Germany by Tony Cragg and the landscape art grounds of Insel Hombroich in Germany's Lower Rhine region that features the Langen Foundation, a pedestrian-accessible art and sculpture museum designed by Tadao Ando.

In the end, all gardens have one thing in common—they provide a space for retreat, being proper private paradises. This GARDEN DESIGN REVIEW contains some exceptional gems. One example is the Niagara and Villa L gardens in St. Tropez, which invite us to immerse ourselves in the relaxed French concept of savoir-vivre.

But just who is behind all of these landscape masterpieces? We certainly don't want to withhold this information. We take a look at important suppliers such as tree nurseries, garden furniture, and stone manufacturers, as well as the landscape architects themselves. All of these interviews with prominent figures in landscaping offer you a glimpse behind the scenes and provide insights into their world of ideas.

I hope you enjoy this fascinating journey, rich in variety, into the world of cultivated nature.

Ralf Knoflach

Vorwort

Jeder Garten ist ein Unikat. Und zugleich etwas sehr Privates. In jede Anlage fließt von der Planung bis zur Pflege viel Persönliches und viel Persönlichkeit mit hinein. Jeder Garten ist ein ganz individuelles Werk: Oft schwingen Gedanken an Vergangenes mit, Bilder aus der Kindheit, oder auch ein besonderer Geruch, der Erinnerungen wachruft. Ich habe immer noch den süßen Duft eines bestimmten Baums in der Nase, den ich mit dem Beginn meines Berufslebens in Verbindung bringe, das ganz im Zeichen der Pflanzen steht: Damals spazierte ich in einer Baumschule an einer Reihe von Lebkuchenbäumen entlang und war vom betörenden Geruch dieses faszinierenden Gehölzes völlig eingenommen. Das ist natürlich nur eine von vielen Facetten, die es so wunderbar machen, sich dem lebendigen Grün zu widmen. Im Zusammenspiel mit Blütenfarben, Kronen- und Schnittformen lassen sie einen Garten zum Meisterwerk werden. Jede gestaltete grüne Oase stellt ein genau abgestimmtes Ensemble aus Pflanzen und anderen Materialien dar, inspiriert von eigenen Erfahrungen und Ideen, vielleicht auch angeregt durch Reisen in andere Kulturen.

Für Gartenarchitekten waren Reisen schon immer eine Inspirationsquelle. Peter Joseph Lenné, der die beeindruckende Parklandschaft rund um Potsdam entwarf, reiste während seiner Studienjahre unter anderem nach Süddeutschland, wo er den Englischen Garten in München und weitere Anlagen von Friedrich Ludwig von Sckell kennenlernte, sowie nach Frankreich, wo er sich auch mit exotischen Pflanzen vertraut machte. Manch einer kam noch weiter herum und überwand sogar das Meer, um sich weiterzubilden: Frederick Law Olmsted, der Schöpfer des Central Parks in New York, reiste von den USA nach Europa und studierte dort die Landschaftsgärten in England, Deutschland und Frankreich.

Ähnlich einer Studienreise führt dieses Buch zu bekannten und unbekannten Gärten und Parks auf der ganzen Welt. Lässt Einblicke hinter die Hecken und Mauern sonst verschlossener Anlagen zu. Und führt zu besonderen Perlen der Gartenarchitektur. Als mich Hendrik teNeues im Sommer 2017 ansprach, ob ich nicht sein erstes Buch über internationale Gärten kuratieren wolle, war mir sofort klar, dass dieser Band keine simple Aneinanderreihung von schönen Gärten werden sollte. Er sollte vielmehr in das vielfältige Spektrum der Gartenkultur einführen und eine Sammlung zeigen, die allen Gartenliebhabern Nützliches und Interessantes als Inspirationsquelle für den eigenen Garten näherbringt. Die Essenz monatelanger Recherche meiner langjährigen Freundin Rosa von Fürstenberg und mir liegt jetzt vor Ihnen: Eine vielfältige und vielschichtige GARDEN DESIGN REVIEW.

Wir haben private und öffentliche Anlagen ausgewählt, die jede für sich für eine Facette der Gartenarchitektur steht. Und blicken auch auf spezielle aktuelle Herausforderungen: In den dichter werden Metropolen wird der Raum für Gärten und Parks eng. Der Botaniker Patrick Blanc gestaltet daher seit vielen Jahren vertikale Gärten, die weiche Akzente in der steinernen Stadt setzen und grüne Schimmer auf Fassaden zaubern. Wir stellen exemplarisch einige seiner Meisterwerke in Asien und Europa vor.

Immer wieder eine Augenweide sind auch die Gräser- und Staudenkompositionen des Niederländers Piet Oudolf. Wir zeigen seine Gestaltung des Umfelds der Kunstgalerie Hauser & Wirth in Somerset in England. Der klassisch angelegte Garten besticht durch seine weiten Wiesen aus farbenprächtig blühenden Stauden und sich im Wind wiegenden Gräsern, die die Gebäude sanft umspielen und die Linien des Gartens immer wieder brechen. Piet Oudolf sagt von sich selbst, dass er letztendlich Landschaften gestaltet. In Somerset ließen ihm seine Auftraggeber dafür freie Hand, ließen ihn sich frei entfalten, es gab nahezu keine Vorgaben. Sie erfahren dementsprechend, wie eine Ideallandschaft von Piet Oudolf aussieht.

Dass Gartenkunst oft mit bildender Kunst einhergeht, zeigen weitere Beispiele privater Kunststiftungen im Buch: der Skulpturenpark Waldfrieden in Wuppertal von Tony Cragg oder der Landschafts-Kunstraum der Insel Hombroich am Niederrhein mit der Langen Foundation, einer begehbaren Museumsskulptur von Tadao Ando.

Letztendlich sind Gärten vor allem jedoch eins: Raum für Rückzug und sehr private Paradiese. Diese GARDEN DESIGN REVIEW enthält davon einige besondere Kleinode: Unter anderem laden uns die Gärten von Niagara und Villa L nach St. Tropez ein, lassen uns eintauchen in die lässige Leichtigkeit des französischen Savoir-vivre.

Doch wer steht hinter all diesen Gartenkunstwerken? Auch diesen Aspekt wollen wir Ihnen nicht vorenthalten. Wir widmen uns sowohl wichtigen Lieferanten wie Baumschulen, Gartenmöbel- und Steinherstellern als auch den Gartenarchitekten selbst. Immer wieder lassen Interviews mit Persönlichkeiten der Gartenszene hinter die Kulissen blicken und geben Einblicke in ihre Ideenwelt.

Freuen Sie sich auf eine abwechslungsreiche und faszinierende Reise in die kultivierte Natur! Eine spannende Lektüre wünscht Ihnen,

Ihr Ralf Knoflach

Préface

Chaque jardin est en même temps une pièce unique et un espace très privé. De sa conception à son entretien, le jardin reflète dans une large mesure de la personnalité de son propriétaire. Chaque jardin est une œuvre à part : il y flotte souvent une évocation du passé, des images de l'enfance ou encore une odeur particulière qui éveille les souvenirs. J'ai toujours en tête le doux parfum d'un arbre que j'associe au début de ma vie professionnelle, toute entière placée sous le signe des plantes : à l'époque, je me promenais dans une pépinière, le long d'une rangée de katsuras (appelés aussi arbres au caramel) et l'odeur envoûtante de ce bosquet fascinant m'avait totalement saisi. Bien entendu, cela n'est qu'un des nombreux aspects de ce merveilleux métier qui permet de consacrer sa vie au vivant et à la verdure. En jouant sur les couleurs des fleurs, la forme des couronnes et des arbres et arbustes taillés, on peut transformer un jardin en chef-d'œuvre. Tout espace vert aménagé constitue un îlot harmonieux, associant les plantes à d'autres matières, inspiré par nos expériences et nos idées, enrichi peut-être aussi par des voyages dans d'autres cultures.

Pour les paysagistes, les voyages ont toujours été une riche source d'inspiration. Pendant ses années d'études, Peter Joseph Lenné, le concepteur du magnifique parc qui entoure la ville de Potsdam, voyage en particulier dans le sud de l'Allemagne, où il découvre le Jardin Anglais de Munich et d'autres créations de Friedrich Ludwig von Sckell, mais aussi en France où il se familiarise avec les plantes exotiques. D'autres sont allés bien plus loin en n'hésitant pas à franchir des océans pour se former : Frederick Law Olmsted, le créateur de Central Park à New York, est venu en Europe pour étudier les jardins paysagers anglais, allemands et français.

À la manière d'un voyage d'études, ce livre guide le lecteur à travers des jardins et parcs du monde entier, connus ou inconnus. Il offre aussi un regard derrière les haies et les murs de sites habituellement invisibles. Et il nous présente des perles de l'architecture paysagère. Lorsqu'à l'été 2017, Hendrik teNeues m'a contacté pour superviser son premier livre sur les jardins internationaux, j'ai tout de suite compris ce que cet ouvrage ne devait pas être : une simple juxtaposition de beaux jardins. Il fallait au contraire qu'il fût une porte d'entrée dans le monde si divers de la culture du jardin et qu'il présente une compilation offrant à tous les passionnés et amateurs des informations utiles et intéressantes pour les inspirer dans leurs propres jardins. Vous avez maintenant entre les mains l'essentiel de longs mois de recherches de ma vieille amie Rosa von Fürstenberg et de moi-même : un ouvrage qui passe en revue des aspects nombreux et divers de la conception et de la réalisation de jardins, intitulé GARDEN DESIGN REVIEW.

Nous avons sélectionné des jardins privés et publics, dont chacun illustre une facette de l'architecture paysagère. Et nous avons aussi jeté un regard sur les défis auxquels notre époque est confrontée : dans les métropoles de plus en plus denses, la place dévolue aux jardins et parcs se rétrécit. Depuis de nombreuses années, le botaniste Patrick Blanc conçoit des jardins verticaux qui adoucissent la minéralité des villes et enchantent les façades par des reflets de vert. Nous présentons des exemples de ses chefs-d'œuvre, en Asie et en Europe.

Les compositions d'herbes et de plantes vivaces réalisées par le Hollandais Piet Oudolf sont toujours un régal pour les yeux. Nous vous montrons comment il a conçu l'environnement de la galerie d'art Hauser & Wirth, à Somerset, en Angleterre. De facture classique, le jardin se distingue par ses vastes prairies de plantes vivaces aux couleurs vives et d'herbes qui flottent dans le vent, entourant de douceur les bâtiments et ne cessant de briser les lignes du jardin. Piet Oudolf dit de lui-même qu'il est un façonneur de paysages. À Somerset, ses clients lui ont donné carte blanche, et il était libre de faire ce qu'il voulait sans devoir suivre pratiquement aucune instruction. Vous saurez ainsi à quoi ressemble le paysage idéal de Piet Oudolf.

L'association entre l'art du jardin et les arts graphiques est illustrée par d'autres exemples de fondations d'art privées : le parc de sculptures de Waldfrieden de Tony Cragg, à Wuppertal (Allemagne) ou bien le paysage artistique de la Insel Hombroich, dans la région allemande de Basse-Rhénanie, avec la Langen Foundation et son bâtiment-sculpture de Tadao Ando.

En fin de compte, le jardin est d'abord et surtout un lieu pour s'extraire du monde, un paradis privé et intime. Cette GARDEN DESIGN REVIEW présente quelques belles réussites : comme les jardins de Niagara et de la villa L à Saint-Tropez qui nous immergent dans la légèreté décontractée du savoir-vivre à la française.

Mais qui trouve-t-on derrière ces œuvres d'art ? C'est aussi cet aspect que nous voulons aborder. Nous consacrons un chapitre aux fournisseurs qui comptent, les pépiniéristes, les fabricants de meubles de jardin ou de pierres, sans oublier bien sûr les paysagistes eux-mêmes. Grâce à nos entretiens avec des personnalités du milieu des jardins, nous jetterons un regard dans les coulisses et dans l'univers de leurs idées.

Prenez plaisir à ce voyage passionnant et divers dans la nature cultivée ! Je vous souhaite une excellente lecture.

Ralf Knoflach

Koiteiche und exklusive Gärten
Reinhold Borsch

Kempen | Germany

14

The gardens of this family-owned company feature a wealth of fascinating shapes and atmospheres. | Ein Reichtum an faszinierenden Formen und Stimmungen zeichnet die Gärten des Familienunternehmens aus. | Les jardins de cette entreprise familiale se distinguent par une grande richesse de formes et d'atmosphères fascinantes.

Creativity united with craftsmanship are two substantial components of garden design, being especially near and dear to Sonja and Reinhold Borsch. With these two, there is no wish too outlandish that does not find an open ear. Since 1992, they have been attending to their ambitious customers in the realization of their garden dreams. In the course of this, the koi pond plays a special role as a source of peace and strength. Bonsais or other topiaries set the tone as living works of art in the garden.

Kreativität in Einheit mit Handwerkskunst sind zwei wesentliche Bausteine der Gartengestaltung, die Sonja und Reinhold Borsch besonders am Herzen liegen. Kein noch so ausgefallener Wunsch, der bei den beiden nicht auf fruchtbaren Boden fällt. Seit 1992 begleiten sie ihre anspruchsvollen Kunden bei der Verwirklichung von deren Gartenträumen. Dabei spielt der Koiteich als Quelle der Ruhe und Kraft eine besondere Rolle. Prägende Akzente im Garten setzen stets Bonsais oder andere Formgehölze als lebende Kunstwerke.

La créativité et l'artisanat d'art sont deux éléments essentiels de l'aménagement des jardins tel que Sonja et Reinhold Borsch aiment le pratiquer. Chez eux, même les souhaits les plus excentriques trouvent une réponse adaptée. Depuis 1992, ils accompagnent leurs clients exigeants dans la réalisation de leurs rêves. Source de repos et de force, le bassin de carpes koï joue un rôle particulier dans leur conception du jardin, de même que les bonsaïs et d'autres arbustes taillés ressemblant à des œuvres d'art vivantes.

In correlation with the architecture of the house, this garden presents clear shapes. Bangkirai wood foot bridges frame the koi pond. A maple specimen is a focal point.

Entsprechend der Architektur des Hauses zeichnen diesen Garten klare Formen aus. Stege aus Bangkirai-Holz rahmen den Koiteich. Einen Schwerpunkt setzt der Ahorn-Solitär.

Conformément à l'architecture de la maison, ce jardin se distingue par ses formes claires. Des passerelles en bois de bangkiraï encadrent le bassin des carpes koï. L'érable solitaire constitue un point d'attraction.

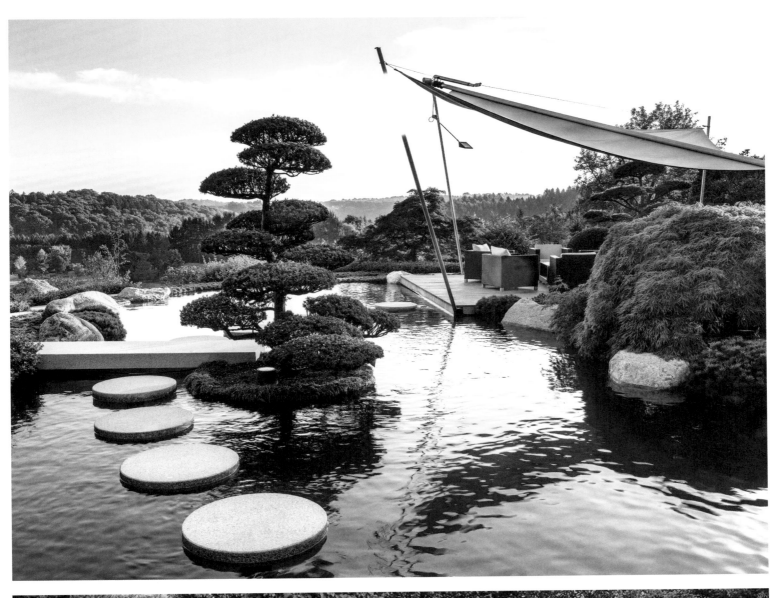

A large koi pond is the focal point of this private garden (left). Maple trees, box balls, and Bonsai pines give the grounds an atmosphere of a Japanese garden. In the Borsch model garden (below), boxwoods, maples, rhododendrons, pines as ground-cover plants and Azaleas come together to form a harmonious composition around the koi pond.

Ein großer Koiteich ist Mittelpunkt dieses Privatgartens (links). Ahorn, Buchskugeln und Kiefer-Bonsai geben der Anlage die Atmosphäre eines Japanischen Gartens. Im Mustergarten der Firma Borsch (unten) fügen sich Buchs, Ahorn, Rhododendron, Kiefern als Bodendecker und Azaleen zu einer harmonischen Komposition um einen Koiteich.

Au cœur de ce jardin privé : un grand bassin de carpes koï (à gauche). Érables, buis en boule et pins bonsaï donnent au site l'atmosphère d'un jardin japonais. Dans le jardin modèle de la société Borsch (ci-dessous), les buis, les érables, les rhododendrons, les pins en couvre-sol et les azalées forment une composition harmonieuse qui entoure le bassin des carpes koï.

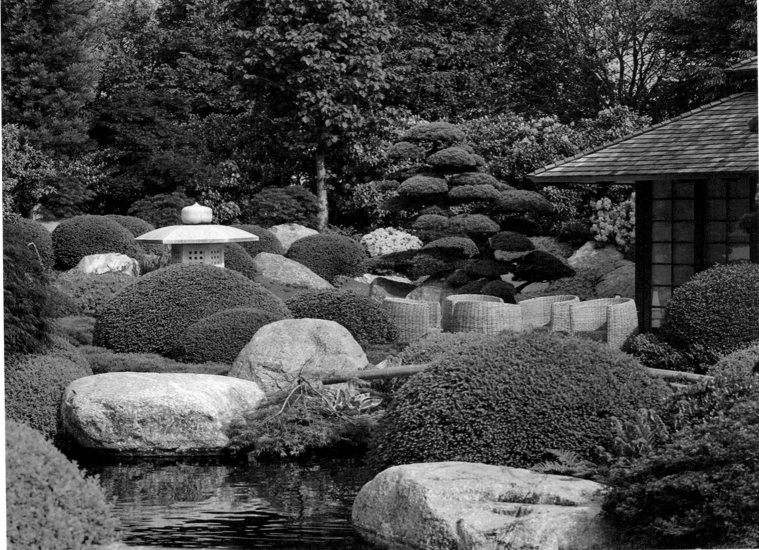

Koiteiche und exklusive Gärten Reinhold Borsch

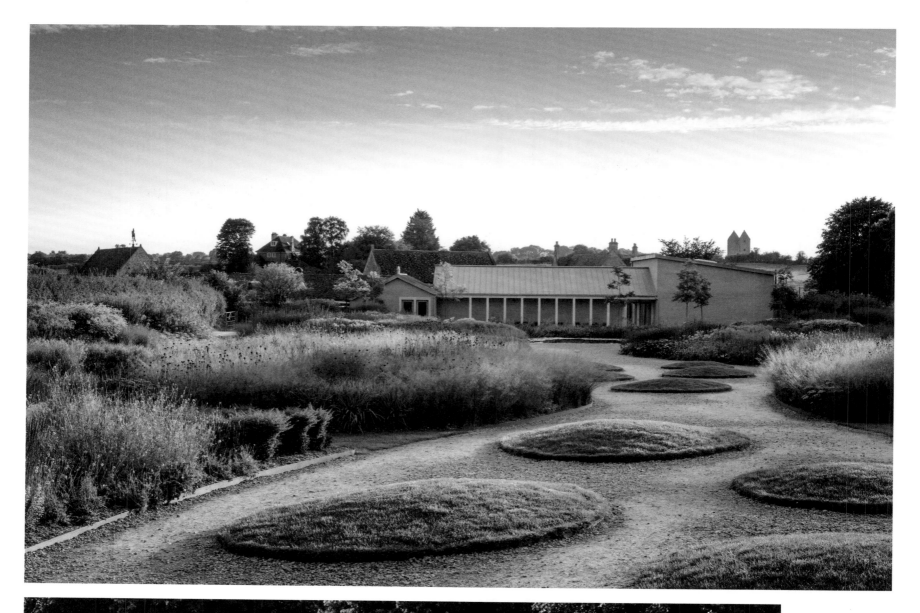

16

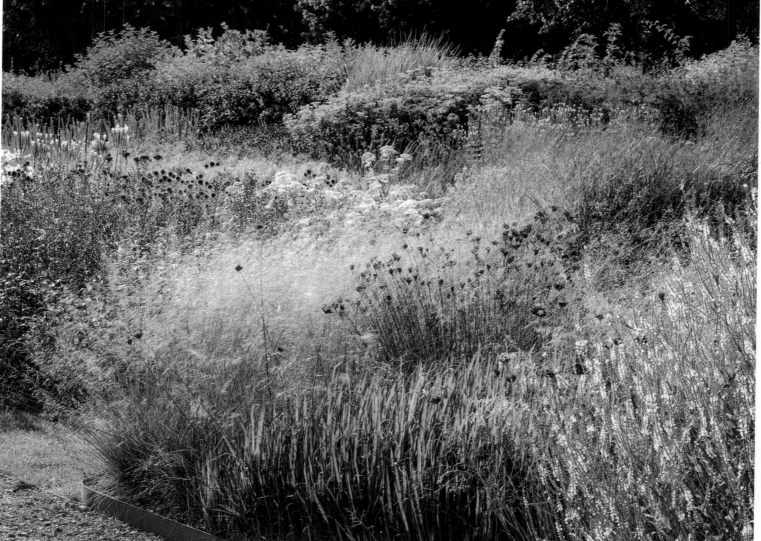

The main path with rounded islands of grass is lined on both sides by meadows of grass and perennials, which Piet Oudolf has arranged to look like a painting made up of 26,000 plants.

Beiderseits des Hauptweges mit den gewölbten Gras-inseln erstrecken sich die Gras- und Staudenwiesen, die Piet Oudolf wie ein Gemälde aus 26 000 Pflanzen inszenierte.

De chaque côté de l'allée princi-pale, avec ses ilots d'herbe courbées, s'étendent les prés d'herbes et de plantes vivaces que Piet Oudolf a mis en scène comme une peinture composée de 26 000 plantes.

Piet Oudolf

Hauser & Wirth, Somerset | England

Piet Oudolf masterfully used perennials and hedges to set the stage for the outer rooms of an art gallery. | Mit Stauden sowie Hecken inszenierte Piet Oudolf meisterhaft die Außenräume einer Kunstgalerie. | Avec des plantes vivaces et des haies, Piet Oudolf met en scène de manière somptueuse les extérieurs d'une galerie d'art.

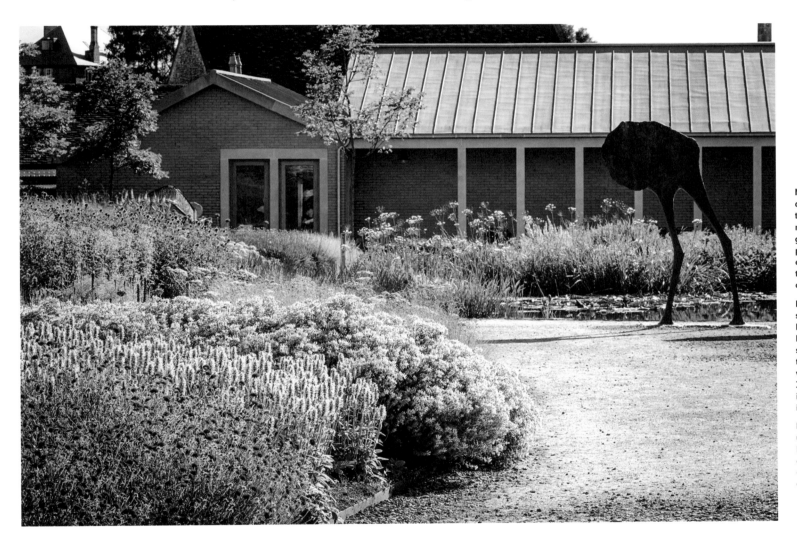

Not a garden, but a landscape within the landscape: The meticulously arrayed groups of plants produce an effect in every season—be it through their color or their structure.

Kein Garten, sondern eine Landschaft in der Landschaft: Die sorgfältig arrangierten Pflanzengruppen wirken zu jeder Jahreszeit – durch ihre Farbe oder ihre Struktur.

Plus qu'un jardin, un paysage dans le paysage : grâce à leurs couleurs ou à leur structure, les groupes soigneusement arrangés de plantes fonctionnent en toute saison.

17

The grounds of Durslade Farm are home to one of eight outbuildings of the international collection of modern art operated by the Hauser & Wirth gallery. The world-renowned landscape designer Piet Oudolf designed the surroundings for the estate. Its central element is the Oudolf Field, an extensive planting of perennials to the north of the gallery building. Drawing from traditional English gardens, here he uses a variety of plants in a mellow style that eschews formality.

Auf dem Gelände der Durslade Farm betreibt die Galerie Hauser & Wirth eine von acht Dependancen der internationalen Sammlung für moderne Kunst. Der weltweit bekannte Landschaftsgestalter Piet Oudolf gestaltete die Umgebung für das Anwesen: Zentrales Element ist das Oudolf Field, eine großflächige Staudenpflanzung nördlich der Galeriegebäude. Mit Bezug auf traditionelle englische Gärten verwendet er hier eine Vielfalt von Pflanzen auf eine weiche, lockere Art, die Formalität vermeidet.

Sur le site de la Durslade Farm, la galerie Hauser & Wirth dispose d'une des huit dépendances qu'elle consacre à sa collection internationale d'art moderne. Piet Oudolf, un paysagiste créateur mondialement connu, a conçu l'environnement du bâtiment dont le cœur est le Oudolf Field, un vaste espace de plantes vivaces situé au nord de la galerie. Dans une évocation des jardins anglais traditionnels, il utilise ici une multitude de plantes, avec douceur et légèreté, mais sans formalisme aucun.

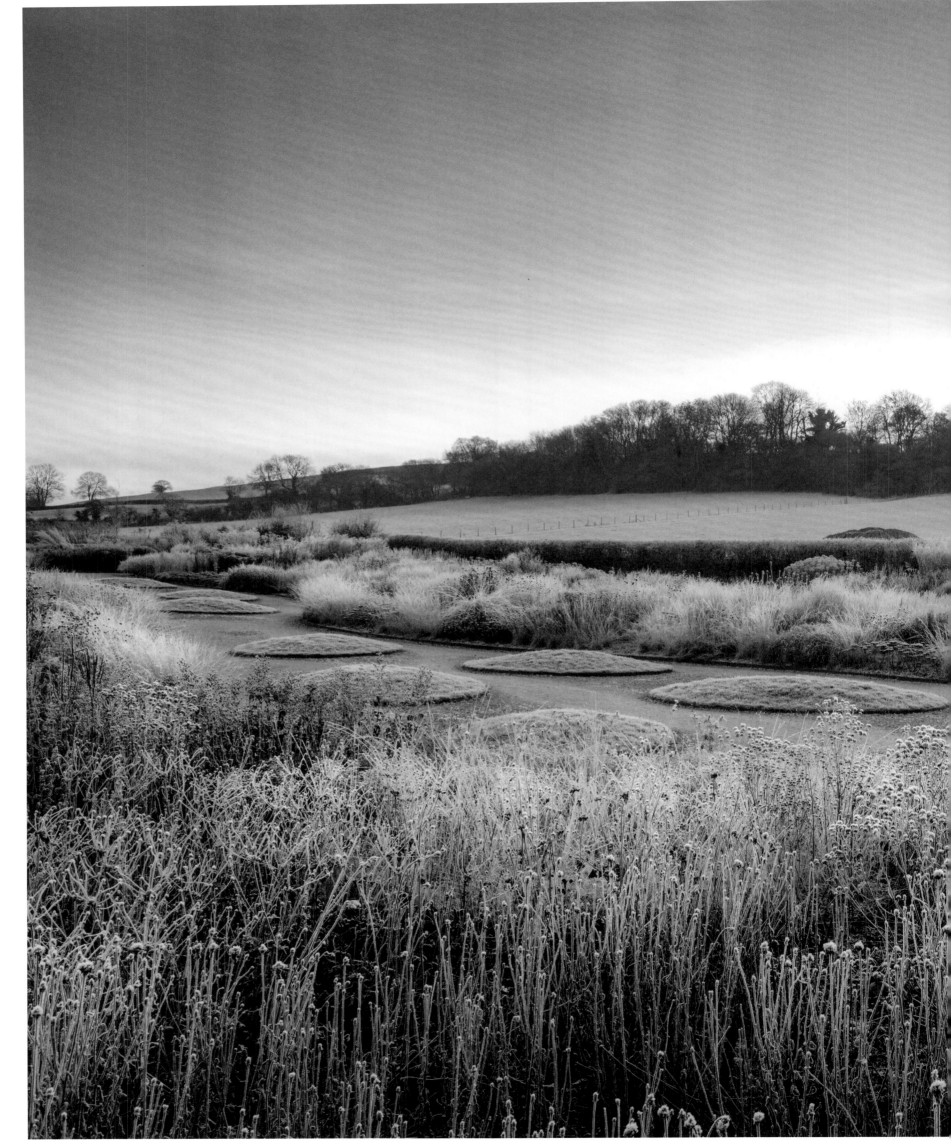

18

Piet Oudolf

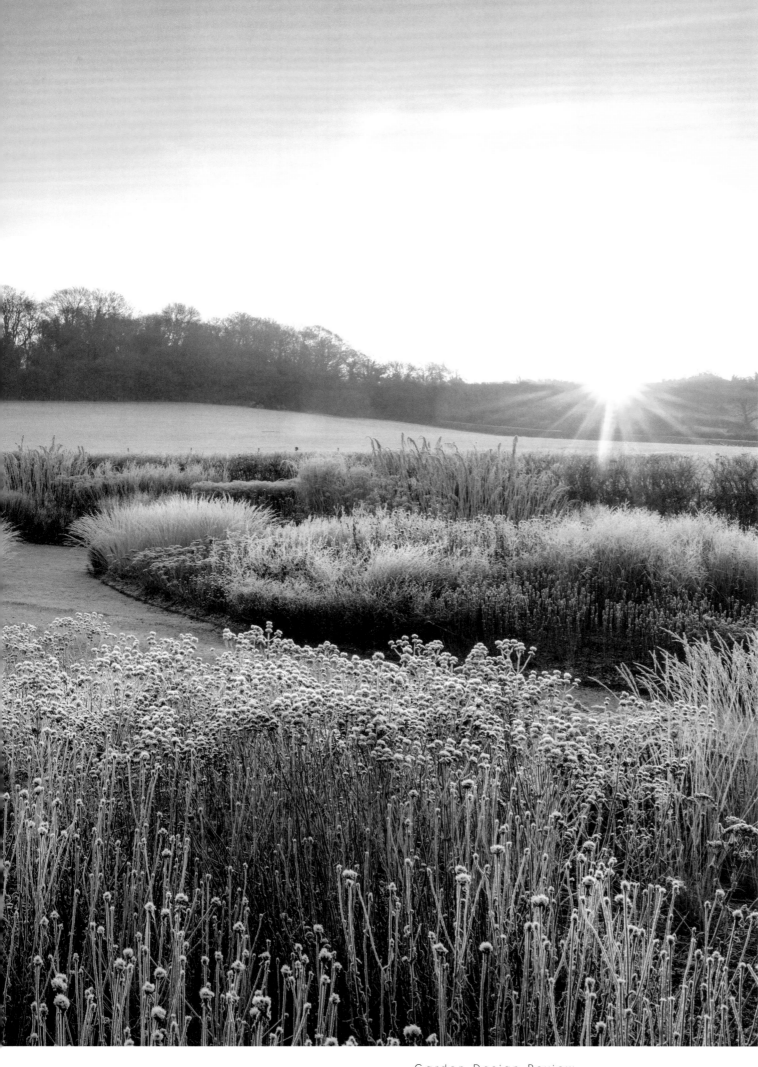

Also when covered
in a morning frost,
these plants impress
visitors with their
texture. Planting
plans are available
to ambitious visitors
as a way to inspire
them to experiment
more in their
own gardens.

Auch im Raureif
beeindrucken die
Pflanzungen mit
ihrer Textur. Für am-
bitionierte Besucher
liegen Pflanzpläne
bereit, die dazu
animieren sollen,
auch im eigenen
Garten mehr zu
experimentieren.

Dès l'aube, les
plantations impres-
sionnent par leur
texture. Et pour les
visiteurs qui ont des
ambitions, des plans
sont mis à disposi-
tion pour les inciter
à expérimenter da-
vantage dans leurs
propres jardins.

Piet Oudolf

The New Naturalism
Der Neue Naturalismus
Le Néonaturalisme

Nature, art and time are Piet Oudolf's parameters for plantings of grasses and perennials that are wild and romantic while also being easy to care for. His garden in Hummelo in the Netherlands has become a pilgrimage site for plant lovers.

Natur, Kunst und Zeit sind Piet Oudolfs Parameter für wildromantische, dabei pflegeleichte Stauden- und Gräserpflanzungen. Sein Garten im niederländischen Hummelo wurde zum Wallfahrtsort für Pflanzenfreunde.

La nature, l'art et le temps sont les éléments qui guident Piet Oudolf dans la création de plantations d'herbes et de plantes vivaces au romantisme sauvage, mais faciles à entretenir. Le jardin qu'il a créé à Hummelo, aux Pays-Bas, est aujourd'hui un lieu de pèlerinage pour les amis des plantes.

©Maarten Schets

What makes your gardens so special?

What I make is metaphorical. The plantings are reminiscent of nature and trigger emotions in the beholder. The gardens that I design are naturalistic, not decoration. It is about processes that one has to foresee because the gardens ought to survive for a long time, even though the plants change dynamically. The seasons are very important to me; a garden should produce an effect even in winter. That is why I work primarily with perennials and grasses. Colors are not as important as structures and textures, leaves, plant parts that have died but are by no means clipped off.

Was macht Ihre Gärten so besonders?

Was ich mache, ist metaphorisch. Die Pflanzungen erinnern an die Natur und lösen beim Betrachter Gefühle aus. Die von mir gestalteten Gärten sind naturalistisch, keine Dekoration. Es geht um Prozesse, die man vorausahnen muss, denn die Gärten sollen lange Zeit bestehen, obwohl sich die Pflanzen dynamisch verändern. Für mich sind die Jahreszeiten sehr wichtig, ein Garten soll auch im Winter wirken. Daher arbeite ich vorwiegend mit Stauden und Gräsern. Farben sind nicht so wichtig wie Strukturen und Texturen, Blätter, abgestorbene Pflanzenteile, die keinesfalls abgeschnitten werden.

Qu'est-ce qui rend vos jardins si particuliers ?

Mon travail est métaphorique. Les plantations rappellent la nature et éveillent des sentiments chez celui qui les contemple. Mes jardins sont naturalistes, ce n'est pas de la décoration. Il s'agit de processus qu'il faut anticiper, car je veux que les jardins aient une vie longue même si les plantes ne cessent de changer. Les saisons sont très importantes pour moi, je veux que le jardin fasse aussi de l'effet en hiver. C'est pour cela que je travaille surtout avec des plantes vivaces et des herbes. Les couleurs ont moins d'importance que les structures et les textures, les feuilles, les parties desséchées qu'il ne faut surtout pas couper.

You experiment a lot and are regarded as a trendsetter ...

Since 1977 we have been occupied with "future plants" in a gardening collective. More than seventy successful strains come from our gardening. These are selections that are valuable for gardens and parks—because of a new color, a new quality or because they are particularly resilient. When we began in Hummelo in 1982, I already had this desire to experiment and find out how to achieve truly good designs with skill and experience. The plants should really be not just beautiful and attractive, but also reliable—ideally also for insects, bees, and birds. At the Lurie Garden in Chicago, I tried to understand prairie plants; that succeeds only by observing and trial and error.

What role does maintenance play in your compositions?

As I more frequently received commissions for public parks, I discovered the advantages of collaborating with others. It enabled me to pass on my ideas. The planting plan is where the work really begins, and after the planting, the enduring success is highly dependent on the people who maintain the park. The informal aesthetics that distinguish my work are borrowed from nature and certainly not easy to maintain. Nature, that is first of all a competition and also chaos. Thus we have to a certain extent formalized the communities

Your freedom as a designer is restricted only by your knowledge.

of plants to obtain stability through plants that get along well and are also adapted to the location. I have a good sense for what will work together well.

Sie experimentieren viel, gelten als Trendsetter ...

Mehr als siebzig erfolgreiche Züchtungen stammen aus unserer Gärtnerei. Seit 1977 befassen wir uns in einem Gärtnerverbund mit „Future Plants". Das sind Selektionen, die für Gärten und Parks wertvoll sind – durch eine neue Farbe, eine neue Qualität oder weil sie besonders widerstandsfähig sind. Als wir 1982 in Hummelo begannen, hatte ich schon diese Experimentierlust, herauszufinden, wie man mit Können und Erfahrung zu wirklich guten Gestaltungen kommt. Die Pflanzen sollen ja nicht nur schön und attraktiv sein, sondern verlässlich – idealerweise auch für Insekten, Bienen und Vögel. Beim Lurie Garden in Chicago versuchte ich, die Präriepflanzen zu verstehen; das geht nur durch Beobachten und Ausprobieren.

Welche Rolle spielt die Pflege bei Ihren Kompositionen?

Als ich zunehmend Aufträge für öffentliche Anlagen bekam, entdeckte ich die Vorteile, mit anderen zusammenzuarbeiten. Das erlaubte es mir, meine Ideen weiterzugeben. Mit dem Pflanzplan beginnt ja erst

Die Freiheit des Gestalters wird nur durch sein Wissen eingeschränkt.

die Arbeit, und nach dem Pflanzen hängt der dauerhafte Erfolg sehr stark von den Menschen ab, die die Anlage pflegen. Die informelle Ästhetik, die mein Werk auszeichnet, ist ja aus der Natur entlehnt und beileibe nicht leicht zu pflegen. Natur, das ist zunächst Wettbewerb und auch Chaos. Also haben wir die Pflanzengesellschaften bis zu einem gewissen Grad formalisiert, um Stabilität zu erhalten durch Pflanzen, die sich vertragen und auch dem Standort angepasst sind. Ich habe ein gutes Gefühl dafür, was funktionieren wird.

Vous expérimentez beaucoup, on vous considère comme un créateur de tendances...

Notre jardinerie a déjà créé plus de soixante-dix variétés recherchées. Depuis 1977, dans le cadre d'un groupement de jardineries, nous travaillons sur un projet appelé « Future Plants ». Il s'agit de sélections comme en recherchent les jardins et les parcs, parce qu'elles apportent du nouveau en matière de couleur, de qualité ou simplement de résistance. Lorsque nous avons commencé à Hummelo en 1982, j'avais déjà cette envie d'expérimenter pour créer des choses

La liberté du créateur n'est limitée que par son savoir.

vraiment intéressantes à partir de mon savoir-faire et de mon expérience. Il ne suffit pas que les plantes attirent le regard, elles doivent aussi être fiables, y compris, dans l'idéal, pour les insectes, les abeilles et les oiseaux. Au Lurie Garden de Chicago, j'ai cherché à comprendre les plantes de prairie et la seule façon d'y parvenir est d'observer et de tester.

Quel rôle joue l'entretien dans vos compositions ?

Lorsque j'ai travaillé pour des espaces publics, j'ai découvert que travailler en équipe me permettait de faire passer mes idées. La conception n'est qu'un début ; une fois la plantation achevée, la réussite dépend très fortement des gens qui entretiennent un site. L'esthétique informelle qui distingue mon travail s'inspire de la nature et l'entretien n'est certainement pas chose facile. Car la nature, c'est d'abord la concurrence et aussi le chaos. Nous avons donc formalisé jusqu'à un certain point les associations de végétaux afin d'obtenir une forme de stabilité en utilisant des plantes qui se supportent tout en étant adaptées au lieu. J'ai en moi cette capacité de bien sentir ce qui peut marcher ou pas.

Tectona

Paris | France

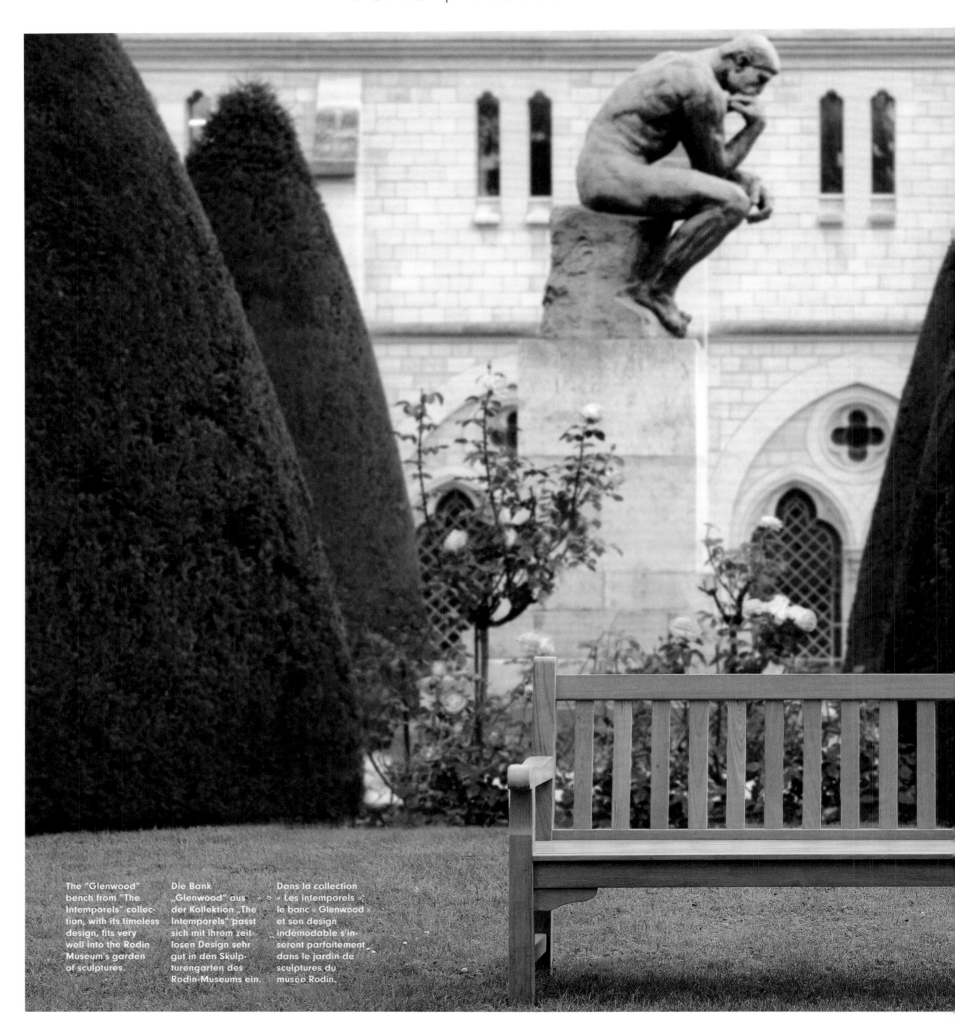

22

The "Glenwood" bench from "The Intemporels" collection, with its timeless design, fits very well into the Rodin Museum's garden of sculptures.

Die Bank „Glenwood" aus der Kollektion „The Intemporels" passt sich mit ihrem zeitlosen Design sehr gut in den Skulpturengarten des Rodin-Museums ein.

Dans la collection « Les intemporels », le banc « Glenwood » et son design indémodable s'insèrent parfaitement dans le jardin de sculptures du musée Rodin.

The outdoor furniture from Tectona features shapes, materials, and design in perfect harmony. | Eine perfekte Harmonie von Formen, Materialien und Design zeichnet die Outdoor-Möbel von Tectona aus. | Les meubles d'extérieur Tectona se distinguent par une harmonie parfaite entre forme, matière et design.

Since 1977 Tectona has been providing furniture for the outdoors that combines timeless design with high-quality materials. Its goal is to offer the best patio furniture that satisfies the requirements for beauty, comfort, and creativity. To achieve this, the company collaborates with renowned designers and invests a lot of energy and care into designing and manufacturing each and every collection. Every piece of furniture is distinguished by quality, timeless elegance, and durability. Numerous famous customers such as the Picasso Museum, the Rodin Museum, and Versailles bear witness to the success of the concept.

Seit 1977 fertigt Tectona Möbel für den Außenraum, die zeitloses Design mit hochwertigen Materialien verbinden. Ihr Ziel ist es, die besten Gartenmöbel anzubieten, die den Anforderungen an Schönheit, Komfort und Kreativität gerecht werden. Dafür arbeitet das Unternehmen mit renommierten Designern zusammen und investiert viel Energie und Sorgfalt in die Entwürfe und die Herstellung jeder einzelnen Kollektion. Jedes Möbelstück zeichnet sich durch Qualität, Eleganz und Langlebigkeit aus. Zahlreiche berühmte Kunden wie das Picasso-Museum, das Rodin-Museum und Versailles zeugen von dem Erfolg des Konzepts.

Tectona produit depuis 1977 des meubles d'extérieur qui allient design intemporel et matériaux d'excellence. Son but est de proposer le meilleur du mobilier de jardin répondant à une exigence de beauté, confort et créativité. L'entreprise travaille pour cela avec des designers renommés et investit beaucoup d'énergie et de soin dans la conception et la fabrication de chaque collection. Chaque meuble se caractérise par son niveau de qualité, son élégance et sa capacité à résister au temps. De nombreux clients réputés, comme le musée Picasso, le musée Rodin et Versailles témoignent du succès du concept.

For the "Southampton" flow armchair and footrest, designer Christophe Delcourt creates a work of art to combine distinct edges and soft lines.

Für den Sessel und die Fußablage „Southampton" schafft Designer Christophe Delcourt das Kunststück, klare Kanten mit sanften Linien zu kombinieren.

Pour le fauteuil et le repose-pieds « Southampton », le designer Christophe Delcourt a réussi un tour de force en associant des arêtes claires à des lignes douces.

The "Chelsea" line
from Constance
Guisset Studio has a
modular design. The
aluminum furniture
has an air of light-
ness and can be
arranged however
you want.

Die Linie „Chelsea"
von Constance
Guisset Studio ist
modular aufgebaut.
Die leicht wirkenden
Alumöbel lassen
sich nach Belieben
arrangieren.

La ligne « Chelsea »
du studio Constance
Guisset est de
conception modu-
laire. Offrant une
apparence de
belle légèreté, ces
meubles en alumi-
nium se combinent
à volonté.

26

Timeless and taking inspiration from English gardens, the carefully handcrafted well-rounded bench in teak defies the elements, lasting for decades.

Zeitlos und von englischen Gärten inspiriert: Die sorgfältig von Hand gefertigte runde Teakholz-Bank trotzt Wind und Wetter und überdauert Jahrzehnte.

Intemporalité inspirée des jardins anglais : ce banc circulaire en teck de fabrication artisanale sait résister à la pluie et au vent pendant des décennies.

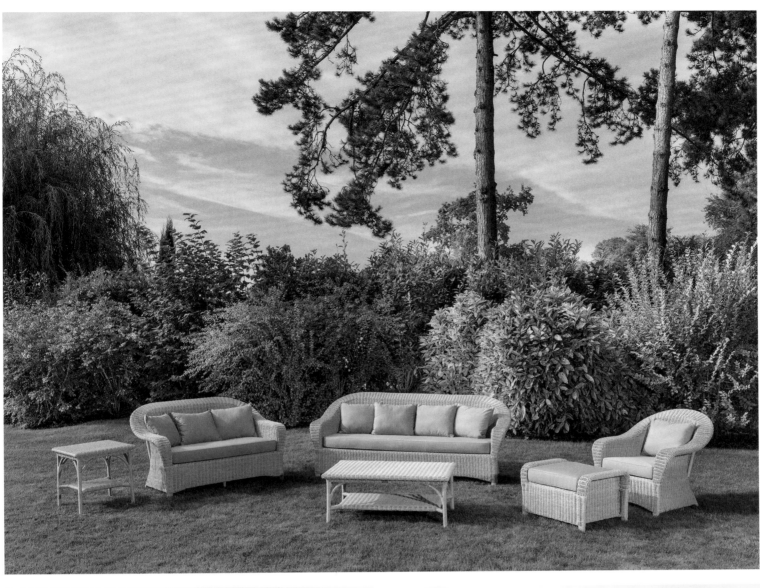

Left: The "Colonial" series made with a rattan-like fiber. Below: The original of this bench initially stood in the garden of the French grande dame of interior design, Madeleine Castaing. The bench provided Tectona's inspiration for the "1800" collection.

Links: Die Serie „Colonial" aus Rattan. Unten: Das Original dieser Bank stand ursprünglich im Garten der französischen Grande Dame des Interior Designs, Madeleine Castaing. Die Bank diente Tectona als Inspiration für die Kollektion „1800".

À gauche : Série « Colonial » en rotin. En bas : L'original de ce banc se trouvait dans le jardin de la grande décoratrice française Madeleine Castaing. Tectona s'en est inspiré pour sa collection « 1800 ».

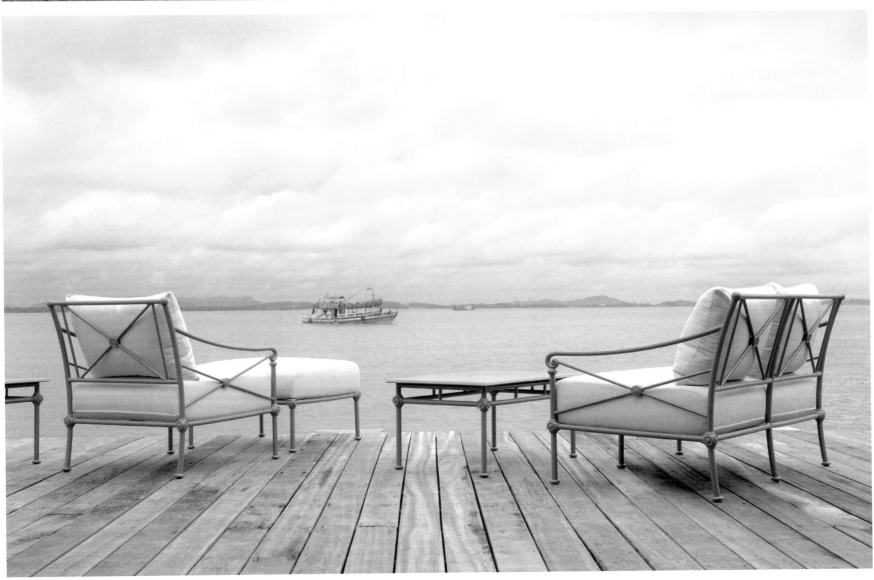

Selling Trees

Tree Brokers:
Service Providers for Plants

The job title "broker" is normally associated with the stock market, with the exchange of stocks and securities. In these transactions, the broker acts as a mediator, arbitrator or go-between. He is a financial service provider. Tree brokers also sell things, but unlike stock brokers, they sell living things: trees.

The garden culture that has deep roots in Europe, as evidenced by numerous wonderful gardens and parks, has been a part of our history and identity for centuries. A large part of their aesthetic is created by selecting the right plants. What would the baroque gardens be without their hidden, secluded areas, surrounded by massive, trimmed hedges? What would landscape gardens be without impressive specimen plants? What would numerous town squares and boardwalks be without a canopy created by plane trees? Even trees can even be a key element in the layout and character of a garden, park or plaza. The thin shade of a delicate birch creates an atmosphere that's completely different from the dense shade of a venerable linden tree.

It is not always easy to find the right specimen in a tree nursery. Spoiled for choice: Over the past 150 years, numerous tree nurseries have developed in Europe and become increasingly larger. Important centers are Northern Italy, the Dordogne in France, and various regions in England, the Netherlands, and Germany. Many tree nurseries grow a wide variety of plants independently, resulting in a tremendous variety of tree nurseries of different sizes. The right tree cannot always be found at the nearest accessible tree nursery. This is especially true when the requests are unusual: One example is if a highly distinctive tree, such as an old pin oak, is the definitive focus of a garden design. Or if a storm has felled a picture-perfect tree specimen in a historic park. Even the request for varietal identity in rare tree species can pose a challenge. Working with a single tree nursery often requires accepting restrictions and, sometimes, making compromises in terms of quality. This is where tree brokers step in. They have established a large network with various tree nurseries that are often specialized. They are familiar with their plant species, the special characteristics and know where to find special, rare plants. Nothing gets by them. These plant service providers find the right tree species and handle the logistics and planting. These are mostly large, old trees that must be handled with great care and transported and planted by individuals who have a deep specialized knowledge in this subject area.

European tree brokers imported this profession from the US, where it has been practiced since the 1960s. It is still a rare profession in Europe. But experience shows that the demand for it is increasing here as well. An impressive building should be coupled with a tree specimen that is just as impressive and will have an effect that won't take decades to be felt. The more specialized the requests, the more difficult the search that tree brokers perform.

Ralf Knoflach is one of the few tree brokers in Germany, and he has been selling trees across Europe for 15 years at "green | Gartenkultur."

Mr. Knoflach, the tree broker profession was virtually unknown in Europe at the time. What made you decide to take this path?

In the 1980s, I was quite fortunate to work in Germany, Italy, France, and the US. Traveling overseas at the time was a big step, but to this day I'm glad that I took that step. I've never learned as many surprising and new things as I did during these trips.

The decisive moment of inspiration came when I was working at a tree nursery in Princeton, New Jersey for a few months. This company operated a separate agency that searched for plants specifically requested by architects. Generally, these were rare or very large or distinctive specimens for projects throughout North America. This agency was called "Tree Broker", and my idea for Europe was born! After all, there are also a wide variety of private builders, building architects and landscape architects in Europe that simply don't have the time to search through numerous tree nurseries to create a specific design and to find the absolute best plants for their garden, courtyard, terrace or park.

What happened next?

I began to expand and optimize my Europe-wide network of tree nurseries, to which I had devoted much of my time establishing. Now, teams throughout Europe work to find the right trees for garden enthusiasts, and deal with the transport, logistics, and planting processes. Over the past 15 years, we have sold hundreds of trees to parks. The largest was an American Pin Oak: It was 49 feet (15 meters) tall and 23 feet (7 meters) wide. It weighed 16.5 US tons (15 metric tons) and a special transport method had to be used to move it from Pistoia, Italy to Paris, France. We supervised this process. It was a logistical masterpiece. We also searched for and found some 33-foot (10-meter) high hedges that had already been trimmed, transported them to the destination and planted them there. We also offer a growth guarantee for these mature trees and hedge plants. Of course, the requirement here is that these plants be given the proper care.

So your area of focus is still Europe?

Yes, that's right. We supervise planners and projects throughout Europe. Our area of operations now spans all the way to St. Petersburg and Moscow. But we're also currently acting as a consultant for the office of the architect Renzo Piano in Seoul and are looking for plants for him in South Korea. So we don't limit ourselves to just one continent. As some of the few tree brokers active in Europe, we are able to frequently work for planners located outside of Europe.

28

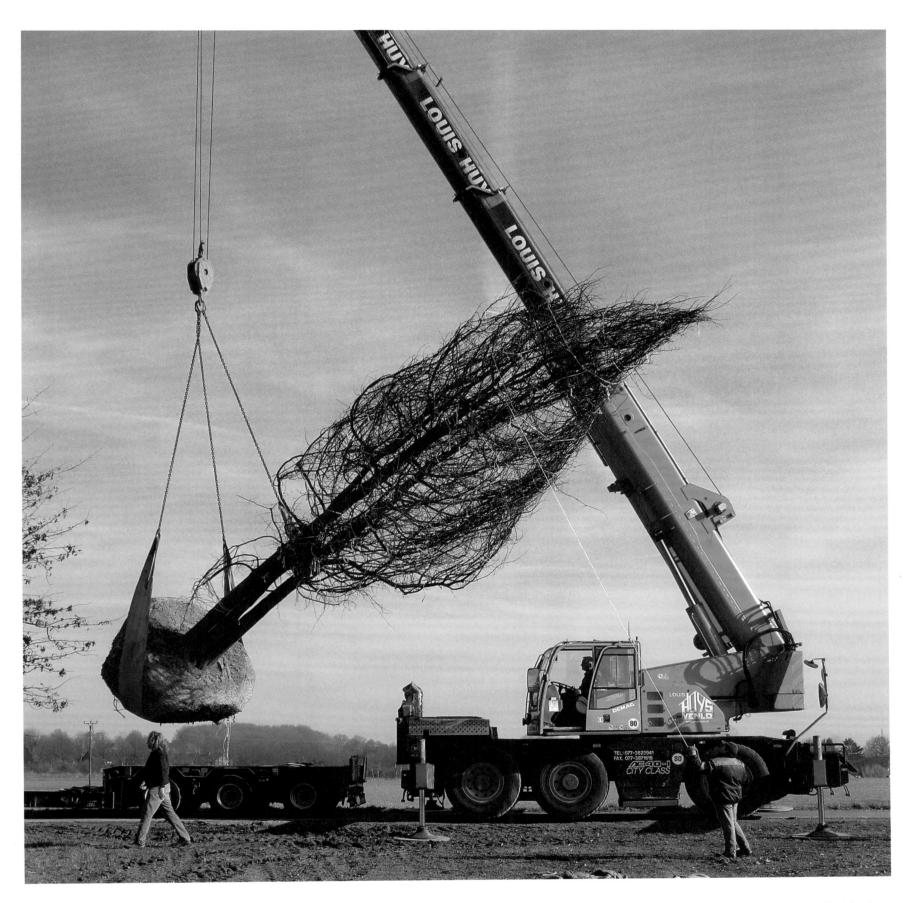

Your profession requires you to have a detailed knowledge of the various tree species. How do you manage to keep abreast of the inventory in the tree nurseries?

My team and I record all of the specimen tree species of interest at each individual tree nursery in our database. These entries include images and exact dimensions. Of course, we visit the sellers at specific intervals to keep the data up-to-date at all times. Our specialists also inspect the tree species for damage and diseases to ensure that we only deliver plants with perfect health. We have to perform these inspections on a regular basis because we are working with living things that are constantly growing and changing. But this is what's interesting about our job. We never get bored. It is always fascinating to see how a specimen plant changes over the years, develops certain characteristics and grows to become a truly unique tree. And, at some point, this specimen becomes the key feature that defines the atmosphere of a garden or park.

This 50-year old, 49-foot (15-meter) high, multi-stemmed oak now stands in a private garden in Paris. The 16.5-US ton (15-metric ton) showcase specimen came from a tree nursery in Italy.

Diese 50 Jahre alte, 15 Meter hohe mehrstämmige Eiche steht heute in einem Privatgarten in Paris. Das 15-Tonnen-Prachtexemplar stammt aus einer Baumschule in Italien.

Ce chêne à plusieurs troncs a 50 ans et mesure 15 mètres de haut ; il orne aujourd'hui un jardin privé de Paris. Ce spécimen fantastique de 15 tonnes provient d'un pépiniériste italien.

Bäume vermitteln

Tree Broker: die Dienstleister für Pflanzen

Den Beruf Broker verbindet man normalerweise mit der Börse, mit dem Handel von Aktien und Wertpapieren. Bei diesen Geschäften fungiert der Broker als Makler, als Vermittler oder Zwischenhändler. Er ist ein Finanzdienstleister. Tree Broker vermitteln auch etwas, aber im Gegensatz zu Börsenmaklern etwas Lebendiges: Bäume.

Die Gartenkultur, tief verankert in Europa, ist durch zahllose wunderbare Gärten und Parkanlagen seit Jahrhunderten wichtiger Teil unserer Geschichte und Identität. Ihre Ästhetik beruht immer auch auf der Auswahl der passenden Pflanzen. Was wären die Barockgärten ohne ihre versteckten, lauschigen Orte, umgeben von mächtigen geschnittenen Hecken? Was die Landschaftsgärten ohne die beeindruckenden Solitäre? Was zahlreiche Stadtplätze und Uferpromenaden ohne ihr Platanendach? Gerade Bäume tragen wesentlich zur Raumbildung und zum Charakter eines Gartens, eines Parks oder eines Platzes bei. Der lichte Schatten einer filigranen Birke erzeugt eine völlig andere Atmosphäre als der dichte Schatten einer ehrwürdigen Linde.

Nicht immer ist es leicht, das passende Exemplar in einer Baumschule zu finden. Wer die Wahl hat, hat die Qual: In den vergangenen 150 Jahren haben sich in Europa zahlreiche, immer größere Baumschulen entwickelt. Wichtige Zentren sind Norditalien, die Dordogne in Frankreich, verschiedene Gegenden in England, den Niederlanden und in Deutschland. Viele Baumschulen produzieren autark ein breites Sortiment. Die Folge ist eine kaum zu überschauende Vielfalt an Baumschulen unterschiedlicher Größe. Nicht immer lässt sich der Idealbaum im nächst erreichbaren Betrieb finden. Vor allem, wenn es um ausgefallene Wünsche geht:

Wenn ein sehr charakteristischer Baum der entscheidende Mittelpunkt eines Gartenentwurfs ist, wie zum Beispiel eine alte Mooreiche. Oder in einem historischen Park ein besonders malerisches Baumexemplar von einem Sturm gefällt wurde. Auch der Wunsch nach Sortenechtheit bei seltenen Gehölzen kann zur Herausforderung werden. Die Zusammenarbeit mit nur einer Baumschule bedeutet dann oft, Einschränkungen hinnehmen zu müssen und manchmal auch, Kompromisse in der Qualität einzugehen. Hier setzen die Tree Broker an. Sie haben sich ein großes Netzwerk zu verschiedenen, oft auch zu spezialisierten Baumschulen aufgebaut. Sie kennen deren Sortimente, die Besonderheiten und wissen, in welchen Quartieren sich spezielle Raritäten verstecken. Ihnen entgeht nichts, und so finden die Pflanzendienstleister die passenden Gehölze, kümmern sich um die Logistik und auch um die Pflanzung. Denn meistens handelt es sich um große, alte Bäume, die mit großer Sorgfalt zu behandeln sind, und deren Transport und Pflanzung eine außerordentliche Fachkenntnis erfordern.

Importiert haben die europäischen Baummakler den Beruf aus den USA, wo er bereits seit den 1960er-Jahren ausgeübt wird. In Europa ist er immer noch selten. Doch die Erfahrung zeigt: Die Ansprüche steigen auch hier. Dem repräsentativen Neubau soll ein ebenso repräsentatives Baumexemplar zur Seite gestellt werden, auf dessen Wirkung nicht Jahrzehnte gewartet werden muss. Je spezieller die Wünsche, desto schwieriger gestaltet sich die Suche –, die dann die Baummakler übernehmen.

Einer der wenigen Tree Broker in Deutschland ist Ralf Knoflach, der seit 15 Jahren mit seiner Firma „green | Gartenkultur" Bäume innerhalb ganz Europas vermittelt.

Herr Knoflach, in Europa war damals der Beruf Tree Broker noch nahezu unbekannt. Wie kam es dazu, dass Sie diesen Weg einschlugen?

In den Achtzigerjahren hatte ich das große Glück auf meinen beruflichen Wanderjahren Stationen in Deutschland, Italien und Frankreich einzulegen – und auch in den USA. Bis nach Übersee war es damals noch ein großer Schritt, und ich bin bis heute froh, dass ich ihn wagte. Denn nirgendwo habe ich mehr Überraschendes und Neues kennengelernt als dort.

Den entscheidenden Impuls erhielt ich in einer Baumschule in Princeton, New Jersey, in der ich einige Monate tätig war. Dieser Betrieb unterhielt eine eigene Agentur, die für Architekten gezielt nach Pflanzen suchte. Es ging in aller Regel um seltene, besonders große oder charakteristische Exemplare für Projekte in ganz Nordamerika. Diese Agentur nannte sich „Tree Broker", meine Idee für Europa war geboren! Denn auch dort gab es eine Vielzahl an privaten Bauherrn, Hochbauarchitekten und Landschaftsarchitekten, denen schlicht die Zeit fehlte, zahlreiche Baumschulen nach dem Passenden zu durchforsten und das wirklich Beste für ihren Garten, ihren Innenhof, ihre Terrasse oder ihren Park zu finden.

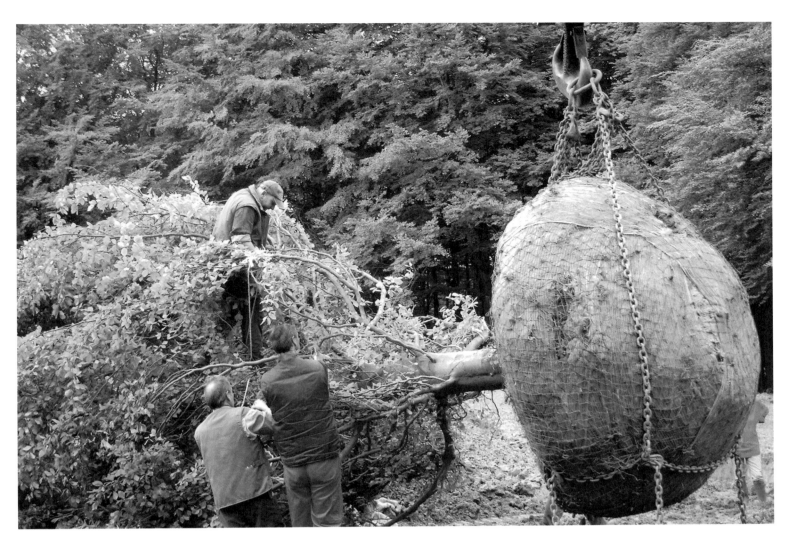

A plant hunter in Essen bought this impressive 40-year old and 43-foot (13-meter) high common beech specimen from northern Germany to add a nice touch to his garden. Its weight during transport was 13.8 US tons (12.5 metric tons).

Ein Pflanzensammler in Essen bereicherte seinen Garten um dieses beeindruckende Exemplar einer 40 Jahre alten und 13 Meter hohen Rotbuche aus Norddeutschland. Sie brachte beim Transport 12,5 Tonnen auf die Waage.

Un collectionneur botaniste de Essen (Allemagne) a embelli son jardin avec cet impressionnant spécimen d'un hêtre rouge de 40 ans et 13 mètres de hauteur, provenant du nord de l'Allemagne. Au moment du transport, la balance indiquait pas moins de 12,5 tonnes.

Wie ging es dann weiter?

Ich fing an, mein europaweites Netzwerk an Baumschulen, das ich mir mit der Zeit aufgebaut hatte, auszuweiten und zu optimieren. Heute kümmern sich Teams in ganz Europa darum, den passenden Baum für Gartenliebhaber zu finden, ebenso um Transport und Logistik und die Pflanzung. So haben wir in den vergangenen 15 Jahren hunderte Parkbäume vermittelt. Der größte war eine Amerikanische Sumpfeiche: 15 Meter groß und sieben Meter breit. Sie wog 15 Tonnen und musste per Spezialtransport – von uns begleitet – von Pistoia in Italien bis nach Paris transportiert werden. Das war ein logistisches Meisterwerk. Auch bereits fertig geschnittene Hecken von zehn Meter Höhe haben wir bereits gesucht, gefunden, zum Zielort gebracht und dort eingepflanzt. Wir geben auch für diese ausgewachsenen Bäume und Heckenpflanzen eine Anwuchsgarantie. Voraussetzung ist natürlich, dass fachgerecht gepflegt wird.

Ihr Schwerpunkt liegt also nach wie vor in Europa?

Ja, das stimmt. Wir betreuen Planer und Projekte in ganz Europa, unser Aktionsraum reicht inzwischen sogar bis nach St. Petersburg und nach Moskau. Doch wir sind derzeit zum Beispiel auch als Consultant für das Büro des Architekten Renzo Piano in Seoul tätig und daher in Südkorea auf Pflanzensuche. Wir beschränken uns also nicht zwingend auf einen Kontinent. Da wir einige der wenigen in Europa tätigen Tree Broker sind, kommt es immer wieder vor, dass wir für hiesige Planer auch außerhalb von Europa tätig werden dürfen.

Sie brauchen für Ihren Beruf ein detailliertes Wissen über das Angebot. Wie gelingt es Ihnen, den Überblick über die Bestände der Baumschulen zu haben?

Mein Team und ich halten sämtliche interessanten Solitärgehölze der einzelnen Baumschulen in unserer Datenbank fest. Mit Bildern und genauen Maßen. Natürlich besuchen wir die Händler in bestimmten Abständen, um die Daten immer aktuell zu halten. Außerdem überprüfen unsere Spezialisten die Gehölze auf Beschädigungen und Krankheiten, damit wir wirklich nur einwandfreie Pflanzen liefern können. Auch das müssen wir regelmäßig machen, denn wir arbeiten mit Lebewesen, die sich ständig weiterentwickeln. Aber das ist das Interessante an unserem Beruf, uns wird nie langweilig. Es ist immer wieder spannend zu beobachten, wie sich ein Solitär über die Jahre verändert, besondere Eigenarten herausbildet, und zu einem wahrlich einzigartigen Baum heranwächst. Und irgendwann die Atmosphäre eines Gartens oder Parks ganz wesentlich prägt.

Chercheur d'arbres
Le courtier en arbres : au service des plantes

Le plus souvent, on associe la profession de courtier à la finance ou aux assurances. Dans ces secteurs, le courtier joue le rôle d'intermédiaire ou d'agent entre un vendeur et un acheteur. C'est un prestataire de services financiers. Le courtier en arbres est lui aussi un intermédiaire, mais un intermédiaire qui travaille sur des produits vivants : les arbres.

Profondément ancrée en Europe, la culture du jardin constitue depuis des siècles un aspect important de notre histoire et de notre identité, comme le montrent les innombrables jardins et parcs merveilleux qui la parsèment. Leur esthétique repose toujours au moins en partie sur le choix des espèces botaniques. Que seraient les jardins baroques sans leurs espaces cachés où l'on se sent bien, entourés de grandes haies bien taillées. Et que seraient les jardins paysagers sans leurs impressionnants arbres isolés ? Et les nombreuses places urbaines et promenades le long des rives de fleuves sans leurs couvertures de platanes ? Les arbres jouent un rôle essentiel dans la configuration des espaces et dans le caractère des jardins, des parcs ou simplement des places. L'ombre clairsemée d'un bouleau fin crée une atmosphère qui n'a rien à voir avec celle d'un vieux tilleul à l'énorme couronne.

Il n'est pas toujours facile de trouver chez un pépiniériste le spécimen qu'on a imaginé. Et avoir l'embarras du choix ne facilite pas non plus les choses : durant les 150 dernières années, les pépinières se sont multipliées en Europe, souvent de plus en plus grandes. On trouve des centres importants dans le nord de l'Italie, en Dordogne, dans diverses régions d'Angleterre, aux Pays-Bas et en Allemagne. Beaucoup de pépiniéristes produisent eux-mêmes des gammes vastes d'espèces. Au bout du compte, on se retrouve face une diversité de pépinières qui rendent la tâche quasiment impossible. Par ailleurs, il n'est pas toujours possible de trouver à proximité de chez soi l'arbre dont on rêve, en particulier lorsqu'on a des désirs un peu exotiques : comme lorsqu'un arbre très caractéristique doit constituer le cœur ou le point d'attraction principal d'un projet paysager, par exemple un vieux chêne des marais. Ou bien pour un parc historique, un spécimen particulièrement pittoresque abattu par une tempête. La recherche d'espèces authentiques rares peut parfois aussi se transformer en défi. Travailler avec un seul pépiniériste oblige souvent à accepter des restrictions, parfois même des compromis sur le plan de la qualité. Les courtiers peuvent pallier cette difficulté. Ils bénéficient d'un vaste réseau de pépiniéristes, souvent spécialisés, dont ils connaissent les gammes de produits et les particularités, et ils savent dans quels coins se cachent les produits rares. Rien ne leur échappe, et ces prestataires de services trouvent les espèces adaptées, s'occupent de la logistique ainsi que de la replantation. Il s'agit en effet souvent d'arbres anciens de grande taille, qu'il faut donc traiter avec beaucoup de soin, et dont le transport et la transplantation requièrent un savoir-faire très poussé.

Cette profession nous est venue des États-Unis où elle est déjà pratiquée depuis les années soixante. En Europe, elle est encore rare. Mais l'expérience montre que les exigences augmentent chez nous aussi. Beaucoup de clients veulent des jardins de prestige dont un spécimen rare constituera le point d'attraction, mais il leur faudra attendre parfois des décennies pour obtenir l'effet recherché. Et plus les souhaits sont pointus, plus la recherche est délicate. C'est là que le courtier peut intervenir.

Un des rares courtiers en arbres allemands est Ralf Knoflach, qui recherche des arbres dans toute l'Europe depuis 15 ans dans le cadre de sa société « green | Gartenkultur ».

Monsieur Knoflach, la profession de courtier en arbres était encore presque inconnue en Europe il y a peu. Comment en êtes-vous venu à vous lancer dans cette voie ?

Dans les années quatre-vingt, j'ai eu la grande chance de séjourner en Allemagne, en Italie et France, mais aussi aux USA, dans le cadre de mes années de migration professionnelle. À l'époque, aller outremer était encore quelque chose de rare, et je suis heureux d'avoir osé me lancer. C'est en effet là que j'ai découvert les nouveautés qui m'ont le plus surpris.

L'impulsion décisive m'est venue d'un pépiniériste de Princeton, au New Jersey, où j'ai travaillé pendant quelques mois. Cette entreprise avait sa propre agence qui recherchait des plantes pour le compte d'architectes. En général, il s'agissait de spécimens rares, très grands ou caractéristiques, destinés à des projets nord-américains. Cette agence se qualifiait elle-même de « tree broker » : c'est l'idée que j'ai reprise pour l'Europe ! En effet, il existait ici aussi un grand nombre de maîtres d'ouvrage privés, d'architectes de grands projets et de paysagistes qui n'avaient tout simplement par le temps de se lancer dans des recherches compliquées chez les nombreux pépiniéristes pour y trouver ce qu'il y a de mieux pour leurs jardins, leurs cours intérieures, leurs terrasses ou leurs parcs.

Et de quelle manière votre activité a-t-elle évolué ?

J'ai commencé à étendre et à optimiser le réseau européen de pépinières que je m'étais constitué avec le temps. Aujourd'hui, dans toute l'Europe, des équipes travaillent à rechercher précisément l'arbre que désirent des passionnés de jardin, puis à en organiser le transport, la logistique et la replantation. Durant les 15 dernières années, nous avons ainsi recherché et trouvé des centaines

32

d'arbres de parc. Le plus grand était un chêne des marais américain : d'une hauteur de 15 mètres, il mesurait sept mètres de large. Comme il pesait 15 tonnes, il a fallu organiser un transport spécial, que nous avons accompagné, de la ville italienne de Pistoia à Paris. Sur le plan logistique, cela a constitué un vrai chef-d'œuvre. Mais nous avons aussi déjà recherché des haies taillées complètes de dix mètres de haut et les avons transportées et plantées sur le lieu de destination. Pour ces arbres et haies déjà adultes, nous accordons une garantie de reprise, bien entendu sous réserve d'un entretien dans les règles de l'art.

Votre activité se concentre donc toujours surtout sur l'Europe.

Oui, effectivement, nous travaillons avec des architectes et urbanistes pour des projets dans toute l'Europe, y compris jusqu'à Saint-Pétersbourg ou Moscou. Mais nous jouons actuellement aussi le rôle de consultant pour le cabinet d'architecte Renzo Piano à Séoul et recherchons donc à ce titre des plantes en Corée du Sud. Nous ne nous limitons donc pas forcément à un seul continent. Comme nous sommes un des rares courtiers en arbres en Europe, il est fréquent que des architectes de notre continent fasse appel à nous lorsqu'ils ont des projets hors d'Europe.

Dans votre métier, vous avez besoin de connaissances approfondies de ce qui existe sur le marché. Comment parvenez-vous à avoir une vision d'ensemble des offres des pépiniéristes ?

Mon équipe et moi, nous entretenons une base de données qui liste tous les arbres isolés intéressants de chaque pépiniériste, avec des photos et leurs dimensions exactes. Et bien entendu, nous allons voir périodiquement les distributeurs pour mettre nos données à jour. De plus, nos spécialistes examinent les arbres pour s'assurer de leur bonne santé, afin que nous puissions livrer exclusivement des végétaux en parfait état. Nous sommes obligés de faire cela régulièrement, car nous travaillons sur du vivant qui évolue en permanence. Mais c'est justement ce qui est intéressant dans notre métier, et nous ne nous ennuyons jamais. Il est vraiment passionnant d'observer l'évolution des arbres sur plusieurs années ; parfois, des caractéristiques spécifiques se développent et un arbre devient un spécimen vraiment unique. Ces arbres sont capables à eux seuls de donner à un jardin ou à un parc une atmosphère incomparable.

For a park belonging to an exclusive estate in Vienna, the customer chose 35-year old, 39-foot (twelve-meter) high and 19- to 23-foot (six- to seven-meter) wide plane trees from France.

Für den Park einer exklusiven Immobile in Wien entschied sich der Auftraggeber für 35 Jahre alte, zwölf Meter hohe und sechs bis sieben Meter breite Platanen aus Frankreich.

Pour le parc d'un bien immobilier exclusif situé à Vienne, le client a voulu des platanes de France, âgés de 35 ans et mesurant douze mètres de haut et de six à sept mètres de large.

Great Dixter

East Sussex | England

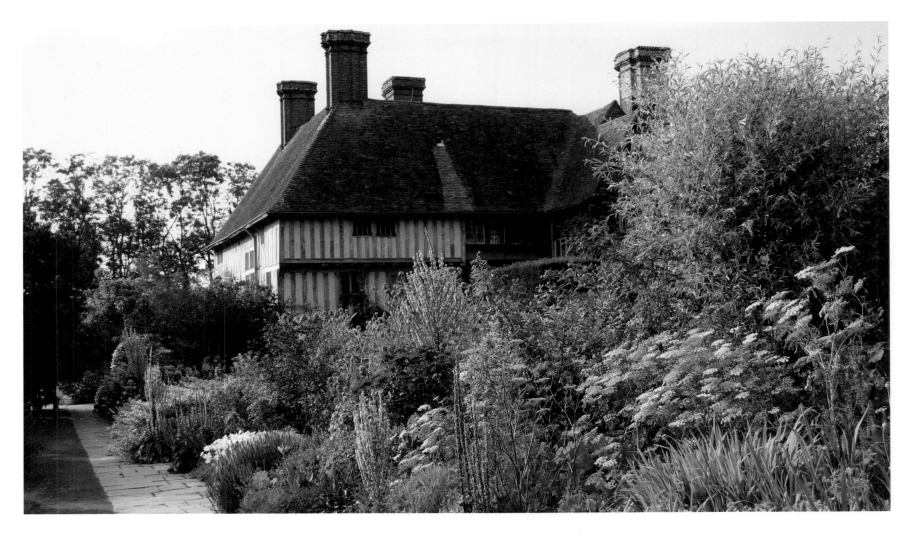

34

The gardens of Great Dixter are closely knitted with the buildings and famous for their experimental planting beds. | Die Gärten von Great Dixter sind eng verzahnt mit den Gebäuden und berühmt für ihre experimentellen Pflanzbeete. | Les jardins de Great Dixter sont étroitement imbriqués avec les bâtiments et sont célèbres pour leurs massifs végétaux expérimentaux.

Great Dixter consists of multiple buildings joined by the architect Edwin Lutyens after the Lloyd family bought the estate. Lutyens also designed the many garden spaces that blend into each other. But it was Christopher Lloyd, gardener and gardening author, who brought fame to the grounds with topiary, flower meadows, sunken gardens and luxurious borders with perennials, annuals, and bushes. The optical effect of the flowering plants stands at the fore; hedges, walls, and trees provide them with structure.

Great Dixter besteht aus mehreren Gebäuden, die der Architekt Edwin Lutyens zusammenfügte, nachdem die Familie Lloyd das Anwesen gekauft hatte. Lutyens legte auch die vielen Gartenräume an, die ineinander übergehen. Doch Christopher Lloyd, Gärtner und Gartenautor, machte die Anlage mit Topiary (Formschnitt), Blumenwiesen, Senkgarten sowie üppigen Rabatten mit Stauden, Einjährigen und Sträuchern berühmt. Die optische Wirkung der Blütenpflanzen steht im Vordergrund, Hecken, Mauern und Bäume geben diesen Struktur.

Great Dixter est constitué de plusieurs bâtiments réunis par l'architecte Edwin Lutyens après l'achat de la propriété par la famille Lloyd. Lutyens a aussi créé les jardins qui sont reliés les uns aux autres. Mais c'est Christopher Lloyd, jardinier et auteur de livres sur les jardins, qui a été à l'origine de la célébrité du lieu avec l'art topiaire (taille décorative), les prairies fleuries, les jardins en bassin ainsi que les plates-bandes luxuriantes de plantes vivaces et remontantes et d'arbustes. L'accent est mis sur l'effet visuel suscité par les plantes en fleurs, dans une structure constituée de haies, de murs et d'arbres.

Top: Great Dixter in July: Richly flowering border as typical English garden art. Right: The Wall Garden is surrounded by a wall and provides ideal conditions for a wide variety of potted plants and bedding plants.

Oben: Great Dixter im Juli: Reich blühende Rabatte als typisch englische Gartenkunst. Rechts: Der Wall Garden ist ummauert und bietet der Topf- und Beetpflanzenvielfalt ideale Bedingungen.

En haut : Great Dixter en juillet : plates-bandes richement fleuries, typiques de l'art anglais du jardin. À droite : Le Wall Garden est entouré d'un mur et offre des conditions idéales à une grande diversité de plantes en pots et en massifs.

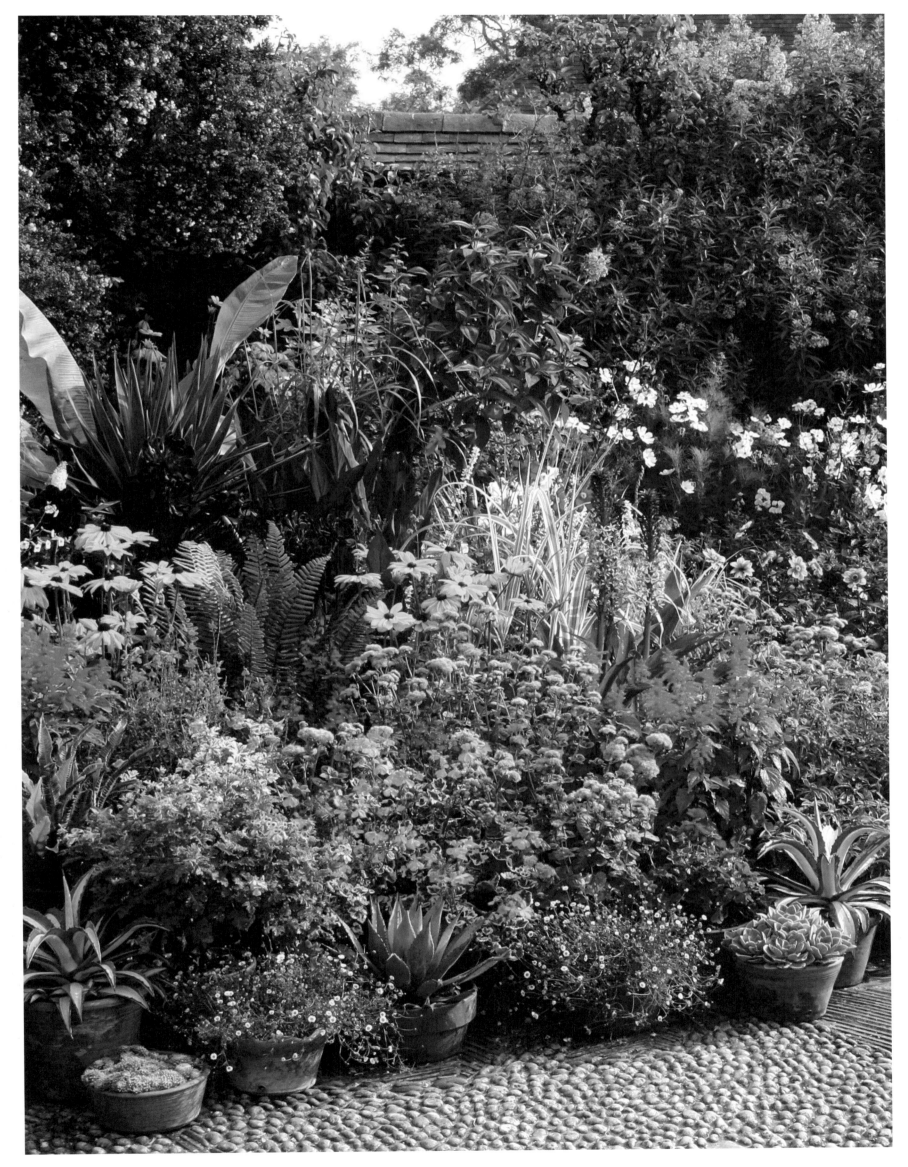

Great Dixter

The walled garden at the foot of Castle Baldern on the Romantic Road: a brief stay in paradise. | Der Walled Garden am Fuße von Schloss Baldern an der Romantischen Straße: eine Stippvisite im Paradies. | Au pied du château de Baldern, le long de la Route romantique, le walled garden (jardin entouré de murs) invite à une visite éclair au paradis.

On one of the most karstified pieces of land of Castle Baldern, Princess Anna of Oettingen-Wallerstein and garden designer Susanne Christner created a garden paradise encircled by yew hedges—a walled garden in the style of an 18th-century English country garden. The different spaces in the garden whisk visitors away to a world far from removed everyday life. Each area offers its own unique experience, from the cool, shady woodland garden to the romantic, enchanted rose garden with its rare varietals.

Auf einem verkarsteten Stück Land an Schloss Baldern schufen Prinzessin Anna zu Oettingen-Wallerstein und die Gartendesignerin Susanne Christner ein Gartenparadies, umschlossen von Eibenhecken: einen Walled Garden im Stil der englischen Landhausgärten des 19. Jahrhunderts. Unterschiedliche Gartenräume entführen die Besucher in eine Welt fernab des Alltags. Jeder Bereich bietet eine eigene Erfahrungswelt: sei es der kühle, schattige Waldgarten oder der romantisch-verzauberte Rosengarten mit seinen seltenen Züchtungen.

Au château de Baldern, sur un morceau de terre karstique, la princesse Anna zu Oettingen-Wallerstein et la designer paysagiste Susanne Christner ont créé un jardin paradisiaque entouré de haies d'ifs : un walled garden dans le style des jardins campagnards anglais du 19e siècle. Le visiteur est emporté vers un monde éloigné du quotidien dans différents espaces qui offrent chacun une expérience différente à vivre : par exemple le bois frais et ombragé ou la roseraie au charme romantique avec ses variétés rares.

36

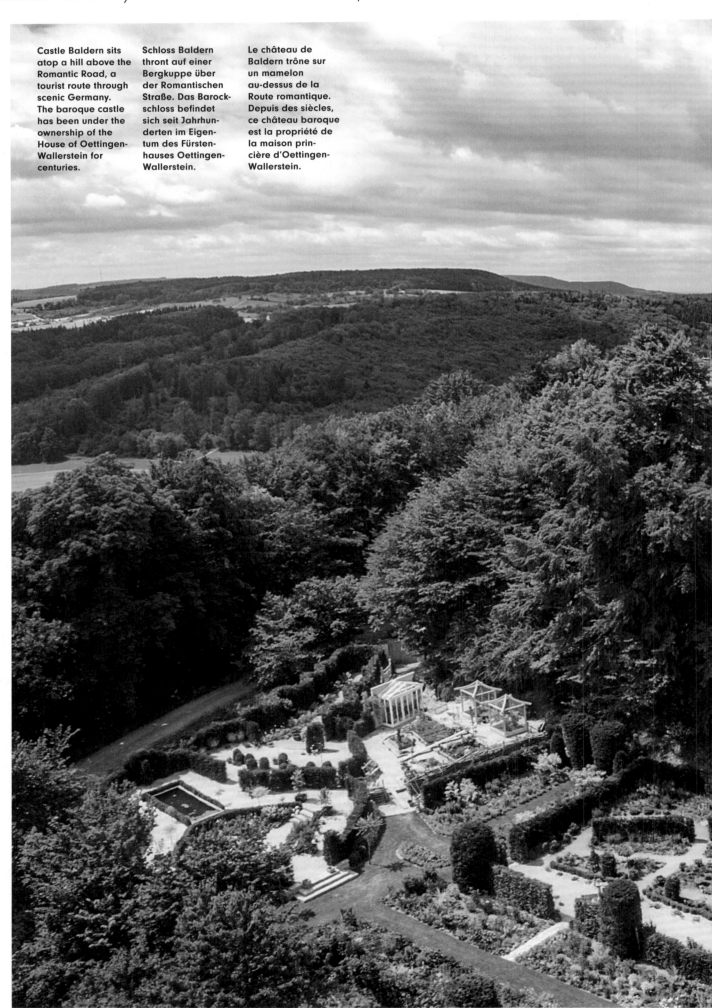

Castle Baldern sits atop a hill above the Romantic Road, a tourist route through scenic Germany. The baroque castle has been under the ownership of the House of Oettingen-Wallerstein for centuries.

Schloss Baldern thront auf einer Bergkuppe über der Romantischen Straße. Das Barockschloss befindet sich seit Jahrhunderten im Eigentum des Fürstenhauses Oettingen-Wallerstein.

Le château de Baldern trône sur un mamelon au-dessus de la Route romantique. Depuis des siècles, ce château baroque est la propriété de la maison princière d'Oettingen-Wallerstein.

Wallerstein Gardens

Schloss Baldern, Baldern | Germany

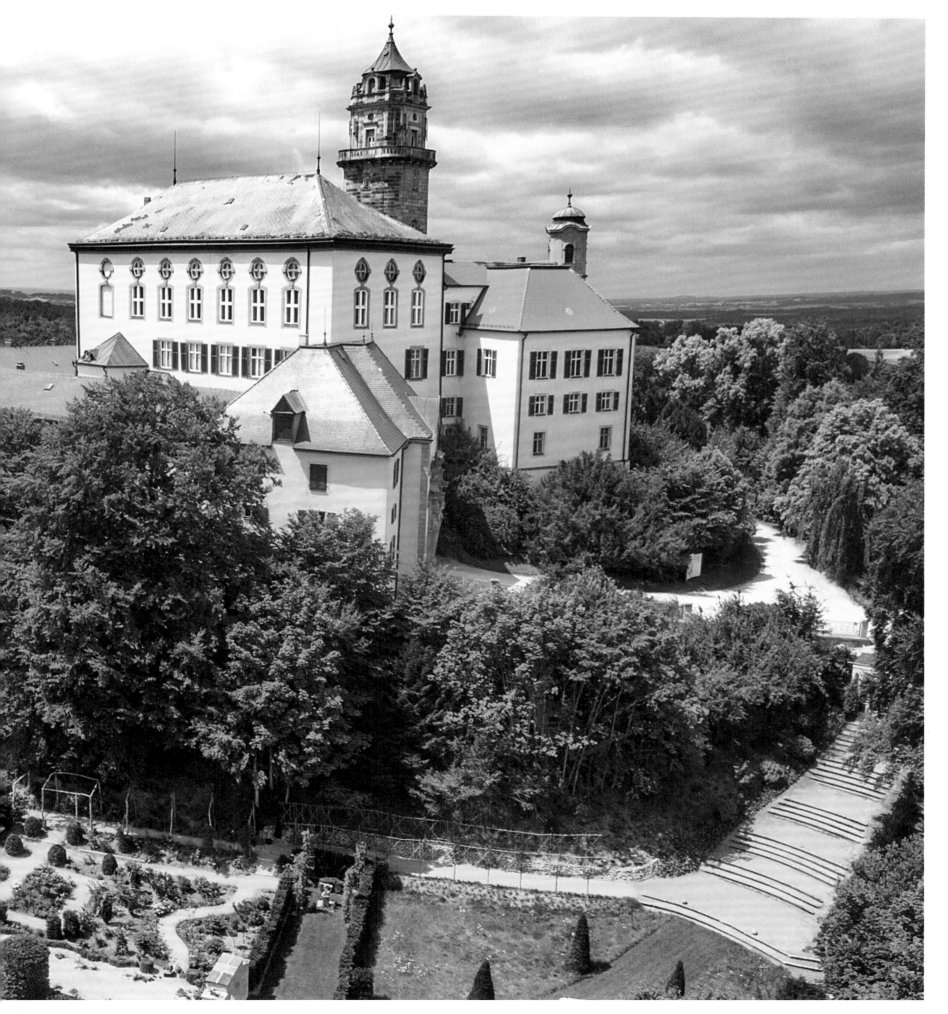

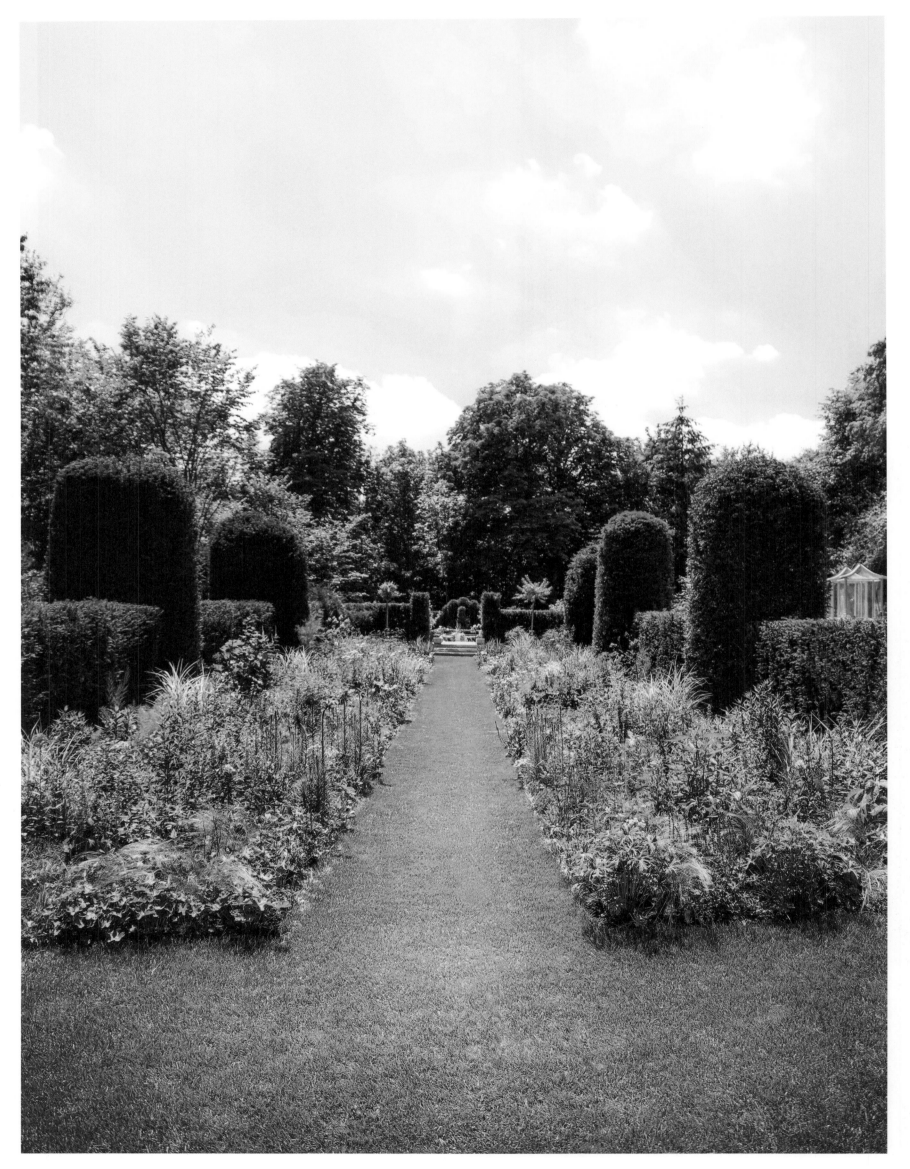

Wallerstein Gardens

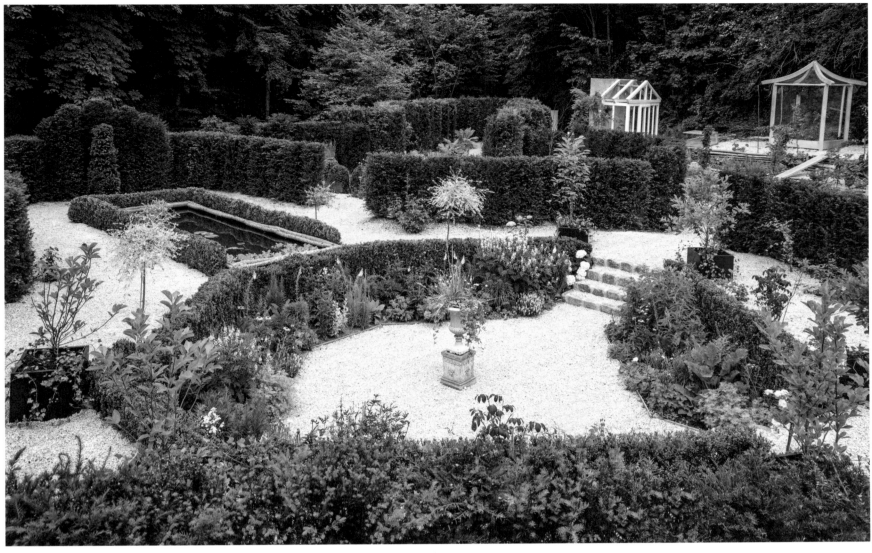

The double border lined with trimmed yews is the heart of the garden (left page). Shrubs grow here that Anna of Oettingen-Wallerstein has collected on her travels. Both of the creators integrated historic elements, such as an old stone bench, and worked with natural materials.

Das Double Border, gesäumt von geschnittenen Eiben, ist das Herzstück des Gartens (linke Seite). Hier wachsen Stauden, die Anna zu Oettingen-Wallerstein auf Reisen gesammelt hat. Die beiden Erschafferinnen integrierten Historisches wie eine alte Steinbank und arbeiteten mit Naturmaterialien.

Le double border, ourlé d'ifs taillés, forme le cœur du jardin (page de gauche). Ici poussent les plantes vivaces qu'Anna zu Oettingen-Wallerstein a ramenées de ses voyages. Les deux créatrices ont intégré des éléments historiques, comme un vieux banc de pierre, et ont travaillé avec des matériaux naturels.

Prinzessin Anna zu Oettingen-Wallerstein

Peace and Serenity for the Soul
Ruhe und Heiterkeit für die Seele
Calme et sérénité de l'âme

Princess Anna of Oettingen-Wallerstein is a newcomer to the horticultural profession. Together with Susanne Christner, she designed the walled garden and build it herself.

Prinzessin Anna zu Oettingen-Wallerstein ist Quereinsteigerin im Gartenmetier. Zusammen mit Susanne Christner hat sie den Walled Garden entworfen und aus eigener Kraft gebaut.

Nouvelle venue dans le monde des jardins, la princesse Anna zu Oettingen-Wallerstein a conçu le walled garden avec Susanne Christner et l'a réalisé de ses propres mains.

Princess Anna of Oettingen-Wallerstein, the walled garden was a dream of yours for some time. Tell us about that.

The idea came about during the course of my work at the ancestral home in Wallerstein. The castle there is surrounded by a magnificent English landscape park with monumental specimen plants, some 300 years old. I worked out and refined a clear picture of this landscape park, its vastness and its simplicity. The walled garden project, entirely contrary to the existing gardens of the noble house, was a vision that I was then able to implement at Castle Baldern.

Were there any inspirations?

Great Dixter, Arne Maynard as well as the gardens of Gertrude Jekyll were definitely influences for us. Of course, we had our own interpretation of a walled garden: some unusual plant combinations, the focus on historic materials, preferably from nature, the use of exclusively old stones. We integrated obscure, rare varietals and also had the rough, untamed environment incorporated into our garden. We wanted to share a space of physical as well as mental relaxation with the visitor.

Why make it a walled garden? What are you communicating with that?

A walled garden like Wallerstein Gardens gives you a feeling of paradise. It is not divisive; it brings people together in their love for nature and the beauty created there. Its closed nature makes it possible to be immersed in a "world of well-being"—the garden is able to fill the soul with peace and serenity, as well as soothe the rocky currents of life and its troubles. That feeling is what I wanted to give visitors.

Prinzessin Anna zu Oettingen-Wallerstein, der Walled Garden war schon lange ein Traum von Ihnen. Erzählen Sie!

Die Idee entstand im Laufe meiner Arbeit am Stammsitz in Wallerstein. Das Schloss dort ist umgeben von einem prachtvollen Englischen Landschaftspark mit monumentalen, zum Teil 300 Jahre alten Solitären. Hier habe ich das klare Bild des Landschaftsparks, seine Weite und Schlichtheit herausgearbeitet und verfeinert. Das Walled Garden-Projekt, gänzlich konträr zu den vorhandenen Gärten des Fürstenhauses, war eine Vision, die ich nun auf Schloss Baldern umsetzen konnte.

Gab es Vorbilder?

Great Dixter, Arne Maynard und auch die Gärten von Gertrude Jekyll haben uns auf jeden Fall beeinflusst. Natürlich hatten wir unsere eigene Interpretation eines Walled Garden: Unsere zum Teil ungewöhnlichen Pflanzkombinationen, die Konzentration auf historische Materialien, möglichst aus der Natur, das Verwenden von ausschließlich alten Steinen. Wir integrierten unbekannte, seltene Züchtungen und ließen auch das Rohe, Ungezähmte der Umgebung in unseren Garten einfließen. So möchten wir dem Betrachter ein Stück körperlicher, aber auch mentaler Entspannung vermitteln.

Warum sollte es ein Walled Garden sein, was verbinden Sie damit?

Ein Walled Garden wie Wallerstein Gardens gibt ein paradiesisches Gefühl. Er polarisiert nicht und vereint Menschen in ihrer Liebe zur Natur und der geschaffenen Schönheit. Seine Abgeschlossenheit ermöglicht es, für einige Stunden in eine „heile Welt" einzutauchen:- Der Garten vermag die Seele mit Ruhe und Heiterkeit zu füllen und Lebensstürme und Nöte zu besänftigen. Dieses Gefühl möchte ich den Besuchern schenken.

Princesse Anna zu Oettingen-Wallerstein, vous rêviez depuis longtemps déjà du walled garden. Racontez-nous !

L'idée m'est venue lorsque je travaillais au château de Wallerstein, le berceau de notre famille, qui est entouré d'un somptueux parc paysager à l'anglaise, dont des arbres solitaires vieux de parfois 300 ans. Ici, j'ai repris et affiné l'image claire du parc paysager, son étendue et sa sobriété. Le projet de walled garden, qui est tout à fait à l'opposé des jardins qui existaient dans la maison princière, est une vision que j'ai pu concrétiser au château de Baldern.

Aviez-vous des modèles ?

Great Dixter, Arne Maynard ainsi que les jardins de Gertrude Jekyll nous ont absolument influencés. Bien entendu, nous avions notre interprétation personnelle de ce qu'est un walled garden : nos associations de plantes, parfois inhabituelles, le recours aux matériaux historiques et naturels autant que cela était possible, l'utilisation de pierres anciennes. Nous avons intégré des variétés rares, parfois inconnues, et nous avons laissé l'environnement brut et indompté s'immiscer dans notre jardin. Nous souhaitions apporter au contemplateur un sentiment de détente physique, mais aussi mentale.

Pourquoi un walled garden, qu'associez-vous à cette notion ?

Un walled garden comme celui de Wallerstein évoque le paradis. Il ne polarise pas et rassemble les gens dans l'amour de la nature et de la beauté créée. Le fait qu'il soit fermé permet de plonger dans un « monde intouché », le jardin est capable de remplir l'âme de calme et de sérénité et d'apaiser les tempêtes de la vie et ses détresses. C'est cette sensation que je veux offrir aux visiteurs.

The garden allows visitors to spend a few hours immersed in a "world of well-being."

Der Garten ermöglicht es, für einige Stunden in eine „heile Welt" einzutauchen.

Le jardin permet de s'immerger dans un « monde intouché » pendant quelques heures.

41

Terra-manus

Bonn-Bad
Godesberg
Germany

Landscape architect Manuel Sauer, owner of Terramanus, is both a designer and a construction manager.

Landschaftsarchitekt Manuel Sauer, Inhaber von Terramanus, ist Gestalter und Baumanager in einer Person.

Manuel Sauer, paysagiste et propriétaire de Terramanus, est concepteur et chef de chantier à lui tout seul.

In Bad Godesberg near Bonn, Manuel Sauer founded the firm Terramanus Landschaftsarchitektur in 2003. He initially attained his practical and technical skills during a landscape gardening apprenticeship and at the Osnabrück University of Applied Sciences where he studied landscape architecture. He learned about sustainable water use in gardens in the same discipline at the University of Arizona in dry Tucson, USA. He now designs parks and gardens throughout Europe, especially water gardens, whereby his experience as engineer and project controller for several horticultural shows has proven advantageous. In 2013, he designed the themed garden "Im Ruhepuls" (meaning "resting heart rate") with objects made by artist Birgitta Weimer for the IGS (International Garden Show) in Hamburg.

A specialty of Manuel Sauer is terrace landscapes with a modern design that connect the house to the garden and create pleasant living areas that often feature a pool. The plants are always understated, but they also always accentuate the structure. They include elegant plant species such as serviceberry plants or sweet gum trees in combination with shrubs and grasses that are full of character.

In Bonn-Bad Godesberg gründete Manuel Sauer 2003 das Büro Terramanus Landschaftsarchitektur. Seine praktischen und technischen Fertigkeiten erwarb er zunächst während einer Landschaftsgärtnerausbildung und beim Studium der Landschaftsarchitektur an der Fachhochschule Osnabrück. Den nachhaltigen Umgang mit Wasser im Garten erlernte er in derselben Fachrichtung an der University of Arizona im trockenen Tucson, USA. Heute realisiert er europaweit Parks und Gärten, insbesondere Wassergärten, wobei ihm seine Erfahrung als Ingenieur und Projektsteuerer bei etlichen deutschen Gartenschauen zugutekommt. So gestaltete er beispielsweise für die IGS (Internationale Gartenschau) in Hamburg im Jahr 2013 den Themengarten „Im Ruhepuls" mit Objekten der Künstlerin Birgitta Weimer.

Eine Spezialität von Manuel Sauer sind modern gestaltete Terrassenlandschaften, die das Haus mit dem Garten verbinden, angenehme Aufenthaltsorte bilden und oft mit einem Wasserbecken oder Pool ausgestattet sind. Die Bepflanzung ist stets zurückhaltend, aber immer strukturbetonend. Sie besteht aus eleganten Gehölzen wie Felsenbirne oder Amberbaum in Kombination mit charaktervollen Stauden und Gräsern.

C'est en 2003 à Bonn-Bad Godesberg que Manuel Sauer crée le cabinet d'architecture paysagère Terramanus. Pour se constituer son expertise pratique et technique, il commence par faire une formation de paysagiste, puis suit des cours d'architecture du paysage à l'institut universitaire de technologie d'Osnabrück. Toujours dans la même discipline, il apprend ensuite à utiliser l'eau au jardin sans la gaspiller, à l'université de Tucson, dans l'État désertique de l'Arizona (USA). Aujourd'hui, il réalise dans toute l'Europe des parcs et des jardins, en particulier des jardins d'eau, profitant dans ce contexte de l'expérience d'ingénieur et de chef de projet acquise dans de nombreuses expositions florales en Allemagne. Il a ainsi conçu l'IGS (exposition horticole internationale), à Hambourg en 2013 sur le thème « Im Ruhepuls » (« Cœur au repos »), avec des œuvres de la sculptrice Birgitta Weimer.

Une des spécialités de Manuel Sauer : les terrasses traitées de façon moderne, qui relient la maison au jardin, forment des endroits où on aime passer du temps et comportent souvent une pièce d'eau ou une piscine. La végétation est toujours en retenue, mais vient en même temps souligner une structure composée d'élégants bosquets d'amélanchiers ou de liquidambars associés à des plantes vivaces et à des herbes de caractère.

42

Right page, top: In this illuminated swimming garden, your gaze wanders from the living room and terrace with a level swimming pool over to the Rhine. The seat plateau area made of graywacke plates seems to float, and LED lights on the bottom and three special developed, back-lit red square glass elements provide exciting lighting.

Right page, bottom: In this urban grass garden, a floating wooden terrace runs from the towering, double-stemmed maple tree to the pool. The lush plants include various types of grass, leafy shrubs, and ferns.

Rechte Seite oben: Frei schweift der Blick in diesem illuminierte Badegarten vom Wohnzimmer über die Terrasse mit flachem Badebecken zum Rhein. Das Sitzplateau aus Grauwackeplatten scheint zu schweben, LED-Leuchten an der Unterkante und drei speziell entwickelte, rot hinterleuchtete quadratische Glaselemente sorgen für die spannende Beleuchtung.

Rechte Seite unten: Vom dominanten doppelstämmigen Ahorn führt in diesem urbanen Gräsergarten eine schwebende Holzterrasse bis zum Pool. Zusammen mit den Gräsern bilden Blattstauden und Farne die üppige Bepflanzung.

Page de droite, en haut : Du séjour, le regard glisse sur les terrasses et leur bassin de piscine plat, flotte librement sur le jardin illuminé, pour venir buter sur la toile de fond du Rhin. Le plateau du salon, en dalles de grauwacke, semble flotter, l'éclairage tout en tension est composé de LED sur le bord inférieur et de trois éléments carrés en verre rétroéclairé de rouge, conçus spécialement pour le site.

Page de droite, en bas : De l'érable dominant avec son double tronc, une terrasse en bois semble flotter dans ce jardin d'herbes urbain, jusqu'à la piscine. Les herbes sont associées à des plantes vivaces feuillues et à des fougères pour former une végétation luxuriante.

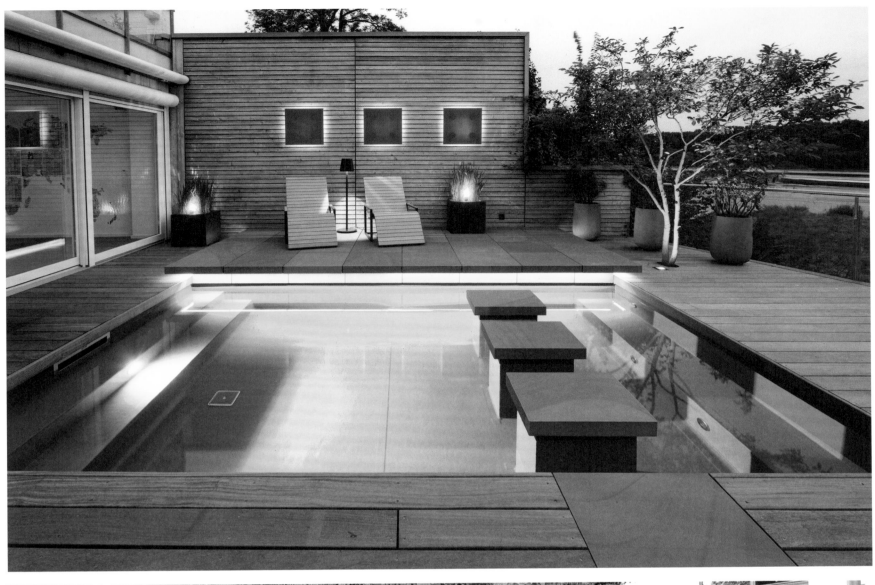

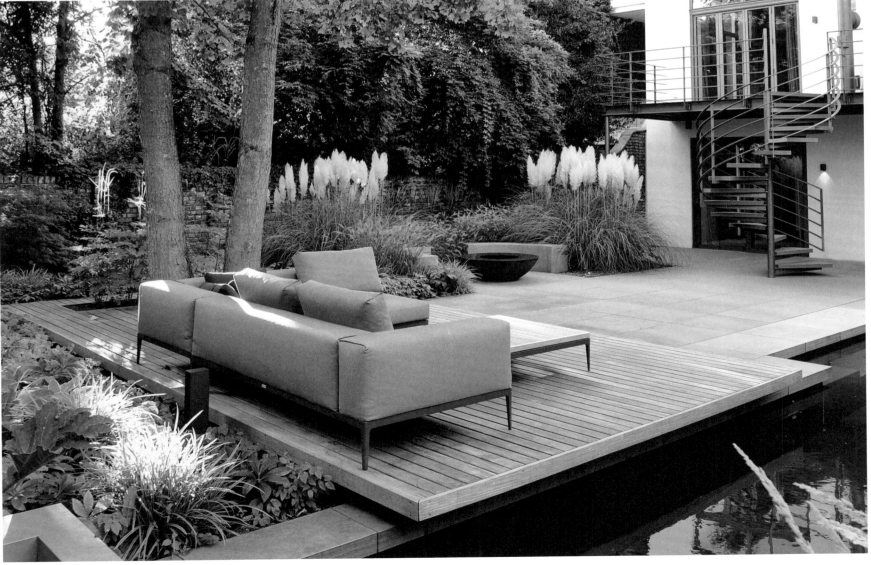

Terramanus

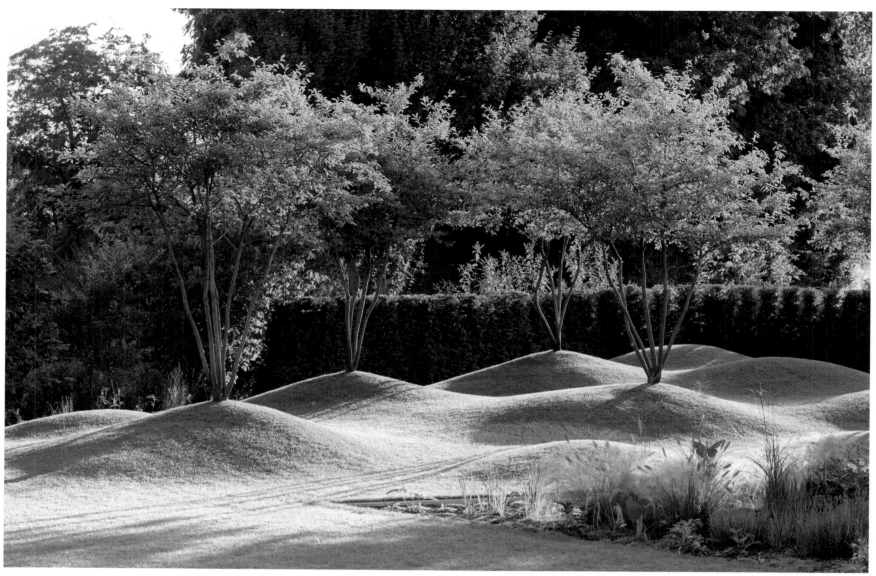

44

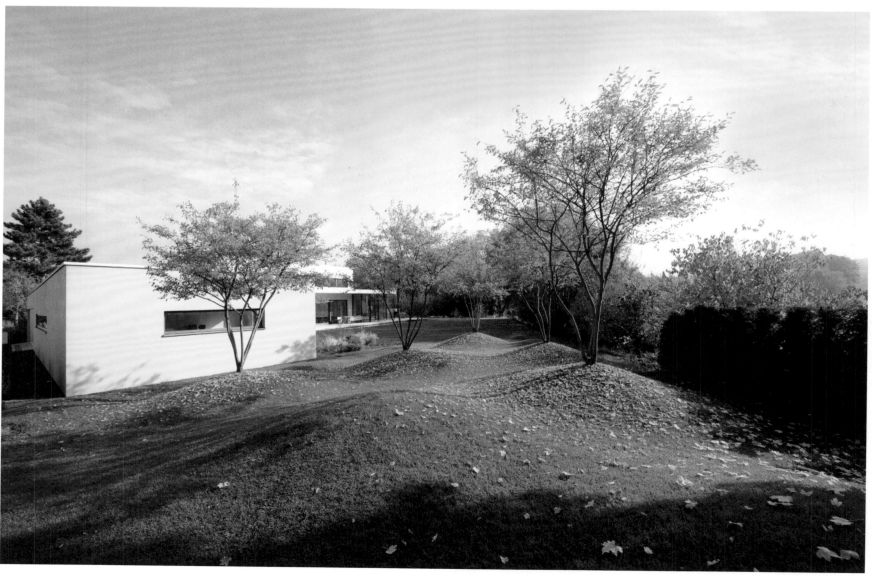

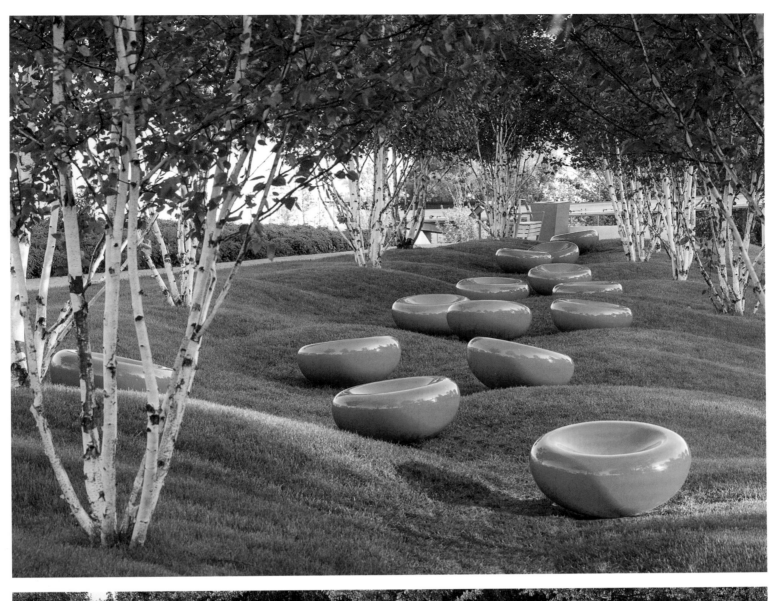

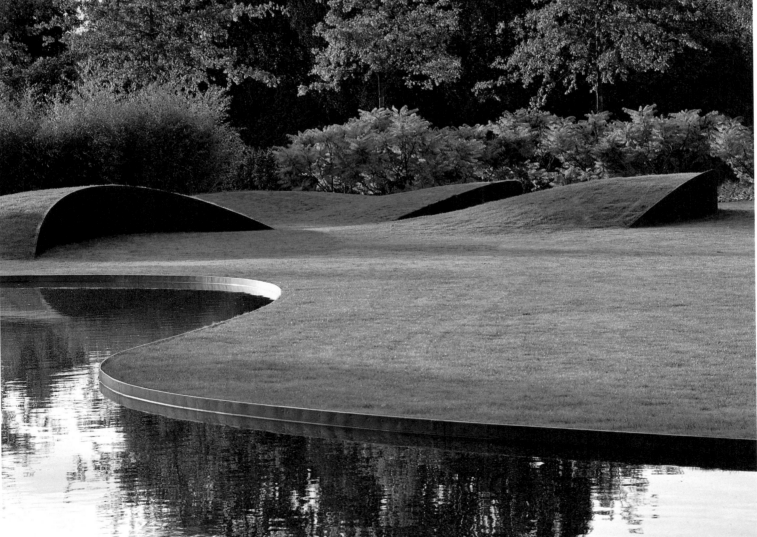

Left page, top and bottom: Five umbrella-shaped serviceberry plants adorn the hills of an elegantly contoured lawn at a house Bamberg, Germany. Top of this page: This themed garden at the IGS in Hamburg included multistemmed Himalayan birches and red objects created by the artist Birgitta Weimer, which were modeled on blood cells. Bottom of this page: Corten steel supports the lawn waves that billow through the garden to the natural pond and light up in red at night.

Linke Seite oben und unten: Fünf schirmförmig gezogene Felsenbirnen zieren die Hügel einer elegant geschwungenen Rasenfläche an einem Haus in Bamberg. Diese Seite oben: Mehrstämmige Himalaya-Birken und von der Künstlerin Birgitta Weimer geschaffene rote Objekte, Blutkörperchen nachempfunden, bildeten diesen Themengarten auf der IGS in Hamburg. Diese Seite unten: Cortenstahl stützt die Rasenwellen, die sich, nachts rot beleuchtet, durch den Garten bis zum Naturteich wogen.

Page de gauche, en haut et en bas : Cinq amélanchiers en forme de parasol ornent les collines engazonnées aux courbes élégantes d'une maison de Bamberg. Même page, en haut : Des bouleaux de l'Himalaya en cépées et des objets rouges créés par l'artiste Birgitta Weimer, inspirés des globules du sang, formaient ce jardin à thème lors de l'IGS de Hambourg. Même page, en bas : De l'acier Corten soutient les vagues de pelouse éclairées d'une lumière rouge nuit, dans un balancement qui mène à la pièce d'eau naturelle.

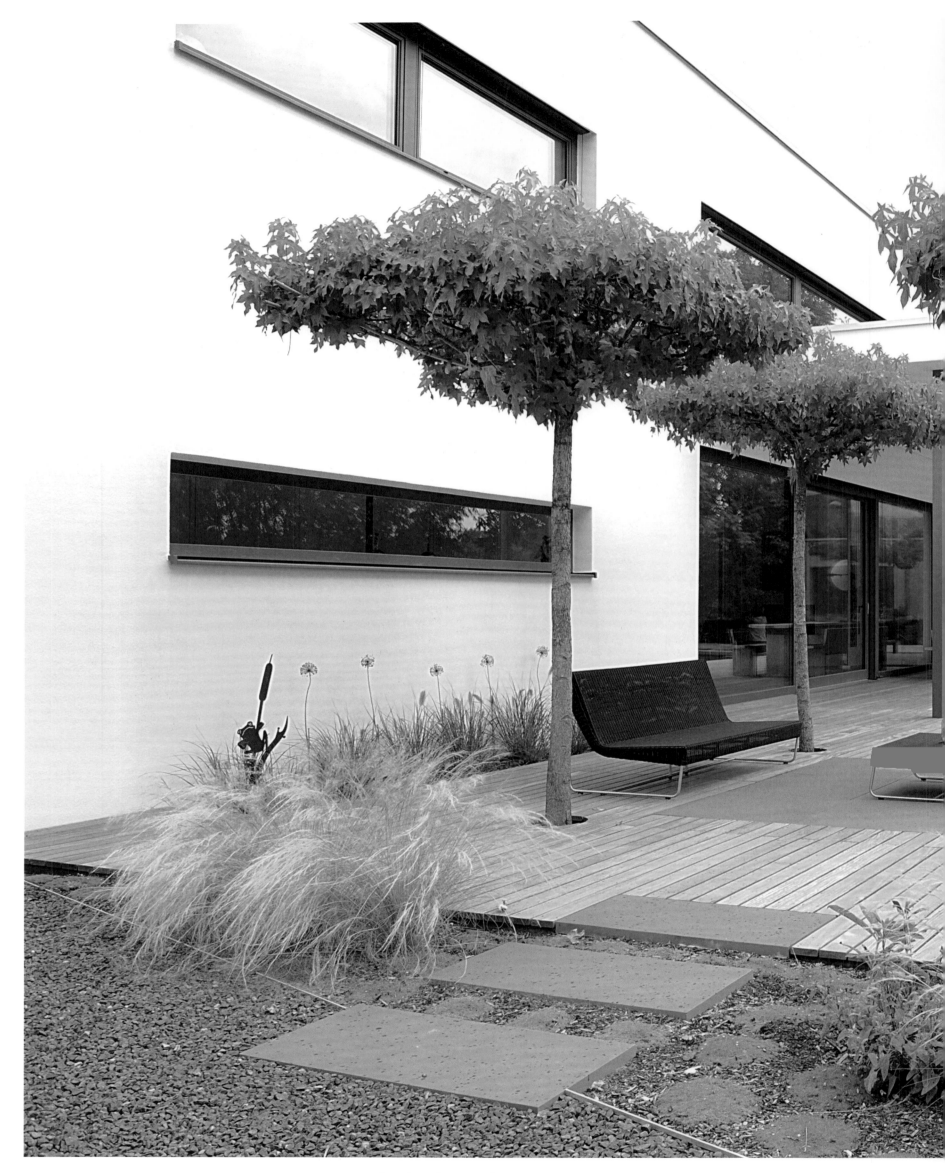

46

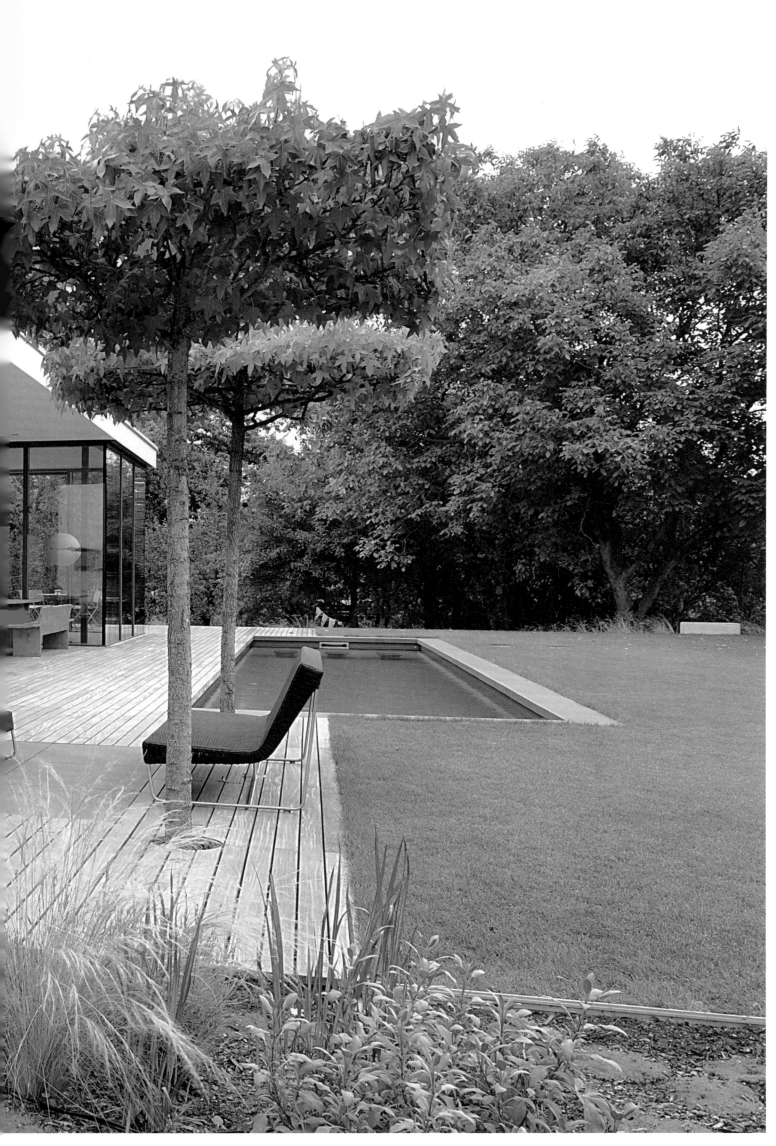

A leisure garden with swimming pool: Four sweet gum trees, surrounded by a wooden terrace, provide shade for the seated area that was installed precisely in the wooden deck as a stone inlay. The garden accommodates the clear contours of the house.

Ein Freizeitgarten mit Swimmingpool: Vier Amberbäume, eingefasst von einer Holzterrasse, spenden Schatten am Sitzbereich, der als Steinintarsie exakt in das Holzdeck eingearbeitet wurde. Der Garten nimmt die klaren Konturen des Hauses auf.

Jardin de loisirs avec piscine : Quatre liquidambars enchâssés dans une terrasse en bois dispensent leur ombre à un salon qui évoque une marqueterie de pierre incrustée dans le plancher de bois. Le jardin s'inspire des contours clairs de la maison.

48

The "Bridal Avenue" in the Keukenhof tulip paradise captivates with a relaxed mixture of spring bloomers and shrubs. Left: 'Ballerina' tulip in interplay with Anthriscus sylvestris 'Ravenswing.'

Die „Hochzeitsavenue" im Tulpenparadies Keukenhof besticht durch eine lockere Mischung von Frühjahrsblühern und Stauden. Links: Tulpe 'Ballerina' im Zusammenspiel mit Rotem Wiesenkerbel 'Ravenswing'.

L'« avenue du mariage » du paradis des tulipes de Keukenhof se distingue par un mélange léger de fleurs printanières et de plantes vivaces. À gauche : Tulipe 'Ballerina' associée à du cerfeuil sauvage rouge 'Ravenswing'.

Jacqueline van der Kloet

Jacqueline van der Kloet

Weesp | The Netherlands

Stylish, eclectic, artful, bold. This is how the popular plant specialist and garden designer showcases her grounds. | Stylish, eklektisch, kunstvoll, kühn – so präsentieren sich die Anlagen der gefragten Pflanzenspezialistin und Gartengestalterin. | Stylés, éclectiques, artistiques, osés : ainsi se présentent les aménagements paysagers de cette spécialiste recherchée des plantes et des jardins.

49

"Bulbs and more" is the motto of the "Bridal Avenue" and the "Flower Ribbon," which Jacqueline van der Kloet planned for the world-famous tulip show in southern Holland: a stimulus for visitors to combine tulips and other spring bloomers with bushes and shrubs.

Linear Park in Blaricum, east of Amsterdam and situated on the IJsselmeer Bay was designed by Loos van Vliet. Van der Kloet added the grass and the surface water bushes in bold color combinations.

„Blumenzwiebeln und mehr" lautet das Motto für die „Hochzeitsavenue" und das „Blumenband", welche Jacqueline van der Kloet für die weltberühmte Tulpenschau Keukenhof im Süden Hollands plante: eine Anregung für die Besucher, Tulpen und andere Frühjahrsblüher mit Stauden und Sträuchern zu kombinieren.

Der Linear Park in Blaricum, östlich von Amsterdam am IJsselmeer gelegen, wurde vom Atelier Loos van Vliet entworfen, van der Kloet fügte dem Rasen und den Wasserflächen Staudenbeete in gewagten Farbkombinationen hinzu.

« Des bulbes et plus », c'est la devise qui a présidé à la création de l'« avenue du mariage » et du « ruban de fleurs », que Jacqueline van der Kloet a conçus pour l'exposition mondialement célèbre de tulipes de Keukenhof, dans le sud de la Hollande : pour les visiteurs, c'est une invitation à associer les tulipes et d'autres fleurs de printemps à des plantes vivaces et arbustes.

Situé à l'est d'Amsterdam, au bord du lac de l'IJssel, le Linear Park de Blaricum a été conçu par l'Atelier Loos van Vliet, van der Kloet a ajouté à la pelouse et aux bassins des massifs de plantes vivaces offrant d'audacieuses combinaisons de couleurs.

Unusual plant neighborship like those in the "flower ribbon" in Keukenhof give the visitors ideas for their own gardens.

Ungewohnte Pflanzennachbarschaften wie am „Blumenband" in Keukenhof sollen den Besuchern Anregungen für den eigenen Garten liefern.

Des voisinages végétaux inhabituels, comme sur le « ruban de fleurs » de Keukenhof, donnent aux visiteurs des suggestions d'associations pour leurs propres jardins.

Jacqueline van der Kloet

51

Boldness in color:
Jacqueline van der
Kloet plants unusual
combinations in
Blaricum Park,
such as Verbena
bonariensis, Lythrum
salicaria 'Blush' and
Salvia nemorosa
'Caradonna' all in
purple and pink.

Mut zur Farbe:
Im Park von
Blaricum pflanzte
Jacqueline van der
Kloet ungewohnte
Kombinationen, zum
Beispiel in Purpur
und Pink mit Argenti-
nischem Eisenkraut,
Blutweiderich 'Blush'
und dem Ziersalbei
'Caradonna'.

Oser la couleur :
dans le parc de
Blaricum, Jacqueline
van der Kloet a créé
des associations
inhabituelles, par
exemple le pourpre
avec le rose, en jux-
taposant verveine
de Buenos Aires,
salicaire commune
'Blush' et sauge des
bois 'Caradonna'.

Stephen Woodhams

London | England, Ibiza | Spain

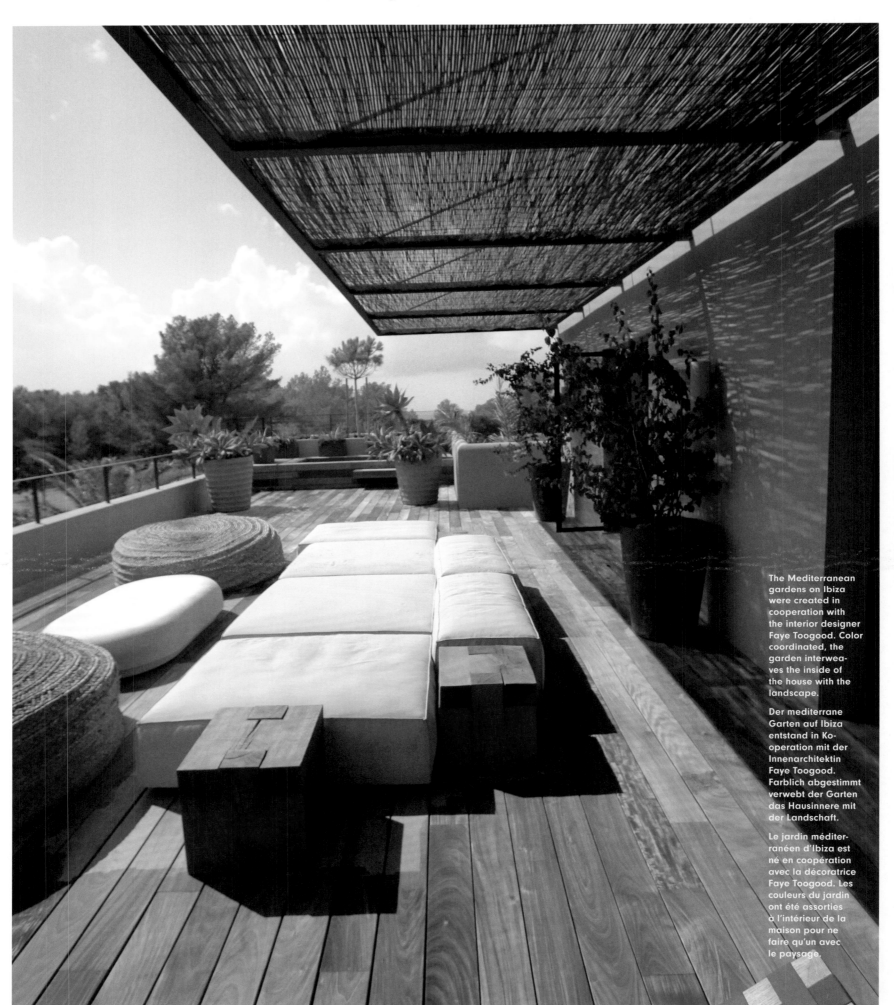

52

The Mediterranean gardens on Ibiza were created in cooperation with the interior designer Faye Toogood. Color coordinated, the garden interweaves the inside of the house with the landscape.

Der mediterrane Garten auf Ibiza entstand in Kooperation mit der Innenarchitektin Faye Toogood. Farblich abgestimmt verwebt der Garten das Hausinnere mit der Landschaft.

Le jardin méditerranéen d'Ibiza est né en coopération avec la décoratrice Faye Toogood. Les couleurs du jardin ont été assorties à l'intérieur de la maison pour ne faire qu'un avec le paysage.

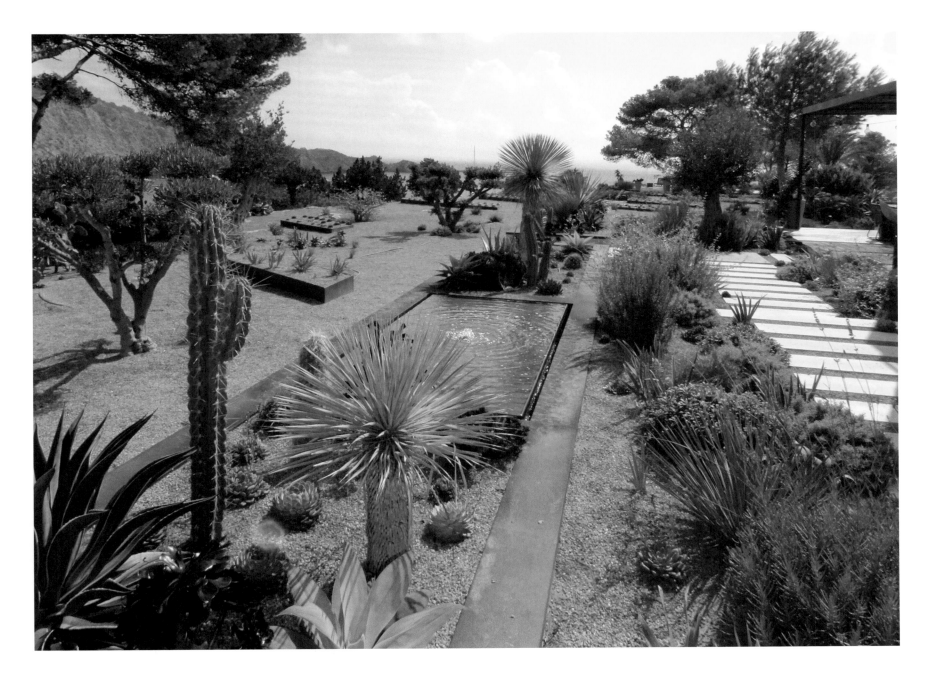

Stephen Woodhams Design Ltd. makes stunning garden oases a reality—from Great Britain to the Balearic Islands all the way to Mauritius. | Stephen Woodhams Design Ltd. realisiert fulminante Gartenoasen von Großbritannien über die Balearen bis Mauritius. | De la Grande-Bretagne à l'île Maurice en passant par les Baléares, Stephen Woodhams Design Ltd. réalise de superbes jardins-oasis.

When Stephen Woodhams won his first gold metal at the Chelsea Flower Show in 1994, he was the youngest horticulturist given the honor. Since then, Stephen Woodhams Design Ltd. has been designing gardens at the highest level in the world—always in close collaboration with the client. This is how one-of-a-kind and very personal paradises come to be. To ensure this, Woodhams runs a branch on Ibiza along with the office location in London. From there he cares for gardens in the Mediterranean region.

Als Stephen Woodhams 1994 auf der Chelsea Flower Show seine erste Goldmedaille gewann, war er einer der jüngsten Gärtner, dem diese Ehre jemals zu Teil wurde. Seitdem gestaltet er mit Stephen Woodhams Design Ltd. Gärten auf höchstem Niveau auf der ganzen Welt – immer in enger Zusammenarbeit mit den Auftraggebern. So entstehen einzigartige und ganz persönliche Paradiese. Um das zu garantieren betreibt Woodhams neben dem Londoner Bürostandort eine Dependance auf Ibiza. Von dort aus betreut er Gärten im Mittelmeerraum.

Lorsque, en 1994, Stephen Woodhams gagne sa première médaille d'or aux floralies de Chelsea, il est l'un des plus jeunes jardiniers à jamais recevoir cette distinction. Depuis, avec sa société Stephen Woodhams Design Ltd., il aménage de magnifiques jardins dans le monde entier, toujours en étroite collaboration avec ses clients. C'est ainsi que naissent des paradis uniques et très personnels. Pour garantir ce succès, Woodhams dispose, en plus de ses bureaux de Londres, d'une succursale à Ibiza d'où il peut s'occuper de jardins dans la zone méditerranéenne.

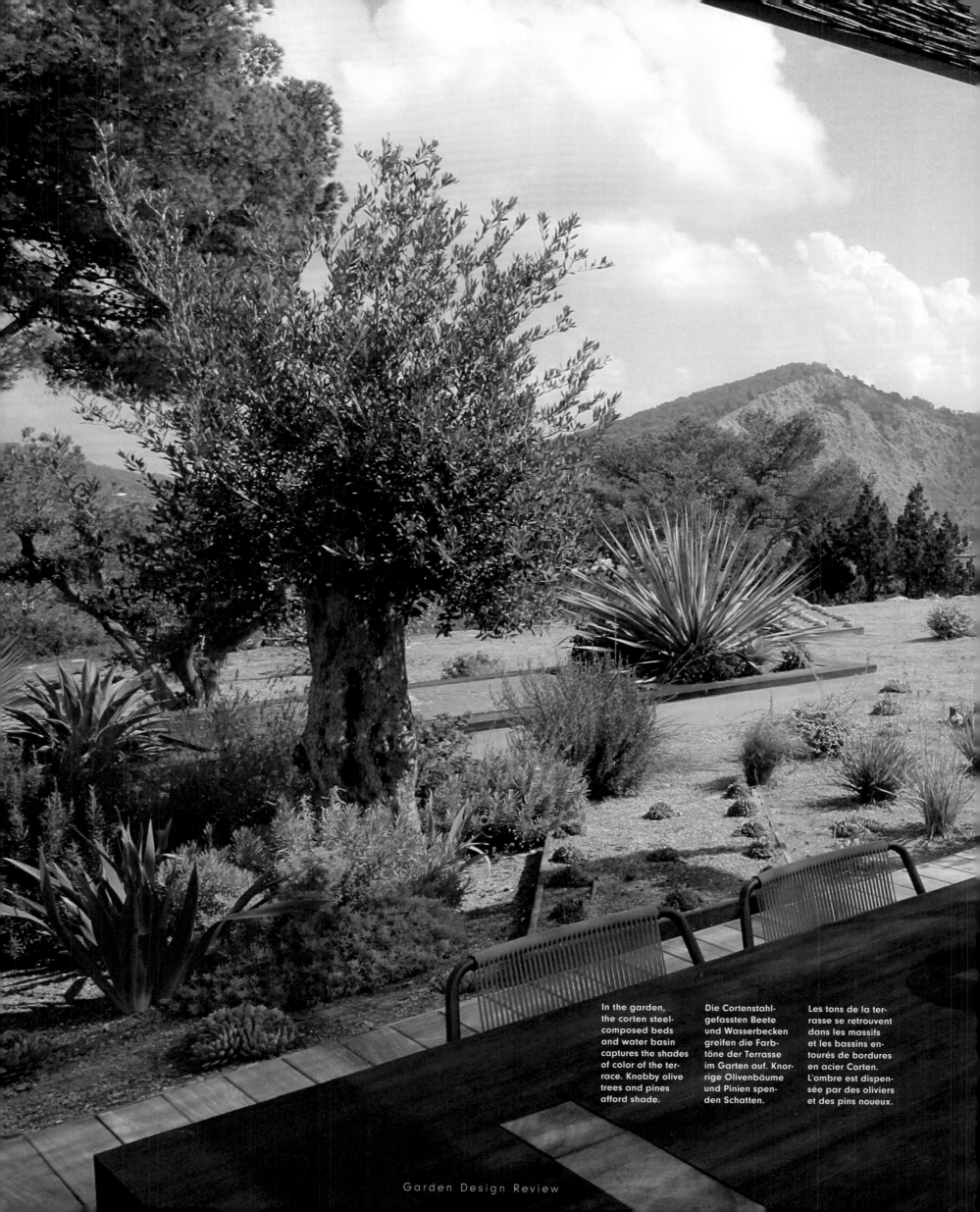

54

In the garden, the corten steel-composed beds and water basin captures the shades of color of the terrace. Knobby olive trees and pines afford shade.

Die Cortenstahl-gefassten Beete und Wasserbecken greifen die Farbtöne der Terrasse im Garten auf. Knorrige Olivenbäume und Pinien spenden Schatten.

Les tons de la terrasse se retrouvent dans les massifs et les bassins entourés de bordures en acier Corten. L'ombre est dispensée par des oliviers et des pins noueux.

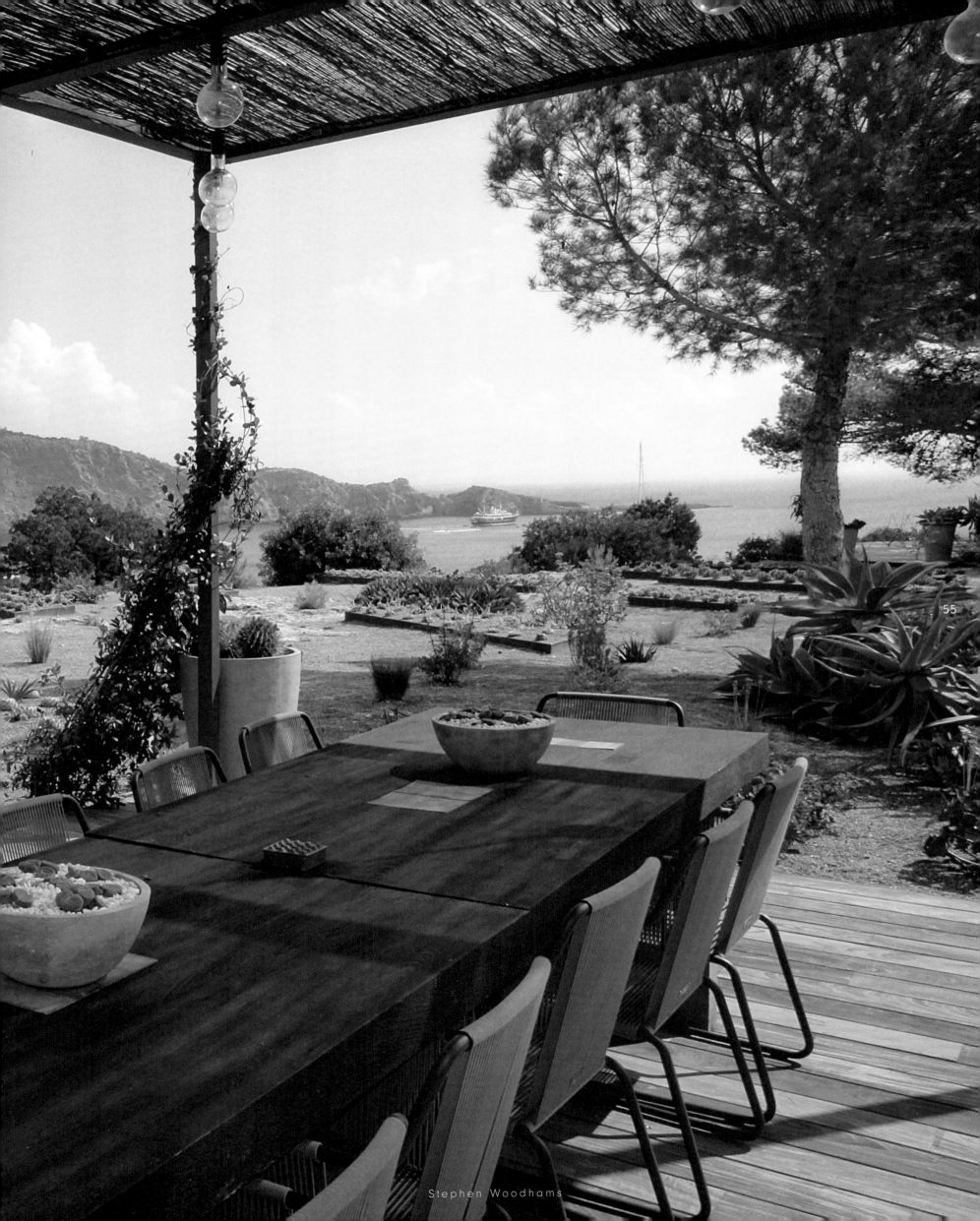

55

Stephen Woodhams

56

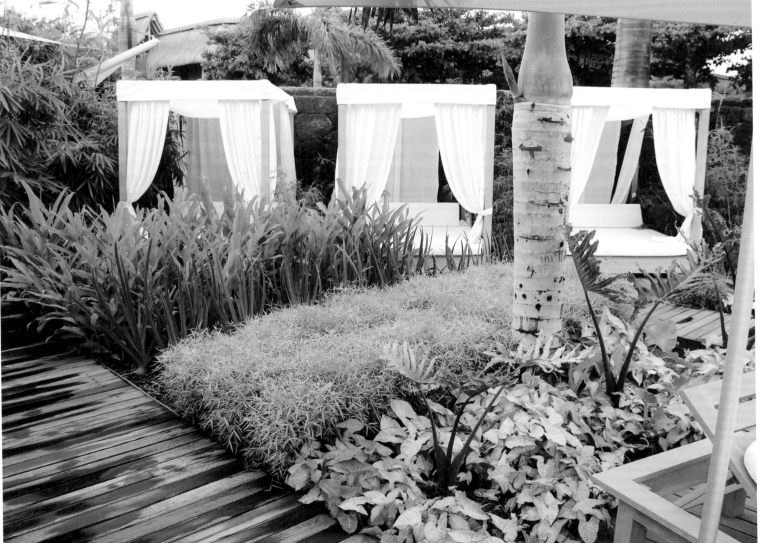

Stephen Woodhams designs tropical gardens on Antigua, Bali, Barbados, and Mauritius. He created a symphony of palms and other tropical plants in various shades of green for two hotels on Mauritius (left Grande Gaube, right Belle Mare).

Stephen Woodhams gestaltet tropische Gärten auf Antigua, Bali, Barbados und Mauritius. Für zwei Hotels auf Mauritius (links Grande Gaube, rechts Belle Mare) schuf er eine Symphonie aus Palmen und weiteren tropische Pflanzen in verschiedenen Grüntönen.

Stephen Woodhams conçoit des jardins tropicaux à Antigua, à Bali, à la Barbade et à l'île Maurice. Pour deux hôtels de l'île Maurice (Grande Gaube à gauche, Belle Mare à droite), il a créé une symphonie de palmiers et d'autres plantes tropicales dans différentes nuances de vert.

Stephen Woodhams

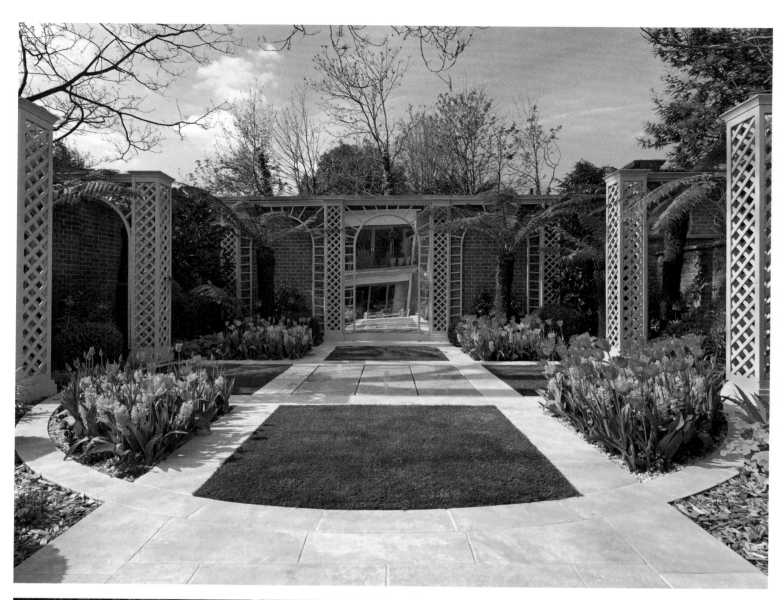

This contemporary garden is distinguished by variety in a confined amount of space. Glass walls allow a view from the terrace to the small garden with climbing trellises. In this way, space appears more generous.

Dieser zeitgenössische Garten zeichnet sich durch Abwechslung auf engstem Raum aus. Glaswände ermöglichen, von der Terrasse aus auf den kleinen Gartenbereich mit den Rankgittern zu blicken. Dadurch wirkt der Raum großzügiger.

Ce jardin contemporain se caractérise par sa diversité dans un espace très réduit. De la terrasse, des panneaux vitrés libèrent la vue sur le petit jardin et ses treillis, donnant ainsi une sensation d'espace plus généreux.

58

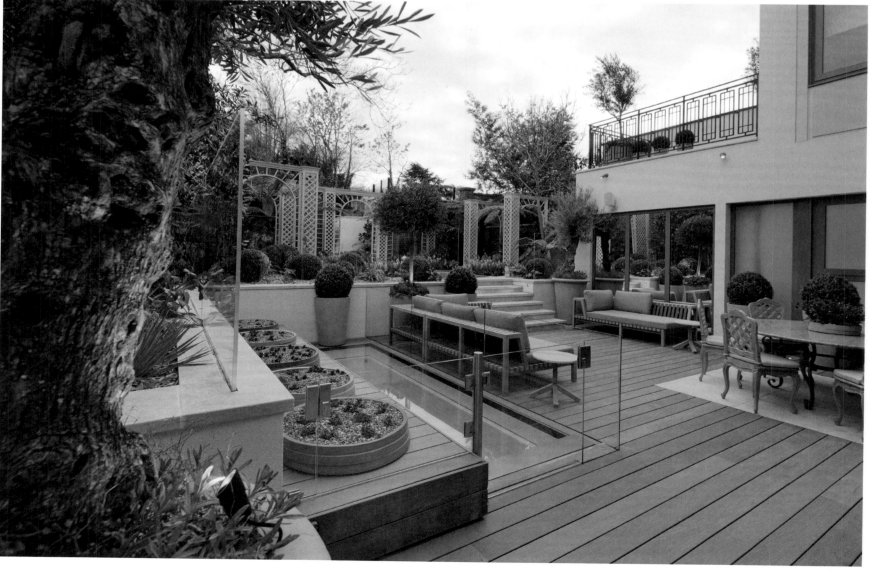

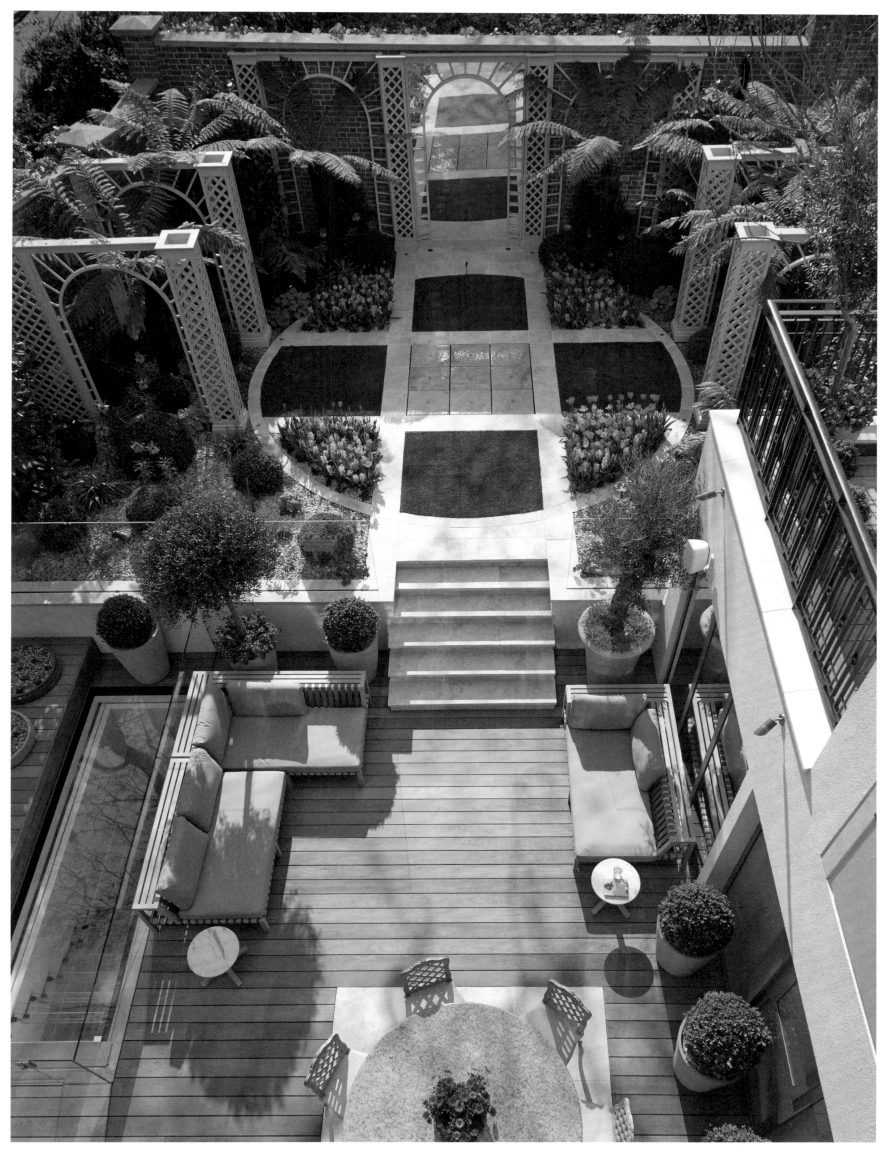

Stephen Woodhams

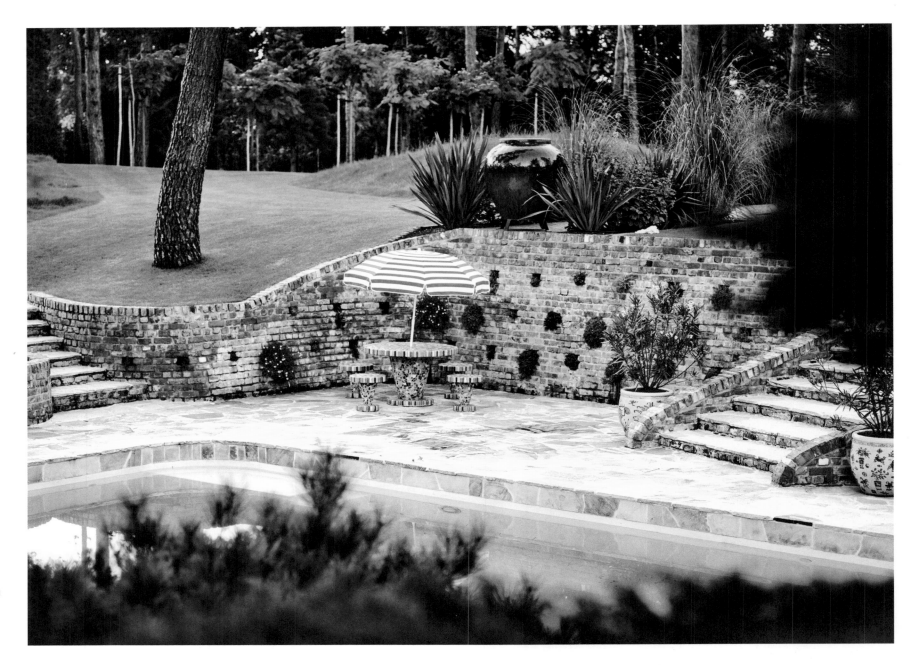

Belgian designer Jean-Philippe Demeyer and his team conceptualize stunning interior worlds and dream landscapes. | Der belgische Designer Jean-Philippe Demeyer und sein Team entwerfen fulminante Innenwelten und Traumlandschaften. | Le designer belge Jean-Philippe Demeyer et son équipe créent des mondes intérieurs et paysages imaginaires à nul autre pareil.

Jean-Philippe Demeyer of JP Demeyer works in the midst of a landscape that has inspired artists and thinkers for centuries. It is fantasy and wonder. It is imagination. It is emotion and—most importantly—it is the place itself which gives him inspiration. The result is nothing short of magical—design that is absolutely extraordinary as well as eclectic, with a "fata morgana" effect. For him, creativity means experiencing as much as you can and putting together ideas and dissimilar things without fear. His philosophy: Approach things leading from the heart.

Jean-Philippe Demeyer von JP Demeyer arbeitet inmitten einer Landschaft, die schon seit Jahrhunderten Künstler und Denker begeisterte. Es sind seine Phantasie und seine Vorstellungsgabe, die Emotionen und der Ort selbst, die ihn inspirieren. Das Ergebnis ist ein magisches, außergewöhnliches und eklektisches Design mit Fata-Morgana-Effekten. Kreativität bedeutet für Demeyer, sich allem auszusetzen und furchtlos Ideen und kuriose Dinge zusammenzufügen. Seine Philosophie: mit dem Herzen an die Dinge herangehen.

Jean-Philippe Demeyer, de l'agence JP Demeyer, travaille au cœur d'un paysage qui inspire nombre d'artistes et de penseurs depuis des siècles. Son inspiration, il la puise dans son imaginaire et son imagination, dans les émotions et dans le lieu lui-même. Il donne ainsi naissance à un design magique, exceptionnel et éclectique avec des effets optiques. Pour Demeyer, la créativité consiste à n'avoir peur de rien et à marier avec audace les idées et objets insolites. Sa philosophie consiste à appréhender les choses avec le cœur.

For a young family, JP Demeyer drafted a wellness oasis with molded hills of grass. A stone stairway leads down to a sunken pool, a rockery, and a pool house.

Für eine junge Familie entwarf JP Demeyer eine Wohlfühloase aus modellierten Rasenhügeln. Eine steinerne Treppe führt zum tiefer liegenden Pool mit Steingarten und Poolhaus hinunter.

Pour une jeune famille, JP Demeyer a imaginé une oasis de bien-être avec des collines de gazon modelées. Un escalier en pierre mène à la piscine en contrebas avec jardin de rocaille et pool house.

Jean-Philippe Demeyer

Brugge | Belgium

For a friend, Demeyer placed a garden room with a pagoda style roof in front of the classic farm house and the pool. The gate which opens to the garden pathway with stone mushrooms on both sides is based on that of Marie Antoinette's hamlet in Versailles (top left on the right side).

Für einen Freund setzte Jean-Philippe Demeyer ein Gartenzimmer mit einem Dach im chinesischen Pagodenstil vor das klassische Bauernhaus und den Pool. Das Tor, das auf den Gartenweg führt und zu beiden Seiten von steinernen Pilzen gerahmt wird, basiert auf dem von Marie Antoinette in Versailles (rechte Seite oben links).

Pour un ami, Jean-Philippe Demeyer a conçu une véranda avec un toit en forme de pagode chinoise devant l'ancienne ferme et la piscine. Le portail qui s'ouvre sur l'allée de jardin bordée de chaque côté par des champignons en pierre est inspiré de celui de Marie-Antoinette à Versailles (en haut à gauche sur la page de droite).

62

Jean-Philippe Demeyer

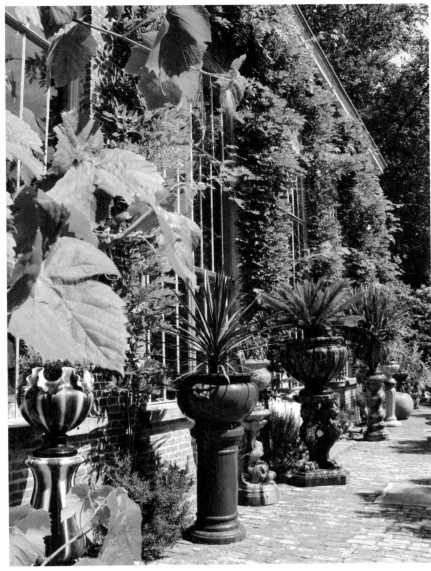

A fountain (bottom) and Mediterranean pots from the French Riviera (top right) provide a happy and colorful atmosphere in front of the orangery in which the design team works. The orangery is inspired by Napoleon III.

Ein Brunnen (unten) und mediterrane Pflanztöpfe von der französischen Riviera (oben rechts) verbreiten eine farbenfrohe und fröhliche Atmosphäre vor der Orangerie, in der das Design-Team arbeitet. The Orangerie selbst ist inspiriert von Napoleon III.

La fontaine (ci-dessous) et les pots de fleurs méditerranéens typiques de la Côte d'Azur (en haut à droite) créent une atmosphère joyeuse et colorée devant l'orangerie où travaille l'équipe de designers. L'orangerie elle-même est inspirée de celle de Napoléon III.

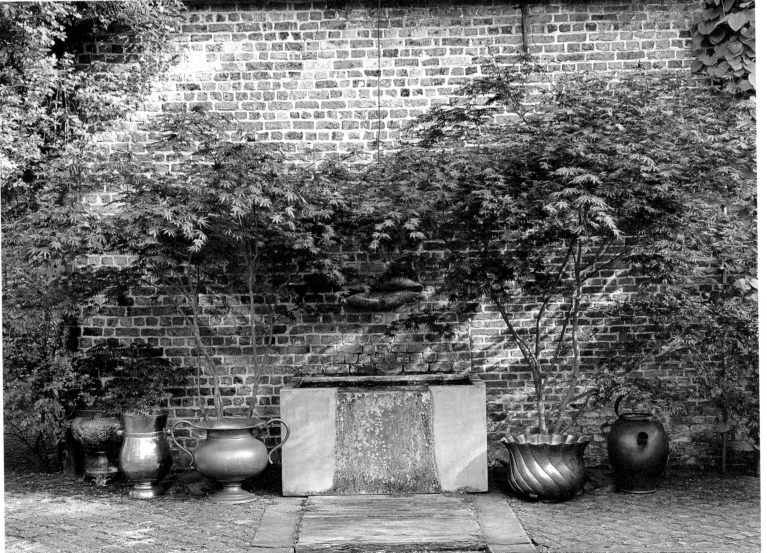

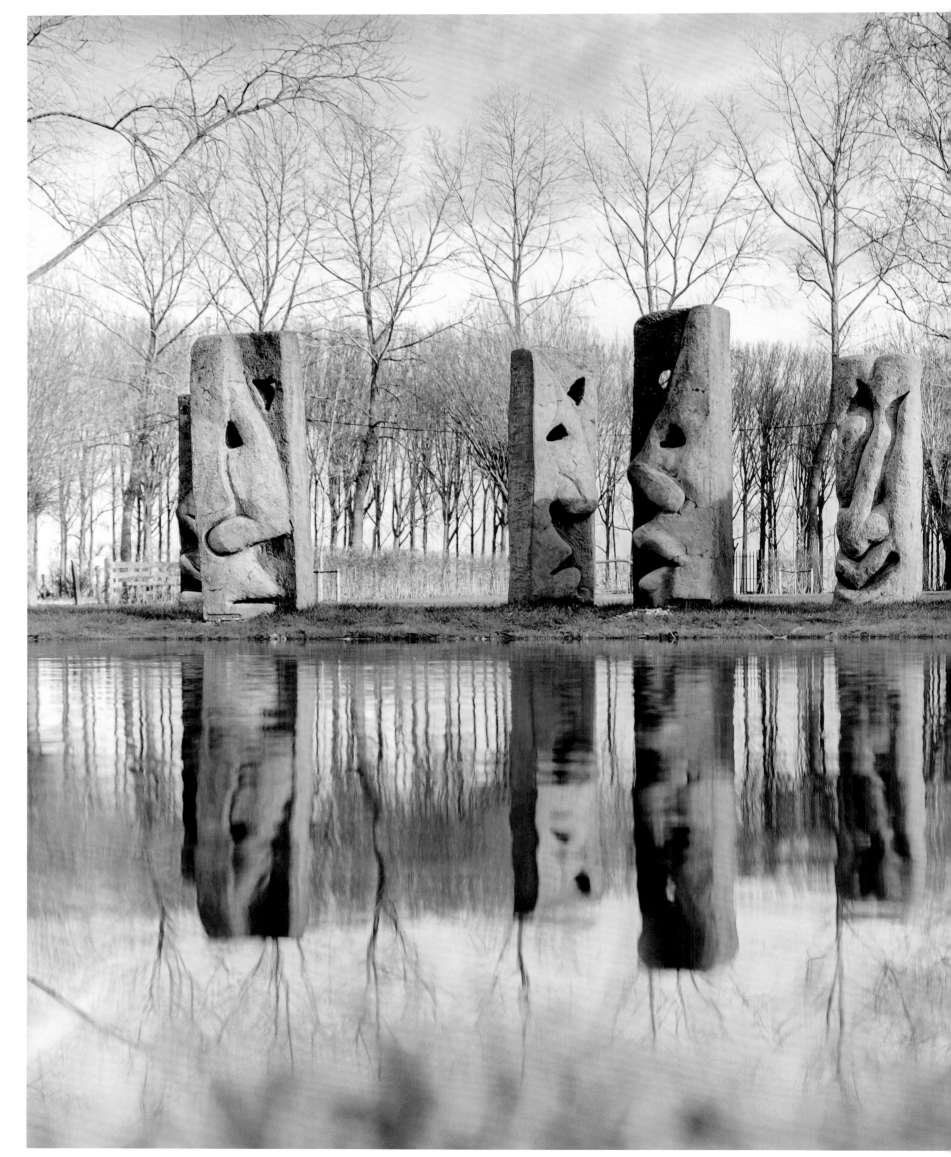

64

Jean-Philippe Demeyer

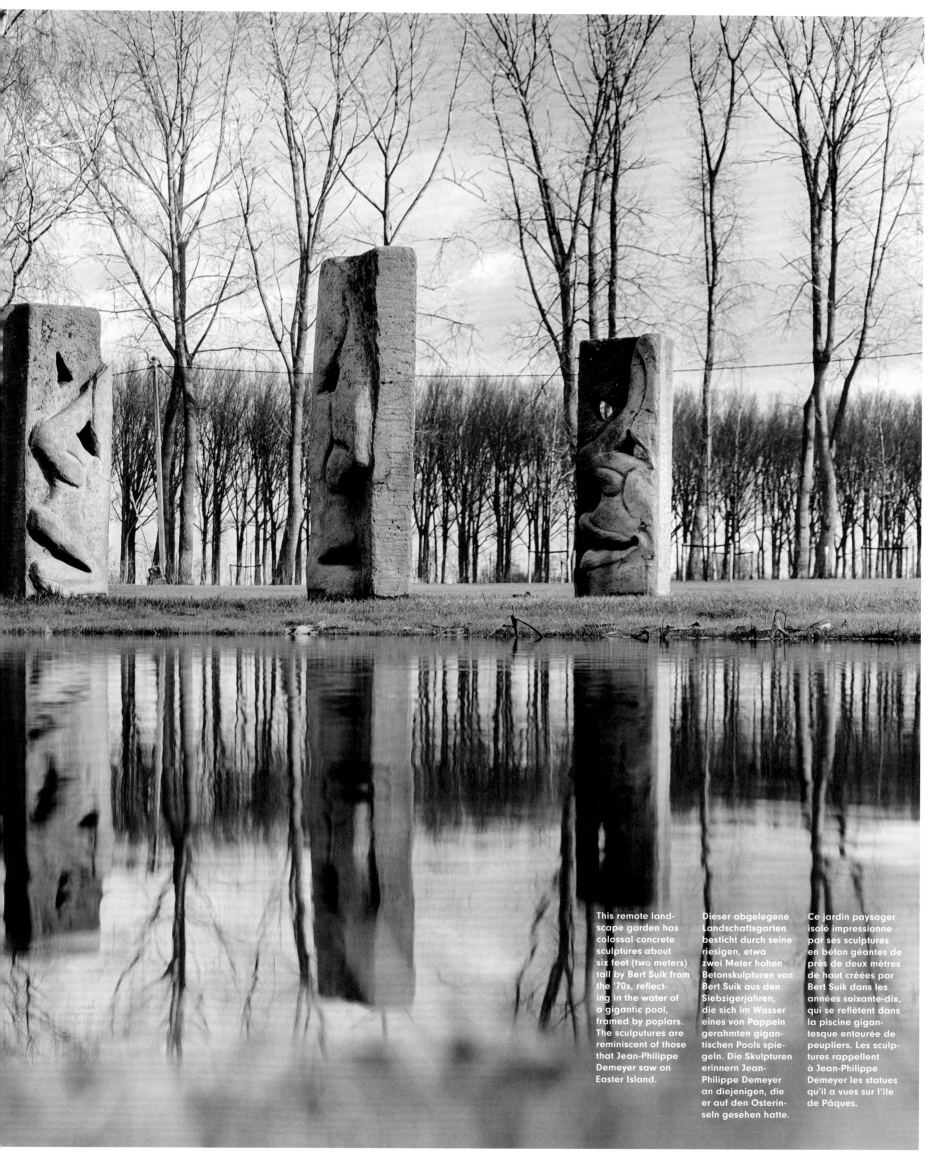

65

This remote landscape garden has colossal concrete sculptures about six feet (two meters) tall by Bert Suik from the '70s, reflecting in the water of a gigantic pool, framed by poplars. The sculputures are reminiscent of those that Jean-Philippe Demeyer saw on Easter Island.

Dieser abgelegene Landschaftsgarten besticht durch seine riesigen, etwa zwei Meter hohen Betonskulpturen von Bert Suik aus den Siebzigerjahren, die sich im Wasser eines von Pappeln gerahmten gigantischen Pools spiegeln. Die Skulpturen erinnern Jean-Philippe Demeyer an diejenigen, die er auf den Osterinseln gesehen hatte.

Ce jardin paysager isolé impressionne par ses sculptures en béton géantes de près de deux mètres de haut créées par Bert Suik dans les années soixante-dix, qui se reflètent dans la piscine gigantesque entourée de peupliers. Les sculptures rappellent à Jean-Philippe Demeyer les statues qu'il a vues sur l'île de Pâques.

Thomas Rösler

Markdorf
Germany

66

Archaic shapes made from oak are the trademark of wood artist Thomas Rösler from Lake Constance.

Archaische Formen aus Eichenholz sind das Markenzeichen des Holzkünstlers Thomas Rösler vom Bodensee.

Les formes archaïques en bois de chêne sont la marque de fabrique de l'artiste Thomas Rösler, installé sur les bords du lac de Constance.

Wood is his life. The Friedrichshafen born Thomas Rösler has always been fascinated by wood as material. First during internships in carpenter's workshops, then during a wood turning apprenticeship, after which he immediately went out on his own. That he initially only made small items and crafts is no longer evident by looking at his sculptural works today. He has turned to heavy duty tools, axe and chainsaw, with which he continues to work only with oak, some pieces as much as 200 years old and primarily from southern Germany.

Trunks weighing several tons are turned to landscaping objects, from hand-held to massive, but nonetheless attractive—one could even say species-appropriate. Because oak trunks are rarely seasoned and dried at the same time, the sculptor affectionately bears down on them in the "green state" with a chainsaw, while moving the saw freely by hand. This intentionally leaves individual grooves behind that can be manually smoothed, according to intention.

Rösler's ideal is "sawing as an immediate action," without hesitating, because he already has already envisioned the final shape when he reaches for the screaming saw. In that moment he already knows where the sculpture will be located, which is always outdoors, for where Rösler works exclusively. In this way, a manageable number of original sculptures, which are already located in many countries of Europe and even in the United States, leave the workshop. There, they bear witness to the creativity of an artist and the skill of a craftsman who loves oak.

Holz, das ist sein Leben. Schon immer war der in Friedrichshafen am Bodensee geborene Thomas Rösler vom Werkstoff Holz fasziniert. Zuerst bei Praktika in Schreinereien, dann während einer Drechslerlehre, nach der er sich sofort selbstständig machte. Dass er zunächst nur kleine Dinge, Kunsthandwerk, herstellte, sieht man seinen heutigen skulpturalen Objekten nicht mehr an. Er wandte sich dem Groben zu, dem Beil und der Kettensäge, mit denen er bis heute nur Eichen bearbeitet, vorwiegend aus dem süddeutschen Raum, manche bis zu 200 Jahre alt.

Aus den tonnenschweren Stämmen werden Landschaftsobjekte, handfest bis massig, aber dennoch anziehend und, man könnte sagen, artgerecht. Da Eichenstämme am Stück kaum ablagern und trocknen, rückt der Skulpteur ihnen im grünen Zustand mit der Kettensäge zu Leibe, wobei die Säge frei mit der Hand geführt wird. Das hinterlässt individuelle Spuren im Objekt, die erwünscht sind und von Hand geglättet werden können, je nach Intention.

Röslers Ideal ist „das Sägen als unmittelbarer Akt", ohne zu zögern, denn die endgültige Form habe er ja schon im Kopf, wenn er zur kreischenden Säge greife. In dem Moment kennt er natürlich schon den zukünftigen Standort, der immer unter freiem Himmel liegt, denn Rösler arbeitet exklusiv. So verlässt nur eine überschaubare Menge an originalen Skulpturen die Werkstatt, die dafür aber schon in vielen europäischen Ländern und sogar in den USA zu finden sind. Dort zeugen sie von der Kreativität eines Künstlers und dem Geschick eines Handwerkers, der die Eichen liebt.

Sa vie, c'est le bois. Né à Friedrichshafen, sur les rives du lac, Thomas Rösler a toujours été fasciné par le matériau bois. Avant de se mettre à son compte, il se forme à l'occasion de stages dans des menuiseries, puis suit un apprentissage de tourneur sur bois. Quand on contemple les objets sculpturaux qu'il crée aujourd'hui, on a du mal à croire qu'il a commencé par des objets d'artisanat d'art de petite taille. Il se consacre au solide, au robuste, il joue de la hache et de la tronçonneuse avec lesquelles il travaille exclusivement des chênes qui proviennent pour l'essentiel du sud de l'Allemagne et peuvent avoir jusqu'à 200 ans d'âge.

À partir de troncs de plusieurs tonnes, il crée des objets paysagers à l'aspect solide, sinon massif, tout en étant beaux à regarder : on peut parler de respect de la matière. Les troncs de chêne achetés à l'unité n'étant pratiquement ni stockés ni séchés, le sculpteur attaque le bois vert à la tronçonneuse en guidant librement l'outil à la main. Cela laisse dans l'objet des traces uniques voulues, mais que l'artiste peut ensuite lisser à la main s'il le souhaite.

L'idéal de Rösler, c'est la « spontanéité de l'acte de scier », d'où les hésitations sont absentes, car lorsqu'il s'empare de son outil au bruit strident, le créateur a déjà la forme définitive en tête. Comme Rösler ne travaille que sur commande exclusive, il sait bien entendu dès le moment où il crée à quel endroit son œuvre sera installée, toujours sur un site en plein air. Il ne sort donc de son atelier qu'une quantité limitée de sculptures originales, que l'on va ensuite retrouver dans de nombreux pays d'Europe et même aux États-Unis. Elles y portent le témoignage de la créativité d'un artiste et de l'habileté d'un artisan amoureux des chênes.

Thomas Rösler at work: All objects are sawn from huge oak trunks using a hand-held chainsaw. Each sphere in the Alpine Rhine valley consists of nine elements each: sculptural and protective seats, loungers and relaxation objects.

Thomas Rösler bei der Arbeit: Alle Objekte werden mit der von Hand geführten Kettensäge aus riesigen Eichenstämmen herausgesägt. Aus jeweils neun Elementen bestehen die Kugeln im Alpenrheintal: skulpturale und schützende Sitz-, Liege- und Relaxobjekte.

Thomas Rösler au travail : tous les objets sont sciés à la tronçonneuse guidée à la main dans de gigantesques troncs de chêne. Les boules de la vallée du Rhin alpin sont composées de neuf éléments : objets pour s'assoir, s'allonger, se relaxer, à la fois sculptures et abris.

Thomas Rösler

68

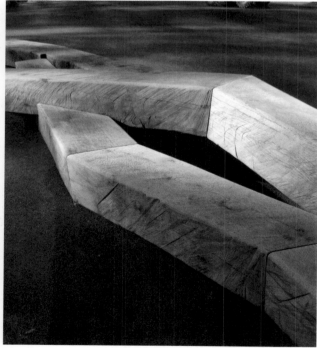

The furniture pieces, comprised of a table and benches, measure nearly 31 feet (9.5 meters). Rösler's classic piece is the shell lounger made of four curved beams. Comfortable sitting sculptures enhance a space in Zurich-Triemli.

Fast 9,5 Meter misst die Möbelgruppe aus Tisch und Bänken. Röslers Klassiker ist die Liegeschale aus vier gekrümmten Balken. Bequeme Sitzskulpturen werten einen Platz in Zürich-Triemli auf.

Composé d'une table et de bancs, ce salon mesure près de 9,5 mètres. Un classique de Rösler est la coque couchette constituée de quatre poutres cintrées. Ces sièges sculptés confortables ornent un site situé à Zürich-Triemli.

Right page: The large shell in Chur creates an ideal symbiosis between architecture and landscape. The varying widths of the oak elements create a lighthearted look among the islands of plants in Ebikon.

Rechte Seite: Die große Muschel in Chur bildet eine ideale Symbiose mit Architektur und Landschaft. Die Pflanzinseln in Ebikon wirken beschwingt durch die verschiedenen Breiten der Eichenelemente.

Page droite : La grande coquille de Coire (Suisse) crée une symbiose idéale entre l'architecture et le paysage. Les îlots végétaux d'Ebikon (Suisse) ondoient à travers des éléments de chêne de largeurs variables.

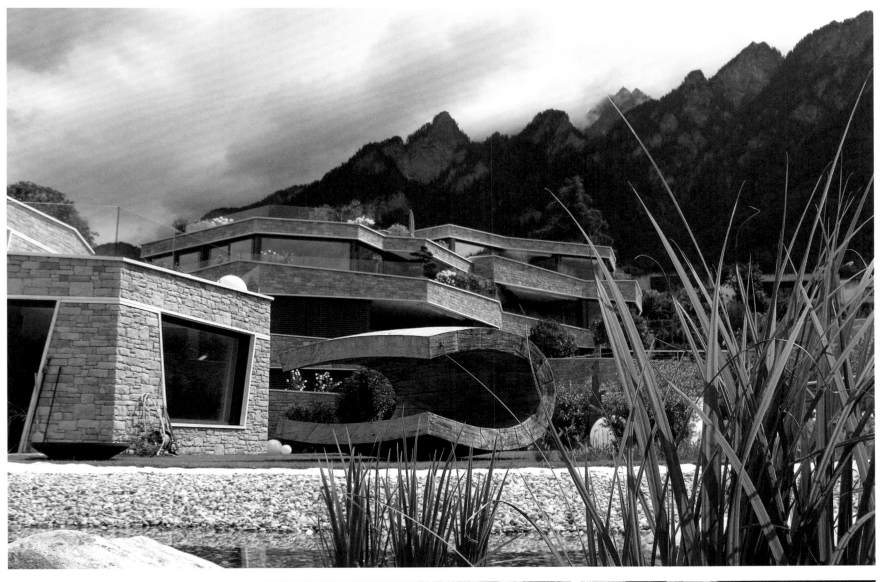

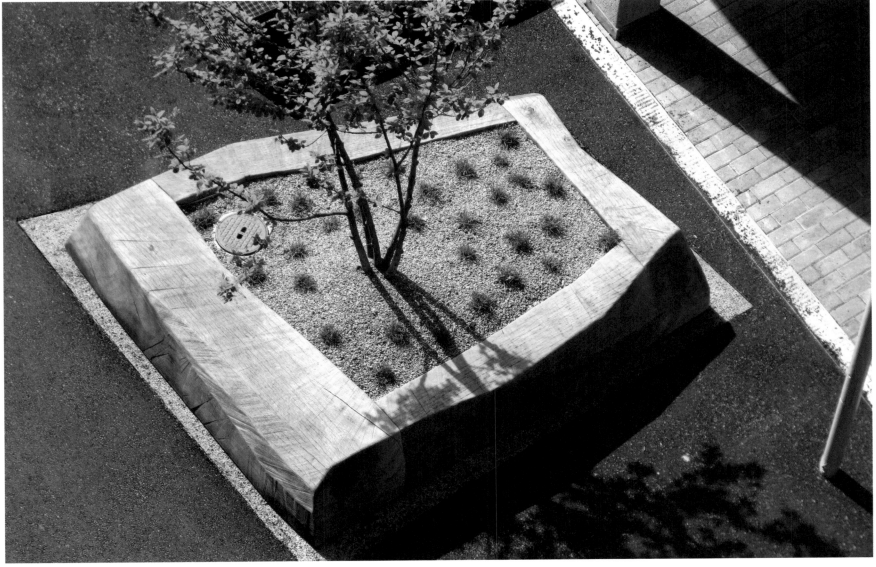

Thomas Rösler

Sophie Walker Studio

London | England

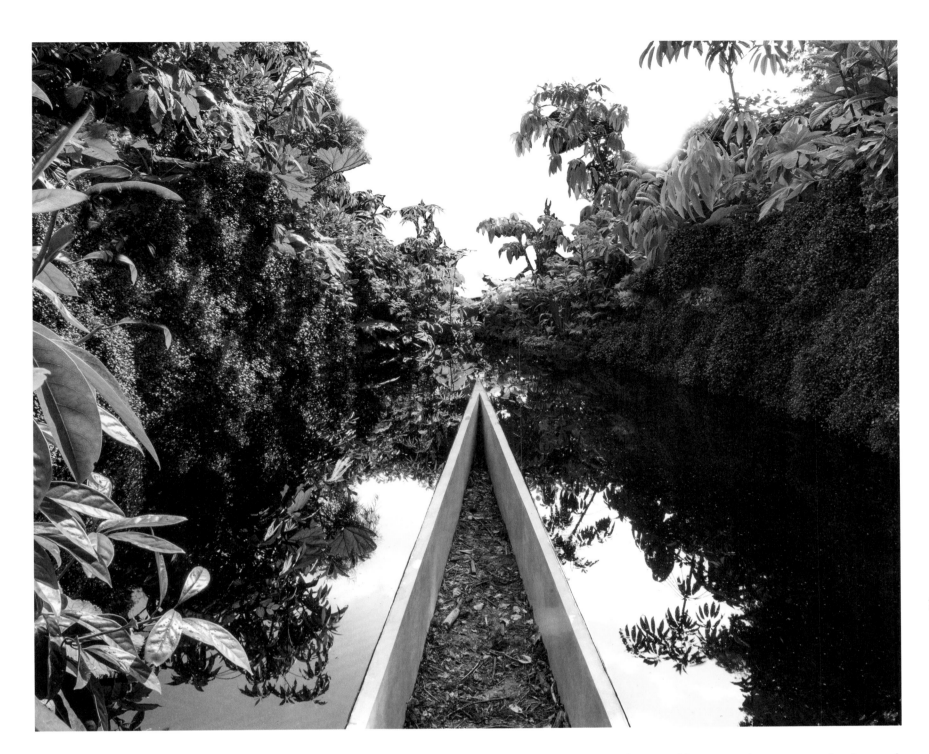

The Cave Pavilion at the Chelsea Flower Show 2014 (left) and A Valley Garden at the Hampton Court Palace Flower Show 2013 both feature thick plantings of rare species.

Sowohl der Cave Pavilion auf der Chelsea Flower Show 2014 (links) als auch A Valley Garden auf der Hampton Court Palace Flower Show 2013 zeigen dichte Pflanzungen mit raren Arten.

Le Cave Pavilion présenté aux floralies de Chelsea en 2014 (à gauche) et le Valley Garden exposé aux floralies de Hampton Court Palace en 2013 se caractérisent par une végétation dense composée d'espèces rares.

Sophie Walker likes to work with rare and valuable plants. Her gardens are designed to be experienced. | Sophie Walker verwendet gerne seltene und wertvolle Pflanzen – ihre Gärten sind zum Erfahren gemacht. | Sophie Walker aime peupler ses jardins à vivre de plantes rares et précieuses.

Walker initially studied psycho-analysis and art history before she discovered landscaping. Back in 2014, this Brit was the youngest woman to create a temporary garden for the renowned Chelsea Flower Show in London. She loves thick plantings that include some unusual plants and gardens in which visitors have to take their time to recognize the wide variety of leaf shapes and textures. The Cave Pavilion in Chelsea, which she created, is a perfect example of this.

Zuerst studierte Sophie Walker Psychoanalyse und Kunstgeschichte, bevor sie zur Gartengestaltung fand. 2014 schuf die Britin dann als bis dahin jüngste Frau einen temporären Garten für die renommierte Chelsea Flower Show in London. Sie liebt dichte Pflanzungen mit zum Teil ungewöhnlichen Gewächsen sowie Gärten, in denen sich der Betrachter nur mit Blicken bewegt und erst allmählich die Vielfalt der Blattformen und Texturen erkennt – wie sie mustergültig in ihrem Cave Pavilion in Chelsea zeigt.

Sophie Walker est devenue paysagiste après avoir étudié la psychanalyse et l'histoire de l'art. En 2014, cette Britannique est la femme la plus jeune jamais appelée à créer un jardin éphémère dans le cadre du Chelsea Flower Show de Londres. Elle aime les plantations denses, composées en partie de végétaux peu connus, ainsi que les jardins dans lesquels l'observateur peut se déplacer simplement en regardant et ne découvrir que peu à peu la diversité des feuillages et des textures, comme l'a montré l'exemple du Cave Pavilion à Chelsea.

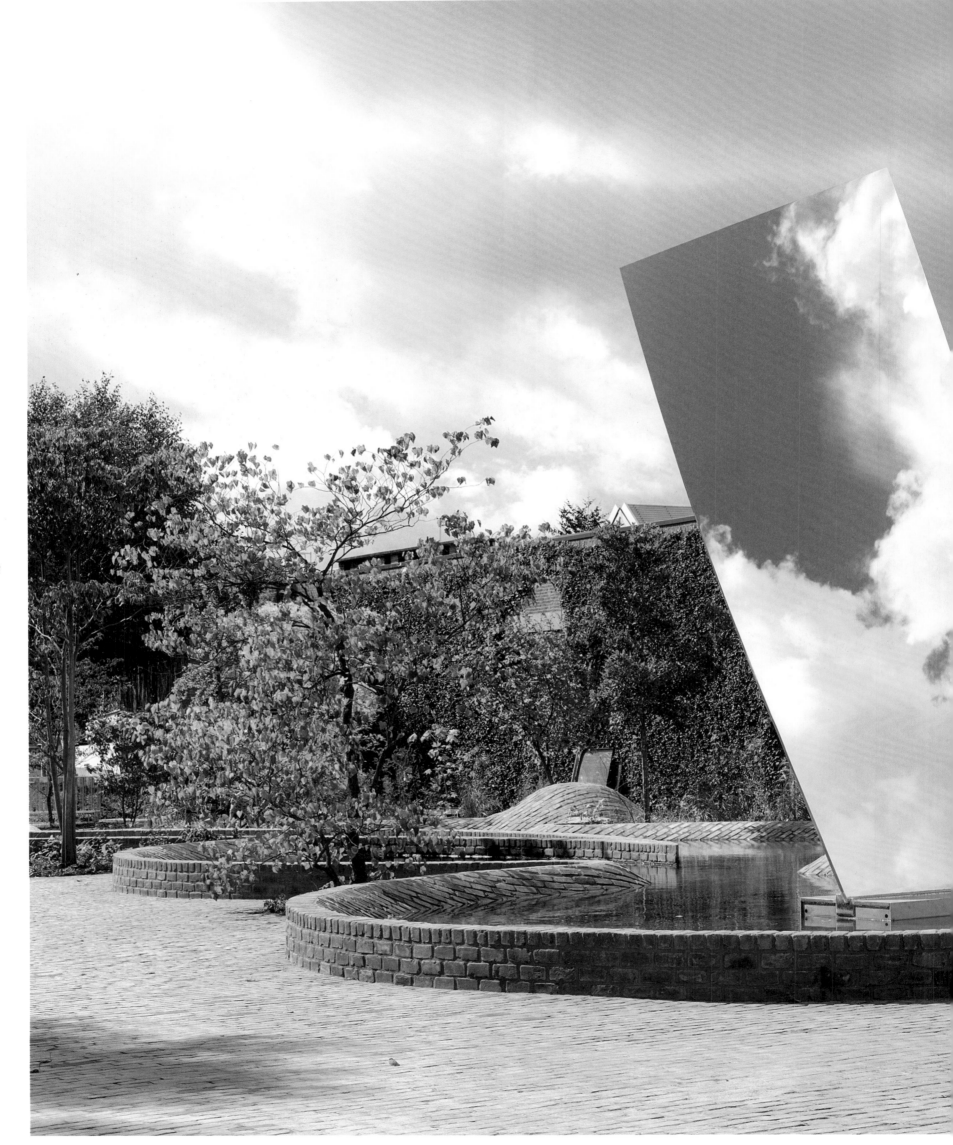

The elaborately
designed garden of
the De Pont Museum
in the Dutch city
of Tilburg enchants
visitors throughout
the year. It surrounds
Anish Kapoor's
Sky Mirror sculpture,
which is posi-
tioned in a curving
brick pool.

Der ausgeklügelt
bepflanzte Garten
des De Pont
Museums im
niederländischen
Tilburg soll zu allen
Jahreszeiten wirken.
Er umrahmt Anish
Kapoors Skulptur
Sky Mirror in
einem geschwun-
genen Becken
aus Ziegelstein.

À Tilbourg (Pays-
Bas), le jardin du
musée De Pont a été
conçu pour briller
en toute saison. Il
entoure la sculpture
Sky Mirror d'Anish
Kapoor dans un
bassin arrondi
en briques.

Sophie Walker Studio

Sophie Walker

Gardens Should Engage.
Gärten sollten Engagement erfordern.
Le jardin synonyme d'engagement

Walker is part of a successful younger generation of English garden landscapers. A plant expert, she collaborates with renowned architects and artists on projects in Europe, America, and Asia.

Sophie Walker gehört zur erfolgreichen jüngeren Generation englischer Gartendesigner. Die Pflanzenexpertin arbeitet mit namhaften Architekten und Künstlern an Projekten in Europa, Amerika und Asien.

Sophie Walker est typique de la jeune génération des designers paysagistes anglais les plus reconnus. Cette spécialiste des plantes travaille avec des architectes et des artistes reconnus sur des projets en Europe, en Amérique et en Asie.

Do you prefer designing for garden shows or for public spaces?

I enjoy making gardens that demand our engagement regardless of context. I am interested in the capacity of the garden as a place of wonder, discovery, intimacy. A garden is not something that just happens beneath your feet, but a place of immersion, a three-dimensional volume to be entered physically and mentally.

Historically, the garden was a high art, a place in which philosophical, poetic and abstract ideas could be externalized. In our 21st-century world of degraded natural habitat, the man-made garden must return to the great ambitions of the

Entwerfen Sie lieber experimentelle Schaugärten oder öffentliche Freiräume?

Ich gestalte gerne Gärten jeder Art, wenn sie mein volles Engagement fordern. Mich interessiert ein Garten als Ort des Staunens, des Entdeckens, der Geborgenheit. Ein Garten ist nicht nur etwas, das du unter den Füßen spürst – er ist dreidimensional, ein Ort, den man körperlich und auch mental betritt.

Historisch gesehen gehörte der Garten zu den großen Künsten, als ein Ort, in dem philosophische, poetische oder abstrakte Ideen geboren wurden. In unserer heutigen Welt, mit den zerstörten natürlichen Lebensräumen, müssen

Vous préférez créer des jardins-expositions expérimentaux ou des espaces publics ?

Je conçois des jardins quels qu'ils soient, pourvu que je puisse m'y engager totalement. Pour moi, le jardin est intéressant lorsqu'il suscite étonnement, découverte, sentiment de protection. Un jardin, ça ne se sent pas uniquement sous les pieds, un jardin se vit dans les trois dimensions, c'est un lieu que l'on rencontre physiquement, mais aussi mentalement.

Historiquement, le jardinage était un art majeur et les jardins des lieux où sont nées des idées philosophiques, poétiques ou abstraites. Dans notre monde actuel, avec ses

past and reconsider the potential of the garden to impact our relationship to our place in the world.

Your gardens contain rare and precious species. How can you ensure that they're given the proper care?

I work with rare plants primarily because of their ability to change our approach to garden design. Working with a plant that isn't necessarily recognizable disorients the visitor, in other words, by changing the plant's palette, we can free

I am interested in the life of the garden beyond the human hand. The garden has a life far beyond our own...

ourselves from memory and association and be free to look.

It is a challenge to work with rare and even previously unknown plants; there is no clear information to indicate their needs, so as gardeners, we have nothing to refer to except the plant's origin and the knowledge of how it grew in the wild. Our most important guide is the plant itself: to watch and learn, to garden with intuition and instinct. I think this approach can lead us to a more profound contact with the garden.

Does your psychology background influence your plant design?

The garden and the practice of psychoanalysis reflect one another as a daily care, a cultivation of the raw untamed. I first decided to study horticulture on a trip to the Bolivian Amazon. We know our internal environment is a powerful governing force, and it was in the Amazon that I saw firsthand the potential power of the external environment. I am interested in the life of the garden beyond the human hand. The garden, of course, has a life far beyond our own...

wir Gärten wieder mit großen Ambitionen gestalten, denn sie haben das Potenzial, uns eine bessere Beziehung zur Umwelt zu vermitteln.

Ihre Gärten enthalten seltene Pflanzen. Wie können Sie die Pflege sichern?

Hauptsächlich arbeite ich mit raren Pflanzen, weil sie den Gestaltungsansatz beeinflussen. Eine Pflanze zu verwenden, die die Besucher erstaunt, also die Palette der verwendeten Arten zu erweitern, befreit uns von gespeicherten Eindrücken und öffnet einen unbeeinflussten Blick auf das Neue.

Es ist herausfordernd, seltene oder bis dahin unbekannte Pflanzen zu verwenden. Man weiß wenig über sie, außer ihrer Herkunft und dem natürlichen Standort. So muss uns die Pflanze selbst Auskunft geben, wir müssen schauen und lernen, intuitiv handeln, was uns einen intensiveren Kontakt mit dem Garten beschert.

Mich interessiert der Garten über den menschlichen Eingriff hinaus. Der Garten hat ein Leben, das weit über unseres hinausreicht ...

Helfen Ihnen die psychologischen Kenntnisse bei der Pflanzplanung?

Der Umgang mit Gärten und die Psychoanalyse reflektieren sich gegenseitig als andauernde Pflege, als Kultivierung des Rohen, Ungezähmten. Nach einer Reise zum bolivianischen Amazonas entschloss ich mich, Gartenbau zu studieren. Wir kennen unsere inneren Triebkräfte, doch am Amazonas erkannte ich die starke äußere Antriebskraft der Natur. Mich interessiert der Garten über den menschlichen Eingriff hinaus. Der Garten hat natürlich ein Leben, das weit über unseres hinausreicht ...

espaces naturels dévastés, nous devons retrouver de grandes ambitions pour les jardins, car ils peuvent nous aider à renouer des liens avec l'environnement.

Vos jardins contiennent des plantes rares. Comment faire pour assurer leur entretien ?

Je travaille surtout avec des plantes rares parce qu'elles ont une influence sur l'approche créative. Utiliser un végétal qui étonne le visiteur, et donc étendre la palette des variétés utilisées, permet de nous couper des impressions

Le jardin m'intéresse au-delà de l'action de l'Homme. De manière naturelle, le jardin a une vie qui va bien au-delà des nôtres...

que nous avons en tête, cela ouvre le regard sur la nouveauté, sans préjugé.

Utiliser des plantes rares ou encore inconnues est un défi. On les connait peu, à part leur origine et les lieux où elles croissent naturellement. C'est donc à la plante de nous parler d'elle-même, nous devons regarder et apprendre, agir de manière intuitive et pour cela, nous avons besoin d'un contact intime avec le jardin.

Vos connaissances en psychologie vous aident-elles à concevoir vos plantations ?

Le jardin et la psychanalyse sont des reflets l'un de l'autre : l'entretien ne s'arrête jamais, il faut savoir cultiver le côté brut, indomptable. Après un voyage en Amazonie bolivienne, j'ai pris la décision d'étudier l'horticulture. Nous connaissons nos motivations intérieures, mais en Amazonie, j'ai découvert la force qui émane de la nature. Le jardin m'intéresse au-delà de l'action de l'Homme. De manière naturelle, le jardin a une vie qui va bien au-delà des nôtres...

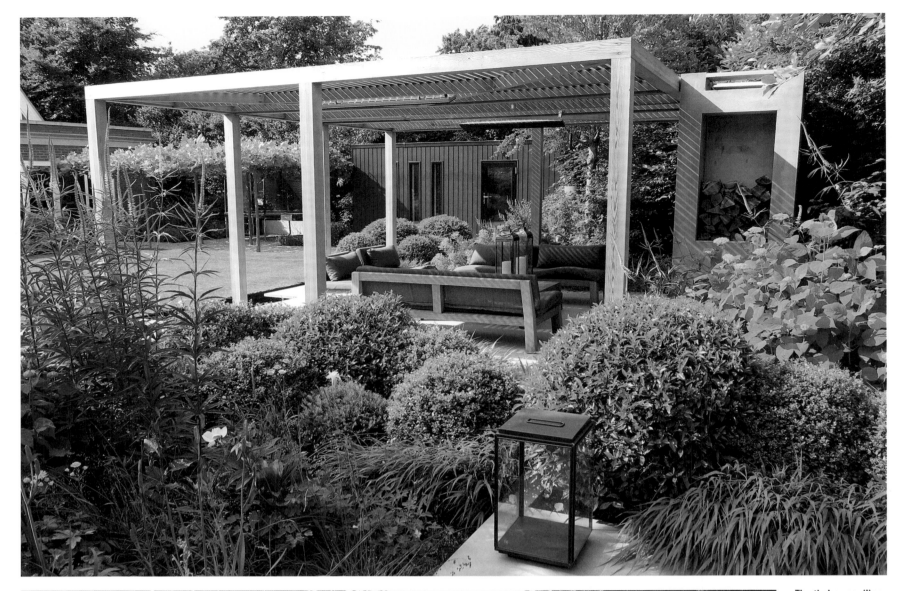

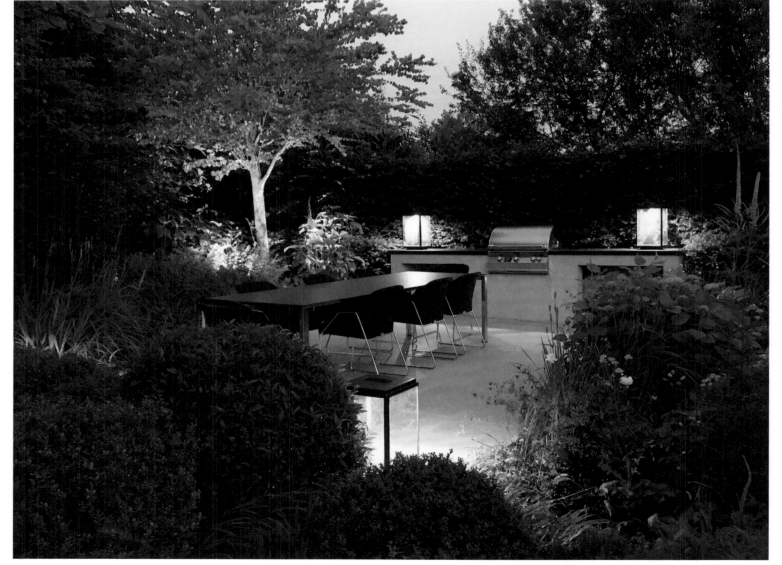

The timber pavilion forms the focus of the garden, which is surrounded by shrubs such as Taxus and Ilex crenata as well as grasses such as Hakonechloa macra. The grill terrace is surrounded by trees and low shrubs, turning it into a magical place for relaxation.

Der Holzpavillon bildet den Fokus des Gartens, darum Sträucher wie Taxus und Ilex crenata sowie Gräser wie Hakonechloa macra. Die Grillterrasse wird umgeben von Sträuchern und Bäumen zum magischen Verweilort.

Point central du jardin, le pavillon en bois est encadré d'arbustes, par exemple d'ifs et de houx crénelés, ainsi que d'herbacées comme l'herbe du Japon Hakonechloa macra. Le coin barbecue de la terrasse est entouré d'arbustes et d'arbres qui en font un lieu magique où on aime passer du temps.

Charlotte Rowe

Charlotte Rowe

London | England

This British garden designer has designed over 200 gardens with architectural style, elegance, powerful colors, and clever lighting. | Über 200 Gärten hat die Britin gestaltet, in architektonischem Stil, elegant, mit kräftigen Farben und cleverer Beleuchtung. | Cette Britannique a conçu plus de 200 jardins dans un style architectural et élégant, alliant couleurs vives et éclairages raffinés.

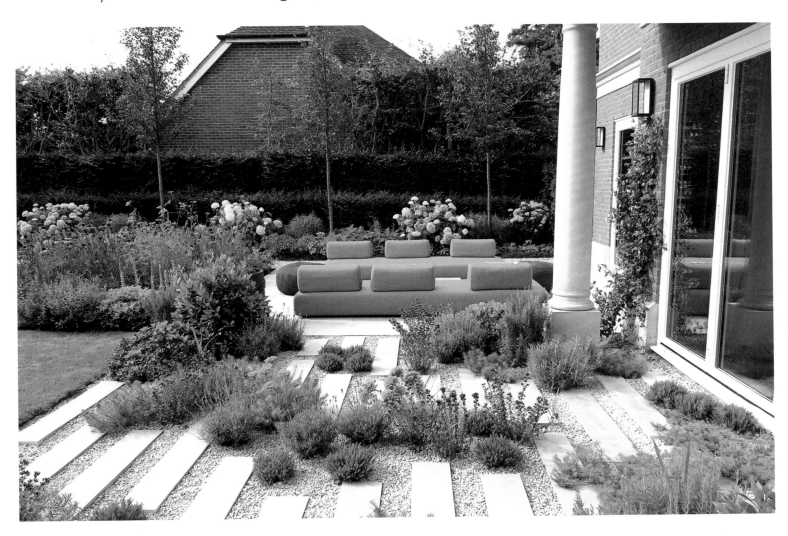

Low sun-loving plants such as cypress spurge 'Fens Ruby,' lavender 'Munstead,' and rosemary are interspersed through the terrace of limestone slabs and light-colored gravel.

Niedrige sonnenliebende Pflanzen wie Zypressen-Wolfsmilch 'Fens Ruby', Echter Lavendel 'Munstead' und Rosmarin lockern die Terrasse aus Kalksteinplatten und hellem Kies auf.

Des plantes basses qui aiment le soleil, comme les euphorbes petits-cyprès 'Fens Ruby', la lavande vraie 'Munstead' et le romarin, mènent le visiteur à la terrasse en dalles de pierre calcaire et gravier clair.

These three examples of her work illustrate her clear design: Cobham Garden in Surrey is a garden for the whole family, with a lawn, water, a terrace, and a grill area; the Woodland Garden complements the addition to an early-Victorian house in London; the Formal Structural Garden near the city shows a stylish contemporary garden with pétanque court and formal planting. In 2014 Charlotte Rowe and her small design studio in London won a gold medal at the RHS Chelsea Flower Show.

Ihre klare Gestaltung lässt sich an drei Beispielen erkennen: Cobham Garden in Surrey ist ein Garten für die ganze Familie, mit Rasen, Wasser, Terrasse und Grillplatz. Woodland Garden ergänzt den Anbau an ein frühviktorianisches Haus in London. Der Formal Structural Garden nahe der Stadt zeigt einen stylischen zeitgenössischen Garten mit Pétanque-Platz und formaler Pflanzung. 2014 gewann Charlotte Rowe mit ihrem kleinen Designstudio in London bei der Chelsea Garden Show eine Goldmedaille.

Trois exemples illustrent la limpidité de ses créations : dans le Surrey, Cobham Garden est un jardin pour toute la famille, avec de la pelouse, de l'eau, une terrasse et un coin barbecue. Woodland Garden complète l'annexe d'une maison londonienne du début de l'époque victorienne. Enfin, le Formal Structural Garden, situé près de la ville, est un jardin contemporain stylé, agrémenté d'une aire de pétanque et de plantations formelles. En 2014, Charlotte Rowe et son petit studio de design londonien ont reçu une médaille d'or à l'occasion du Chelsea Garden Show.

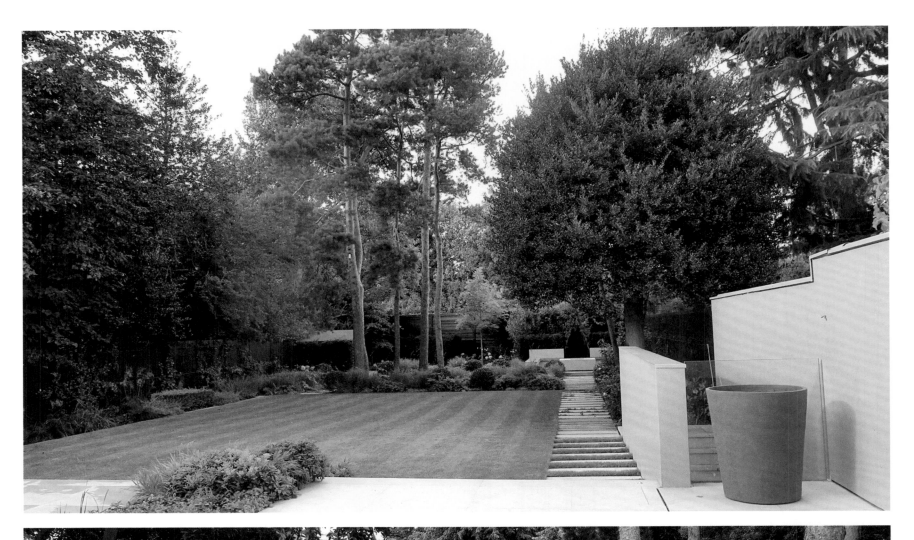

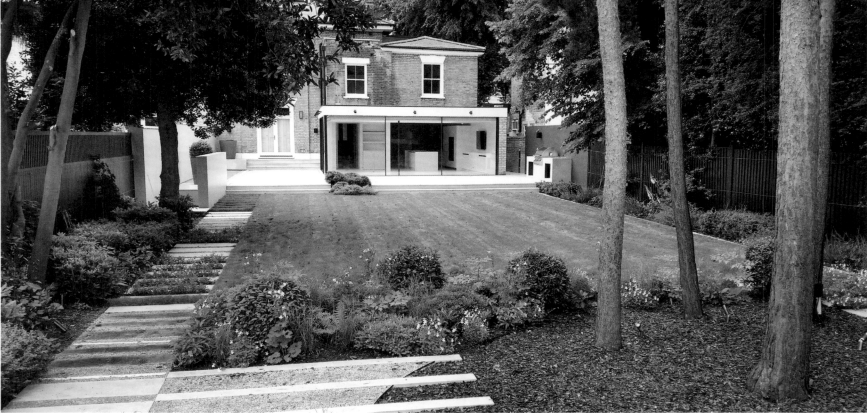

The terrace and walkways made of limestone and granite connect the house and garden. The planting consists of four large Scotch pines and evergreen shrubs such as Portugal laurel, Pittosporum tobira 'Nanum', 'Actaea', Viola cornuta 'Alba' and 'Carex muskingumensis.'

Terrasse und Wege aus Kalkstein und Granit verbinden Haus und Garten. Die Bepflanzung besteht aus vier großen Waldkiefern und immergrünen Sträuchern wie Portugiesischer Kirschlorbeer, Chinesischer Klebsame 'Nanum', Oktober-Silberkerze, weiße Hornweilchen und Palmwedel-Segge.

Constituées de pierre calcaire et de granit, la terrasse et les allées relient la maison au jardin. La végétation est composée de quatre grands pins sylvestres et de buissons toujours verts, comme le laurier du Portugal, le pittospore du Japon 'Nanum', l'Actaea simplex, la violette cornue blanche et la laîche palmée.

Charlotte Rowe

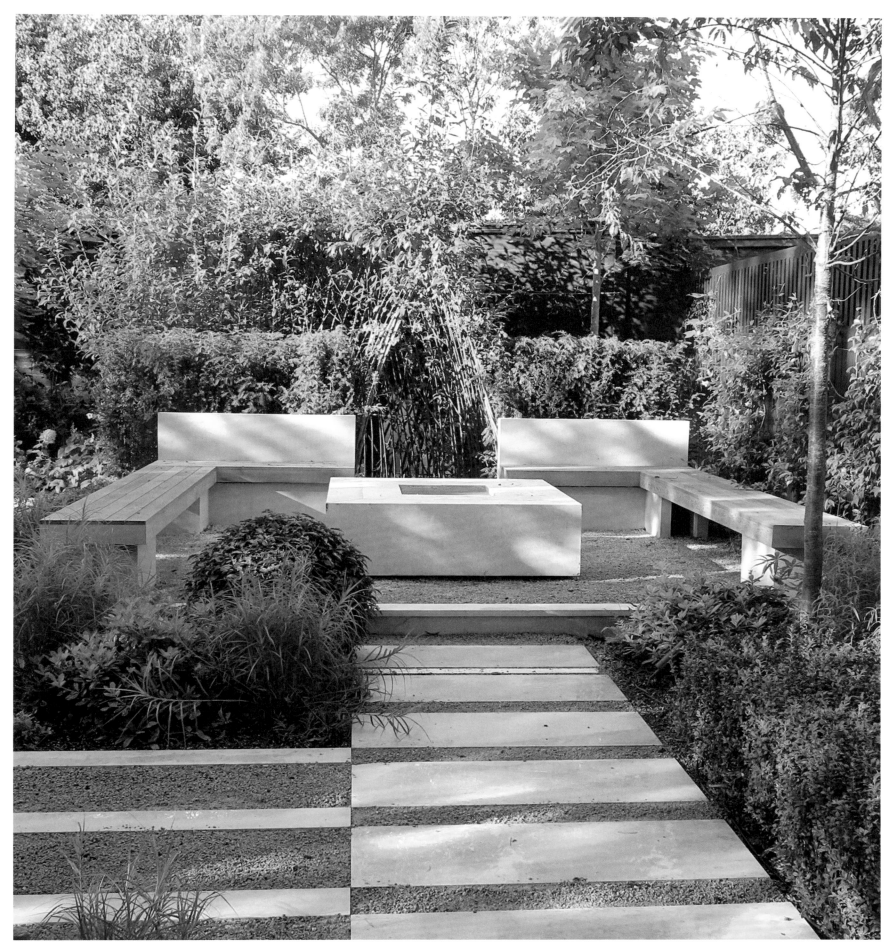

79

A fire pit was built in at the sunniest part of the garden. The living willow tunnel behind this leads to a play area for the children.

Im sonnigsten Teil des Gartens wurde eine Feuerstelle errichtet. Der Weidentunnel dahinter führt zum Spielbereich für die Kinder.

Une aire de feu a été installée dans la partie la plus ensoleillée du jardin. Juste derrière, un tunnel de saules mène à l'aire de jeux des enfants.

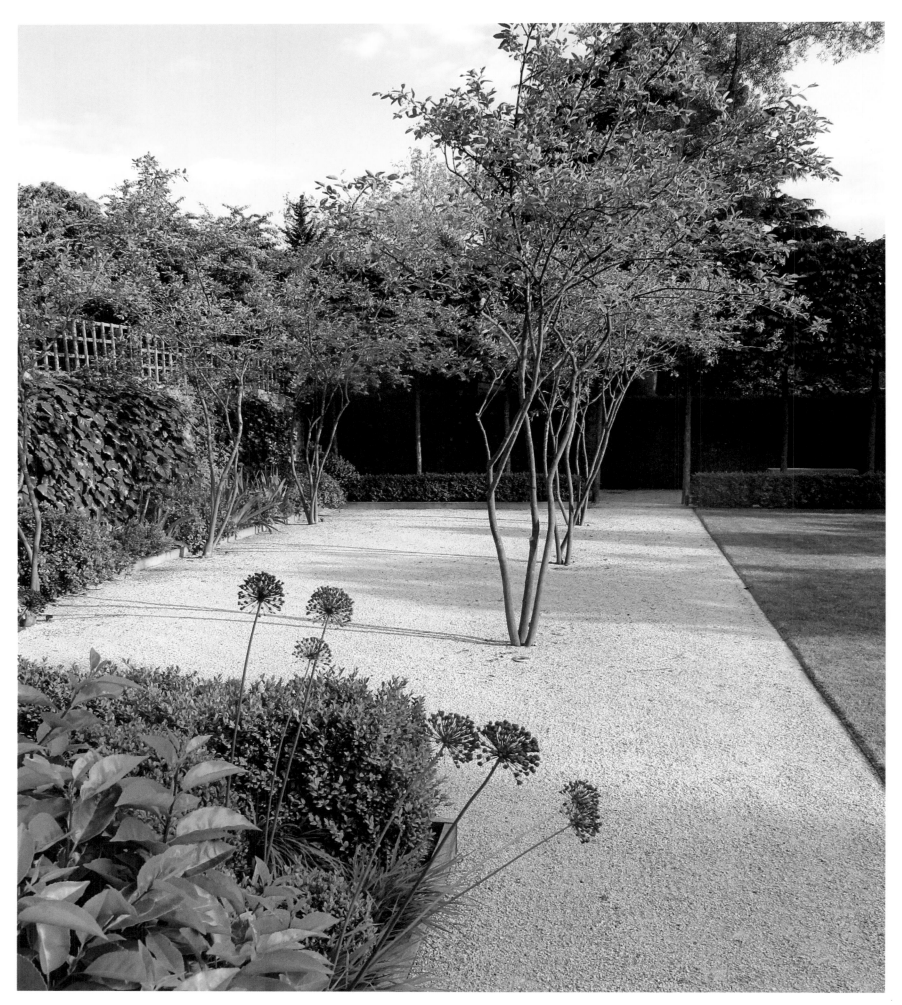

80

The pétanque court was part of the client's brief and has six multi-stem Amelanchier trees and a row of hornbeam which blend well into the structural garden.

Der von den Besitzern gewünschte Pétanque-Platz mit formaler Pflanzung aus sechs mehrstämmigen Kupfer-Felsenbirnen und einer Reihe Hainbuchen fügt sich gut in den strukturierten Garten ein.

Voulu expressément par les propriétaires, le terrain de pétanque s'intègre harmonieusement à la structure du jardin, avec sa végétation formelle constituée de six amélanchiers multitiges et d'une rangée de charmes communs.

A water rill cuts through the upper terrace of English limestone and "Cloud" planting of Buxus and Rosemary.

Eine Wasserstelle durchschneidet die obere Terrasse aus englischem Kalkstein sowie eine dichte Pflanzung aus Gewöhnlichem Buchsbaum und Rosmarin.

Une pièce d'eau traverse la terrasse supérieure en pierre calcaire anglaise, de même qu'un massif dense de buis commun et de romarin.

Charlotte Rowe

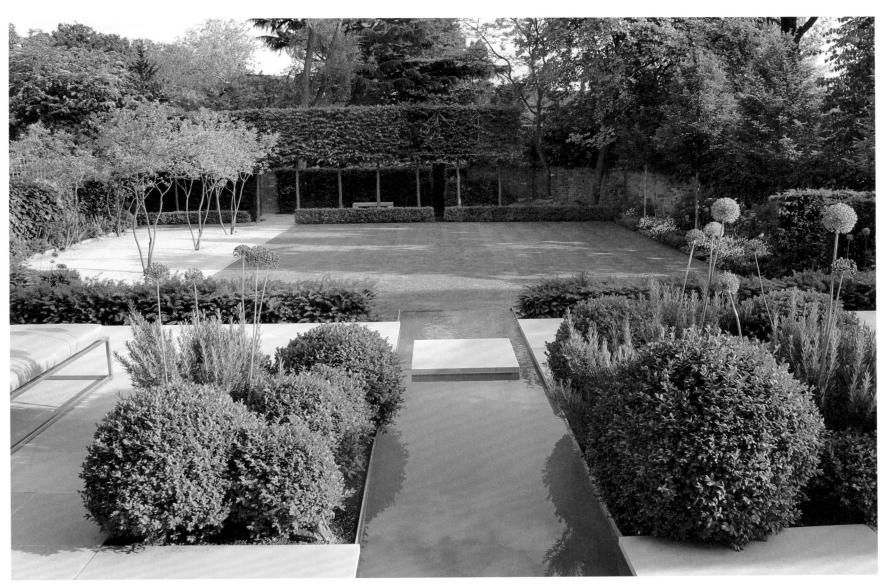

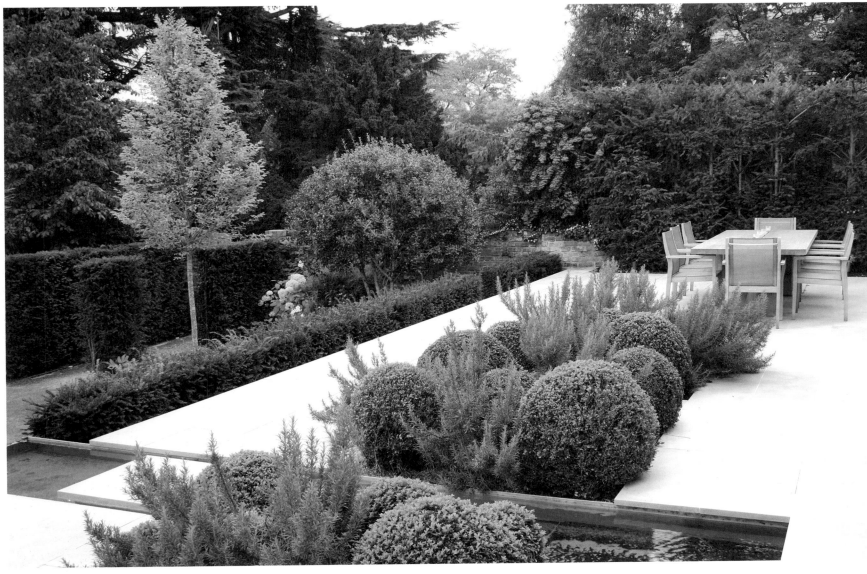

World-famous sculptures enhance this Sonoma Valley vineyard, which, upon these rolling hills, produces award-winning wines. | Skulpturen von Weltrang adeln das Weingut im Sonoma Valley, das auf sanften Hügeln Spitzenweine produziert. | Dans la Sonoma Valley, sculptures de renommée mondiale et grands crus fusionnent sur les douces collines du domaine.

In the Carneros Region of Sonoma, Anne Moller-Racke, who is of German descent, founded a vineyard in 1981 with the goal of producing the best pinot noir and chardonnay, which she achieved after only a decade. When the Dane Allan Warburg, who was successful in the fashion business in China and Hong Kong, came in as the majority shareholder in 2011, he began to enhance the extensive vineyard landscape by installing large-scale sculptures by major international artists. The aim is to bring together diverse cultures with art as well as wine.

In der Carneros-Region von Sonoma gründete die deutschstämmige Anne Moller-Racke 1981 ein Weingut mit dem Ziel, besten Pinot Noir und Chardonnay zu produzieren – was ihr bereits nach einem Jahrzehnt gelang. Als der Däne Allan Warburg, erfolgreich im Modebusiness in China und Hongkong, 2011 als Mehrheitseigner einstieg, begann er, die weitläufige Weinberglandschaft mit großformatigen Skulpturen internationaler Künstler aufzuwerten. Ziel ist es, verschiedene Kulturen mit Kunst und Wein zusammenzubringen.

Dans le terroir des Carneros (comté de Sonoma), Anne Moller-Racke, d'origine allemande, se lance en 1981 dans la production de pinots noirs et de chardonnays dont l'excellence va s'imposer en à peine dix ans. En 2011, le Danois Allan Warburg, connu pour sa réussite dans la mode en Chine et à Hongkong, devient premier actionnaire de l'entreprise et décide de mettre en valeur les douces collines du domaine en y installant des sculptures d'artistes internationaux. Son but : associer la diversité culturelle à l'art et au vin.

82

Donum Estate

Donum Estate

Sonoma, California | USA

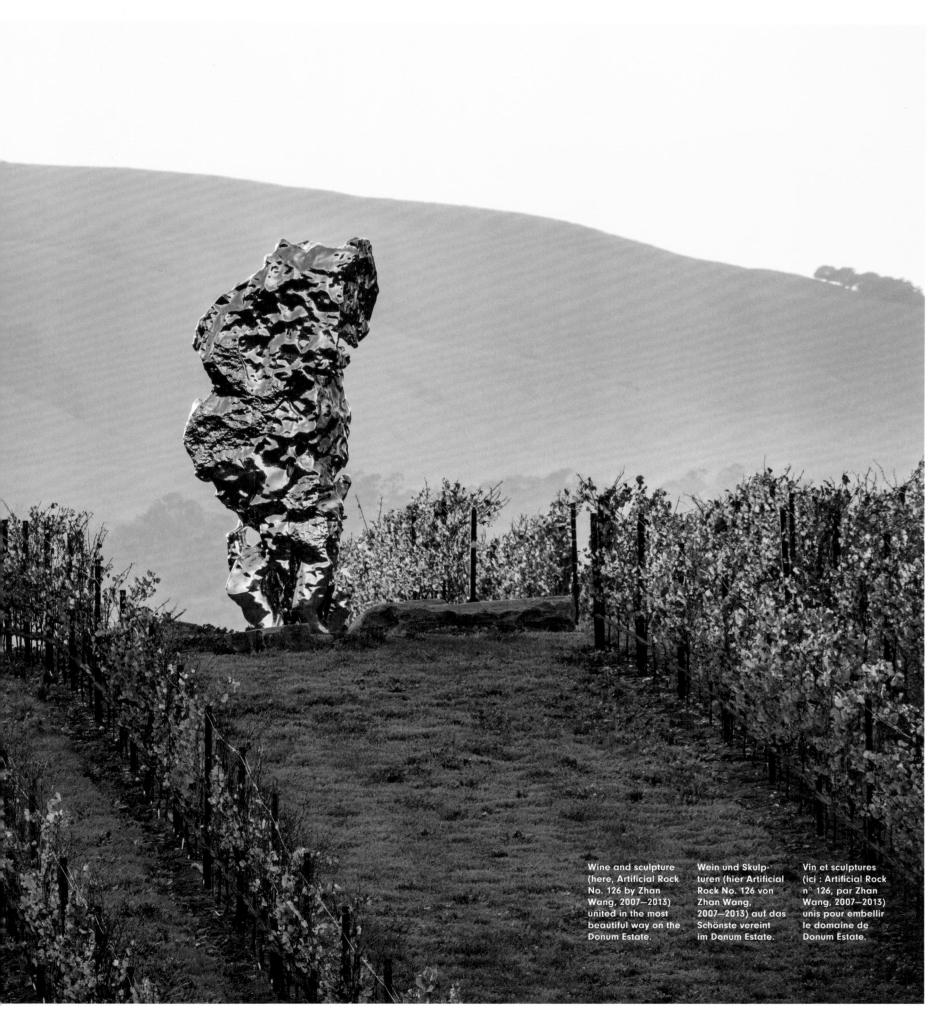

Wine and sculpture (here, Artificial Rock No. 126 by Zhan Wang, 2007—2013) united in the most beautiful way on the Donum Estate.

Wein und Skulpturen (hier Artificial Rock No. 126 von Zhan Wang, 2007—2013) auf das Schönste vereint im Donum Estate.

Vin et sculptures (ici : Artificial Rock n° 126, par Zhan Wang, 2007—2013) unis pour embellir le domaine de Donum Estate.

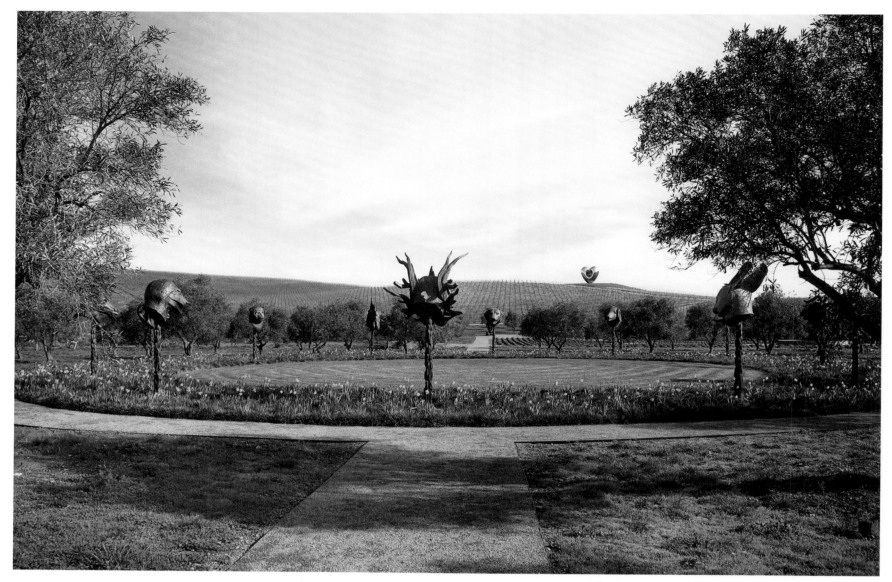

84

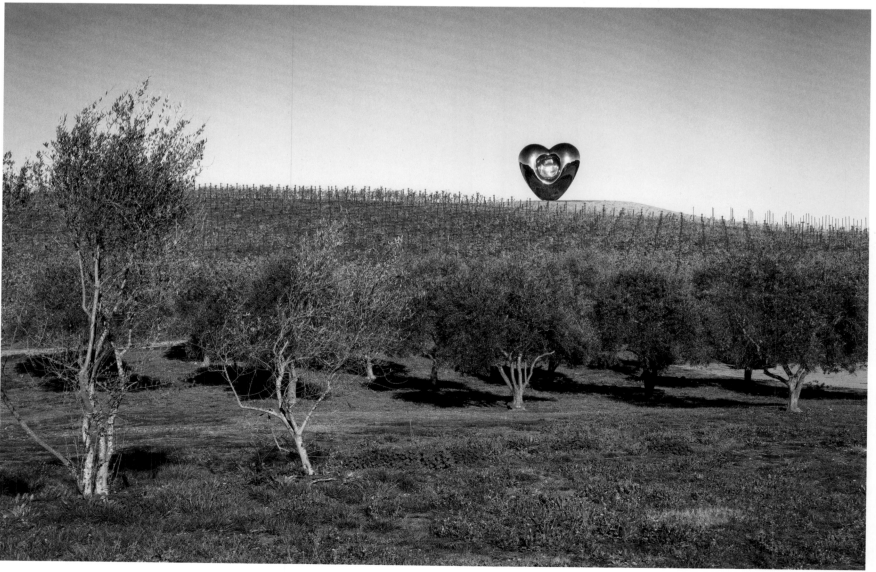

Donum Estate

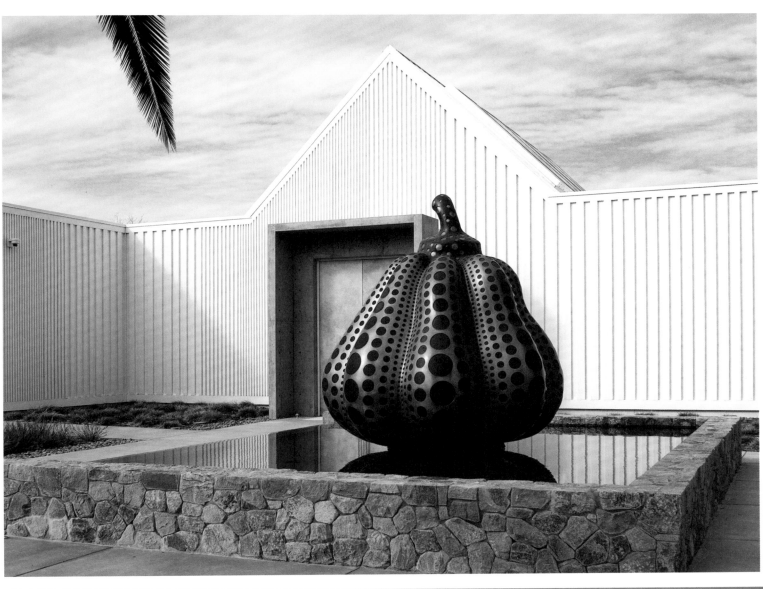

Sculptural highlights of the vineyard. Left side: Circle of Animals/Zodiac Heads by Ai Weiwei, 2011 and Love Me by Richard Hudson, 2016. Right side: Pumpkin by Yayoi Kusama, 2014 and Maze by Gao Weigang, 2017.

Skulpturale Glanzlichter im Weingut. Linke Seite: Circle of Animals/Zodiac Heads von Ai Weiwei, 2011 und Love Me von Richard Hudson, 2016. Rechte Seite: Pumpkin von Yayoi Kusama, 2014 und Maze von Gao Weigang, 2017.

Des sculptures pour mettre les vignes en valeur. Page de gauche : Circle of Animals/Zodiac Heads, par Ai Weiwei, 2011, et Love Me, de Richard Hudson, 2016. Page de droite : Pumpkin, de Yayoi Kusama, 2014, et Maze, de Gao Weigang, 2017.

85

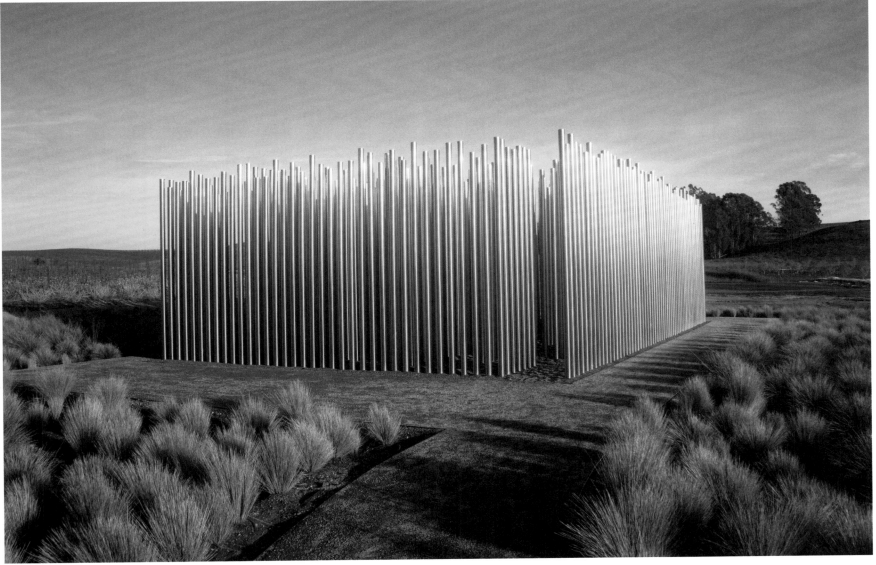

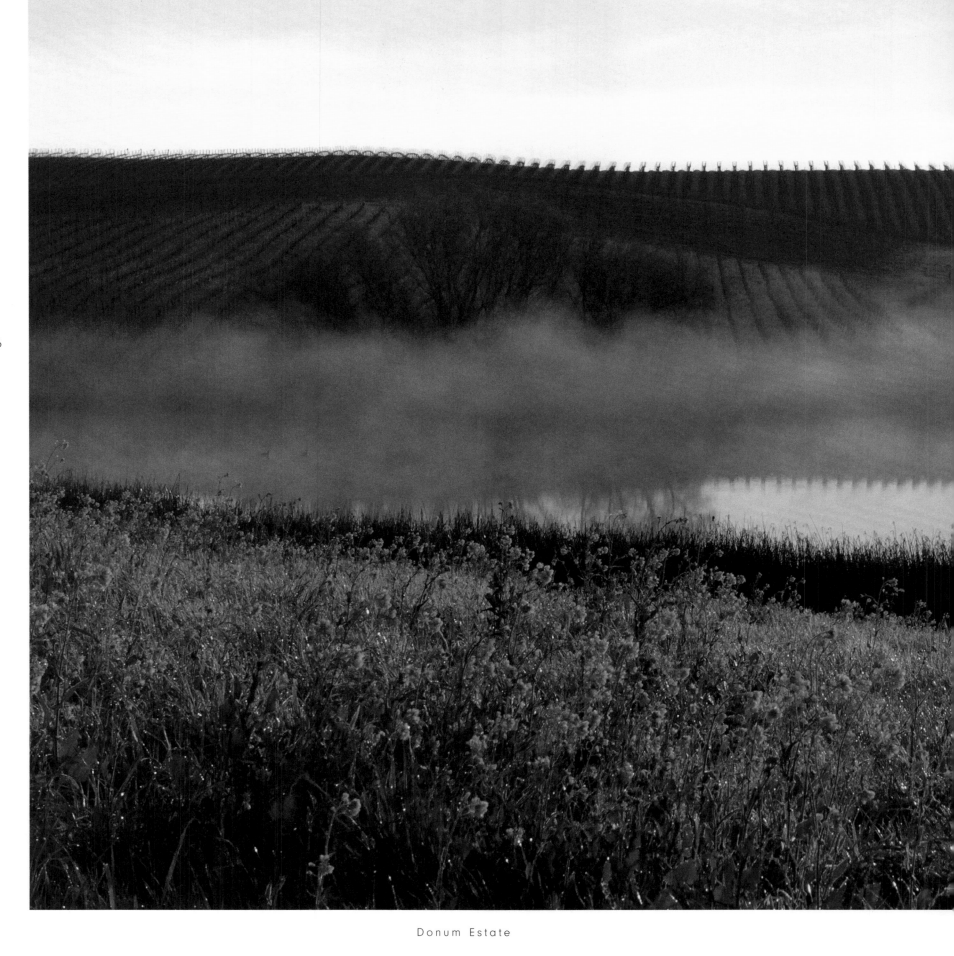

Award-winning Pinot Noir wines are produced in this Carneros, California landscape, on land where dairy cattle once grazed. The open air sculpture collection on this estate was begun in 2015 and launched in 2018.

Preisgekrönte Pinot Noir-Weine werden in dieser Landschaft von Carneros, Kalifornien, auf dem Land produziert, auf dem einst Milchvieh weidete. Die Open-Air-Skulpturensammlung auf dem Anwesen wurde ab dem Jahr 2015 angelegt und im Jahr 2018 eröffnet.

Dans ce terroir des Carneros, en Californie, des pinots noirs primés sont produits sur une terre qui accueillait autrefois des vaches laitières. L'installation des sculptures dans la propriété a commencé en 2015 et la collection peut être vue depuis 2018.

86

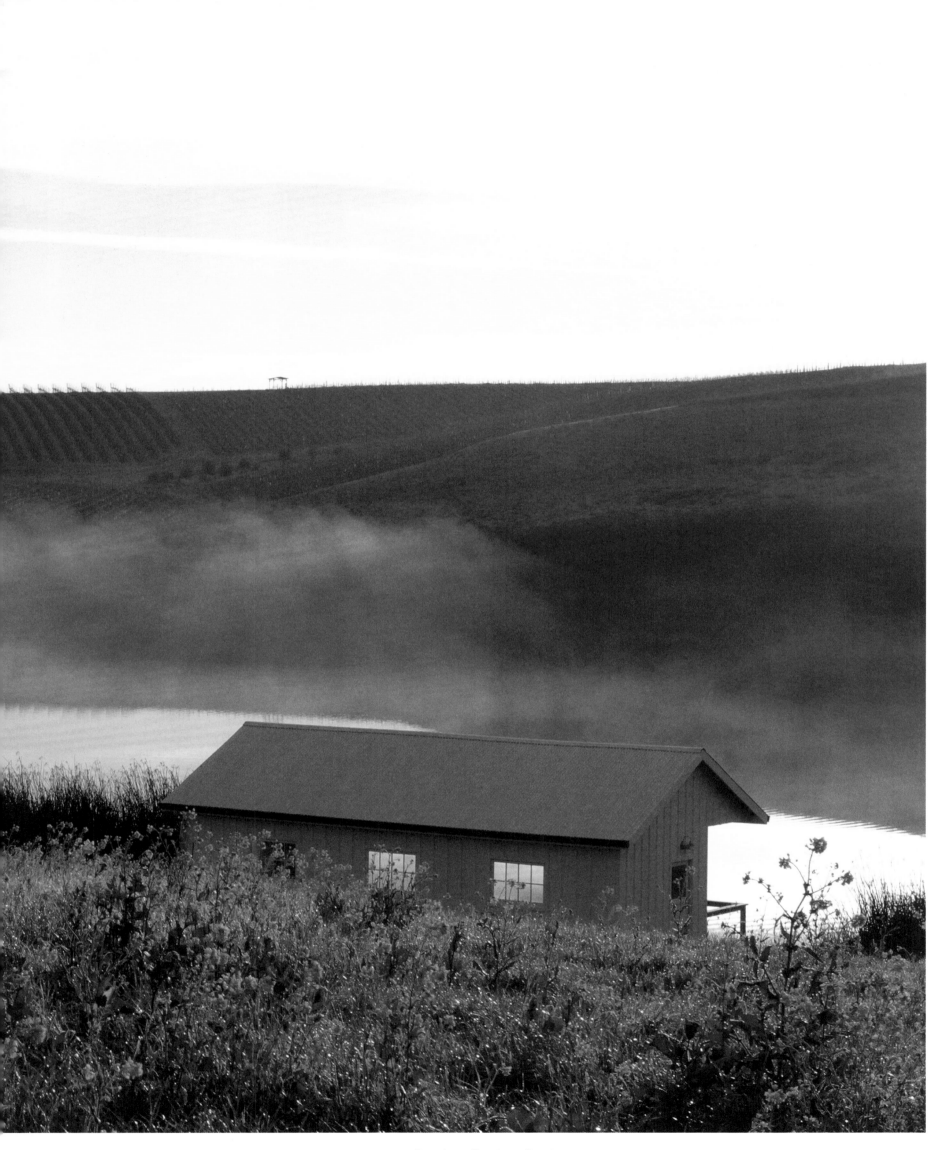

Over 50 bamboo species and varieties from Asia, America, and Africa grow in the "Bamboo Forest." The glass house is dedicated to tropical crop plants and a terrarium features animals and insects from all over the world.

Im „Bambuswald" wachsen über 50 Bambusarten und -sorten aus Asien, Amerika und Afrika. Das Glashaus zeigt tropische Nutzpflanzen und ein Terrarium mit Tieren aus aller Welt.

La forêt de bambous comprend plus de 50 variétés et espèces provenant d'Asie, d'Amérique et d'Afrique. La serre abrite des plantes tropicales utiles et un terrarium dans lequel on peut admirer des animaux du monde entier.

Die Gärten von Schloss Trauttmansdorff

Die Gärten von Schloss Trauttmansdorff

Merano | Italy

Nature, culture, and art come together in the multifarious garden worlds of one of South Tirol's tourist attractions. | Natur, Kultur und Kunst sind vereint in den facettenreichen Gartenwelten eines der Tourismusmagneten Südtirols. | Les univers paysagers que l'on peut découvrir dans un des principaux lieux touristiques du Tyrol du Sud associent la nature, l'art et la culture dans une grande richesse de nuances.

A maze, spherically manicured boxwoods, and geometrically shaped plant beds evoke Italian Renaissance Gardens. It stretches down to the Water Lily Pond (Seerosenteich).

Ein Irrgarten sowie kugelig geschnittene Buchsbäume und geometrisch geformte Beete verweisen auf italienische Gärten der Renaissance. Die Anlage erstreckt sich bis hinab zum Seerosenteich.

Un labyrinthe ainsi que des buissons taillés en boule et des massifs aux formes géométriques évoquent les jardins italiens de la Renaissance. Le jardin forme une pente allant jusqu'au bassin des nénuphars.

89

Exotic, Mediterranean landscapes, views of the surrounding mountain ranges and sun-kissed Merano: Encompassing 30 acres (twelve hectares), the gardens of Trauttmansdorff Castle bring together over 80 natural and cultural landscapes, themed gardens, artist pavilions, and experience stations. The grounds are nestled in a downy oak forest and extend out in the shape of a natural Amphitheater on terraced grounds with an altitude differential of more than 328 feet (100 meters) throughout. The Botanical Garden is owned by the province of South Tyrol.

Exotisch-mediterrane Landschaften, Ausblicke auf die umliegenden Bergketten und das sonnenverwöhnte Meran: Die Gärten von Schloss Trauttmansdorff versammeln auf zwölf Hektar über 80 Natur- und Kulturlandschaften, Themengärten, Künstlerpavillons und Erlebnisstationen. Eingebettet in einen Flaumeichenwald erstreckt sich die Anlage in Form eines natürlichen Amphitheaters auf terrassiertem Gelände über einen Höhenunterschied von mehr als 100 Metern. Der Botanische Garten ist im Besitz des Landes Südtirol.

Paysages à l'exotisme méditerranéen, vues sur les chaînes de montagnes environnantes et sur la ville ensoleillée de Merano : les jardins du château de Trauttmansdorff offrent sur douze hectares plus de 80 paysages de nature et de culture, des jardins à thème, des pavillons d'artistes et des stations de découverte. Enchâssée dans une forêt de chênes pubescents, le site a la forme d'un amphithéâtre naturel sur un terrain en terrasse offrant une dénivellation de plus de 100 mètres. Le jardin botanique est la propriété de la région du Trentin-Haut-Adige.

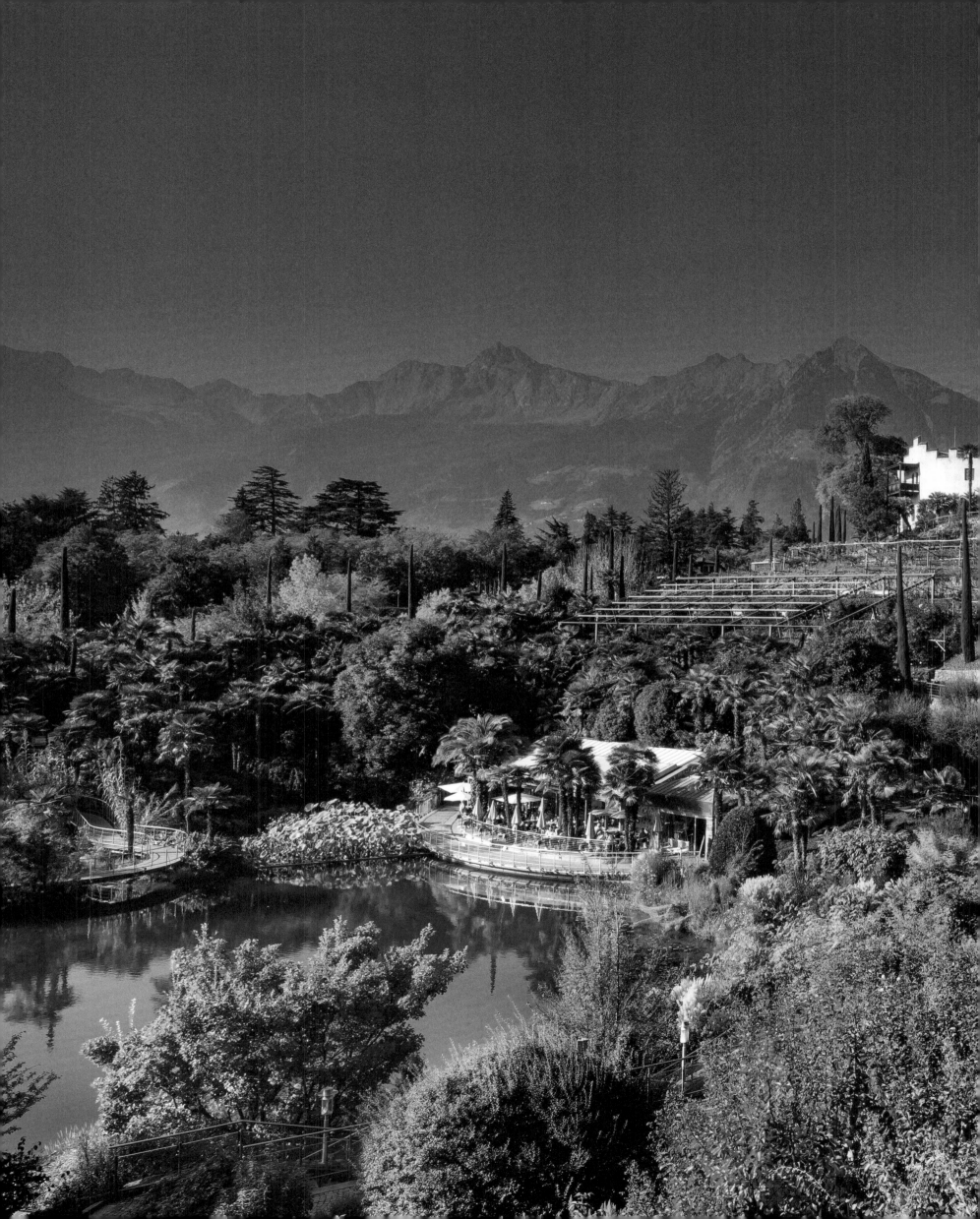

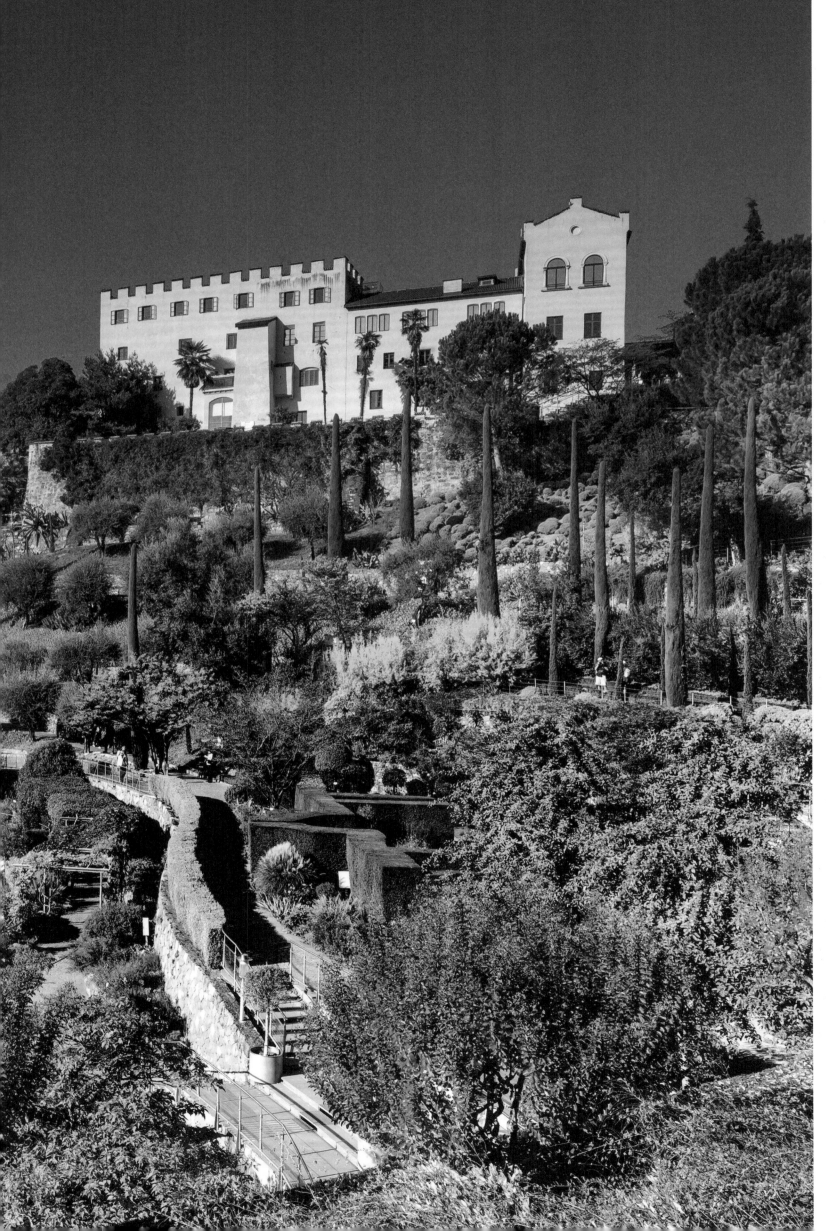

91

At the foot of the castle and in front of a 10,000-feet (3,000-meter) high mountain backdrop, the diversely-themed gardens are presented in bright fall colors with an exotic palm forest and a Mediterranean landscape.

Vor einer 3 000 Meter hohen Bergkulisse präsentieren sich die vielfältigen Themengärten zu Füßen des Schlosses in bunter Herbstfärbung, mit exotischem Palmenwald und mediterraner Landschaft.

Sur fond de décor montagneux culminant à 3 000 mètres d'altitude, les différents jardins thématiques s'étirent au pied du château, offrant aux regards leurs couleurs d'automne chatoyantes, où s'associent la forêt exotique de palmiers et le paysage méditerranéen.

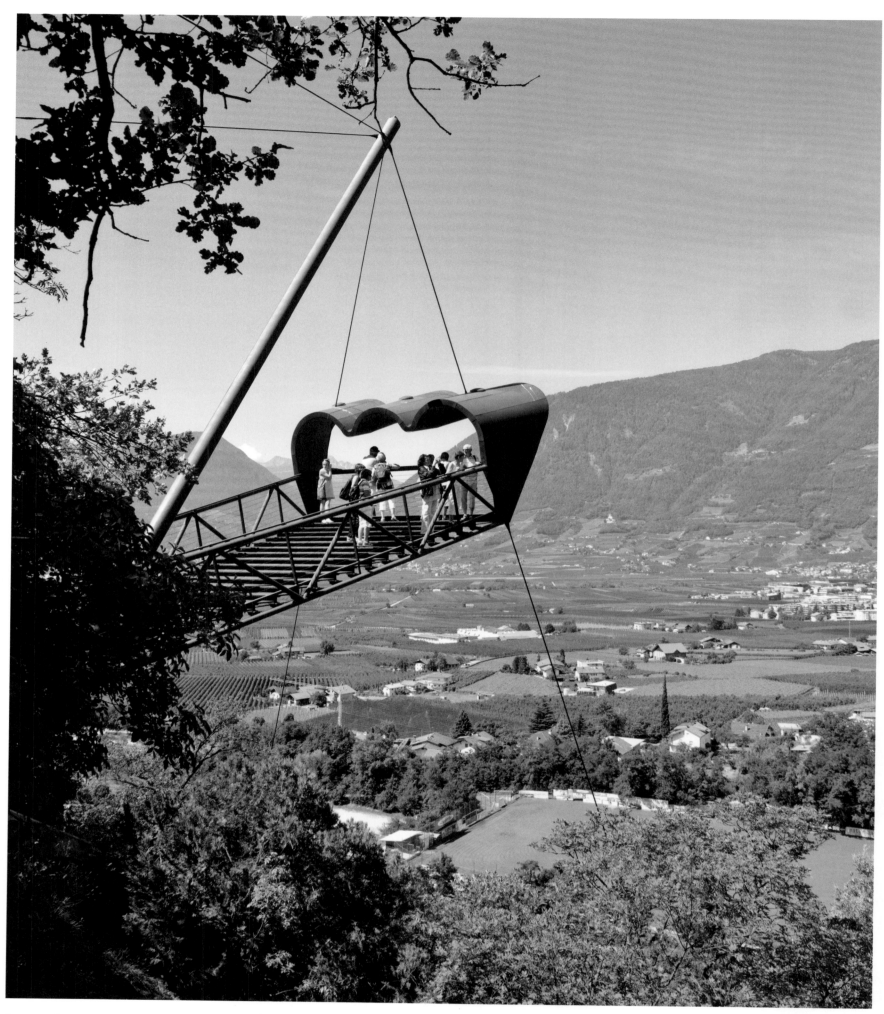

A spectacular outlook platform, the idea of the South Tyrolean architect, Matteo Thun, offers a panoramic view over the Merano Valley Basin and the Adige (Etsch) Valley.

Die spektakuläre Aussichtsplattform nach einer Idee des Südtiroler Architekten Matteo Thun bietet einen Panoramablick auf den Meraner Talkessel und das Etschtal.

Conçue sur une idée de l'architecte sud-tyrolien Matteo Thun, la spectaculaire plate-forme panoramique offre un point de vue sur le bassin de Merano et la vallée de l'Adige.

The "Garden for Lovers" with sensuous plants such as roses and star jasmine is the centerpiece of three pavilions: monumental flower bouquets in a water basin.

Der „Garten für Verliebte" mit sinnlichen Pflanzen wie Rose und Sternjasmin besitzt als Herzstück drei Pavillons: überdimensionale Blumensträuße in einem Wasserbassin.

Avec ses végétaux sensuels, comme les roses et les trachelospermum, le « jardin des amoureux » abrite en son sein trois pavillons en forme de bouquets de fleurs surdimensionnés plantés dans un bassin.

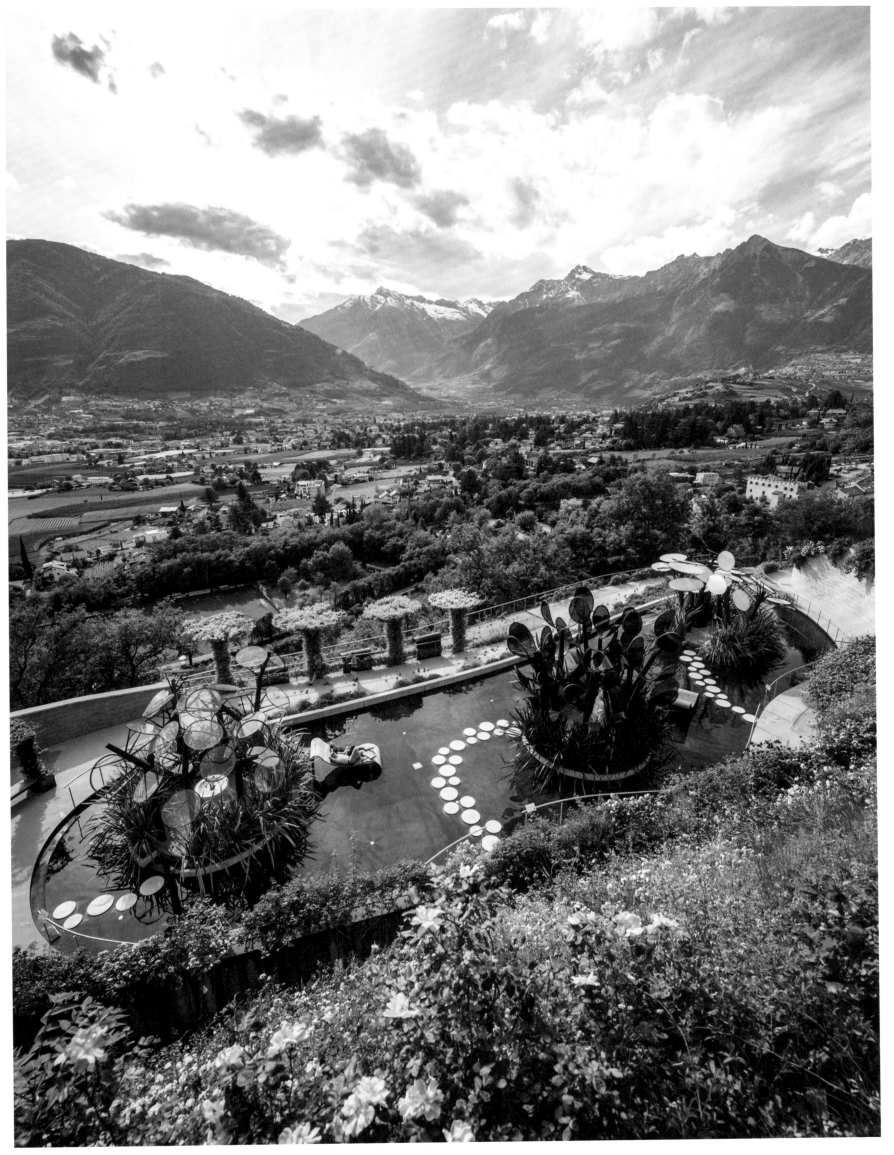

Gardens in Transition
Garden Design: From Ancient Egypt throughout Antiquity to Today

A pool with lotus and papyrus, surrounded by sycamores, date palms and olive trees—this tomb painting from the age of Thutmose III, created around 1475 BC, is just one of many demonstrating that gardens played an important role in ancient Egypt. Sculpted gardens adorned scores of temple structures, palaces of pharaohs and the living quarters of the upper classes. Plants were valuable in the agrarian land of Egypt, where they were made to flourish in the barren ground through grueling effort.

The Nile provided the lifeblood for the entire region and the Egyptians farmed through the aid of an ingenious canal system. This arrangement provided the foundation for the land's prosperity. The Egyptians tended to the vegetation in turn and surrounded temples—the homes of the gods—with lush greenery. Sacred groves and ornamental trees occupied extensive portions of temple grounds. Canals wove across the landscape, giving the grounds a regular geometry. This pattern can be considered one of the oldest stylistic devices in garden design. This green luxury was reserved exclusively for gods, rulers, and dignitaries of the highest order. And it stayed that way for ages. Even the Hanging Gardens of Babylon—a world wonder whose factual existence remains uncertain to this day—are attributed to the royal dynasty in what was then Mesopotamia.

Ancient Rome presented a similar picture. The affluent were the ones who embellished their townhouses and estates with gardens ornamented with sculptures, pools, and fountains shaded by trees. For the Romans, the garden was a place of well-being, a *locus amoenus*. It provided a place where one can be at peace while also serving as a prominent means of showing off wealth and power to visitors. The villa of emperor Hadrian lies a bit outside of Rome and offers an example reconstructed in good detail. It was more a small city than an estate, containing expansive garden courtyards, pools, waterfalls, and fountains that offered a bit of pomp and amusement to residents and their guests.

It took several centuries before garden design achieved this level of refinement again. The Middle Ages did not bring any dramatic new changes, even though the garden continued to play a role as an extension of living space. Paintings, illuminated manuscripts, and lyrical poetry demonstrate this aspect. In fact, green spaces were confined to castles and monasteries and, whether kitchen gardens or herb gardens in monasteries or decorative gardens in castles, they were always enclosed by walls or hedges. They were a protected, enclosed space—a *hortus conclusus*. In castles, they were primarily meeting points, places for banquets and sites of celebrations. Many writings and images from this period also make reference to love. The landscaped garden is simultaneously a pleasure garden, a place for an intimate tête-à-tête and even a location for a lavish celebration while enjoying a bit of bathing. The *hortus conclusus* blocks out the everyday life of the war-torn Middle Ages. The garden carried an aura of idleness and enjoyment of life—a life like in Paradise. The Christianization of the West shaped medieval garden design. The imagery of the Garden of Eden and the longing for Paradise weave a connecting thread throughout the centuries.

But the actual jewels of landscaping design from this age came from elsewhere: the East. After the fall of the Byzantine Empire, the Arabs built an empire that stretched from India to Spain. Here, on the western edge of the Mediterranean, it is still possible to marvel at the influences of eastern garden culture. The garden courtyards of Alhambra are still considered masterpieces to this day. In Islam, the garden also played an important role on par with that in Christendom. The garden of the afterlife serves as the reward for a righteous and faithful life.

INFLUENCES FROM ITALY—THE RENAISSANCE OF GARDEN DESIGN

In the rest of Europe, the Renaissance assisted in the revival of garden design. In the 14th and 15th centuries, the focus turned back to humanity together with the spiritual and cultural achievements of antiquity. This made an impact on the design of gardens. The innovation began in Italy where the legacy from antiquity could still be felt. The revival of villa culture from antiquity embodies this vision of rebirth. The manors usually belonged to townspeople who retired to the countryside in the summer months. They worked the soil while longing for the great vastness of nature. It made them feel free and led to discussions and philosophical debates. The construction of the villas and gardens no longer followed the enclosed castle style, but instead openly flowed into the landscape. Terraces, balconies, and belvederes on homes in the countryside framed the view into the surroundings. These villas and their gardens represent a means for man to get closer to nature while also providing contemplative immersion in the world expressed through geometry following strict rules of harmonious design and clear symmetries. Now divinity and humanity stand at the center of the unity of metaphysics and aesthetics.

The Italian garden quickly gained popularity. Artists traveled to Italy and brought the ideas back home. The new forms and thoughts at the core of these ideas spread across Europe. As the ideas proliferated, the Italian model was never simply copied; it was constantly adapted to specific possibilities, conditions, and cultural influences. This led to the creation of gardens based on the Italian archetype at princely residences throughout Europe. The Italian influence on garden design did not begin to diminish until the rise of the Baroque. Beginning in the 17th century, the gardens of sovereigns developed primarily

94

in the bastions of absolutism, with France foremost among them. Now man was taming nature. Where the Renaissance continued to create vistas of the landscape, now lanes were cut through the woods to allow the landscape to become part of the garden arrangement. While Renaissance gardens were human in scale—they were never so large that it would be impossible to stroll through them on foot—gardens of the Baroque age spread deep into the surroundings. You rode through these works of art on horseback or in a carriage. The boundary that remained present in Italian villa gardens expanded ever farther into the countryside. The absolute monarch also reigned over

FROM PRESTIGIOUS TO PRIVATE—
THE GARDEN RETREAT

Only the spirit of the Enlightenment in the 18th century put an end to this absolutism and to the predominance of geometry, symmetry and point perspectives along with it. The social revolution in France in 1789 was preceded by an aesthetic revolution in England, which led to a new garden style: The landscape garden or English garden. It presents the world as a seemingly natural landscape. Paradise now looks just like nature. The ideal has stepped away from formality and the garden serves as an extract from nature instead—a nature

The landscape garden reached its limits at the end of the 19th century specifically because it thrived on not having any. Since some of the gentry lacked the holdings of a monarch but still wanted to have a garden that was en vogue, the concept spread to many parcels of land that were too small for the purpose. In these plots, the design elements evoked randomness. The winding paths in such small spaces became derisively known as "pretzel paths." Enthusiasm for other styles of gardens also increased again: As sources of inspiration, Italian renaissance gardens were joined by Japanese and Chinese gardens as well as gardens from antiquity and the Middle Ages. The path was open to an international, hybrid style that has defined garden design to this day.

95

The imagery of the Garden of Eden and the longing for Paradise weave a connecting thread throughout the centuries. Along the way, the ideal transformed from a representative showroom to a refuge and retreat where every visitor can make their dreams a reality.

nature. The palace grounds at Versailles, created by landscape architect André Le Nôtre who began work on them in 1662, represent the high point of this style. Every area of this immense park is subject to a strict axis system consisting of alleys, a central axis, pools, parterres, bosquets—refuges surrounded by clipped hedges. The meticulously organized baroque garden left no room for untamed nature. The hedges were artistically sculpted with this in mind, shaping them into labyrinths, rooms, and theaters or forming them into pyramids, balls, and cones. Humanity was sculpting Paradise according to its own rules.

The baroque garden spread from France, marching across the whole of Europe. Every ruler from Spain to Russian hinterland wished to showcase their power, including their authority over nature.

that has been refined and made to be more natural. Gently rolling lawns and meadows, wooded areas, groves and specimen trees combine together to create an idyllic pastoral landscape. The landscape garden did not have any limits; it transitioned into the surrounding landscape and formed a cohesive whole with it. As knowledge of nature and technology progressed, nature transformed from a place of trepidation to a place of fascination. The focus of the parks was on landscape elements instead of buildings. Wörlitzer Park in Germany is one of the most important works in Europe from this era. It was created by Prince Leopold III Friedrich Franz von Anhalt-Dessau in the second half of the 18th century and makes up a significant portion of the Dessau-Wörlitzer Garden Realm, which is now a UNESCO world heritage site. A large lake with four arms stands at the center of the expansive park.

Industrialization brought unimagined prosperity to the middle and upper-middle classes. The new upper class also strove for social recognition and the villa with garden was an inevitable part thereof. After all, the greenery was viewed as a representative extension and framework of the residence.

In Germany, the Bauhaus style defined the period between both world wars. While the Bauhaus institution only existed for a few years, the style has defined the 20th century in Germany and beyond since its champions also contributed to new housing developments in the post-war period. The Bauhaus proponents saw the home and garden as one design unit. Like a home, a garden should be purposeful and practical, while also being beautiful and perfect in form. As a result, Bauhaus transformed the garden into something suitable for everyday appreciation. It became a living space and less a representative showroom as was consistently the case in the preceding centuries. The garden became a private affair—a refuge and retreat. And it remains that way to this day. An individual, personal paradise where every visitor can make their dreams a reality.

Garten im Wandel
Gartenkunst: vom alten Ägypten über die Antike bis heute

Ein Wasserbecken mit Lotus und Papyrus, umrahmt von Sykomoren, Dattelpalmen und Olivenbäumen – die Grabmalerei aus der Zeit von Thutmosis III., entstanden etwa um 1475 v. Chr., ist nur eine von vielen, die zeigt: Bereits im alten Ägypten spielten Gärten eine bedeutende Rolle. Gestaltete Gärten schmückten zahlreiche Tempelbauten, die Paläste der Pharaonen und die Wohnhäuser der Oberschicht. Im Agrarland Ägypten galten Pflanzen als wertvoll, war ihr Gedeihen doch mühsam dem kargen Boden abgerungen. Der Nil fungierte als Lebensader für die gesamte Region, mithilfe eines ausgeklügelten Kanalsystems betrieben die Ägypter Ackerbau. Das Wohlergehen des Landes hing davon ab. Dementsprechend achteten sie Pflanzen und Früchte und umgaben die Tempel, die Wohnstätten der Götter, mit üppigem Grün. Heilige Haine und Baumgärten nahmen weite Flächen der Tempelanlagen ein. Immer durchzogen von Kanälen, die den Anlagen eine regelmäßige Geometrie gaben: Das Raster kann somit als eines der ältesten Stilmittel der Gartenkunst gelten. Vorbehalten war der grüne Luxus neben den Göttern nur Herrschern und besonders angesehenen Würdenträgern. Und blieb es für lange Zeit. Auch die hängenden Gärten der Semiramis, von denen bis heute ungewiss ist, ob dieses Weltwunder tatsächlich existiert hat, werden dem Königshaus im damaligen Zweistromland zugeschrieben.

Im antiken Rom bot sich ein ähnliches Bild. Es waren die Wohlhabenden, die ihre Stadthäuser und Landgüter mit Gärten versahen, die sie mit Skulpturen, Wasserbecken und Springbrunnen unter schattenspendenden Bäumen schmückten. Für die Römer war der Garten ein Ort des Wohlbefindens, ein *locus amoenus*, in den man sich zurückzog, aber durchaus auch etwas, mit dem man seinen Gästen Reichtum und Macht präsentierte. Ein gut rekonstruiertes Beispiel ist die Villa Kaisers Hadrian etwas außerhalb Roms. Sie war eher eine kleine Stadt als ein Landgut, in der großzügige Garten-höfe, Wasserbecken, Kaskaden und Brunnen den Bewohnern und ihren Gästen einiges an Prunk und Amüsement boten.

Bis die Gartenkunst diese Raffinesse wieder erreichte, vergingen einige Jahrhunderte. Das Mittelalter gab keine nennenswerten neuen Impulse, obgleich der Garten als erweiterter Wohnraum nach wie vor eine Rolle spielte. Gemälde, Buchillustrationen und Minnelieder belegen das. Allerdings beschränkten sich die Grünanlagen auf Burgen und Klöster, und – ob Nutz- und Heilkräutergarten in den Klöstern oder Schmuckgarten in den Burgen – sie waren immer umgeben von Mauern oder Hecken: ein geschützter, abgeschlossener Raum, ein *hortus conclusus*. In den Burgen waren sie vor allem Treffpunkte, Orte für Bankette oder für Feiern. Und: Viele Texte und Bilder aus dieser Zeit nehmen Bezug auf die Liebe. Der gestaltete Garten ist zugleich Lustgarten, Ort für ein lauschiges Tête-à-tête oder auch für rauschende Feste mit Badefreuden. Der *hortus conclusus* sperrt den Alltag des kriegerischen Mittelalters aus. Hier herrschen Müßiggang und Lebensfreude – ein Leben wie im Paradies: Die Christianisierung des Abendlandes prägte die mittelalterliche Gartenkunst ganz entscheidend. Das Bild des Garten Edens, die Sehnsucht nach dem Paradies zieht sich wie ein roter Faden durch die Jahrhunderte.

Die wirklichen gartenkünstlerischen Schmuckstücke dieser Zeit entstanden allerdings woanders: im Orient. Nach dem Ende des Oströmischen Reichs bauten die Araber ein Imperium auf, das vom Indus bis nach Spanien reichte. Hier, im westlichen Mittelmeerraum, lassen sich die Einflüsse der orientalischen Gartenkultur noch immer bewundern. Die Gartenhöfe der Alhambra gelten bis heute als Meisterwerke. Auch im Islam spielt der Garten als Symbol eine ähnlich wichtige Rolle wie im Christentum. Der Garten im Jenseits ist der Lohn für ein rechtschaffenes und gläubiges Leben.

EINFLÜSSE AUS ITALIEN – DIE RENAISSANCE DER GARTENKUNST

Im restlichen Europa ist es die Renaissance, die der Gartenkunst zur Wiedergeburt verhilft. Im 14. und 15. Jahrhundert rückte der Mensch in den Mittelpunkt und damit die geistigen und kulturellen Errungenschaften der Antike. Das wirkte sich auch auf die Gestaltung von Gärten aus. Die Erneuerung nahm in Italien ihren Ausgang, denn dort war das Erbe der Antike noch greifbar. Stellvertretend für die Vision vom Aufbruch steht die Wiederbelebung der antiken Villenkultur. Die Landgüter gehörten meist Stadtbürgern, die in den Sommermonaten aufs Land flüchteten. Sie betrieben Landwirtschaft, und zugleich suchten sie die Weite der Natur. Hier fühlte man sich frei, es wurde diskutiert und philosophiert. Die Villen und Gärten wurden nicht mehr länger burgartig gebaut, sondern öffneten sich zur Landschaft. Terrassen, Loggien und Belvederes an den Landhäusern inszenierten den Blick in die Umgebung. Diese Villen und ihre Gärten stehen für eine Annäherung des Menschen an die Natur und gleichzeitig für eine gedankliche Durchdringung der Welt, die in der den strengen Regeln der Harmonielehre folgenden Geometrie und klaren Symmetrie der Gärten ihren Ausdruck findet. Im Mittelpunkt der Einheit aus Metaphysik und Ästhetik stehen jetzt Gott und Mensch.

Der italienische Garten setzt sich rasch durch. Künstler reisten nach Italien und brachten die Ideen mit nach Hause. Die neuen Formen und die Gedanken, die dahinterstanden, verbreiteten sich europaweit, wobei das italienische Modell nie einfach nur kopiert, sondern stets den jeweiligen Möglichkeiten, Gegebenheiten und kulturellen Einflüssen angepasst wurde. An den fürstlichen Residenzen in ganz Europa entstanden so Gärten nach italienischem Vorbild. Erst mit dem Barock schwand der Einfluss Italiens auf die Gartenkunst, denn die Herrschergärten ab dem 17. Jahrhundert

96

entwickelten sich vor allem in den Hochburgen des Absolutismus, allen voran in Frankreich. Der Mensch zähmte jetzt die Natur. Wo in der Renaissance noch Ausblicke auf die Landschaft geschaffen wurden, werden jetzt Schneisen in Wälder geschlagen, die die Landschaft zu einem Teil der Garteninszenierung werden lassen. Während den Renaissancegärten der menschliche Maßstab zugrunde lag – nie waren sie so groß, als dass man nicht zu Fuß hätte durchflanieren können –, greifen die Barockgärten weit in die Umgebung aus. Man reitet oder fährt in der Kutsche durch das Kunstwerk. Die Abgrenzung, die die italienischen Villengärten noch aufwiesen, schob sich immer weiter in die Umgebung. Der absolutistische Regent herrschte auch über die Natur. Seinen Höhepunkt fand dies im Schlosspark von Versailles, den der Gartenarchitekt André Le Nôtre ab 1662 anlegte. Sämtliche Bereiche der riesigen Anlage unterliegen einem strengen Achsensystem: Alleen, Mittelachse, Wasserbecken, Parterregärten und sogenannte Boskette, Rückzugsräume, die von

VOM REPRÄSENTATIVEN INS PRIVATE – DER GARTEN ALS RÜCKZUGSRAUM

Erst der Geist der Aufklärung im 18. Jahrhundert beendet nicht nur den Absolutismus, sondern mit ihm auch die Vorherrschaft von Geometrie, Symmetrie und Zentralperspektive. Der gesellschaftlichen Revolution in Frankreich 1789 geht in England eine ästhetische voraus, die ein neues Gartenmodell hervorbringt: den Landschaftsgarten oder Englischen Garten. Der zeigt die Welt als scheinbar natürliche Landschaft. Das Paradies sieht nun aus wie die Natur selbst. Das Ideal liegt nicht mehr im Formalen, sondern der Garten ist ein Ausschnitt aus der Natur, die allerdings verfeinert und in ihrer Wirkung gesteigert wird. Sanft schwingende Rasen- und Wiesenflächen, Waldstücke, Baumgruppen und Solitärbäume fügen sich zum Idealbild einer pastoralen Landschaft zusammen. Der Landschaftsgarten hatte keine Grenze, er ging in die umgebende Landschaft über, um mit ihr eins zu werden. Mit fortschreitendem Wissen über Natur und Technik wirkte die Natur nicht mehr

Ende des 19. Jahrhundert kam der Landschaftsgarten an seine Grenzen – gerade, weil er davon lebte, keine zu haben. Da nicht jeder Landadelige über den Grundbesitz eines Monarchen verfügte, aber einen Garten besitzen wollte, der en vogue war, wurde das Konzept auch auf viel zu kleine Grundstücke übertragen. In diesen wirkten die Gestaltungselemente beliebig, die gewundenen Wege auf kleinem Raum wurden als „Brezelwege" verspottet. Die Begeisterung auch für andere Gartenstile nahm wieder zu: So diente der italienische Renaissancegarten als Inspirationsquelle, ebenso japanische und chinesische Gärten, die Antike und auch mittelalterliche Gärten. Der Weg war frei für einen internationalen, gemischten Stil, der bis heute die Gartenkunst bestimmt.

Die Industrialisierung bescherte dem Bürger- und Großbürgertum einen ungeahnten Wohlstand. Die neue Oberschicht strebte auch nach gesellschaftlicher Anerkennung, und dazu gehörte unweigerlich die Villa mit Garten. Denn das Grün wurde als repräsentative Erweiterung und als Rahmen des Wohnhauses gesehen.

In Deutschland prägte der Bauhausstil die Zeit zwischen den beiden Weltkriegen. Zwar gab es die Institution Bauhaus nur ein paar Jahre, aber der Stil hat das 20. Jahrhundert auch über Deutschland hinaus maßgeblich geprägt, da die Protagonisten auch in der Nachkriegszeit an neuen Wohnanlagen mitwirkten. Die Bauhaus-Vertreter sahen Haus und Garten als gestalterische Einheit: Der Garten sollte ebenso wie das Wohnhaus zweckmäßig und sachlich, und zugleich formvollendet und schön sein. Das Bauhaus machte den Garten damit alltagstauglich: Er wurde zum Wohnraum, war weniger repräsentativer Showroom wie er es die vorherigen Jahrhunderte immer auch war. Der Garten wurde zur Privatsache, zum Rückzugsraum und Refugium. Das ist er bis heute. Ein individuelles, eigenes Paradies, in dem jeder seine Träume verwirklicht.

Das Bild des Garten Edens, die Sehnsucht nach dem Paradies zieht sich wie ein roter Faden durch die Jahrhunderte. Dabei wandelte er sich vom repräsentativen Showroom zum Rückzugsraum und privaten Refugium, in dem jeder seine Träume verwirklicht.

geschnittenen Hecken umgeben sind. Der durchorganisierte Barockgarten ließ der ungezähmten Natur keinerlei Raum. Dementsprechend kunstvoll wurden die Hecken geschnitten: zu Labyrinthen, Kabinetten und Theatern; zu Pyramiden, Kugeln und Kegeln. Der Mensch formt sich das Paradies nach seinen Regeln.

Von Frankreich aus erobern die Barockgärten ganz Europa. Kein Herrscher von Spanien bis hinein nach Russland, der nicht seine Macht auch mit der Herrschaft über die Natur zeigen wollte.

furchteinflößend, sondern wurde zum Sehnsuchtsort. Mittelpunkt der Parks waren nicht Gebäude, sondern Landschaftselemente. Als europaweit eines der bedeutendsten Werke dieser Zeit gilt der Wörlitzer Park in Deutschland, den Fürst Leopold III. Friedrich Franz von Anhalt-Dessau in der zweiten Hälfte des 18. Jahrhunderts schuf und ein bedeutender Teil des heute als UNESCO-Welterbe gelisteten „Dessau-Wörlitzer Gartenreiches" ist. Im Zentrum der weitläufigen Anlage steht ein großer See mit vier Seitenarmen.

Jardins en mutation
L'art du jardin : de l'ancienne Égypte à aujourd'hui en passant par l'Antiquité

Un bassin d'eau rempli de lotus et de papyrus, encadré de sycomores, de palmiers à dattes et d'oliviers – la peinture funéraire de l'époque du pharaon Thoutmôsis III, datant d'environ 1475 avant J. C., n'est qu'un des nombreux exemples montrant que dès l'ancienne Égypte, les jardins ont joué un rôle important. À l'époque, des jardins aménagés ornaient de nombreux temples, les palais des pharaons et les maisons des classes supérieures. Dans ce pays agricole qu'était l'Égypte, les plantes avaient une grande valeur parce que pour les faire pousser, il fallait travailler péniblement une terre stérile. C'est grâce au Nil, source de vie pour toute la région, que les Égyptiens ont pu pratiquer l'agriculture grâce à un réseau très élaboré de canaux d'irrigation. Le bien-être du pays en dépendait. Très attentifs aux plantes et aux fruits, ils entouraient d'une végétation luxuriante les temples, où résidaient leurs dieux. Bosquets sacrés et jardins arboricoles occupaient de vastes surfaces autour des temples, toujours traversées par des canaux qui donnaient un aspect géométrique aux aménagements : on peut d'ailleurs estimer que le plan en damier est un des plus anciens procédés de style de l'art du jardin. Outre les dieux, seule les classes dominantes, en particulier les dignitaires les plus en vue, pouvaient profiter de ce luxe vert. Il en fut ainsi pendant longtemps. De la même façon, les jardins suspendus de Sémiramis, merveille du monde dont aujourd'hui encore nous ne savons pas si elle a réellement existé, sont attribués à la maison royale du Pays des Deux Fleuves.

Dans la Rome antique, les choses se présentent de manière similaire. Les classes aisées ornent leurs maisons de ville et leurs villas campagnardes de sculptures, de bassins et de fontaines, tout cela sous des arbres indispensables pour procurer l'ombre recherchée. Pour les Romains, le jardin est un lieu de bien-être, un *locus amoenus* dans lequel on se retirait, mais aussi un élément qui permettait de manifester à ses hôtes sa richesse et son pouvoir. Un exemple bien reconstitué est la villa de l'empereur Hadrien, située un peu à l'extérieur de Rome. Il s'agissait plus d'une petite cité que d'un domaine campagnard, puisqu'on y trouvait de généreux jardins, des bassins, des cascades et des fontaines qui offraient luxe ostentatoire et divertissement aux habitants et à leurs invités.

Il faudra ensuite attendre plusieurs siècles pour que l'art du jardin renoue avec ce raffinement. Le Moyen Âge ne fut pas très innovateur en la matière, bien que le jardin y joue aussi un rôle en tant que prolongement de l'habitation. C'est ce que nous montrent les peintures, illustrations livresques et chansons d'amour courtois. Mais les espaces verts aménagés étaient limités aux châteaux-forts et monastères et, qu'ils servent de potagers ou de jardins médicinaux, ils étaient toujours entourés de murs ou de haies : c'était un lieu protégé et clos, un *hortus conclusus*. Dans les châteaux-forts, les jardins servent surtout de lieux de rencontres, et on y organisait fêtes et banquets. Et puis : beaucoup de textes et d'images de l'époque font référence à l'amour. Le jardin aménagé est à la fois lieu de plaisance, pour des tête-à-tête discrets, ou site de fêtes fastueuses où se pratiquait le plaisir du bain. Le quotidien du Moyen Âge guerrier reste à la porte du *hortus conclusus*. Il y règne l'oisiveté et la joie de vivre, d'une vie qui se veut évocation du Paradis : la christianisation de l'Occident imprègne de manière déterminante l'art du jardin médiéval. L'image du Jardin d'Éden, l'aspiration au Paradis traversent ces siècles comme un fil rouge.

Mais c'est ailleurs qu'apparaissent à la même époque de véritables bijoux de l'art du jardin : en Orient. Après la fin de l'Empire romain d'Orient, les Arabes établissent un empire qui s'étend de l'Indus à l'Espagne. C'est là, dans la partie occidentale de l'espace méditerranéen nous nous pouvons toujours admirer l'influence de la culture orientale du jardin. Aujourd'hui encore, nous considérons les jardins de l'Alhambra comme des chefs-d'œuvre. En Islam, le jardin joue un rôle important, similaire à celui du christianisme. Le jardin de l'au-delà est la récompense d'une vie pieuse et honnête.

INFLUENCES ITALIENNES – LA RENAISSANCE DE L'ART DU JARDIN

Dans le reste de l'Europe, c'est la Renaissance qui va donner une nouvelle vie à l'art du jardin. Aux 14e et 15e siècles, l'Homme devient le centre de l'univers, il s'intéresse aux apports intellectuels et culturels de l'Antiquité. Cela ne sera pas sans effet sur l'aménagement des jardins. Le renouvellement part d'Italie, pays où l'héritage de l'Antiquité est encore perceptible. La renaissance de la culture antique de la villa symbolise parfaitement cette vision de renouveau. Les domaines campagnards appartiennent le plus souvent aux citadins qui fuient la ville durant la saison chaude. Ils y pratiquent l'agriculture, mais recherchent aussi les grands espaces naturels pour se sentir libres, débattre et philosopher. Les villas et jardins ne sont plus fortifiés, mais s'ouvrent aux espaces qui les entourent. Des terrasses, loggias et belvédères mettent en scène le spectacle des alentours. Ces villas et leurs jardins illustrent le rapprochement de l'Homme avec la nature et, en même temps, l'imprégnation intellectuelle du monde exprimée dans la géométrie, suivant les règles strictes de l'harmonie, et dans les symétries claires des jardins. Au centre de l'ensemble que constituent la métaphysique et l'esthétique, il y a désormais Dieu et l'Homme.

Le jardin italien s'impose rapidement. Les artistes font le voyage d'Italie et en ramènent des idées neuves. Les formes nouvelles et les idées qui les sous-tendent se répandent dans toute l'Europe, le modèle italien n'est toutefois jamais copié de manière servile, mais toujours adapté aux possibilités existantes, aux caractéristiques des lieux, aux influences culturelles. Des jardins inspirés du modèle italien apparaissent alors dans les résidences princières de toute l'Europe. Il faut attendre le Baroque pour que l'influence italienne s'estompe, car à partir du 17e siècle, les jardins des souverains et des nobles apparaissent essentiellement dans les fiefs de l'absolutisme, d'abord en France. Désormais, l'Homme dompte la nature.

Là où la Renaissance voulait créer des perspectives sur le paysage, on réalise maintenant dans les forêts des coupes qui transforment le paysage en un élément de la mise en scène du jardin. Les jardins de la Renaissance reposaient sur une échelle humaine (ils n'étaient jamais si grands que l'on ne puisse pas y flâner en paix à pied), les jardins baroques partent à la conquête des alentours. Désormais, le parcours à travers l'œuvre d'art se fait à cheval ou en carrosse. Les limites qui caractérisaient encore les jardins des villas italiennes sont repoussées de plus en plus loin dans l'espace environnant. Le monarque absolu veut maîtriser aussi la nature. L'apogée du jardin baroque est illustrée par le parc du château de Versailles, aménagé par le paysagiste André Le Nôtre à partir de 1662. Toutes les parties de ce gigantesque parc suivent un système d'axes strict : les allées, l'axe central, les bassins, les terrasses et les bosquets, les espaces de repos entourés de haies taillées. Totalement aménagé, le jardin baroque n'accorde aucune

L'image du Jardin d'Éden, l'aspiration au Paradis traversent ces siècles comme un fil rouge. Précédemment « showroom », il se transforme en lieu de repli et refuge privé où chacun réalise ses rêves.

place à la nature laissée à elle-même. Les haies sont taillées de manière artistique : on en fait des labyrinthes, des cabinets et des théâtres, ou encore des pyramides, des boules et des quilles. L'Homme se crée un paradis selon ses propres règles.

Les jardins baroques à la française ne tardent pas à gagner toute l'Europe. De l'Espagne à la Russie, aucun souverain ne manque de manifester son pouvoir en démontrant sa maîtrise de la nature.

DE L'EXHIBITION DE LA RICHESSE À LA VIE PRIVÉE – LE JARDIN LIEU DE REPLI

Au 18e siècle, l'esprit des Lumières ne met pas seulement un terme à l'absolutisme, mais marque aussi la fin de la domination de la géométrie, de la symétrie et de la perspective centrale. La Révolution française de 1789 est précédée en Angleterre d'une révolution esthétique qui donne naissance à un nouveau modèle de jardin : le jardin paysager ou jardin à l'anglaise qui montre le monde comme s'il s'agissait d'un paysage naturel. Le paradis ressemble désormais à la nature. L'idéal n'est plus dans les formes, mais le jardin est un extrait de la nature, avec en plus le raffinement et une recherche supplémentaire d'amplification de l'effet visuel. Les douces sinuosités des pelouses et des prés, les bois, les bosquets et les arbres isolés s'assemblent pour donner l'image idéale d'un paysage pastoral. Le jardin paysager n'a pas de limite, il se fond dans la campagne environnante pour ne plus faire qu'un avec elle. Le progrès des connaissances en matière de sciences de la nature et de techniques ne suscite plus la crainte, mais fait de la nature un lieu désirable. Les parcs ne sont pas conçus autour des bâtiments, et ces derniers ne sont plus que des éléments du paysage. En Allemagne, le parc de Wörlitz est considéré comme une des œuvres les plus importantes en Europe à l'époque. Créé par le prince Léopold III Frédéric François de Anhalt-Dessau dans la seconde moitié du 18e siècle, il constitue aujourd'hui un élément important des jardins de Dessau-Wörlitz, qui figurent sur la liste du patrimoine de l'humanité de l'UNESCO. Au centre d'un espace très étendu se trouve un grand lac comportant quatre bras latéraux.

À la fin du 19e siècle, le jardin paysager touche à ses limites pour la bonne raison qu'il vivait de ne pas en avoir. En effet, bien que tous les nobles ne disposent pas de terres aussi grandes que le monarque, chacun d'entre eux veut son jardin à la dernière mode, si bien que le concept est transposé à des surfaces beaucoup trop petites. Au bout

du compte, les éléments paysagers semblent quelconques et les chemins qui serpentent sur une petite surface suscitent les moqueries et sont même qualifiés de « chemins de bretzel ». Les gens commencent alors à se passionner pour d'autres styles de jardin : on s'inspire du jardin italien de la Renaissance, mais aussi des jardins japonais ou chinois, de l'Antiquité et même des jardins médiévaux. La voie s'ouvre vers un style international mélangé qui est la marque de l'art du jardin d'aujourd'hui.

L'industrialisation a apporté à la petite et à grande bourgeoisie un bien-être inédit. Les nouvelles élites recherchent elles aussi la reconnaissance sociale, dont la villa et son jardin sont un élément indispensable. En effet, l'espace vert est considéré comme une extension visible de la maison d'habitation à laquelle il sert de cadre.

En Allemagne, le style Bauhaus marque l'entre-deux-guerres. En tant qu'institution, le Bauhaus n'a certes duré que quelques années, mais son style a eu une influence déterminante sur le 20e siècle, y compris hors d'Allemagne, car ses protagonistes ont contribué à l'élaboration d'un nouvel habitat jusque dans l'après-guerre. Les représentants du Bauhaus voyaient la maison et le jardin comme un ensemble conceptuel : le jardin comme l'habitation devaient être à la fois pratiques et sobres, mais aussi beaux et esthétiques dans leurs formes. Le Bauhaus fait ainsi du jardin un élément du quotidien : il devient espace de vie et est beaucoup moins le « showroom » qu'il a représenté en permanence durant les siècles précédents. Le jardin passe dans le domaine du privé, lieu de repli et refuge, et c'est ce qu'il est aujourd'hui encore. Un paradis bien à soi, où chacun réalise ses rêves.

Thonet

Frankenberg (Eder) | Germany

100

Thonet makes Bauhaus furniture from steel tubing like the S 33 and S 34 chairs by Mart Stam using a special weather-proof coating, making it suitable for the outdoors.

Thonet machte Bauhaus-Möbel aus Stahlrohr wie die Stühle S 33 und S 34 von Mart Stam mithilfe einer speziellen Beschichtung wetterfest und damit Outdoor-tauglich.

Thonet fabrique aussi des meubles Bauhaus en tube d'acier, comme les chaises S 33 et S 34 de Mart Stam, revêtues d'une couche spéciale qui les rend insensibles aux intempéries et donc utilisables en extérieur.

Bauhaus classics steeped in tradition and in contemporary outfitting and coating bring design and function into the garden. | Traditionsreiche Bauhaus-Klassiker in zeitgemäßem Outfit bringen Design und Funktion in den Garten. | Revus et remis au goût du jour, les grands classiques du Bauhaus font entrer dans les jardins le design et la fonction.

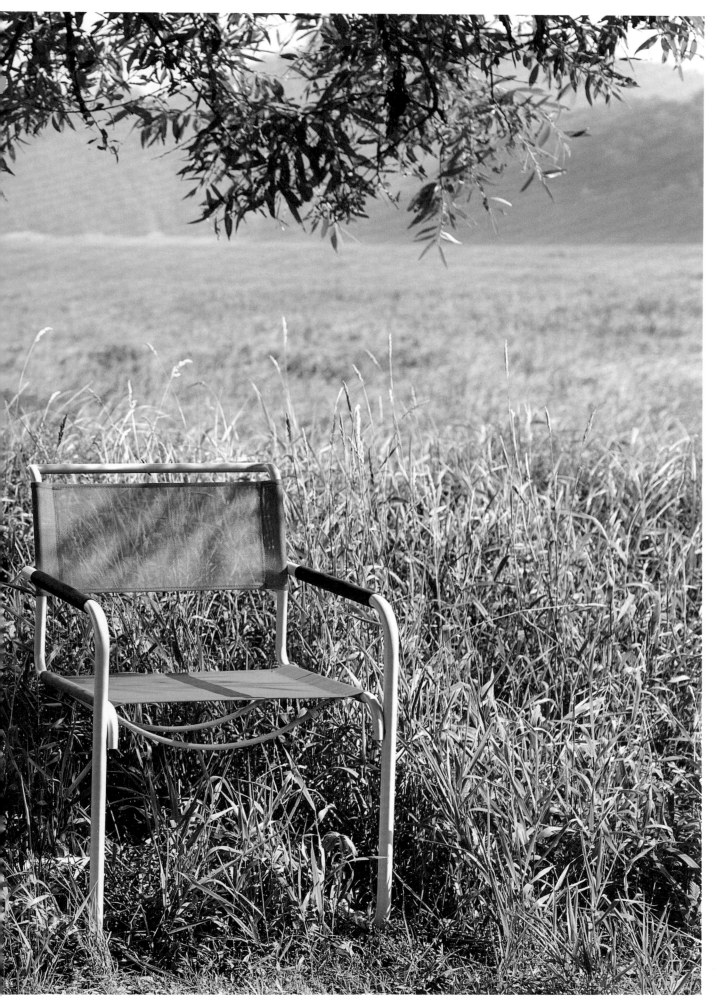

With the Thonet All Seasons collection, this long-established company gives Bauhaus icons like Ludwig Mies van der Rohe's S 533 cantilever chair the opportunity to stand out in the garden, thanks to special technology. The recently introduced collection draws on the beginnings of the company's history: Back in the mid-19th century, the company's founder, Michael Thonet, experimented with materials—successfully bending solid wood for the first time: With that, the first serially-produced chair was born, the iconic Bentwood Chair 214 (formerly No. 14).

Mit Thonet All Seasons gibt die Traditionsfirma Bauhaus-Ikonen wie dem Freischwinger S 533 von Ludwig Mies van der Rohe durch eine neue Technologie die Chance, auch im Garten Akzente zu setzen. Die kürzlich eingeführte Kollektion knüpft an die Anfänge der Unternehmensgeschichte an: Schon der Firmengründer Michael Thonet experimentierte mit Materialien – ihm gelang es Mitte des 19. Jahrhunderts erstmals, massives Holz zu biegen. Damit war der erste seriell hergestellte Stuhl geboren, der ikonische Bugholzstuhl 214 (ehemals Nr. 14).

Avec sa collection All Seasons, Thonet redonne aux produits phares du Bauhaus, comme la chaise cantilever S 533 de Ludwig Mies van der Rohe, la possibilité d'être des points d'attraction du jardin. Lancée récemment, cette gamme rappelle les débuts de l'entreprise : son créateur, Michael Thonet, faisait déjà des essais avec divers matériaux, et au milieu du 19e siècle, il parvient à cintrer pour la première fois le bois massif. la première chaise fabriquée en série était née, la fameuse Bugholz 214 (anciennement n° 14).

101

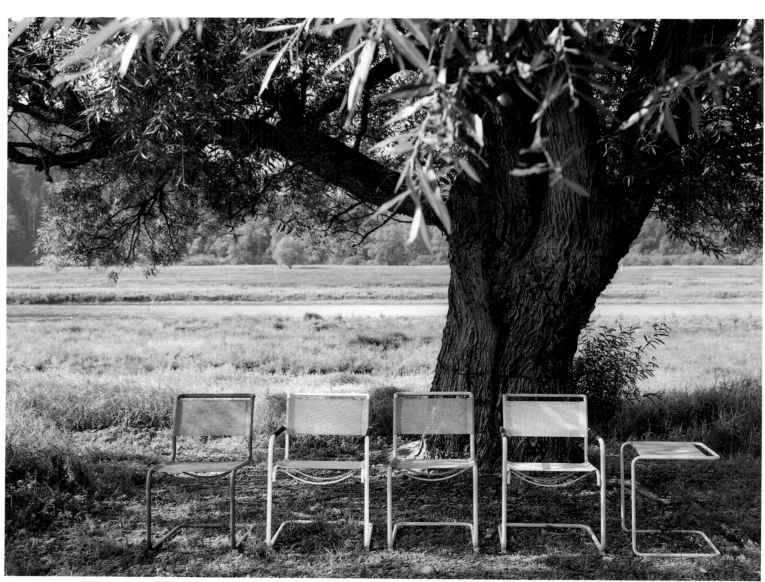

The steel tube classics have been given a new, modern outfitting and coating: An extensive palette of colors for the frame and the fabric can also be combined with cushions in a customized fashion.

Die Stahlrohr-Klassiker haben ein neues, zeitgemäßes Outfit bekommen: Eine breite Farb-palette für die Gestelle und das Gewebe lässt sich individuell auch mit Kissenauflagen kombinieren.

Ces classiques tubulaires bénéfi-cient aujourd'hui d'un traitement plus contemporain. Une large palette de couleurs pour les piétements et le tissu permet de combiner à volonté, y compris en asso-ciant des coussins.

102

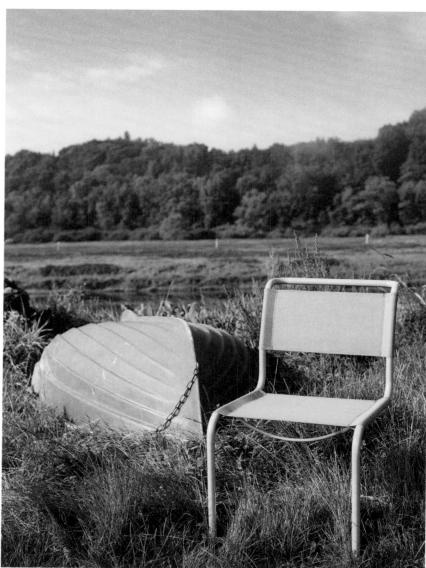

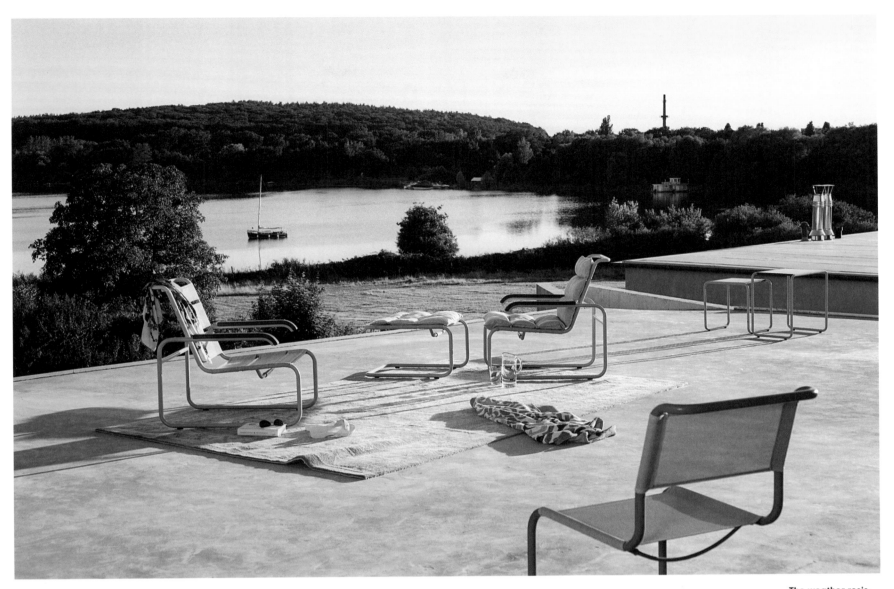

The weather-resistant collection, to which the B 9 end table and the S 35 lounge chair by Marcel Breuer also belong, can be used all year long—indoors and out.

Die witterungsbeständige Kollektion, zu der auch der Beistelltisch B 9 und der Loungesessel S 35 von Marcel Breuer gehören, funktioniert das ganze Jahr über – drinnen und draußen.

Cette collection tout-temps, qui comprend aussi la desserte B 9 et le fauteuil S 35 de Marcel Breuer, est fonctionnelle toute l'année, à l'intérieur comme à l'extérieur.

Vicki Hinrichs

Hamburg | Germany

104

From cultural management to garden design: The Hamburg native found fulfillment in garden design as a space for peace. | Vom Kulturmanagement zur Gartenkunst: Die Hamburgerin fand Erfüllung im Entwerfen von Gärten als Orte der Ruhe. | De la gestion de la culture à l'art du jardin : la Hambourgeoise Vicki Hinrichs a trouvé sa vocation en concevant des jardins comme des lieux de repos.

When the journey takes you from film to the art market to garden design, the gardens must have a special dramatic effect and allure. Vicki Hinrichs studied Garden Design in England and turned from the cultural business when she recognized how much joy and satisfaction contact with plants and green spaces brings her. Since 2011, she has conceptualized formal style gardens with symmetry and a stringently reduced use of plants.

Wenn der Weg vom Film über den Kunstmarkt zur Gartengestaltung führt, müssen Gärten eine besondere Dramaturgie und Anziehungskraft haben. Vicki Hinrichs studierte in England Garden Design und kehrte dem Kulturgeschäft den Rücken, als sie erkannte, wie viel Freude und Zufriedenheit ihr der Umgang mit Pflanzen und grünen Räumen bereitet. Seit 2011 entwirft sie Gärten im formalen Stil, mit Symmetrie und strikt reduzierter Pflanzenverwendung.

Lorsqu'on devient paysagiste après avoir travaillé dans le cinéma, puis dans le marché de l'art, rien d'étonnant à ce qu'il émane des jardins une dramaturgie et un pouvoir d'attraction particuliers. Après avoir étudié l'architecture paysagère en Angleterre, Vicki Hinrichs tourne le dos au monde de la culture lorsqu'elle constate le bonheur et la joie qu'elle ressent à vivre au milieu des plantes et des espaces verts. Depuis 2011, elle conçoit des jardins au style formel, marqués par la symétrie et une utilisation minimaliste de la végétation.

A curved hedgerow of Ilex crenata 'dark green' splits the property on the Alster river and leads to a gravel terrace which is bordered by wild grape vines and Miscanthus sinensis 'Gracillimus.'

Eine geschwungene Hecke aus Ilex crenata 'Dark Green' teilt das Grundstück an der Alster und führt auf eine Kiesterrasse, eingefasst von Wildem Wein und Miscanthus sinensis 'Gracillimus'.

Tout en courbes, une haie de houx crénelé 'Dark Green' partage le terrain situé sur les bords de la rivière Alster et débouche sur une terrasse en gravier entourée de vigne sauvage et de miscanthus sinensis 'Gracillimus'.

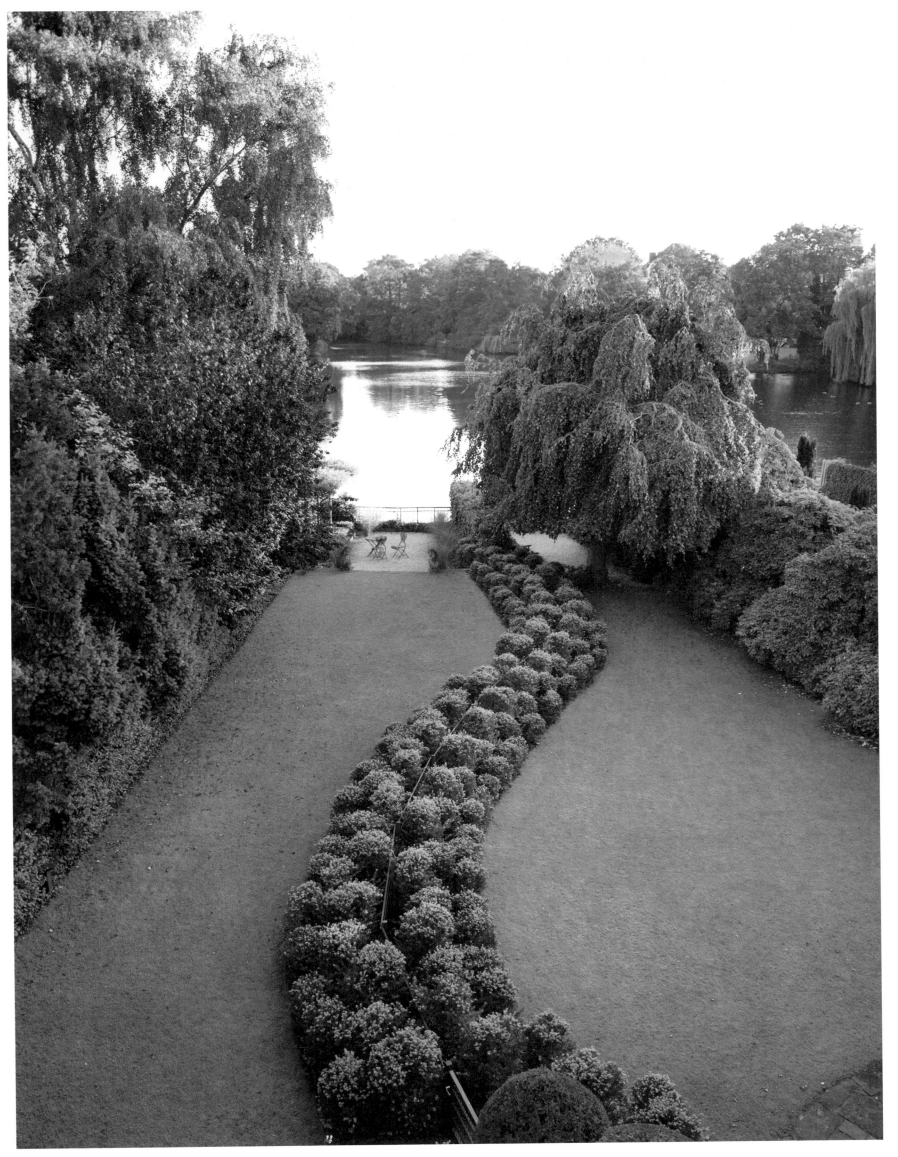

Vicki Hinrichs

106

In order to bring some light to the renovated lower level of a house in Hamburg, the adjoining grounds were terraced with wide, curved, corten steel steps.

Um dem umgebauten Untergeschoss eines Hauses in Hamburg Licht zuzuführen, wurde das angrenzende Gelände mit breiten Stufenbögen aus Cortenstahl terrassiert.

Pour faire entrer la lumière au rez-de-chaussée réaménagé d'une maison de Hambourg, le terrain environnant a été terrassé au moyen de grands et larges arcs étagés en acier Corten.

The view from the windows falls upon low Pinus mugo 'mops' and Japanese sedge and then beyond into the garden where the lawn is composed of trees, shrubs, and hydrangeas.

Der Blick aus den Fenstern fällt auf die niedrige Bepflanzung mit Pinus mugo 'Mops' und Japan-Segge und weiter in den Garten, dessen Rasen von Gehölzen und Hortensien gefasst wird.

À travers les fenêtres, le regard tombe sur la verdure basse composée de pins nains de montagne (Pinus mugo 'Mops') et de laîches du Japon, puis se dirige vers le jardin dont la pelouse est encadrée par des bosquets et des hortensias.

Vicki Hinrichs

Vicki Hinrichs

I Prefer Overalls to Cocktail Dresses.
Lieber Latzhose als Cocktailkleid
Plutôt la salopette que la robe de cocktail

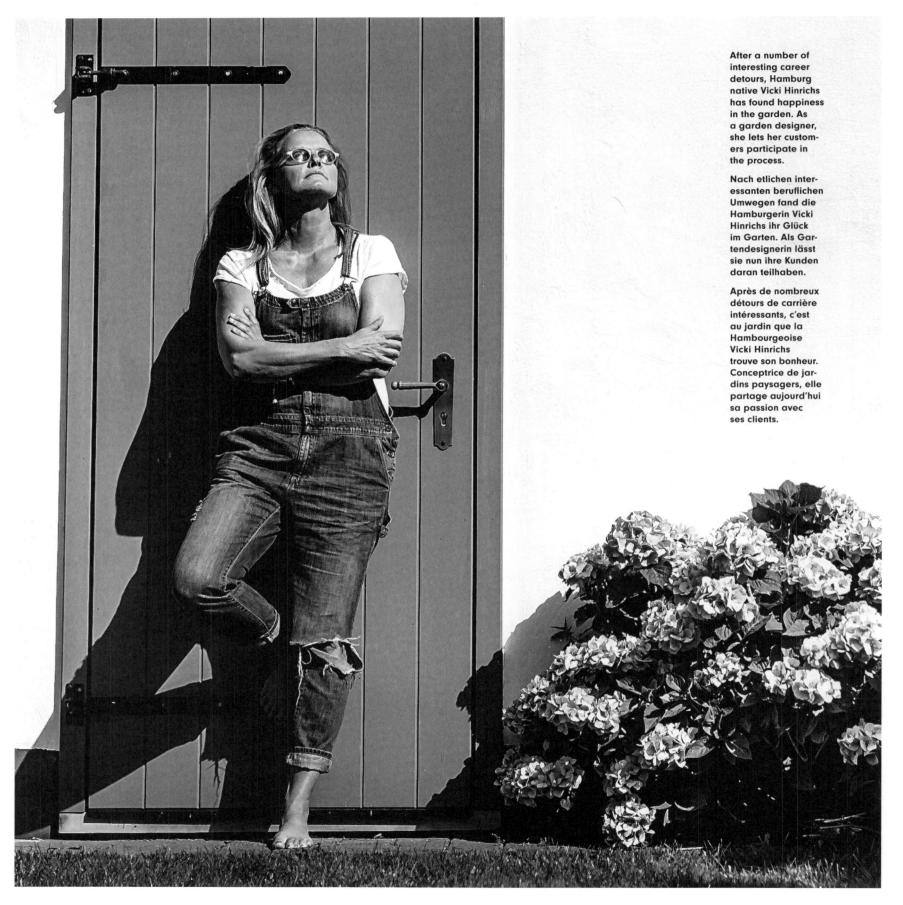

After a number of interesting career detours, Hamburg native Vicki Hinrichs has found happiness in the garden. As a garden designer, she lets her customers participate in the process.

Nach etlichen interessanten beruflichen Umwegen fand die Hamburgerin Vicki Hinrichs ihr Glück im Garten. Als Gartendesignerin lässt sie nun ihre Kunden daran teilhaben.

Après de nombreux détours de carrière intéressants, c'est au jardin que la Hambourgeoise Vicki Hinrichs trouve son bonheur. Conceptrice de jardins paysagers, elle partage aujourd'hui sa passion avec ses clients.

108

What does your ideal garden look like?

The expulsion from Paradise plays a central role in Western culture. Since that time, humans have been searching for a replacement for the "Paradiso Perduto, " or Paradise Lost. Whoever creates a garden for themselves, no matter how big or small, gets closer. For me, the ideal garden is one in which its inhabitants feel comfortable. Whoever walks across their property after mowing the lawn and sits on a bench and smells the new-mown grass knows exactly what I mean.

Are you giving up on colorful perennials despite having studied in England?

I love to provide the garden with a clear structure. I prefer to select plants that are modest rather than exuberant, more elegant than baroque. So think more Jil Sander rather than Versace.

Formal gardens need care to preserve the overall appearance. Do your customers have an appreciation for this?

The garden is the hairstyle of the house. A well-designed garden fills me with the excitement that I otherwise feel for art. For me, a trip to a good tree nursery is much like visiting a museum. My customers are highly discerning, and yes, they have a high level of appreciation for the care required for gardens I have plotted. The aspects of humility and patience are always rewarding. Everyone has to learn this. Plants lead their own lives. If one does not care, they can be offended, sulk and even die. This is true for all living things.

Wie sieht für Sie der ideale Garten aus ?

Eine zentrale Rolle in der abendländischen Kultur spielt die Vertreibung aus dem Paradies. Seither sind die Menschen auf der Suche nach einem Ersatz für das „Paradiso Perduto", dem verlorenen Paradies. Wer sich einen Garten anlegt – egal ob groß oder klein –, kommt der Sache näher. Der ideale Garten sieht für mich genau so aus, dass sich seine Bewohner darin wohl fühlen. Wer nach dem Rasenmähen barfuß über sein Grundstück läuft, auf der Parkbank sitzt und den frisch gemähten Rasen riecht, weiß genau, was ich meine.

Trotz des Studiums in England verzichten Sie auf farbige Staudenbeete?

Ich liebe es, dem Garten eine klare Struktur zu geben. Ich bin dabei in der Auswahl meiner Pflanzen eher schlicht als üppig, eher elegant als barock verspielt. Also eher Jil Sander als Versace.

Formale Gärten brauchen Pflege, um das Gesamtbild zu erhalten. Verstehen das ihre Kunden?

Der Garten ist die Frisur des Hauses. Ein gut gestalteter Garten erfüllt mich inzwischen mit der Begeisterung, die ich ansonsten für Kunst empfinde. Ein Ausflug zu einer guten Baumschule kommt für mich einem Museumsbesuch sehr nahe! Ich habe anspruchsvolle Kunden, und ja, die sind sich bewusst, dass ein von mir geplanter Garten Pflege braucht. Interessant ist immer der Aspekt der Demut und der Geduld. Das muss jeder Mensch lernen. Pflanzen führen ein Eigenleben. Wenn man sich nicht kümmert, können sie beleidigt sein, schmollen und sogar eingehen. Das ist bei allen Lebewesen so.

Pour vous, à quoi ressemble le jardin idéal ?

Dans la culture occidentale, l'expulsion du Paradis joue en rôle central. Depuis, les Hommes sont à la recherche d'un espace de substitution pour le paradis perdu. Aménager un jardin, qu'il soit petit ou grand, c'est se rapprocher de cet idéal. Le jardin idéal, pour moi, c'est celui dans lequel ses habitants se sentent bien. Il suffit de marcher pieds nus sur une pelouse fraichement tondue, d'en sentir l'odeur ou de s'assoir sur un banc de parc pour comprendre ce que je veux dire.

Malgré vos études en Angleterre, vous vous passez des massifs de plantes vivaces multicolores ?

J'aime bien donner au jardin une structure claire. Lorsque je sélectionne mes végétaux, je fais dans la simplicité plutôt que dans l'exubérance, dans l'élégance plus que dans la fantaisie baroque. On pourrait dire aussi que je suis plus Jil Sander que Versace.

Les jardins formels requièrent de l'entretien pour préserver leur aspect. Est-ce que vos clients comprennent cette exigence ?

Le jardin est la coiffure de la maison. Un jardin bien conçu me remplit du même bonheur que celui que je ressens pour l'art. Pour moi, une escapade chez un bon pépiniériste, c'est presque comme la visite d'un musée ! J'ai des clients exigeants, et oui, ils savent qu'un jardin que j'ai créé a besoin d'entretien. Patience et l'humilité sont toujours des aspects intéressants. Et chaque être humain doit apprendre cette leçon-là. Les plantes ont leur vie propre. Si l'on ne s'occupe pas d'elles, elles peuvent nous en vouloir, bouder et même en mourir. Il en va ainsi de tous les êtres vivants.

A well-designed garden fills me with the excitement that I otherwise feel for art.

Ein gut gestalteter Garten erfüllt mich inzwischen mit der Begeisterung, die ich ansonsten für Kunst empfinde.

Un jardin bien conçu me remplit du même bonheur que celui que je ressens pour l'art.

This restoration is a way of implementing the original idea of capturing the poetry of the landscape in a garden. | Eine Sanierung schreibt die ursprüngliche Idee fort, die Poesie der Landschaft in den Garten zu holen. | Une rénovation qui reste fidèle à l'idée originelle : faire entrer dans le jardin la poésie du paysage.

Back in 1914, landscape architect Paul Hermann Schädlich designed garden rooms around the Baroque property overlooking Lake Zurich. When the building was converted to a conference center, ASP gave new life to the aging gardens. In this project, the landscape architects remain true to the approach that they have been practicing since 1972. This approach is defined by locational respect, for its interaction with the landscape, its patterns and principles. A composition consisting of the old and new is created.

Bereits 1914 hatte der Gartenarchitekt Paul Hermann Schädlich Gartenzimmer um das barocke Anwesen oberhalb des Zürichsees komponiert. Als das Gebäude zum Konferenz- und Tagungszentrum umgebaut wurde, belebte ASP den in die Jahre gekommenen Garten neu. Die Landschaftsarchitekten blieben auch hier ihrer Arbeitsweise treu, die sie seit 1972 praktizieren. Sie ist geprägt von Respekt vor dem Ort, von der Auseinandersetzung mit der Landschaft, ihren Mustern und Prinzipien. So entstehen stimmige Gesamtkompositionen aus alt und neu.

Dès 1914, l'architecte paysager Paul Hermann Schädlich avait composé des vérandas autour de la propriété baroque située au-dessus du lac de Zurich. Lorsque le bâtiment fut transformé en centre de conférences, ASP redonna vie aux jardins qui avaient subi les outrages du temps. Ici aussi, les architectes paysagers ne dérogèrent pas à leurs habitudes et appliquèrent les mêmes méthodes que depuis 1972, caractérisées par le respect du lieu et la confrontation avec le paysage, ses modèles et ses principes. Ainsi naissent des compositions d'ensemble harmonieuses, associant l'ancien et le nouveau.

Landhaus Bocken

Landhaus Bocken

Horgen | Switzerland

112

Current uses and garden images are integrated into the existing landmarked structure of the garden. In front of the guest house, old French pear trees grow in ornamental grass in oak barrels. Views of the lake have been restored, and walls and steps renovated (also see previous pages).

Aktuelle Nutzungen und Gartenbilder fügen sich in die bestehende, denkmalgeschützte Struktur des Gartens ein. Vor dem Gästehaus wachsen alte französische Birnen über Ziergras in Eichenholz-Gefäßen. Blickbezüge zum See wurden wiederhergestellt, Mauern und Treppen saniert (siehe vorhergehende Seiten).

Les usages actuels et la vision contemporaine du jardin se fondent dans la structure existante qui est classée monument historique. Devant la maison des invités, d'anciens poiriers français plantés dans des fûts de chêne poussent au-dessus d'herbes d'ornement. Les vues sur le lac ont été restaurées, les murs et les escaliers ont été restaurés (voir aussi les pages précédentes).

113

ASP Landschaftsar-
chitekten kept the
landscape images
with the old trees
(see also following
pages). They orien-
ted the new plants
according to modern
aesthetics, such as
the undergrowth
of the trees, which
addresses the topic
of the encroachment
of scrubs into the
alpine pastures.

ASP Landschaftsar-
chitekten erhielten
die Landschaftsbil-
der mit den alten
Bäumen (siehe auch
folgende Seiten).
Neupflanzungen
orientierten sie an
heutigen Sehge-
wohnheiten, wie zum
Beispiel der Unter-
wuchs der Bäume,
der die Verbuschung
der Alpweiden zum
Thema hat.

Les perspectives
paysagères, avec
les arbres anciens,
ont été conservées
par les paysagistes
d'ASP (voir aussi les
pages suivantes).
Les nouvelles plan-
tations ont été faites
de façon à retrouver
les habitudes
visuelles anciennes,
par exemple les
végétaux implantés
sous les arbres
et évoquant le
buissonnement
des alpages.

Landhaus Bocken

Skulpturenpark Waldfrieden

Wuppertal | Germany

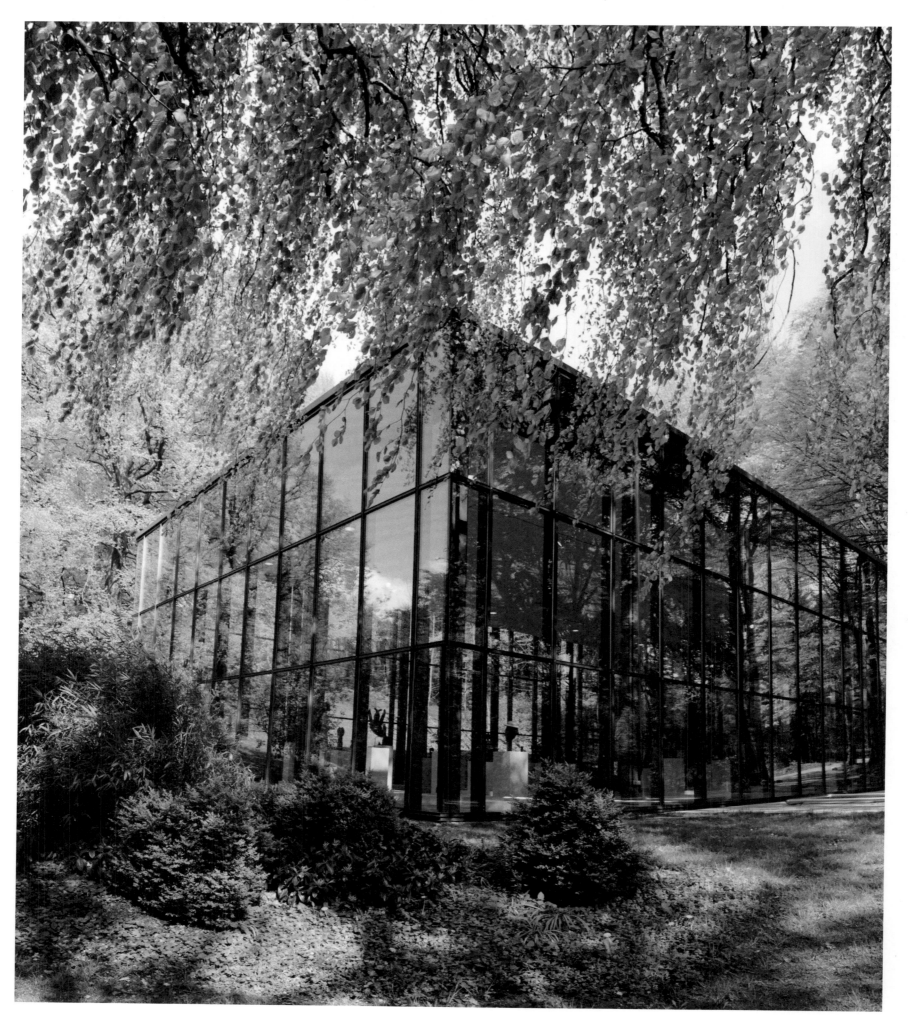

In the Cragg Foundation sculpture park, art and the experience of nature are inseparable. | Im Skulpturenpark der Cragg Foundation sind Kunst und Naturerfahrung untrennbar miteinander verbunden. | Dans le parc de sculptures de la Fondation Cragg, l'art et la nature sont indissolublement liés.

Old deciduous trees give the Waldfrieden Sculpture Park above the Wupper Valley its picturesque atmosphere. The expansive grounds, along with the Villa, were created by industrialist Kurt Herberts, with designs by architect Franz Krause, between 1947 and 1950. When sculptor Tony Cragg secured the property for his sculpture park in 2006, it had long been left untended. The artist had the landmarked structure carefully renovated and the grounds delicately repaired; all while leaving the enchanting character of the park intact.

Alte Laubbäume verleihen dem Skulpturenpark Waldfrieden über dem Tal der Wupper seine malerische Atmosphäre. Die weitläufige Anlage samt Villa ließ der Fabrikant Kurt Herberts nach Entwürfen des Architekten Franz Krause von 1947 bis 1950 anlegen. Als der Bildhauer Tony Cragg das Anwesen im Jahr 2006 für seinen Skulpturenpark erwarb, war es lange sich selbst überlassen gewesen. Der Künstler ließ den denkmalgeschützten Bau sorgfältig sanieren und das Gelände behutsam instand setzen – der verwunschene Charakter des Parks blieb dabei erhalten.

Les vénérables feuillus qui peuplent le parc de sculptures de Waldfrieden, au-dessus de la vallée de la Wupper, lui donnent une atmosphère pittoresque. La villa et le vaste domaine qui l'entoure ont été réalisés entre 1947 et 1950 par le fabricant Kurt Herberts, sur les plans de l'architecte Franz Krause. En 2006, le sculpteur Tony Cragg se rend acquéreur du domaine pour y installer son parc de sculptures, à un moment où la propriété est laissée à l'abandon. L'artiste fait d'abord restaurer soigneusement le bâtiment classé monument historique et remettre le terrain en état avec beaucoup de soin de façon à préserver le caractère enchanteur du parc.

Franz Krause designed the Villa Waldfrieden as an organic form that fuses with the park. Three pavilions provide space for temporary exhibits.

Franz Krause entwarf die Villa Waldfrieden als organische Form, die mit dem Park verschmilzt. Drei Pavillons bieten Platz für Wechselausstellungen.

Franz Krause avait conçu la villa Waldfrieden comme un ensemble organique en symbiose avec le parc. Trois pavillons peuvent recevoir des expositions temporaires.

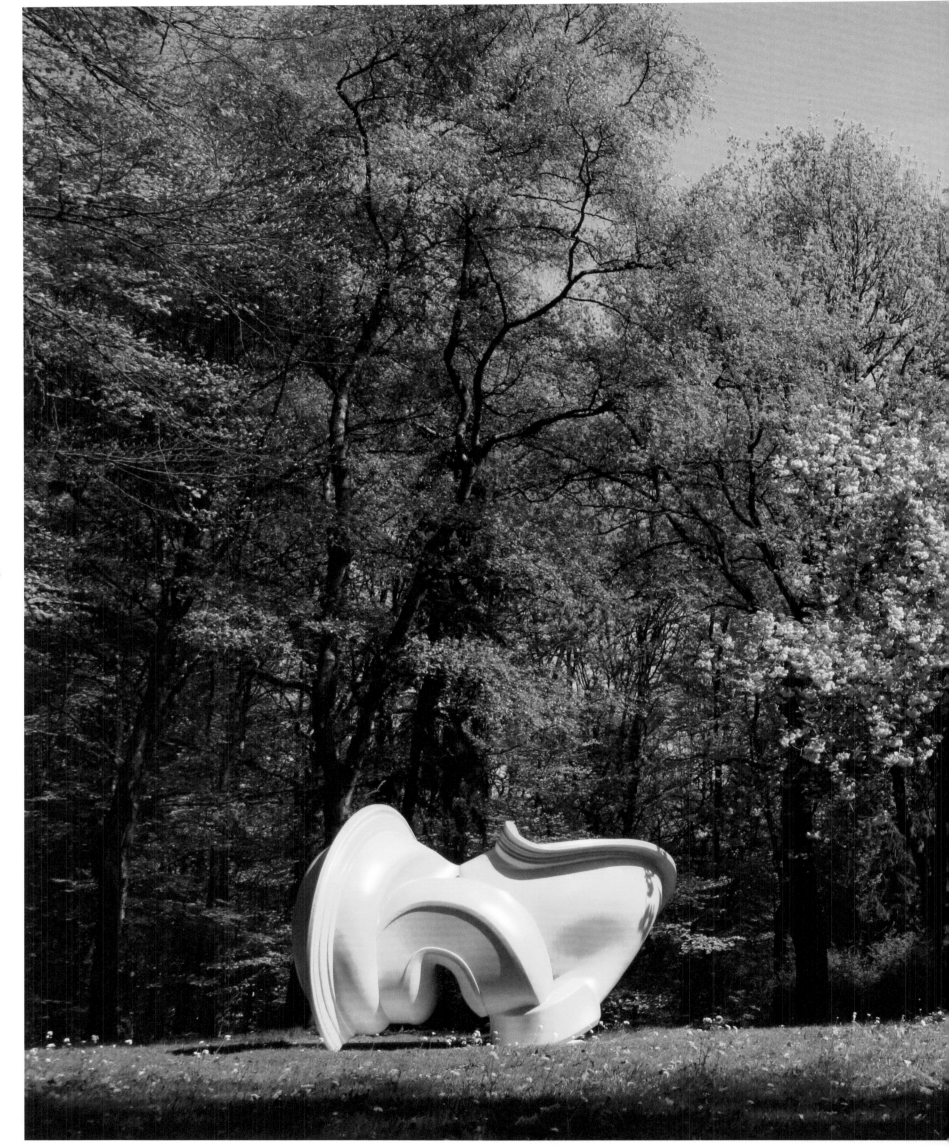

Skulpturenpark Waldfrieden

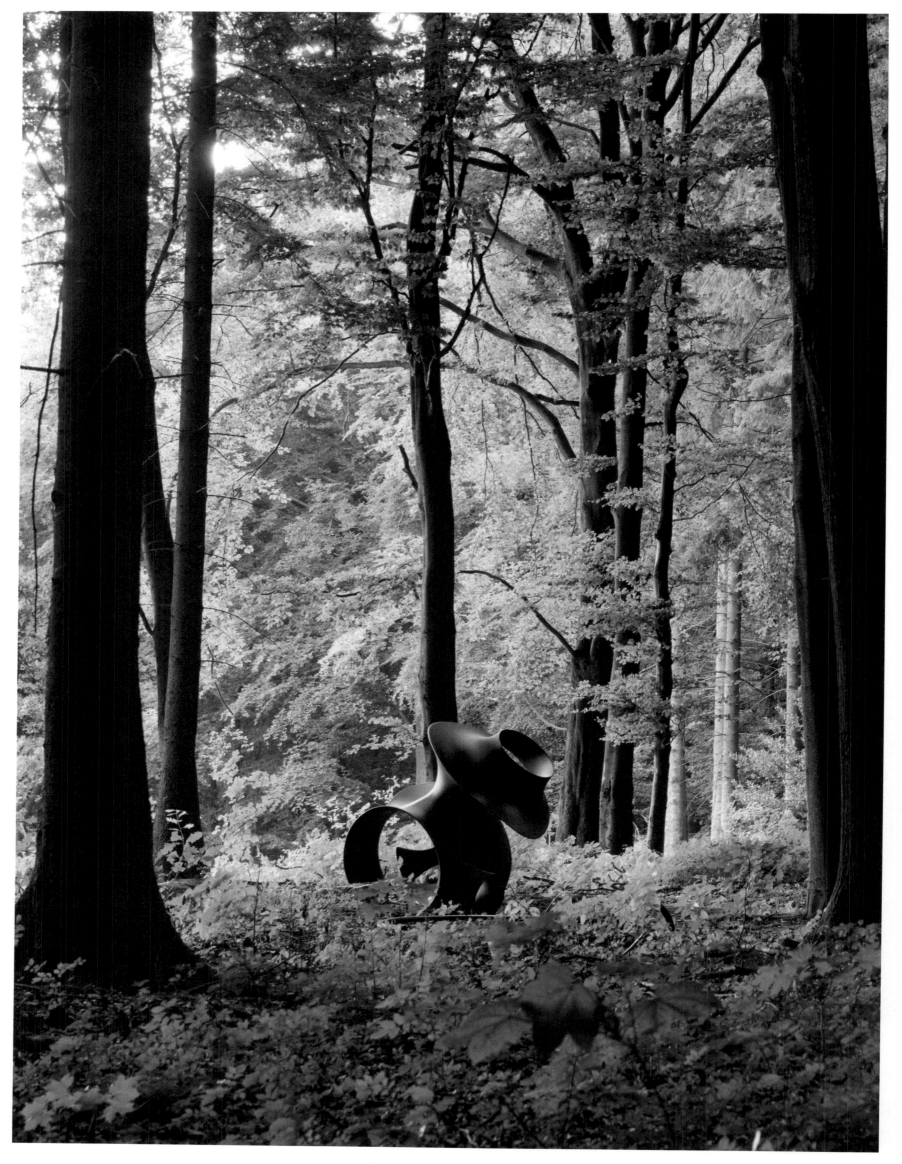

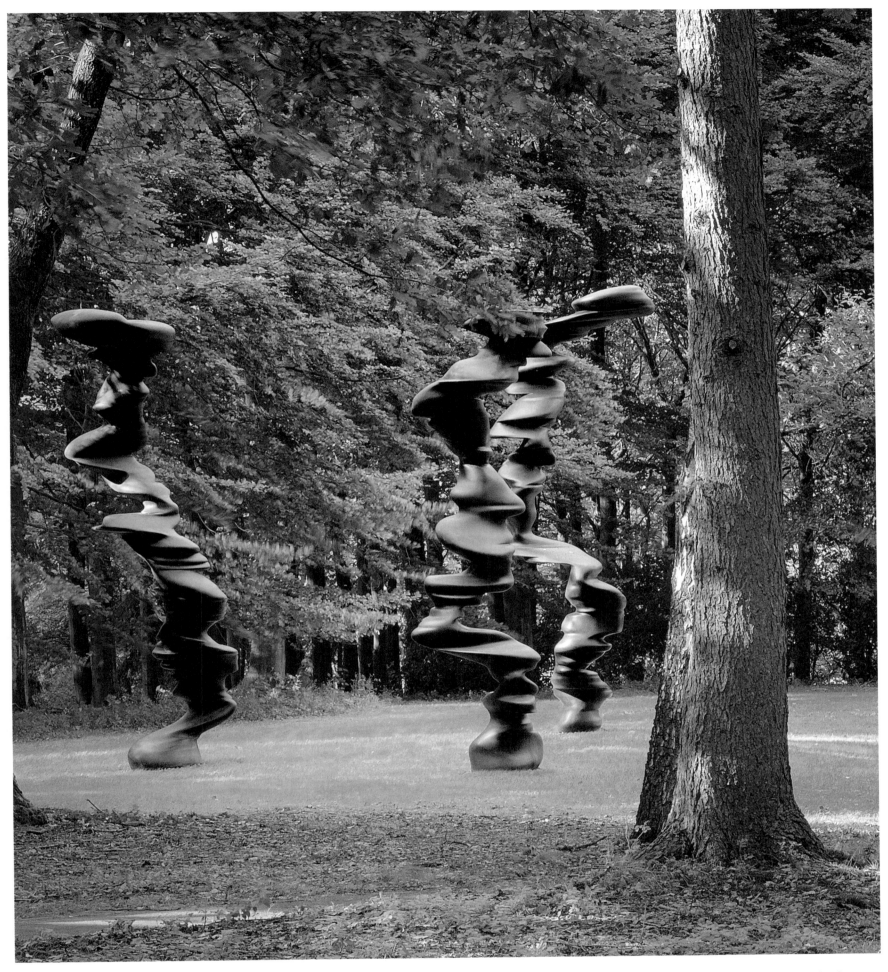

On the clearings and hidden in the forest, the sculptures of Tony Cragg and other artists engage in a dialog with nature. Pages 118–119: Declination, Tony Cragg, 2004; Page 120: Irruption, Eva Hild, 2011; Page 121: Points of View, Tony Cragg, 2007.

Auf Lichtungen und versteckt im Wald treten die Skulpturen von Tony Cragg und weiteren Künstlern in einen Dialog mit der Natur. Seiten 118–119: Declination, Tony Cragg, 2004; Seite 120: Irruption, Eva Hild, 2011; Seite 121: Points of View, Tony Cragg, 2007.

Installées dans des clairières ou cachées dans les bois, les sculptures de Tony Cragg et d'autres artistes dialoguent avec la nature. Pages 118–119 : Declination, Tony Cragg, 2004 ; page 120 : Irruption, Eva Hild, 2011 ; page 121 : Points of View, Tony Cragg, 2007.

Skulpturenpark Waldfrieden

Lorenz von Ehren

Hamburg | Germany

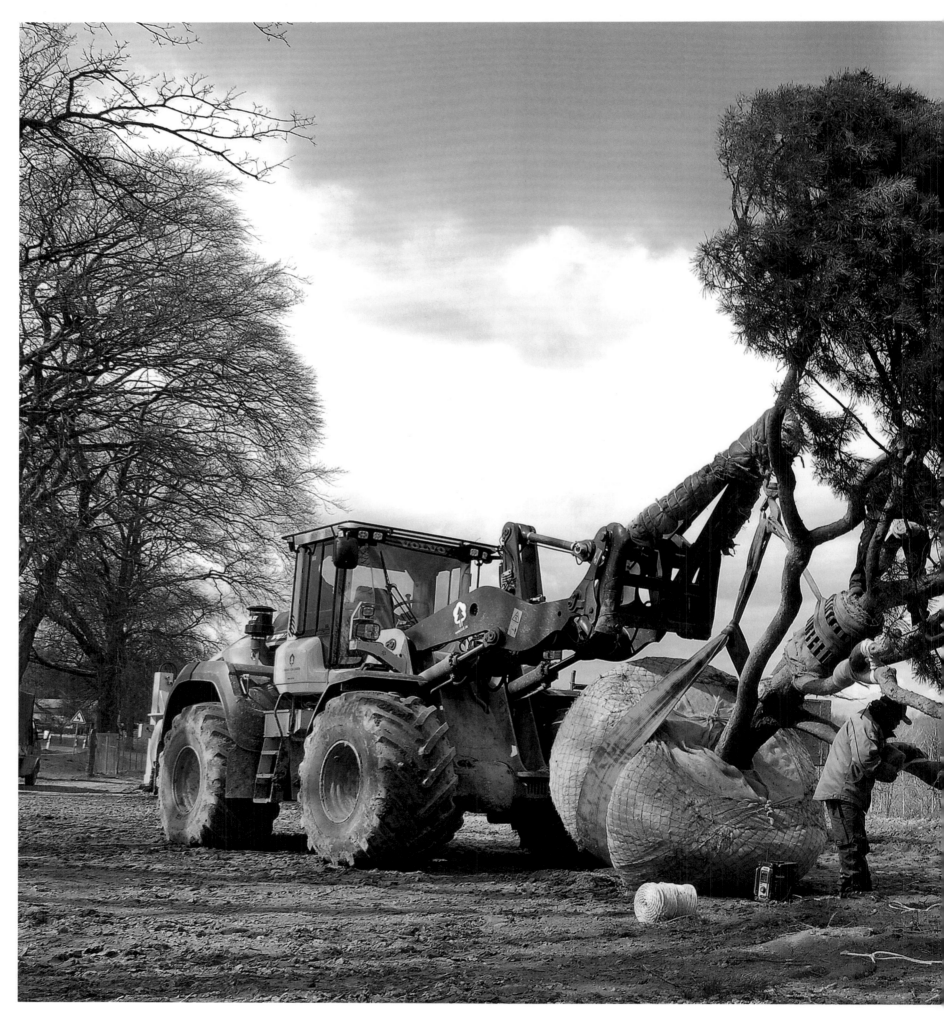

Lorenz von Ehren ranks as the leading tree nursery in Europe and ships approximately 1.5 million plants annually. | Lorenz von Ehren zählt zu den führenden Baumschulen in Europa – und liefert jährlich rund 1,5 Millionen Pflanzen aus. | Lorenz von Ehren est un des plus grands pépiniéristes européens, avec des livraisons annuelles de 1,5 millions de végétaux.

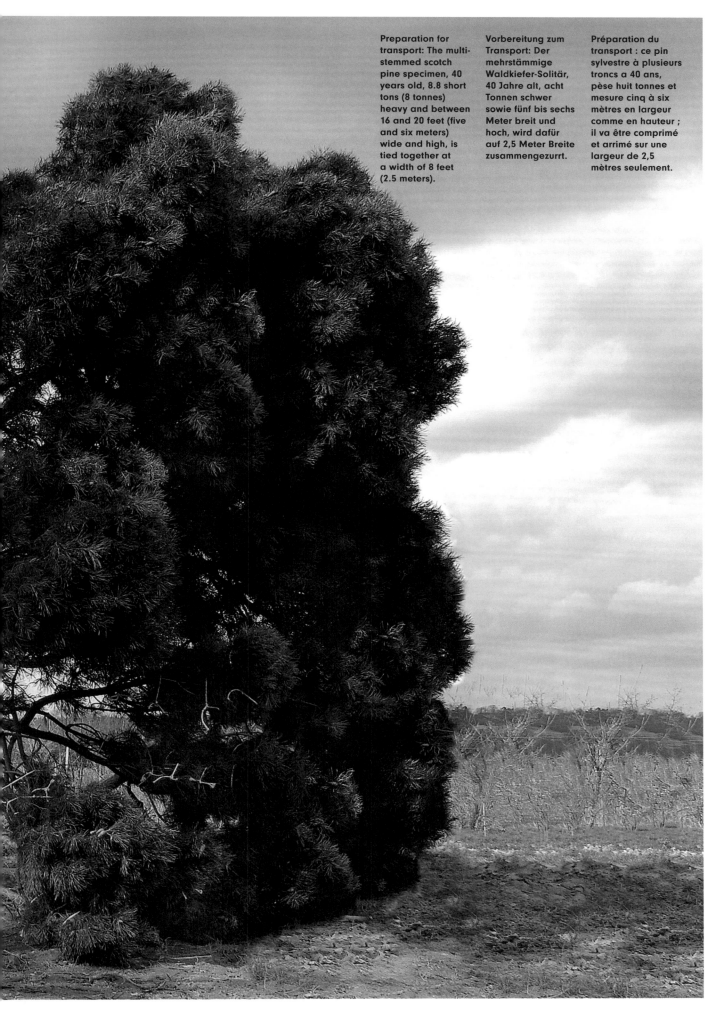

Preparation for transport: The multi-stemmed scotch pine specimen, 40 years old, 8.8 short tons (8 tonnes) heavy and between 16 and 20 feet (five and six meters) wide and high, is tied together at a width of 8 feet (2.5 meters).

Vorbereitung zum Transport: Der mehrstämmige Waldkiefer-Solitär, 40 Jahre alt, acht Tonnen schwer sowie fünf bis sechs Meter breit und hoch, wird dafür auf 2,5 Meter Breite zusammengezurrt.

Préparation du transport : ce pin sylvestre à plusieurs troncs a 40 ans, pèse huit tonnes et mesure cinq à six mètres en largeur comme en hauteur ; il va être comprimé et arrimé sur une largeur de 2,5 mètres seulement.

In the von Ehren Tree Nursery, founded in 1865, 2,000 plant genera, species, and varieties are cultivated on a 1,483-acre (600-hectare) cultivation area—from singular trees to hedges and fruit trees to topiaries. Many noble avenue trees have been in the culture for over 70 years, which were shaped by hand in the impressive garden Bonsais over decades. Currently, the focus is on the "city trees for the future": climate suitable and stress-resistant specimens.

In der im Jahr 1865 gegründeten Baumschule von Ehren werden auf 600 Hektar Anbaufläche 2 000 Pflanzengattungen, -arten und -sorten kultiviert – von Solitärbäumen über Hecken und Obstbäumen bis hin zu Formgehölzen. Viele stattliche Alleebäume sind über 70 Jahre in Kultur, die eindrucksvollen Garten-Bonsais wurden Jahrzehnte von Hand geformt. Aktuell liegt der Fokus auf den „Stadtbäumen der Zukunft" – klimagerechten und stress-resistenten Exemplaren.

Créées en 1865, les pépinières von Ehren cultivent sur 600 hectares 2 000 espèces et variétés, arbres isolés, haies et arbres fruitiers, bosquets aux formes particulières. De nombreux arbres d'allées sont cultivés depuis plus de 70 ans, tandis que les impressionnants bonsaïs de jardins sont modelés à la main pendant des décennies. Actuellement, l'entreprise se consacre aux « arbres des villes du futur », des spécimens résistants au stress et adaptés au climat.

123

Top: The littleleaf linden avenue tree area with specimen plants in rank and file. Just as they are here in the tree nursery, they will also later stand in the espalier landscape. In the formal private garden below, diverse topiaries communicate with the landscape architecture: Box-shaped trimmed hornbeams, a yew hedge made of plants preferred for privacy and as a dramatic eye-catcher a black pine cut like a bonsai.

Oben das Winterlinden-Allee-baum-Quartier mit Solitären in Reih und Glied. Wie hier in der Baumschule werden sie auch später in der Landschaft Spalier stehen. In dem formalen Privatgarten unten korrespondieren unterschiedliche Formgehölze mit der Gartenarchitektur: Kastenförmig geschnittene Hainbuchen, als Sichtschutz eine Eibenhecke aus vorgezogenen Pflanzen und als markanter Blickfang eine bonsaiartig geschnittene Schwarzkiefer.

En haut : le coin des tilleuls d'hiver, alignés en vue de former des allées. Plus tard, ils seront replantés en haies comme ici à la pépinière. Dans le jardin privé ci-dessous, différents bosquets aux formes spécifiques s'adaptent à l'architecture paysagère : hêtres de bosquets taillés en caissons, haie d'ifs servant d'occultation avancée et, pour accrocher le regard, un pin noir taillé comme un bonsaï.

124

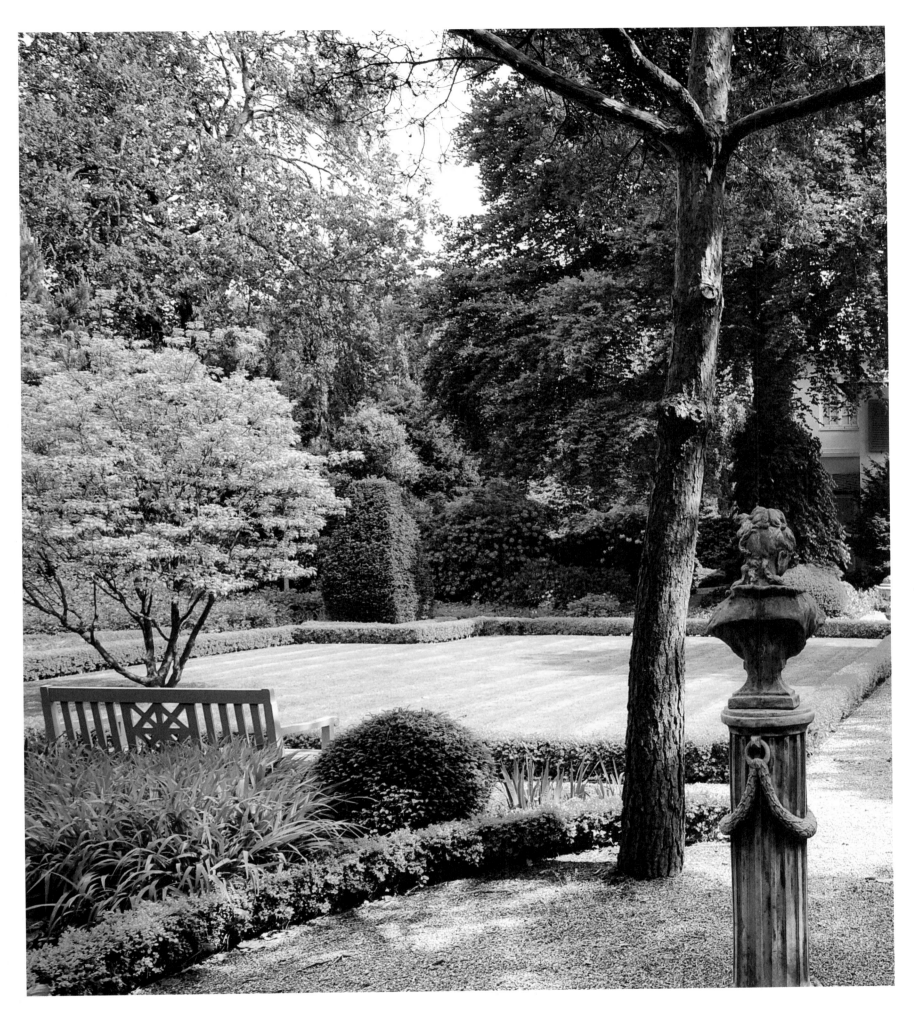

125

This villa garden area was designed with a park-like backdrop and striking specimen plants, with yew as a shaped grove and including scotch pine and downy Japanese maple.

Diese Villengarten-anlage wurde mit parkartiger Kulisse und auf-fälligen Solitären gestaltet – mit Eibe als Formgehölz, dazu Waldkiefer und Japanischer Ahorn.

Ce jardin de villa a été aménagé avec un décor de type parc et des arbres isolés mis en évidence, un bosquet d'ifs taillés ainsi qu'un pin sylvestre et un érable japonais.

Jnane Tamsna Gardens Marrakech | Morocco

126

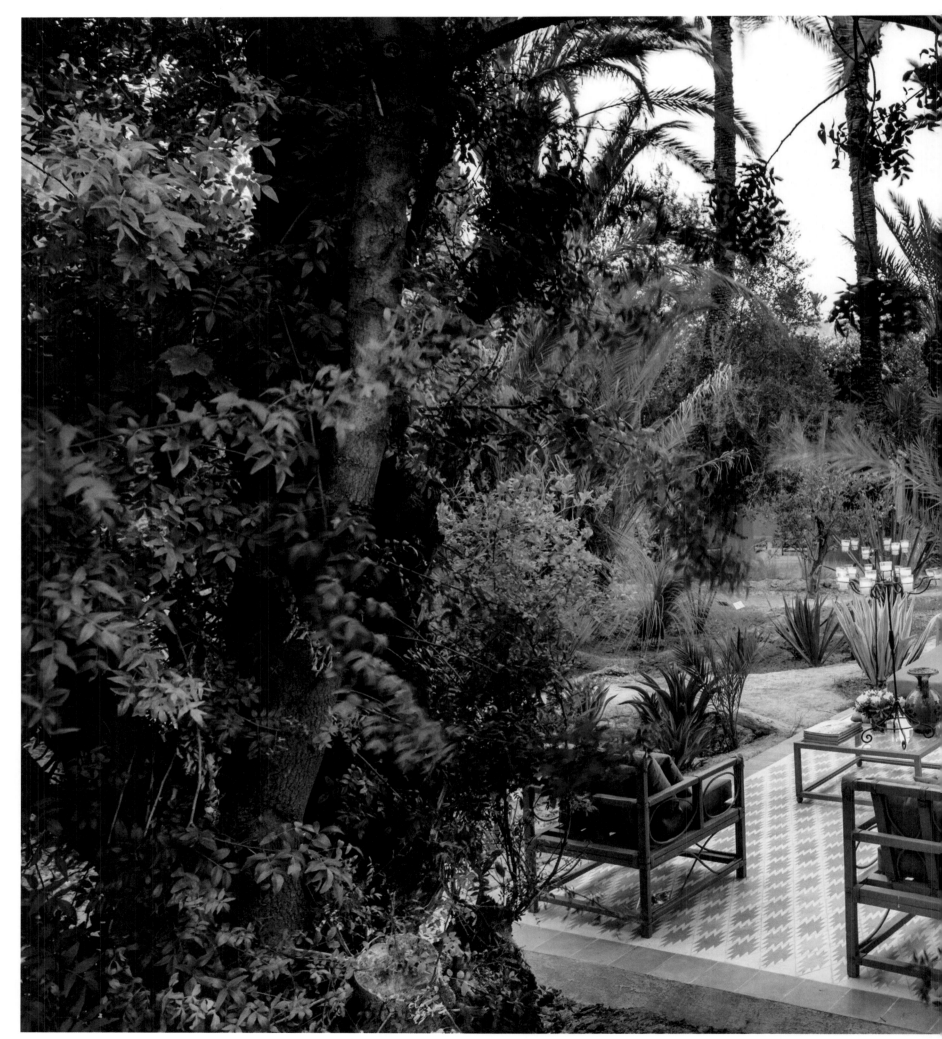

Traditional horticultural design inspired the gardens in this boutique hotel in Marrakesh, Morocco.
Traditionelle Gartenkunst stand Pate bei der Gestaltung der Gärten des Boutique-Hotels in Marrakesch.
Les jardins de cette boutique hôtel de Marrakech s'inspirent de l'art traditionnel du jardin.

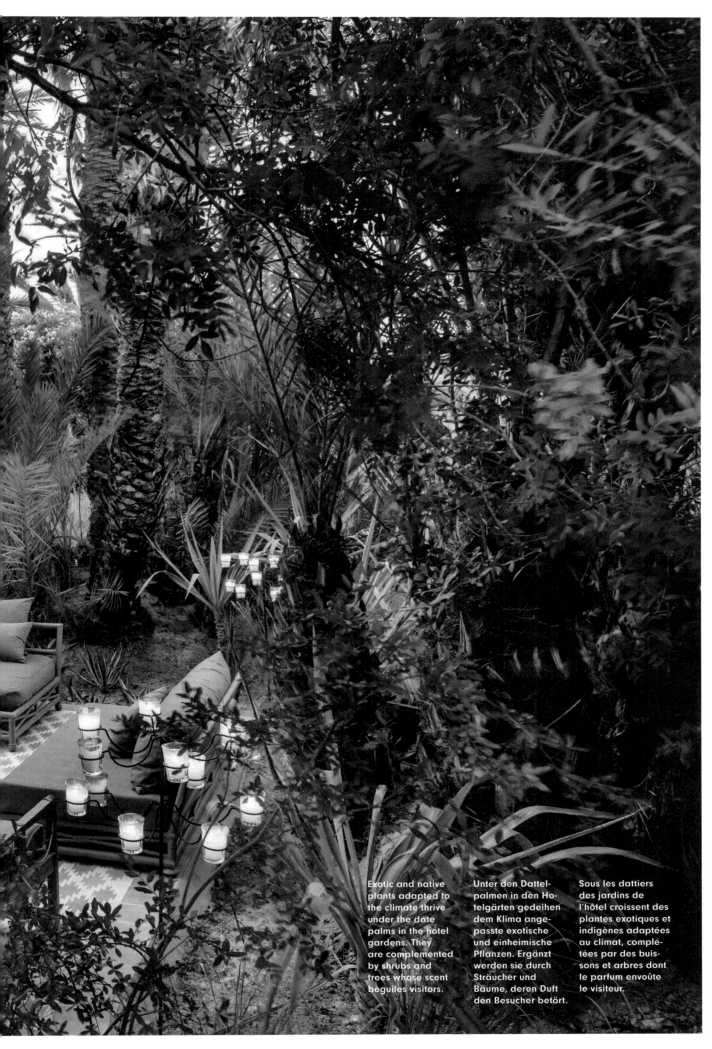

Exotic and native plants adapted to the climate thrive under the date palms in the hotel gardens. They are complemented by shrubs and trees whose scent beguiles visitors.

Unter den Dattelpalmen in den Hotelgärten gedeihen dem Klima angepasste exotische und einheimische Pflanzen. Ergänzt werden sie durch Sträucher und Bäume, deren Duft den Besucher betört.

Sous les dattiers des jardins de l'hôtel croissent des plantes exotiques et indigènes adaptées au climat, complétées par des buissons et arbres dont le parfum envoûte le visiteur.

Renowned ethnobotanist Gary Martin purchased land in the Marrakesh palm grove to build a hotel with North African style gardens, including *arsats* (orchard gardens), *bustans* (perfumed gardens), and *riads* (courtyard gardens). In 2001, he built a wall around the date palm-covered property, and then established citrus fruits orchards, themed gardens, courtyards, and pools. In an experimental area, Martin is testing agaves, aloes, and palms as well as endemic plants for expanded horticultural use.

Der bekannte Ethnobotaniker Gary Martin erwarb Land im Palmenhain von Marrakesch, um ein Hotel zu bauen und Gärten in den arabischen Stilen *arsat* (Obstgarten), *bustan* (Duftgarten) und *riad* (Innenhof) anzulegen. 2001 wurde eine Mauer um das mit Dattelpalmen bestandene Gelände gezogen, es entstanden Obstgärten mit Agrumen, Themengärten sowie Höfe und Pools an den Hotelpavillons. In einem experimentellen Bereich testet Martin Agaven, Aloen und Palmen sowie endemische Pflanzen für die weitere Verwendung.

Gary Martin, un ethnobotaniste connu, avait acheté un terrain dans la palmeraie de Marrakech pour y construire un hôtel et y aménager des jardins dans le style nord-africain, en particulier des *arsats* (vergers), *boustans* (jardins de parfum) et des *riads* (cours intérieures). En 2001, il fit construire un mur autour du terrain planté de palmiers dattiers, puis commence l'aménagement des jardins, avec des citronniers, des jardins à thèmes, des cours intérieures et des piscines. Dans une partie expérimentale, Gary Martin fait des essais avec des agaves, des aloès et des palmiers ainsi que des plantes endémiques, qu'il compte utiliser ensuite dans le jardin.

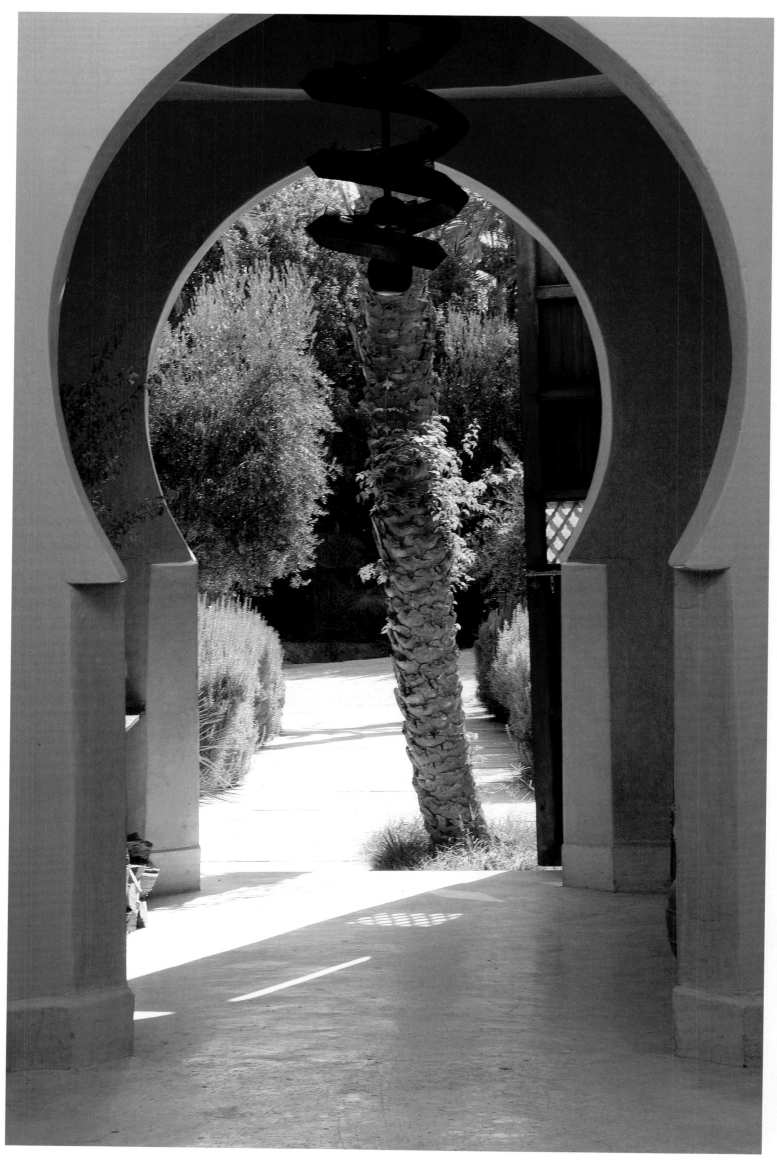

128

The view from a *riad* frames a date palm, the symbol and relic of the formerly vast palm grove. In the background, olive and wild pistachio trees grow with rosemary in the undergrowth.

Der Blick aus einem *riad* fällt auf eine Dattelpalme, ein Symbol und Relikt des ehemals riesigen Palmenhains. Im Hintergrund wachsen Oliven- und wilde Pistazienbäume, im Unterwuchs Rosmarin.

D'une *riad*, le regard tombe sur un dattier, symbole et vestige de l'ancienne gigantesque palmeraie. À l'arrière-plan croissent des oliviers et des pistachiers sauvages, couvrant des romarins.

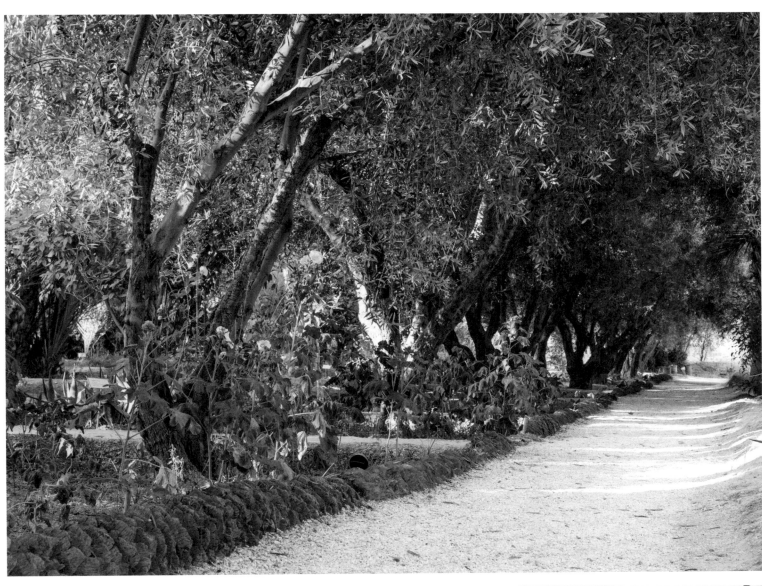

Olive trees line the path separating an *arsa* (orchard garden) on the left and a *bustan* (perfumed garden) on the right. Under the trees are seasonal flower beds.

Olivenbäume säumen den Weg, der links eine *arsa*, (Obstgarten) und rechts einen *bustan* (Duftgarten) trennt. Unter den Bäumen: Blumenbeete mit saisonaler Wechselbepflanzung.

Les oliviers bordent l'allée qui sépare une *arsa* (verger, à gauche) d'un *boustan* (jardin de parfum, à droite). Sous les arbres s'étalent des massifs de fleurs saisonnières.

129

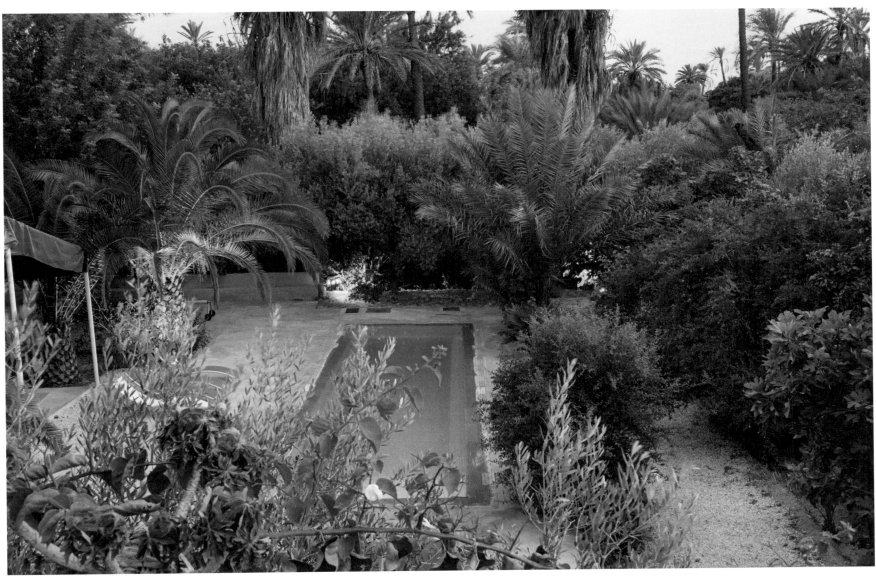

Jnane Tamsna Gardens

Gary Martin

My Dream: A Botanical Garden
Mein Traum: ein botanischer Garten
Mon rêve : un jardin botanique

Gary Martin is an ethnobotanist and founder of the Global Diversity Foundation. He advocates for the sustainable use of plant resources and has been working on the botanical garden at his hotel in Marrakesh since 2001.

Gary Martin ist Ethnobotaniker und Gründer der Global Diversity Foundation. Er setzt sich für die nachhaltige Nutzung pflanzlicher Ressourcen ein und arbeitet seit 2001 am Botanischen Garten seines Hotels in Marrakesch.

Gary Martin est ethnobotaniste et créateur de la Global Diversity Foundation. Il s'engage en faveur de l'exploitation durable des ressources végétales et travaille depuis 2001 au jardin botanique de son hôtel de Marrakech.

What drove you to transform an overused palm grove into a paradise garden?

Initially, it was the responsibility to respect this valuable cultural and ecological heritage. The old canals and reservoirs inspired me to conserve the vestiges of the traditional use of the land and to develop it into a *jnane*, a paradise garden. The people here used to practice subsistence agriculture. They cultivated grain, fruit, and vegetables for themselves and for those who lived in the Medina, the walled old city of Marrakesh. Among the centuries-old date palms, I planted citrus trees and vegetables in order to once again create an *arsa*, a traditional orchard garden.

Was trieb Sie an, einen übernutzten Palmenhain in einen Paradiesgarten umzuwandeln?

Ursprünglich war es die Verantwortung, dieses wertvolle kulturelle und ökologische Erbe zu respektieren. Die alten Kanäle und Reservoirs inspirierten mich, die Überreste der traditionellen Landnutzung zu erhalten und zu einem *jnane*, einem Paradiesgarten, auszubauen. Die Menschen hier praktizierten früher Subsistenzwirtschaft. Sie kultivierten Getreide, Obst und Gemüse für sich selbst und für diejenigen, die in der Medina, der ummauerten Altstadt von Marrakesch, lebten. Zwischen die jahrhundertealten Dattelpalmen pflanzte ich Zitrusbäume und Gemüse, um wieder einen *arsa*, einen traditionellen Obstgarten, zu schaffen.

Qu'est-ce qui vous a poussé à transformer en jardin paradisiaque une palmeraie surexploitée ?

Au début, je me suis senti responsable de la préservation de ce précieux patrimoine culturel et écologique. Les anciens canaux et réservoirs m'ont inspiré et donné l'idée de conserver les vestiges de l'agriculture traditionnelle et d'aménager un *jnane*, un jardin paradisiaque. Autrefois ici, les gens pratiquaient une agriculture vivrière. Ils faisaient pousser des céréales, des fruits et des légumes pour eux-mêmes et ceux qui vivaient dans la médina, la vieille ville ceinte de murs. Entre les palmiers dattiers centenaires, j'ai planté des citronniers et des légumes pour recréer un *arsa*, un verger traditionnel.

Are heat and water shortages considered the greatest stress factors for the plants?

The plants I choose are adapted to summer heat and low water availability, but they must also with-

With this garden, I would like to conserve Moorish agricultural and horticultural heritage.

stand the freezing temperatures of winter. Other stress factors include water hardness and high salt concentration in soil and water. High alkalinity limits the availability of soil minerals like iron or zinc, making the leaves of vulnerable plants turn yellow. Marrakesh gardeners learn which species thrive in these extreme conditions, creating a collective horticultural memory. Interior courtyards *(riads)* are one solution, as they provide protection from cold, drought and wind, allowing some exotic plants like gardenias, plumerias, and pritchardia palms to thrive when they would not survive outside.

Do you prefer to be a gardener or a scientist?

Practical gardening and applied research are both exciting ways to fulfill my private and professional goals. These parts of my life are intertwined. In 2001, when we created Jnane Tamsna and its gardens, I also founded the Global Diversity Foundation, a non-profit organization that seeks to protect biological and cultural diversity in order to improve livelihoods and well-being. The two work in lockstep.

Bilden Hitze und Wasserknappheit die größten Stressfaktoren für die Pflanzen?

Die Pflanzen, die ich auswähle, sind an die Hitze im Sommer und die geringe Wasserverfügbarkeit angepasst, müssen aber auch den eisigen Temperaturen im Winter trotzen. Weitere Stressfaktoren sind die Wasserhärte und die hohe Salzkonzentration in Boden und Wasser. Die hohe Alkalität schränkt die Verfügbarkeit von Bodenmineralien wie Eisen oder Zink ein, wodurch die Blätter empfindlicher Pflanzen gelb werden. Die Gärtner in Marrakesch lernen, welche Arten unter diesen extremen Bedingungen gedeihen und schaffen so ein kollektives gärtnerisches Gedächtnis. Innenhöfe *(riads)* sind eine Lösung: Sie bieten Schutz

Mit diesem Projekt möchte ich das landwirtschaftliche und gärtnerische Erbe der Mauren bewahren.

vor Kälte, Trockenheit und Wind und lassen Exoten wie Gardenien, Plumerien oder Pritchardia-Palmen gedeihen, wenn sie draußen nicht überleben würden.

Sind Sie lieber Gärtner oder Wissenschaftler?

Praktische Gartenarbeit und angewandte Forschung sind spannende Wege, um meine privaten und beruflichen Ziele zu erreichen. Diese Teile meines Lebens sind miteinander verflochten. Als wir Jnane Tamsna und seine Gärten 2001 ins Leben riefen, gründete ich auch die Global Diversity Foundation, eine gemeinnützige Organisation für den Schutz der biologischen und kulturellen Vielfalt, um die Lebensgrundlagen und das Wohlbefinden zu verbessern. Diese beiden Disziplinen sind eng miteinander verzahnt.

La chaleur et le manque d'eau sont-ils les plus grands facteurs de stress pour les plantes ?

Les plantes que j'ai sélectionnées sont habituées à la chaleur estivale et à la disponibilité limitée de l'eau, mais en hiver, elles doivent aussi résister à des températures glaciales. Les autres facteurs de stress sont la dureté de l'eau et la forte concentration en sel du sol et

Par ce projet, je souhaite préserver le patrimoine agricole et botanique des Maures.

de l'eau. L'alcalinité élevée limite la disponibilité des minéraux du sol, comme le fer et le zinc, de sorte que les feuilles des plantes fragiles jaunissent. Les jardiniers de Marrakech apprennent les variétés qui se développent dans ces conditions extrêmes et créent ainsi une mémoire botanique collective. Les cours intérieures *(riads)* sont une solution : elles abritent du froid, de la sécheresse et du vent et font s'épanouir des variétés exotiques comme les gardénias, les frangipaniers ou les palmiers Pritchardia qui ne survivraient pas à l'extérieur.

Préférez-vous être jardinier ou scientifique ?

Le travail de jardinage et la recherche appliquée sont des moyens passionnants d'atteindre mes objectifs privés et professionnels. Ces parties de ma vie sont étroitement imbriquées. Lorsque nous avons donné naissance à Jnane Tamsna et à ses jardins en 2001, j'ai créé aussi la Global Diversity Foundation, une organisation à but non lucratif qui se consacre à la protection de la diversité biologique et culturelle afin d'améliorer les conditions de vie et le bien-être. Ces deux disciplines sont étroitement liées.

Tradewinds

Drongen | Belgium

Tradewinds produces and distributes authentic products for outdoors and gardens, from stools to outdoor showers. The designs mostly use well-known and well-used items that are thought over and re-designed, easy to use, pleasing to the eyes and durable. Since 1995, proven craftsmanship and modern technique have come together. This results in high-quality objects for discerning users, hand-crafted and continually improved.

Tradewinds produziert und vertreibt authentische Produkte für den Außenbereich und den Garten – vom Hocker bis zur Outdoor-Dusche. Bei den Entwürfen handelt sich überwiegend um altbekannte und viel benutzte Dinge, die jedoch überdacht und neu gestaltet werden – benutzerfreundlich, gefällig fürs Auge und langlebig. Seit 1995 kommen so bewährte Handwerkskunst und moderne Fertigungstechniken zusammen. Das Resultat sind hochwertige Objekte für anspruchsvolle Nutzer, handgemacht und stetig verbessert.

Tradewinds fabrique et commercialise des produits authentiques pour la vie en plein air et au jardin, du tabouret à la douche d'extérieur. Les objets proposés à la vente sont le plus souvent biens connus et d'usage très courant, mais ils ont été revus et redessinés, ils sont faciles à utiliser, plaisants pour le regard et durables. Depuis 1995, l'entreprise associe ainsi un travail d'artisan d'art à des techniques modernes de fabrication. Résultat : des objets de valeur, pour des utilisateurs exigeants, faits à la main et toujours améliorés.

Claro! is a cordless storm lamp with a polycarbonate glare-fee shade to allow night-time reading. The battery powered waterproof lantern offers 20 hours of light.

Claro! ist eine kabellose Sturmlampe mit einem Schirm aus gefrostetem Acryl. Die batteriebetriebene Laterne bietet 20 Stunden lang Licht und erlaubt auch bei Nacht blendfreies Lesen.

Claro ! est une lampe-tempête sans fil dotée d'un abat-jour en acrylique givré. Alimentée par une pile, la lanterne a une autonomie de 20 heures et permet de lire la nuit sans être ébloui.

The art of living outside: This is the motto of Jean-Pierre Galeyn and his fellow craftsmen.
Die Kunst, draußen zu leben: So lautet das Motto von Jean-Pierre Galeyn und seinen Mitarbeitern.
L'art de vivre en plein air : telle est la devise de Jean-Pierre Galeyn et de ses collaborateurs.

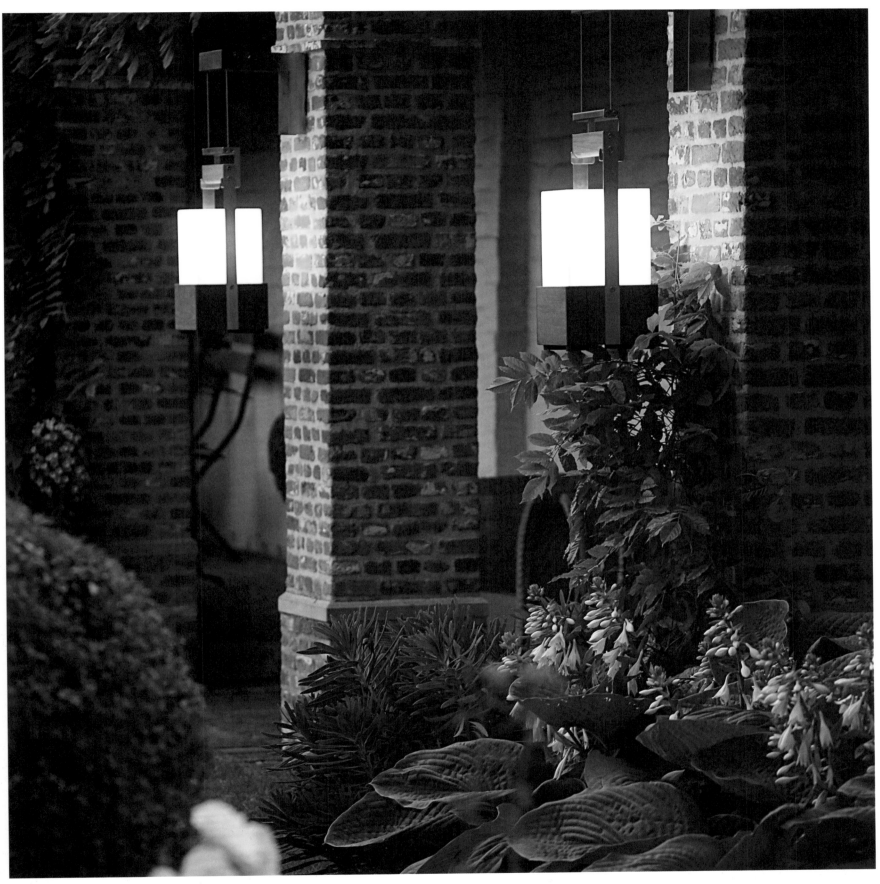

Made of materials resistant to sun and water, the Moon Soon storm lamp contents a 12 V battery that offers twenty hours of light.

Aus wasser- und sonnenbeständigen Materialien gefertigt und mit einer aufladbaren 12 V-Batterie ausgestattet, spendet die Sturmlampe Moon Soon zwanzig Stunden Licht.

Fabriquée dans des matières résistant à l'eau et au soleil et dotée d'une pile rechargeable de 12 V, la lampe-tempête Moon Soon diffuse sa lumière pendant vingt heures.

134

135

Shelt^r is a minimalist tent that can be assembled on any surface: The frame is made from galvanized steel, a stable wooden floor is laid down and a weatherproof tarp cover is spread over. As a shelter in your back yard or in parks, used by hotels or restaurants, it is the perfect place to take refuge from the weather and requires no building permit.

Shelt^r ist ein minimalistisches Zelt, das auf jedem Untergrund montiert werden kann: Eine verzinkte Stahlkonstruktion dient als Gerüst, auf das ein stabiler Holzboden aufgelegt sowie eine witterungsbeständige Plane gespannt wird. Als Unterstand in Gärten oder Parks, für Hotels oder Restaurants verwendet, dient es als perfekter Wetterschutz, der keine Baugenehmigung benötigt.

Shelt^r est un abri minimaliste en toile qui se monte sur n'importe quelle surface : l'armature est constituée d'une structure en acier galvanisé qui reçoit un solide plancher en bois tandis qu'une bâche résistant aux intempéries est tendue sur l'ensemble. Utilisée comme abri dans des jardins ou des parcs, dans des hôtels ou restaurants, elle offre une protection parfaite contre le mauvais temps et ne nécessite pas de permis de construire.

Monica Viarengo

San Francisco, California | USA

Monica Viarengo sculpts gardens and landscapes that take you into a world of enchantment. | Monica Viarengo formt Gärten und Landschaften, die in eine andere, zauberhafte Welt entführen. | Monica Viarengo modèle des jardins et des paysages qui transportent le visiteur dans un monde différent et enchanté.

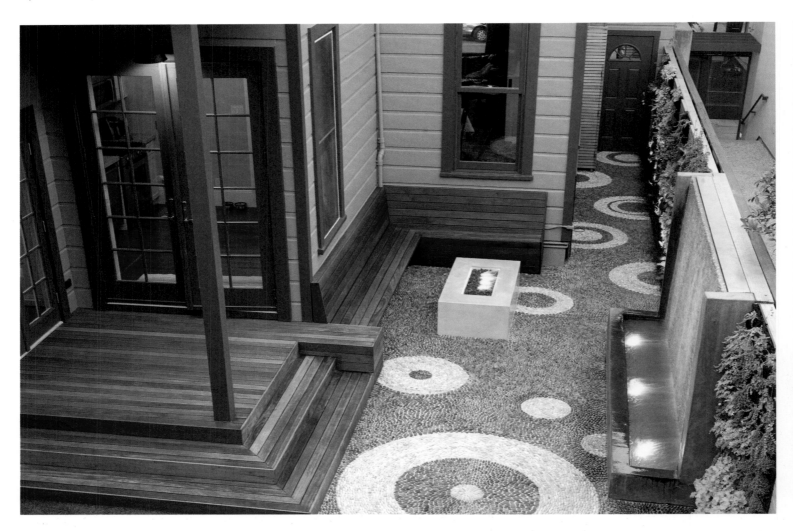

136

Viarengo and her design team at MVLD designed the wall fountain cast in place concrete and the mosaic pavement. The Genoese artist Luciano Bonzini laid the pebble pavement using the traditional risseu tecnique of his homeland.

Monica Viarengo und ihr Design-Team von MVLD entwarfen den Wandbrunnen und den Mosaikboden. Der Genueser Künstler Luciano Bonzini verlegte das Kieselpflaster in der traditionellen Risseu-Technik seiner Heimat.

Monica Viarengo et l'équipe de designers de son entreprise MVLD ont conçu la fontaine murale et le sol en mosaïque. L'artiste génois Luciano Bonzini a posé les dalles gravillonnées selon la technique du « risseu », traditionnelle de son pays natal.

She combines poetry with ecology. For Viarengo, designing gardens and landscapes means listening closely to nature, location, and client. And in this way, to find out what is important—including for herself. She gets her inspiration not least from her personal background. Born in Genoa, Italy, she lives and works in the United States and in Europe. Her worlds find a point of connection in this private garden in San Francisco. The pebble pavement mosaic typical of her hometown brings some Mediterranean flair into the little inner-city oasis.

Sie kombiniert Poesie mit Ökologie. Für Monica Viarengo bedeutet, Gärten und Landschaften zu gestalten, genau zuzuhören: der Natur, dem Ort, dem Kunden. Und so herauszufinden, was wichtig ist – auch für sie selbst. Ihre Inspiration zieht sie nicht zuletzt aus ihrem persönlichen Hintergrund: In Genua geboren, lebt und arbeitet sie in den USA und in Europa. Auch in dem Privatgarten in San Francisco verbindet sie ihre Welten. Das für ihre Heimatstadt typische Mosaikpflaster aus Kieseln bringt mediterranen Flair in die kleine Innenstadtoase.

Associant poésie et écologie, Monica Viarengo estime qu'aménager des jardins et des paysages, c'est d'abord savoir écouter : la nature, le lieu, le client ; et ainsi en extraire ce qui est important, y compris pour elle-même. Son inspiration, elle la puise en particulier dans son histoire personnelle : née à Gênes, elle vit et travaille aux États-Unis et en Europe, et réunit ses univers dans son jardin privé de San Francisco. Dans cette petite oasis de ville, le dallage en mosaïque typique de sa ville natale évoque l'ambiance méditerranéenne.

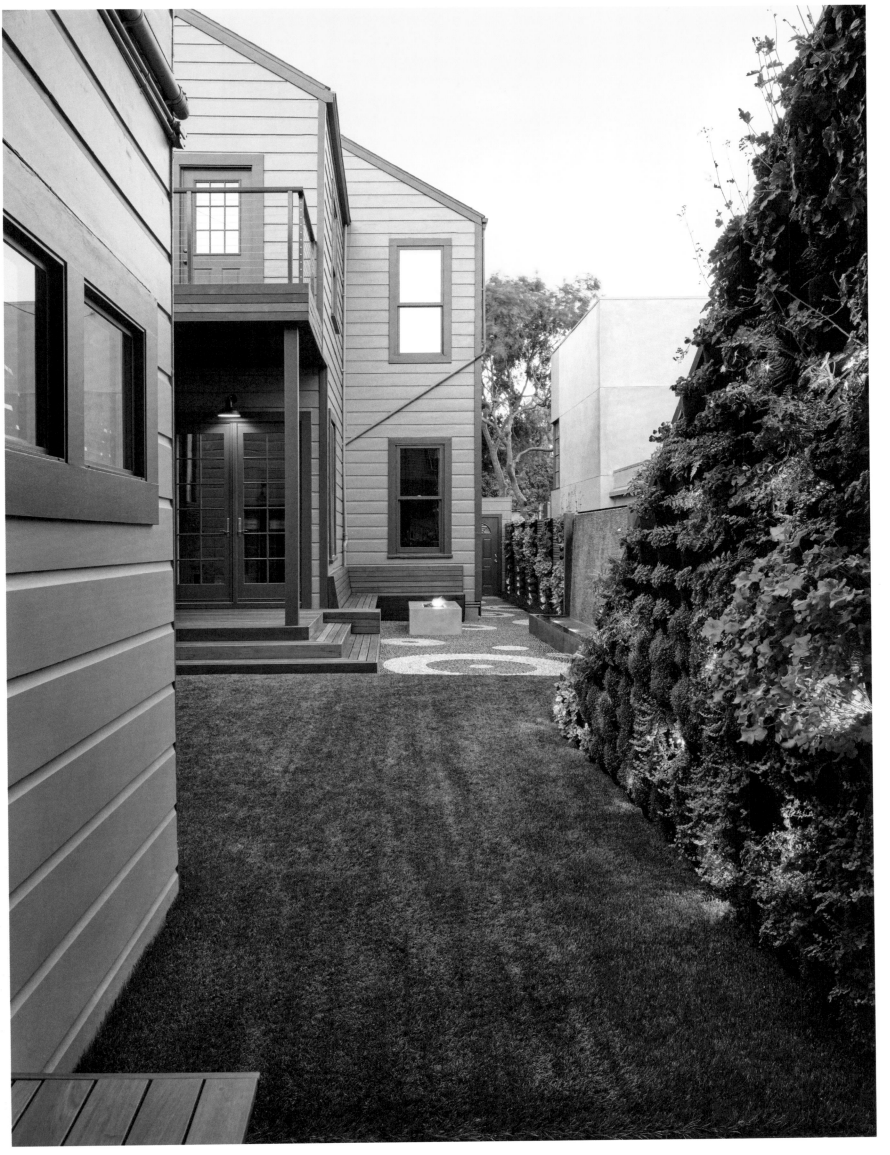

Monica Viarengo

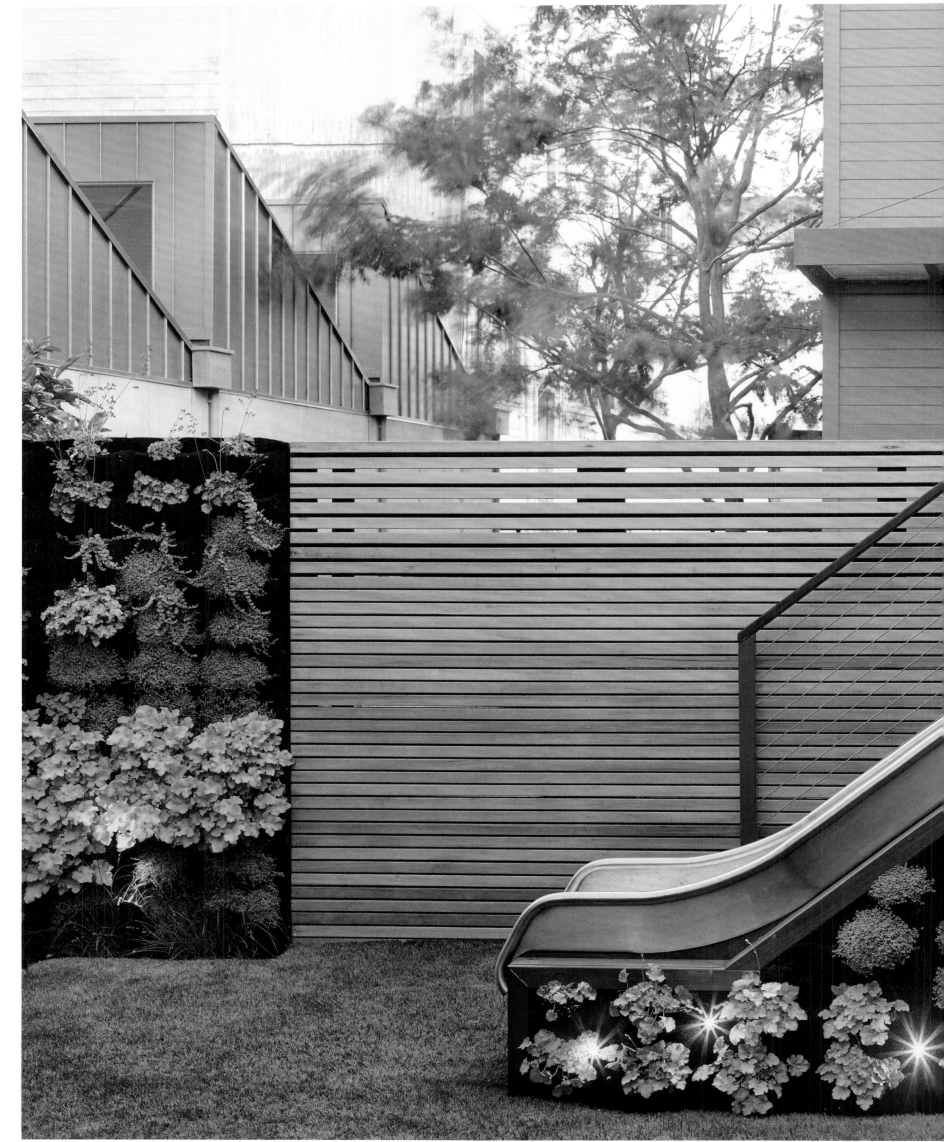

138

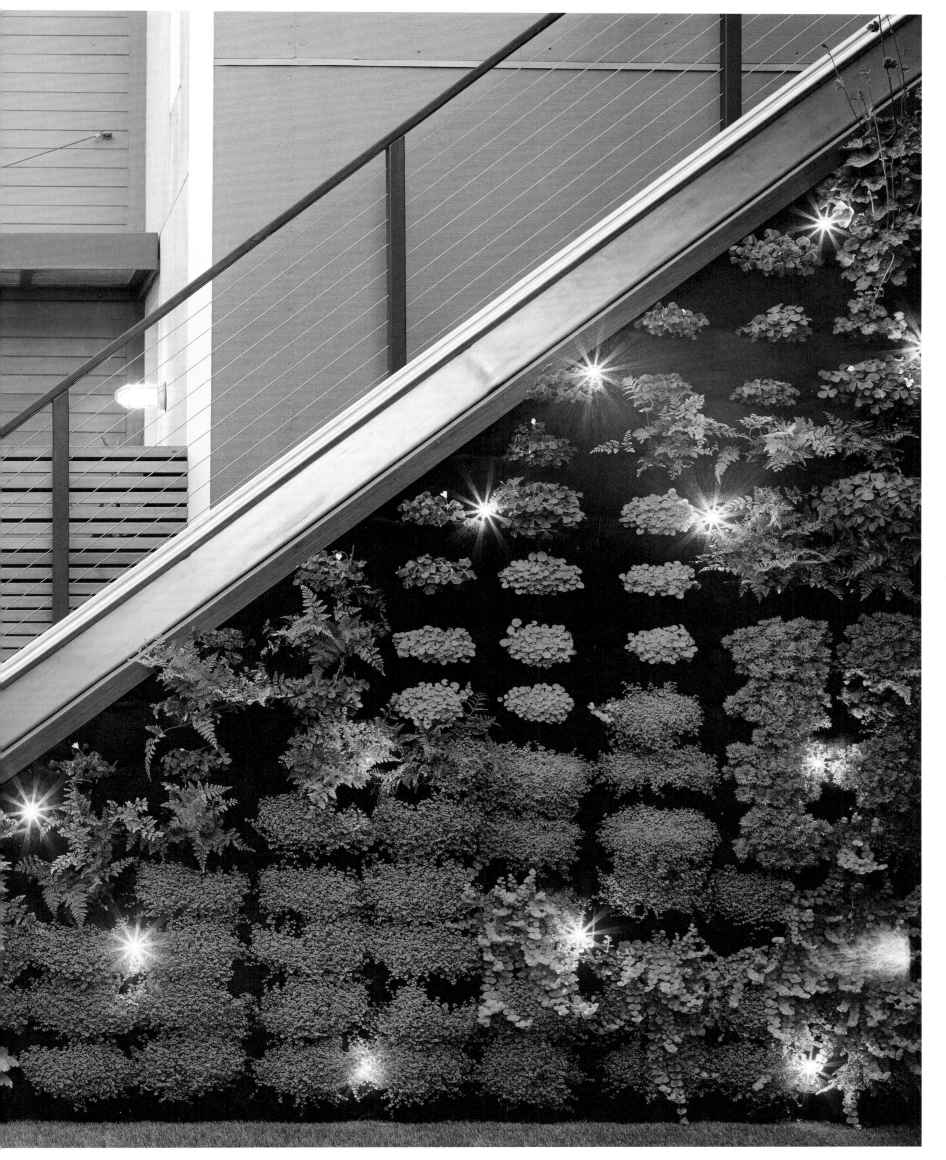

Monica Viarengo

The Mission District of San Francisco is known for its murals. The MVLD team headed by Viarengo asked the artist Erik Otto to paint a mural that will bring the vibrancy of the neighborhood into the garden as well as mimic the movement of water and light waves. Due to the size of the garden respectively the courtyard Viarengo used and emphasized the walls in the garden—using textures made from wood, stone, and plants. There is also a coloring wall for children.

Das Stadtviertel Mission in San Francisco ist bekannt für seine Wandmalerei. Das MVLD-Team um Viarengo bat den Künstler Erik Otto eine Wand so zu gestalten, dass sie sowohl die Lebendigkeit des Viertels in den Garten holt als auch die Bewegungen von Wasser und Lichtwellen imitiert. Aufgrund der begrenzten Größe des Gartens bzw. des Innenhofs nutzte und betonte Viargengo dessen Wände – durch Texturen aus Holz, Stein und Pflanzen. Für die Kinder gibt es darüber hinaus eine Malwand.

Le quartier de Mission est connu pour ses peintures murales. L'équipe de MLVD et Monica Viarengo a donc demandé à l'artiste Erik Otto de créer un mur qui évoque à la fois la vitalité du quartier et les mouvements de l'eau et des ondes lumineuses. Compte tenu de la surface limitée du jardin et de la cour intérieure, Monica Viarengo en a utilisé et mis en valeur les murs au moyen de textures en bois, pierre et végétaux. Les enfants n'ont pas été oubliés puisqu'un mur de peinture a été aménagé.

Monica Viarengo

Urban Gardening
From the Estates of Charlemagne to Urban Agriculture

When humans first settled in Mesopotamia 13,000 years ago, they invented the garden. They grew crops and fenced in their fields for protection from wild animals. The kitchen garden is the ur-form of garden—a parcel of cultivated land. The garden has been a companion to humanity throughout the ages. Plant cultivation and animal husbandry had long been part of everyday life in cities as well. Options for food preservation and transportation were so poor that food products had to be produced where they were intended to be eaten. Separation between the production of food and the realities of life for city dwellers did not emerge until industrialization and the steady growth of cities. Today, the urban and the agricultural seem to have little in common.

But now that is changing. Shared gardens, city farms, community gardens, *jardins partagés*, intercultural gardens, neighborhood gardens, gardens for residents, herb and vegetable gardens—these are just a few of the terms illustrating the new kitchen garden trend, which extends well beyond traditional small urban garden plots. These gardens have their roots in industrialization. Gardens for the poor and for factory workers were founded at that time in the growing cities with the intention of providing supplemental sustenance.

The origin of gardening in Europe actually extends even further into the past, back into the Middle Ages to the gardens of manors and monasteries. In the eighth century, Charlemagne established administrative structures based on those same monasteries and manors. Monasteries, in particular, developed into social and spiritual centers—places which also saw the cultivation of horticulture. A capitulary dating from 812 contained corresponding instructions for the royal estates to provide food for subjects. This document covered a range of topics, including recommendations for tending fruit and vegetable gardens. It describes the cultivation of fruit trees, vineyards, ,and vegetables in detail. The final chapter lists plants and herbs that were intended to improve basic medical care for the population within the Frankish Empire. The herb gardens in monasteries tended to by nuns and monks for their own use, provided the template for this botanical collection. They grew tormentil, chamomile, lemon balm, clary, caraway, hepatica, dandelion, peppermint, yarrow, horseradish, poppy, and juniper. We can, therefore, thank this capitulary on agriculture for a number of plants that remain part of traditional cottage gardens to this day.

FROM THE RURAL BACK TO THE URBAN

Even if the age of Charlemagne seems like a world away, urban agriculture never really disappeared. Today, farms are part of the scenery in suburbs and on the outskirts of cities. But despite this close proximity, agriculture is only loosely associated with the city. City dwellers largely ignore agriculture and the expanses of agricultural land are viewed as a sort of reserve for future urban development or the roads through the fields are simply used as cycling and walking paths on weekends. The agriculture on the outskirts of a city does not produce for the city itself but rather for the world market. Food preservation and transportation no longer set the limits. Today, food comes from all over.

But that trend is gradually heading back towards the regional. As an approach geared towards efficiency, industrial agriculture is being viewed with an ever more critical eye. It is harried for the use of monocultures and pesticides, along with all the resulting adverse effects on insects and beyond. In recent years, cultivation of fruits and vegetables for personal consumption in cities is thriving once again for this reason and more. Herb and vegetable gardens—pieces of land that amateur horticulturists could lease—led the way. Now community gardens are popping up in empty lots as residents seek to grow their own. Berlin, for instance, has the Allmend-Kontor urban community garden at the disused Tempelhof airport or the Prinzessinnengärten area in the inner-city area of Kreuzberg. The Gartendeck urban gardening project in the St. Pauli district of Hamburg is thriving. London is growing Food from the Sky on the roof of a supermarket. Community gardens are also booming in other major cities across Europe. They are often envisioned as temporary projects, giving them the charm of spontaneity and a makeshift feel. The Prinzessinnengärten, for example, came about in 2009 on a vacant lot adjoining the Moritzplatz public space. Residents took the initiative, cleared up the site and founded an association that leases the space from the city year after year. Everything has a portable design as a result. The café is located in a container and the plants grow out of baker's crates, carton packaging, and bags of rice. Now the garden is a permanent fixture in the neighborhood. A garden does not really mesh that well with the idea of being temporary.

All of these initiatives have emerged in the last decade. But in major cities in the United States, like Los Angeles and New York City, these types of gardens have been around since the 1970s. Residents took up the cause, hoping to clear up blight and deterioration in their surroundings. They took over vacant lots, picked up the trash, and planted herbs and vegetables—all while creating meeting points in the neighborhood and a social network built on greenery. Now New York City has more than 500 community gardens, with an increasing number taking shape on the rooftops of the city. And some of them are also commercial enterprises. The Brooklyn Grange at the former Brooklyn Navy Yard is one of those rooftop farms. It sells its harvests through supermarkets and farmers' markets in the neighborhood. It covers 1.5 acres (6,000 square meters) of cultivated area, making it one of the largest gardens of its kind. In addition, Brooklyn Grange also supports refugees and immigrants through a training program. New York City itself operates a similar initiative called Grow New York City (GrowNYC), which is a sort of service organization attached to the Office of the Mayor. GrowNYC promotes education about the environment and nutrition by supporting school gardens and even offering a one-year retraining program for urban farmers. Volunteers, primarily consisting of disadvantaged youths, work during the

seven summer months in a variety of community gardens or city farms while receiving education in the theory behind their work. Afterwards, opportunities such as working in market gardens or managing a produce market are available.

There are similar initiatives in the growing major cities around the world, some of which have also been around for quite a while, as South Africa demonstrates. In Cape Town, urban agriculture is a tradition. The social aspects are just as important as the produce here as well. Abalimi Bezekhaya came about in the townships of Cape Town during apartheid in the 1980s. The organization continues to support community gardens on vacant lots in the city to this day. These gardens serve as a means of cultivation for personal consumption and are intended to provide prospects for the unemployed.

MORE THAN A TREND:
GARDENING AS A MEANS OF ACTIVELY
SHAPING URBAN LIVING SPACE

A number of university research projects are now studying urban agriculture. After all, the increasing population in metropolitan areas inevitably leads to the demand for sustainable, social and environmentally friendly development in these urban centers. Community-organized agriculture—ground-up agriculture—has a special role in this context. Not least because it has the potential to provide an environmentally sound means of supporting the population. TU Berlin's research into urban agriculture in Casablanca is just one example. In this project, German and Moroccan partners from research, specialized institutions and non-governmental organizations are working together to make the rapidly growing Moroccan city livable into the future. The opportunity: The city's rapid expansion into surrounding agricultural land is leaving islands of farmsteads and fields open amid the urban sprawl. This is leading to urban/rural initiatives that are providing the city with new perspectives.

The examples show that, especially in emerging economies, supporting the population as well as social and economic aspects take the focus in large metropolitan areas. Different goals take the focus in Europe with all its wealth. The rediscovery of harvesting for yourself persists as the deliberately designed antithesis to globalization. The relatively small urban garden, occasionally consisting of little more than a single leased furrow, provides people with their own clod of earth for growing the fruits and vegetables for their kitchens. This gives people refuge from the complexity of global production and transportation paths and gives them more independence from industrial food production.

What is more, it facilitates community and participation. City gardeners do not just want to care for a plot in a garden, they want to be active. They want to be a part of shaping neighborhoods and their city as a whole—even if it's not always done through official channels, as the guerrilla gardening phenomenon demonstrates. Flowers are sprouting up in cities at every possible and impossible location wherever guerrilla gardeners strike, whether the grating around a tree or the edge of a footpath—a peaceful yet clear sign of civil disobedience.

City residents are captivated by the idea of organizing gardens for themselves. These efforts let them take back their city by growing tomatoes, potatoes and herbs on vacant lots, brownfield sites and even on rooftops. Always as part of a small community, almost like a village within the city. Urban gardens bring the human scale back to the metropolis. And in their creation, they clearly point to the original idea of the garden as paradise. Gardens consistently reflect the collective desires of a society.

City residents are captivated by the idea of organizing gardens for themselves—from the ground up. These efforts let them take back their city, with the social benefits being just as important as the produce they harvest.

Gärtnern in der Stadt
Von den Landgütern Karls des Großen
bis zur urbanen Landwirtschaft

Als die Menschen vor etwa 13 000 Jahren in Mesopotamien sesshaft wurden, erfanden sie den Garten: Sie betrieben Feldbau und zäunten ihre Äcker zum Schutz vor wilden Tieren ein. Der Nutzgarten ist die ursprünglichste Form des Gartens, ein Stück Kulturland. Er begleitete den Menschen über Jahrtausende. Auch in den Städten gehörten der Anbau von Lebensmitteln und die Tierhaltung lange zum alltäglichen Bild. Die Transport- und Konservierungsmöglichkeiten waren so schlecht, dass die Nahrungsmittel dort erzeugt werden mussten, wo sie gegessen werden sollten. Erst mit der Industrialisierung und mit dem stetigen Wachstum der Städte entkoppelte sich die Produktion von Esswaren von der Lebensrealität der Stadtbevölkerung. Stadt und Landwirtschaft schienen nur noch wenig miteinander zu tun zu haben.

Doch das ändert sich derzeit: Gemeinschaftsgärten, *Community Gardens, Jardins Partagés, City Farms,* interkulturelle Gärten, Nachbarschaftsgärten, Bewohnergärten, Krautgärten – das sind nur einige Schlagworte, die den neuen Nutzgarten-Trend zeigen, der weit über die traditionellen Kleingärten in den Städten hinausgeht. Diese Anlagen haben ihre Wurzeln in der Industrialisierung: In den wachsenden Städten wurden damals Armengärten und Gärten für Fabrikarbeiter gegründet, die zu deren Lebensunterhalt beitragen sollten.

Der Ursprung des Gartenbaus in Europa reicht freilich noch weiter zurück: bis ins Mittelalter, zu den Gärten der Landgüter und Klöster. Karl der Große errichtete im 8. Jahrhundert Verwaltungsstrukturen, die auf eben diesen Klöstern und Landgütern basierten. Vor allem die Klöster entwickelten sich zu sozialen und geistigen Zentren, in denen auch die Gartenkultur gepflegt wurde. Für die königlichen Landgüter enthält eine Verordnung aus dem Jahr 812 entsprechende Anweisungen für die Versorgung der Untertanen mit Lebensmitteln. Diese sogenannte Landgüterverordnung gibt unter anderem auch Empfehlungen für die Bewirtschaftung von Obst- und Gemüsegärten: Bis ins Detail ist der Anbau von Obstbäumen, Weinreben und

Gemüse beschrieben. Im letzten Kapitel sind Pflanzen und Heilkräuter aufgelistet, die die medizinische Grundversorgung der Bevölkerung innerhalb des Frankenreichs verbessern sollten. Vorbild für diese Pflanzensammlung waren die Kräutergärten der Klöster, die Nonnen und Mönche für den Eigenbedarf angelegt hatten: Sie bauten Blutwurz, Echte Kamille, Melisse und Salbei an, Kümmel, Leberblümchen, Löwenzahn, Pfefferminze und Schafgarbe, Meerrettich, Schlafmohn und Wacholder. Dieser Landgüterverordnung verdanken wir also zahlreiche Pflanzen, die bis heute wichtiger Teil der klassischen Bauerngärten sind.

VOM LAND ZURÜCK IN DIE STADT

Auch wenn die Zeit Karls des Großen weit weg scheint: Ganz verschwunden war die Landwirtschaft aus den Städten tatsächlich nie. Äcker gehören auch heute zum Landschaftsbild der städtischen Außenbezirke und Stadtränder. Doch trotz der räumlichen Nähe ist die Landwirtschaft nur lose mit der Stadt verknüpft: Sie wird von den Städtern weitgehend ignoriert, ihre Flächen werden als Flächenvorrat für städtische Entwicklung wahrgenommen, oder die Feldwege an den Wochenenden als Rad- oder Spazierwege genutzt. Die Landwirtschaft am Stadtrand selbst produziert nicht für die eigene Stadt, sondern für den Weltmarkt. Transport und Konservierung sind keine Einschränkung mehr. Heute kommen die Lebensmittel von überallher.

Doch der Trend bewegt sich Schritt für Schritt wieder hin zum Regionalen. Die auf Effizienz ausgerichtete industrielle Landwirtschaft wird zunehmend kritisch betrachtet. Monokulturen und Pestizideinsatz mit all den Nebenwirkungen zum Beispiel auf Insekten machen sie angreifbar. Seit einigen Jahren hat nicht zuletzt deshalb der Anbau von Obst und Gemüse für den Eigenbedarf in der Stadt wieder Konjunktur. Die Krautgärten, ein Stück Acker, das Hobby-Gartenbauer pachten konnten, machten den Anfang. Inzwischen entstehen in Eigeninitiative auch auf Brachen gemeinschaftlich betriebene Stadtgärten. In Berlin zum Beispiel der

Allmend-Kontor auf dem stillgelegten Flughafen auf dem Tempelhofer Feld oder die Prinzessinnengärten im innerstädtischen Kreuzberg. In Hamburg gedeiht das Garten-Deck in St. Pauli, in London wächst Food from the Sky auf dem Dach eines Supermarkts. Und auch in anderen europäischen Metropolen boomen die Mitmach-Gärten. Sie sind oft nur temporär gedacht und besitzen daher den Charme des Spontanen, des Provisorischen. Die Prinzessinnengärten zum Beispiel entstanden 2009 auf einer Brache am Moritzplatz. Anwohner ergriffen damals die Initiative, räumten auf und gründeten einen Verein, der die Fläche jedes Jahr erneut von der Stadt anmietet. Dementsprechend ist alles mobil gestaltet: Das Café befindet sich in einem Container, die Pflanzen wachsen in Bäckerkisten, Tetra Paks und Reissäcken. Inzwischen ist die Anlage fester Bestandteil des Quartiers. So richtig passt temporär und Garten dann doch nicht zusammen.

Alle diese Initiativen etablierten sich in den vergangenen zehn Jahren. Doch zum Beispiel in US-amerikanischen Großstädten wie Los Angeles oder New York existieren solche Gärten schon seit den 1970er-Jahren. Dort packten die Bewohner das Thema an, weil sie nicht länger mit ansehen wollten, wie ihre Umgebung verkam. Sie eroberten sich Restflächen, entsorgten Müll, pflanzten Kräuter und Gemüse an und schufen zugleich Treffpunkte in der Nachbarschaft und damit ein soziales Netz aus Grün. Inzwischen gibt es in New York über 500 *Community Gardens,* die sich zunehmend auch die Dächer der Stadt zu eigen machen. Und die teilweise auch kommerziell tätig sind: Die Brooklyn Grange auf der ehemaligen Brooklyn Navy Yard ist ein solche Dachfarm, die ihre Ernte über Supermärkte und Wochenmärkte in der Nachbarschaft vertreibt. Mit 6 000 Quadratmetern biologischem Anbau gehört sie zu den größten solcher Gärten. Außerdem unterstützt Brooklyn Grange auch Flüchtlinge und Einwanderer mit einem Traineeprogramm. Die Stadt New York selbst betreibt eine ähnliche Initiative: Grow New York City (GrowNYC) ist eine Art Behörde, die direkt beim

144

Bürgermeister angesiedelt ist. GrowNYC setzt sich unter anderem für Umwelt- und Ernährungsbildung ein, indem es Schulgärten unterstützt, und bietet sogar ein einjähriges Umschulungsprogramm zum Stadtbauern an. Die vor allem jungen Leute aus schwierigen sozialen Verhältnissen arbeiten während der sieben Sommermonate als Freiwillige in verschieden Community-Gärten oder City-Farmen mit und erhalten zugleich theoretischen Unterricht. Anschließend können sie zum Beispiel in Gärtnereien tätig werden oder einen Gemüsemarkt leiten.

In den wachsenden Metropolen gibt es weltweit ähnliche Initiativen, teilweise auch schon sehr lange, wie ein Blick nach Südafrika zeigt: In Kapstadt hat urbane Landwirtschaft schon Tradition, und auch hier stehen die sozialen Aspekte gleichwertig neben der Versorgungsleistung. Abalimi Bezekhaya entstand in den 1980ern während der Apartheid in den Townships von Kapstadt. Die Organisation unterstützt bis heute Gemeinschaftsgärten auf städtischen Restflächen, die nicht nur zur Selbstversorgung dienen, sondern auch Arbeitslosen eine Perspektive bieten sollen.

MEHR ALS EIN TREND:
GÄRTNERN ALS AKTIVE MITGESTALTUNG
DES STÄDTISCHEN LEBENSRAUMS

Zahlreiche Forschungsprojekte an Universitäten beschäftigen sich inzwischen mit der urbanen Landwirtschaft. Denn die wachsende Bevölkerungsdichte in den Ballungszentren führt unweigerlich zur Frage, wie sich diese Metropolen nachhaltig, sozial und umweltgerecht entwickeln können. Der gemeinschaftlich organisierten Landwirtschaft, einer Landwirtschaft von unten, wird in diesem Kontext eine besondere Rolle zugeschrieben. Nicht zuletzt, da sie das Potenzial hat, die Bevölkerung auf umweltverträgliche Weise zu versorgen. Nur ein Beispiel ist die Forschung zur urbanen Landwirtschaft der TU Berlin in Casablanca. In diesem Projekt arbeiten deutsche und marokkanische Partner aus Forschung, Fachbehörden sowie zivilgesellschaftlichen Organisationen zusammen,

um die rasant wachsende marokkanische Stadt auch künftig lebenswert zu machen. Die Chance: Da sich die Stadt schnell ins bäuerliche Umland frisst, eröffnen sich inmitten der städtischen Bebauung Inseln mit Gehöften und Feldern. So entstehenden nachbarschaftliche Stadt-Land-Initiativen, die der Stadt neue Perspektiven eröffnen.

Die Beispiele zeigen: In den großen Metropolen, insbesondere der Schwellenländer, stehen vor allem die Versorgung der Bevölkerung sowie soziale und wirtschaftliche Aspekte im Vordergrund. Im reichen Europa rücken noch andere Wünsche in den Fokus: Die Wiederentdeckung des Selber-Erntens ist immer auch ein bewusst gestalteter Gegenpol zur Globalisierung. Der noch so kleine Stadtgarten, manchmal auch nur die gepachtete Ackerfurche, ist die eigene Scholle, auf der Obst und Gemüse für die eigene Küche angebaut werden. So entzieht man sich der Unübersichtlichkeit globaler Produktions- und Transportwege, macht sich unabhängiger von der industriellen Nahrungsmittelproduktion.

Und es geht um Gemeinschaft und Teilhabe. Die Stadtgärtner wollen sich nicht nur an einem Garten beteiligen, sondern auch darüber hinaus aktiv sein. Sie wollen Nachbarschaften und die Stadt mitgestalten – wenn auch nicht immer in den offiziell dafür vorgesehenen Bahnen, wie das Phänomen *Guerilla Gardening* zeigt: An allen möglichen und unmöglichen Orten, ob auf Baumscheiben oder Randstreifen von Gehwegen sprießen in den Städten Blumen, wenn die Guerilla-Gärtner zuschlagen – ein friedliches, aber deutliches Zeichen zivilen Ungehorsams.

Es ist der selbst organisierte Garten, der die Städter in ihren Bann zieht. Mit ihm erobern sie sich die Stadt zurück: bauen Tomaten, Kartoffeln und Kräuter auf Brachen, Restflächen und auch auf Dächern an. Immer in einer kleinen Gemeinschaft, fast wie ein Dorf in der Stadt. Der Stadtgarten bringt den menschlichen Maßstab in die Metropolen zurück. Und in ihrer Entstehung verweist er deutlich auf den Ursprungsgedanken des Gartens als Paradies: Gärten spiegeln immer auch die Sehnsüchte einer Gesellschaft wider.

Es ist der selbst organisierte Garten, der Garten von unten, der die Städter in ihren Bann zieht. Mit ihm erobern sie sich die Stadt zurück, und soziale Aspekte stehen gleichwertig neben der Versorgungsleistung.

145

Jardiniers citadins
Des domaines de Charlemagne
à l'agriculture urbaine

Lorsque l'être humain devient sédentaire il y a environ 13 000 ans en Mésopotamie, il invente le jardin : il cultive la terre, mais entoure les champs de clôtures pour les protéger des animaux sauvages Le jardin d'utilité est la forme la plus ancienne du jardin, un morceau de terre cultivée. Il accompagnera l'Homme pendant des millénaires. Dans les villes aussi, la culture des aliments et l'élevage font longtemps partie du décor quotidien. Les moyens de transport et de conservation sont très limités et il faut produire les aliments là où ils sont consommés. Il faut attendre l'industrialisation et la croissance ininterrompue des villes pour que produise le découplage entre production alimentaire et réalité quotidienne des populations urbaines. La ville et l'agriculture semblent être deux univers qui n'ont plus que grand-chose à se dire.

Les temps changent pourtant : les jardins partagés, *community gardens, Gemeinschaftsgärten, city farms,* jardins interculturels, jardins de voisinage, jardins d'habitants, jardins d'herbes – ne sont que quelques-unes des appellations nouvelles qui illustrent cette nouvelle tendance du jardin d'utilité, bien au-delà des traditionnels petits jardins ouvriers de nos villes. Ces aménagements s'enracinent dans l'industrialisation : dans les villes qui ne cessaient de grandir, on avait créé des jardins de pauvres et jardins pour les ouvriers d'usine, qui devaient les aider à assurer leur subsistance.

Bien entendu, l'origine de la culture des jardins en Europe remonte beaucoup plus loin : au Moyen Âge, avec les jardins des domaines et des monastères. Au 8e siècle, Charlemagne institue des structures administratives basées justement sur ces monastères et domaines. Les monastères en particulier deviennent des centres sociaux et intellectuels où le jardinage est pratiqué. Pour les domaines royaux, une ordonnance de l'année 812 donne des instructions sur l'approvisionnement des sujets en denrées alimentaires. Cet acte législatif appelé Capitulaire De Villis donne en particulier des recommandations sur l'exploitation des jardins fruitiers et potagers : la culture des arbres

fruitiers, de la vigne et des légumes y est décrite jusque dans les moindres détails. Le dernier chapitre contient une liste des plantes et herbes médicinales qui devaient améliorer la prise en charge médicale de base de la population dans le royaume des Francs. Le modèle de ce compendium végétal était basé sur les jardins d'herbes que les nonnes et les moines avaient créés pour leurs besoins : ils y cultivaient la potentille dressée, la camomille sauvage, la mélisse et la sauge, le cumin, l'anémone hépatique, le pissenlit, la menthe et l'achillée, le raifort, le pavot somnifère et le genévrier. Nous sommes donc redevables à ce capitulaire De Villis de nombreuses plantes qui aujourd'hui encore sont des éléments importants des jardins paysans classiques.

DE LA CAMPAGNE À LA VILLE, LE RETOUR

Même si l'époque de Charlemagne nous semble lointaine, l'agriculture n'a en fait jamais totalement disparu des villes. Aujourd'hui encore, les champs cultivés font partie de l'aspect des paysages des périphéries urbaines. Toutefois, malgré la proximité géographique, l'agriculture n'a que des liens lâches avec la ville : elle est dans une large mesure ignorée des citadins, les terres sont considérées comme des réserves pour le développement urbain, ou bien les chemins de terre sont utilisés les fins de semaine pour les promenades à pied ou en vélo. Et l'agriculture péri-urbaine ne produit pas pour l'agglomération dont elle dépend, mais pour le marché mondial, puisque le transport et la conservation ne constituent plus des obstacles et que de nos jours, les produits alimentaires viennent de n'importe où.

Pourtant, une tendance de retour aux produits régionaux se fait jour peu à peu. L'agriculture industrielle et productiviste est vue de façon de plus en plus critique. Les monocultures, le recours aux pesticides, avec tous leurs effets secondaires, par exemple sur les insectes, suscitent les attaques. C'est une des raisons fortes pour lesquelles depuis quelques années, on assiste à un retour de la culture des fruits et légumes en ville, pour

l'autoconsommation. Les jardins d'herbe, un morceau de champ que peuvent louer les jardiniers amateurs ont marqué les débuts. Aujourd'hui, des initiatives citoyennes donnent naissance à des jardins urbains exploités en commun sur des terres en jachère. À Berlin, on peut citer en exemple l'association Allmend-Kontor, sur l'ancien aéroport de Tempelhof, ou encore les Prinzessinnengärten, dans le quartier urbain de Kreuzberg. À Hambourg, le Garten-Deck se développe dans le quartier de Sankt Pauli, tandis qu'à Londres, les jardins Food from the Sky se développent sur le toit d'un supermarché. Et d'autres métropoles européennes voient apparaître ces jardins participatifs. Souvent temporaires, ils ont le charme de la spontanéité, de l'éphémère. Les Prinzessinnengärten, par exemple, sont nés en 2009 sur un terrain en jachère de la place Moritz. À l'époque, l'initiative est prise par des habitants qui nettoient le site et créent une association pour gérer le terrain en location dans le cadre d'un bail annuel signé avec la ville. Rien n'est donc définitif : le café est logé dans un conteneur, les plantes croissent dans des caisses de boulangerie, des Tetra Paks et des sacs de riz. Pourtant, le lieu fait aujourd'hui totalement partie du quartier. Il est difficile d'associer le provisoire et le jardin.

Toutes ces initiatives sont nées dans les dix dernières années. Mais par exemple dans les grandes villes américaines comme Los Angeles ou New York, il existe des jardins de ce type depuis les années soixante-dix. À l'époque, refusant de voir se dégrader leur environnement, les habitants s'emparent du sujet. Ils prennent possession de surfaces inoccupées, en éliminent les ordures, plantent herbes et légumes et créent par là-même des lieux de rencontre dans le voisinage, régénérant ainsi le tissu social. Aujourd'hui, on compte à New York plus de 500 *community gardens,* de plus en plus souvent installés sur les toits de la ville, et parfois exploités à titre commercial : situé sur l'ancien terrain de la marine, le Brooklyn Grange est une de ces fermes de toit qui commercialise sa récolte dans le voisinage

146

via des supermarchés ou des marchés hebdomadaires. Il s'agit d'un des plus grands jardins de ce type, avec plus de 6 000 mètres carrés de culture biologique. Par ailleurs, Brooklyn Grange aide les réfugiés et les migrants dans le cadre d'un programme de formation. La ville de New York elle-même gère une initiative similaire : « Grow New York City » (GrowNYC) est une espèce de service communal dépendant directement du maire. GrowNYC s'engage en particulier pour la formation à l'environnement et à l'alimentation en aidant les jardins scolaires et en offrant même un programme de recyclage d'un an aux paysans urbains. Les gens qui sont présents ici sont essentiellement des jeunes de mieux sociaux difficiles, ils travaillent comme bénévoles durant les sept mois de la belle saison dans différents jardins communautaires ou fermes urbaines, tout en recevant un enseignement théorique. Ensuite, ils sont aptes à travailler par exemple dans des jardineries ou à diriger un magasin de légumes.

Il existe dans les métropoles de croissance du monde entier des initiatives similaires, parfois même depuis très longtemps comme le montre l'exemple de l'Afrique du Sud : au Cap, l'agriculture urbaine est une activité traditionnelle et là aussi, les aspects sociaux sont aussi importants que les questions d'approvisionnement alimentaire. Abalimi Bezekhaya est apparu dans les années quatre-vingt dans les townships du Cap, durant la période de l'Apartheid. L'organisation aide toujours les jardins communautaires installés sur des surfaces urbaines inoccupées et qui permettent non seulement l'auto-approvisionnement, mais ont aussi pour but de donner une perspective à des personnes sans emploi.

PLUS QU'UNE TENDANCE : LA PARTICIPATION ACTIVE DES JARDINIERS AU FAÇONNAGE DES ESPACES DE VIE URBAINS

De nombreux projets de recherche universitaires traitent aujourd'hui des questions d'agriculture urbaine. En effet, la densité démographique croissante des agglomérations amène inévitablement à se demander comment ces métropoles peuvent se développer de manière durable, sociale et écologique. Dans ce contexte, on reconnait un rôle particulier à l'agriculture communautaire, une agriculture qui vient d'en bas, sans oublier le fait qu'elle a le potentiel pour approvisionner la population sans nuire à l'environnement. Un seul exemple : les recherches menées par la TU de Berlin sur l'agriculture urbaine à Casablanca. Ce projet rassemble des partenaires allemands et marocains du monde de la recherche, des administrations spécialisées et d'organisations citoyennes, et a pour but de rendre plus agréable la vie de cette ville marocaine en croissance. La

perspective : étant donné que la ville grignote rapidement la périphérie agricole, des îlots fermiers et agricoles se forment au milieu des constructions. On voit ainsi apparaître des initiatives ville-campagne de voisinage qui offrent à la ville de nouvelles possibilités de développement.

Des exemples le montrent : dans les grandes métropoles, en particulier dans les nouveaux pays industrialisés, l'approvisionnement de la population et les aspects socio-économiques sont prioritaires. Dans une Europe développée et riche, l'accent est mis sur d'autres objectifs : la redécouverte de la récolte personnelle est toujours un contre-point voulu à la mondialisation. Aussi petit qu'il soit, le jardin de ville, même le simple sillon loué en fermage, est le lopin de terre individuel sur lequel je peux faire pousser les fruits et les légumes que je vais moi-même cuisiner. On échappe ainsi au manque de transparence qui entoure les moyens de production et de transport internationaux, et on se rend moins dépendants des productions agro-alimentaires industrielles.

Et puis : il y a aussi l'aspect communautaire et participatif. Les jardiniers urbains ne veulent pas seulement être partie prenante d'un jardin, ils veulent aller plus loin, en étant partie prenante de la ville et du voisinage – même s'ils choisissent pour ce faire des voies non prévues officiellement, comme le montre le phénomène du *guerilla gardening* : dans tous les endroits possibles ou impossibles, autour des arbres, sur les bordures d'allées, les jardiniers guérilleros font surgir des fleurs, en signe de désobéissance civile pacifique.

C'est le fait d'organiser soi-même le jardin qui attire les citadins et leur permet de reconquérir la ville : ils cultivent des tomates, des pommes de terre et des herbes sur des jachères, des surfaces inutilisées, et même sur les toits. Toujours en petites communautés, comme des villages intégrés à la ville. Le jardin urbain fait revenir la dimension humaine dans la métropole. Et sa naissance fait clairement référence à l'idée originelle du jardin vu comme un paradis : les jardins sont toujours le reflet des désirs profonds d'une société.

C'est le fait d'organiser soi-même le jardin qui attire les citadins, le jardin « d'en bas ». Ils reconquièrent ainsi la ville, et les aspects sociaux jouent un rôle aussi important que l'approvisionnement en produits alimentaires.

Studio Piet Boon

Oostzaan | The Netherlands

Studio Piet Boon exports the Dutch design philosophy to downtown New York.
Piet Boon Studio exportiert die niederländische Designphilosophie in die Innenstadt von New York.
Piet Boon Studio implante au centre de New York la philosophie néerlandaise du design.

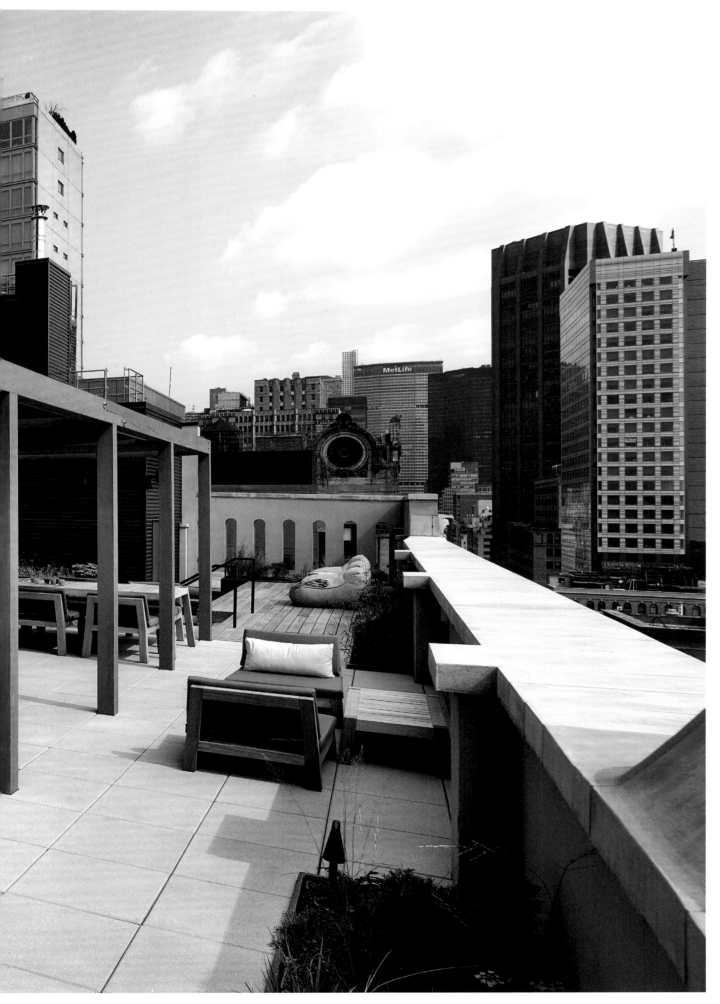

Function, aesthetics, and individuality—the philosophy of the Dutch design studio Piet Boon is committed to perfection. The result is unpretentious sophistication. This idea also transported the team to a rooftop terrace at 404 Park Avenue South in New York, where they transformed an office building into a luxurious apartment house. Combining the flair of the lively metropolis with the tranquility of a private place of refuge was the great challenge. The result is an inimitable Piet Boon design.

Funktion, Ästhetik und Individualität – die Philosophie des niederländischen Designstudios Piet Boon verpflichtet zur Perfektion. Schlichte Raffinesse ist das Ergebnis. Diese Idee transportierte das Team auch auf eine Dachterrasse in der 404 Park Avenue South nach New York, wo es ein Bürogebäude in ein luxuriöses Apartmenthaus verwandelte. Das Flair der quirligen Metropole mit der Ruhe eines privaten Rückzugsraums zu verbinden, war die große Herausforderung. Das Ergebnis ist ein einzigartiges Piet Boon Design.

Fonction, forme, originalité : la philosophie du studio de design néerlandais Piet Boon vise la perfection, pour finalement offrir une alliance de raffinement et de sobriété. L'équipe du studio a appliqué l'idée à une terrasse de toit située à New York 404 Park Avenue South, en transformant un immeuble de bureaux en luxueux appartements. Le défi était grand pour l'équipe puisqu'il s'agissait d'associer l'atmosphère d'une métropole turbulente au calme d'une retraite conçue pour le repos. Le résultat est une création unique de Piet Boon.

149

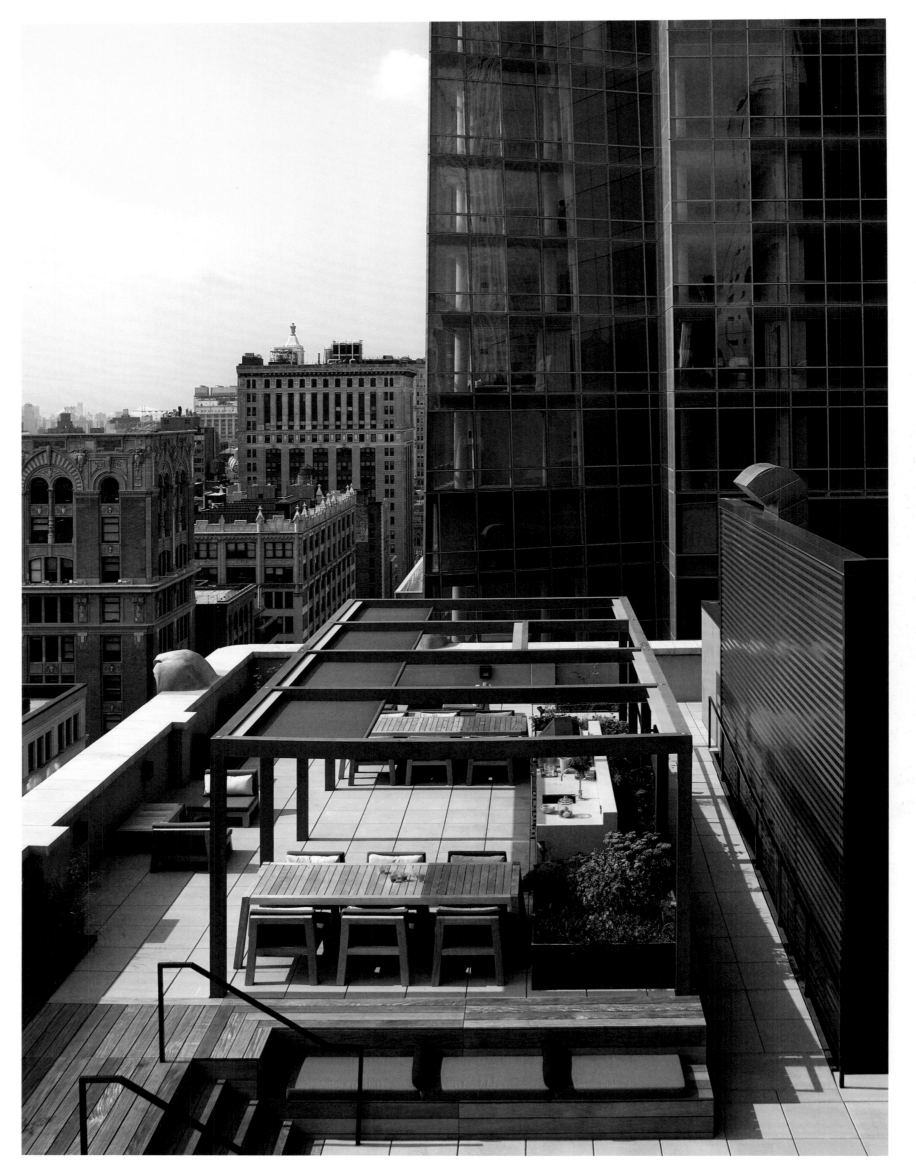

150

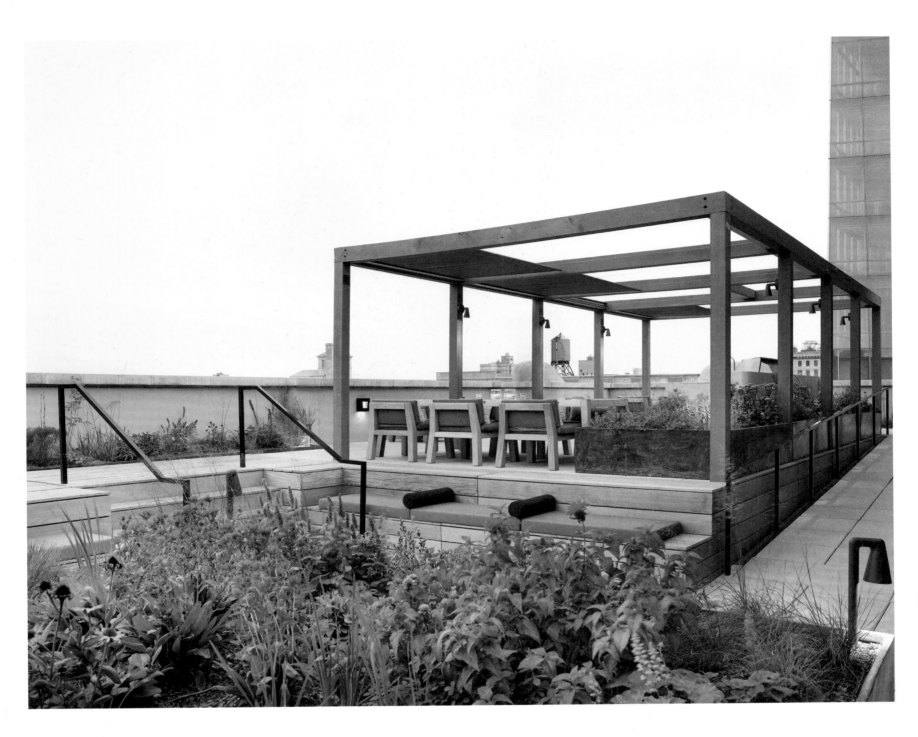

151

The choice of materials for the rooftop terrace came down to light-colored natural stone and wood for sections of the floor as well as for the pergolas and furnishings. The team from Studio Piet Boon specially highlighted the transitions from the interior to the exterior. For the wooden planting boxes Piet Oudolf composed small landscapes of bushes and grasses (see also the following pages).

Die Materialwahl für die Dachterrasse reduziert sich auf hellen Naturstein und Holz für Teilbereiche des Bodens sowie für die Pergolen und die Möblierung. Das Team von Studio Piet Boon legte besonderen Wert auf die Übergänge von innen nach außen. Für die Pflanzkästen aus Holz komponierte Piet Oudolf kleine Stauden- und Gräserlandschaften (siehe auch die folgenden Seiten).

Le choix des matériaux de la terrasse s'est limité à la pierre naturelle claire et au bois pour des parties du sol ainsi que pour les pergolas et le mobilier. L'équipe du studio Piet Boon s'est concentrée en particulier sur les transitions entre l'intérieur et l'extérieur. Pour les bacs à végétaux en bois, Piet Oudolf a composé de petits paysages de plantes vivaces et herbacées (voir aussi les pages suivantes).

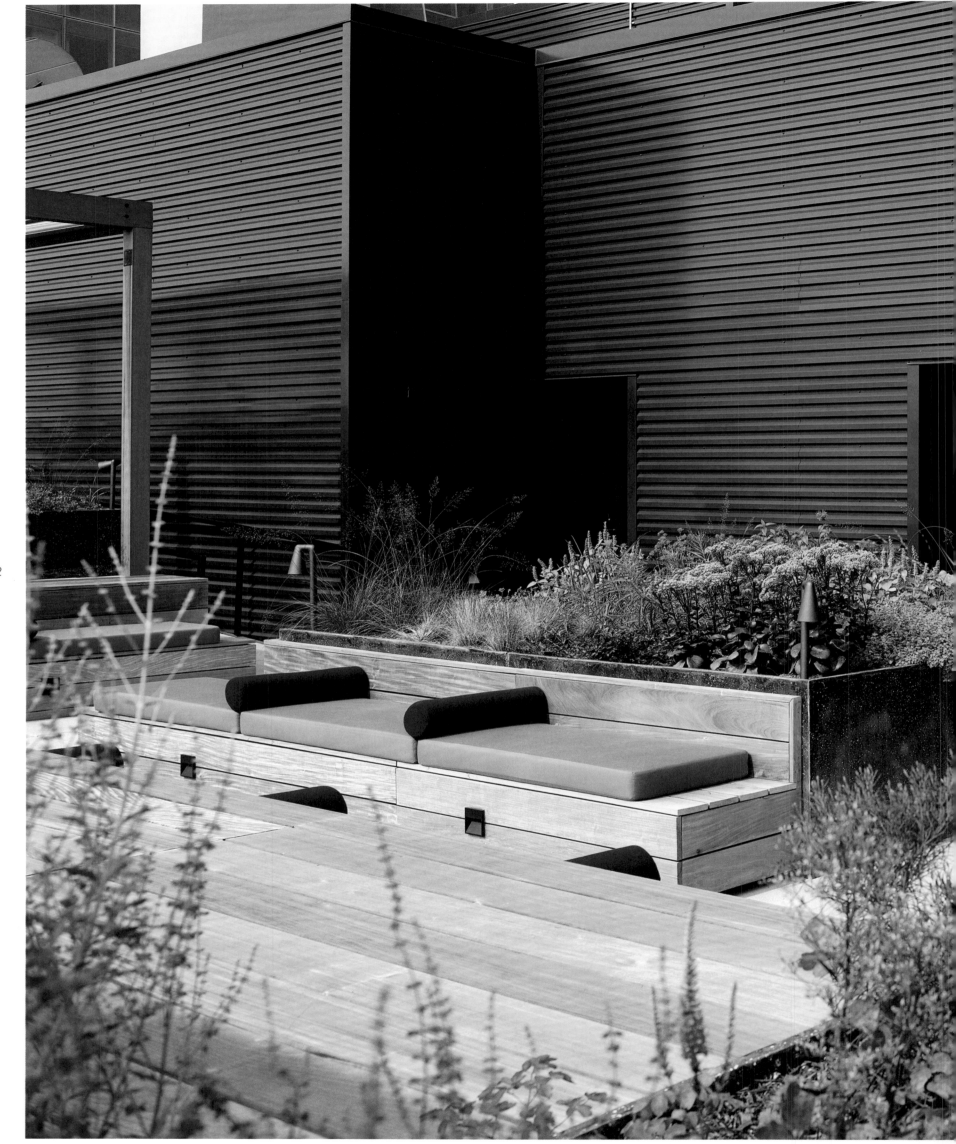

152

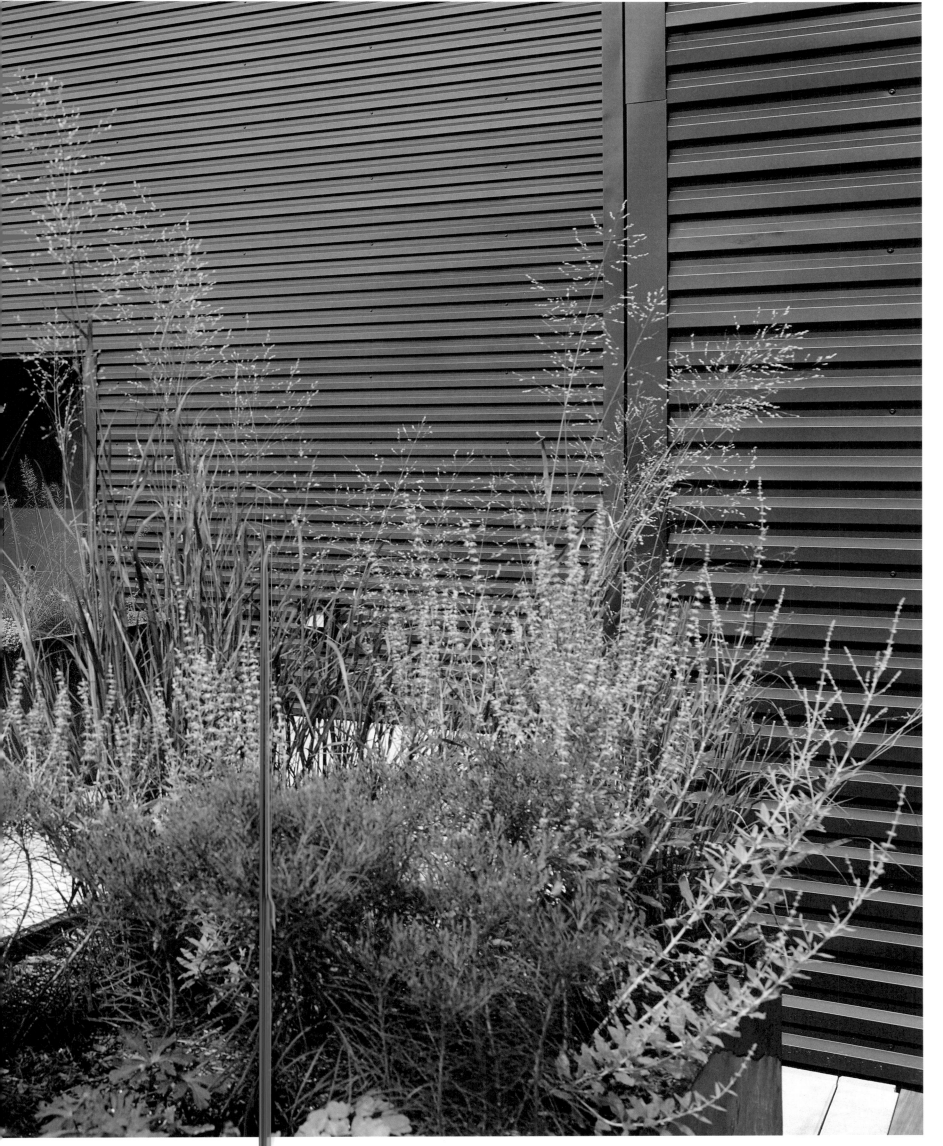

153

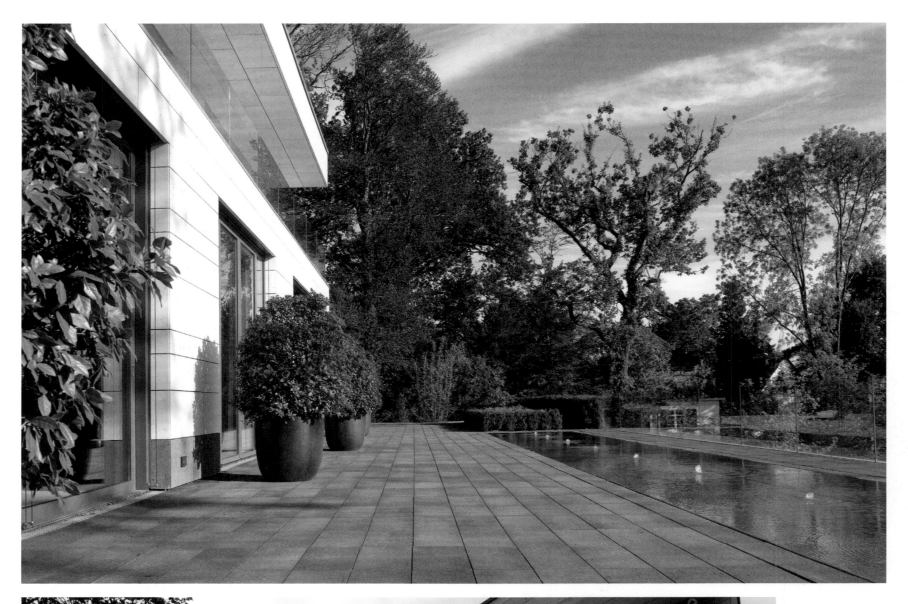

154

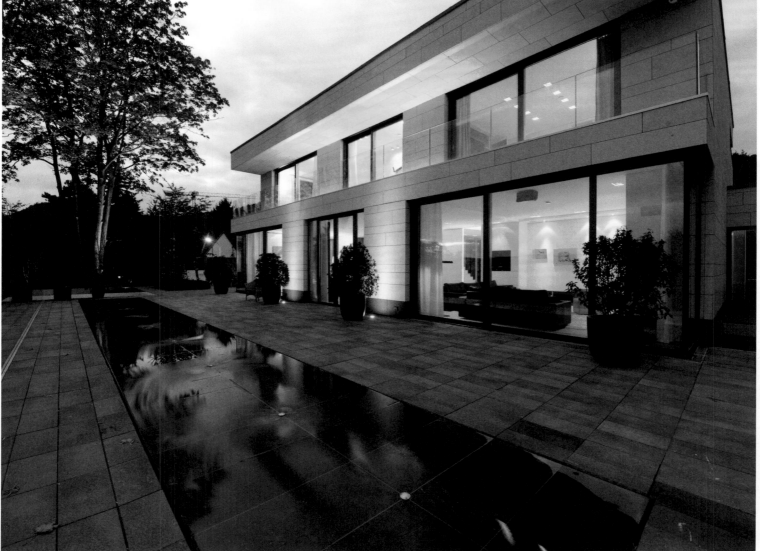

The landscape architects incorporated the geometry and orientation of the residence in Bad Honnef for the terrace. The dark, Umbriano concrete block appears to extend the facade.

Die Landschafts-architekten nahmen Geometrie und Ausrichtung des Wohnhauses in Bad Honnef für die Terrasse auf. Der dunkle Beton-stein Umbriano scheint die Fassade fortzusetzen.

Pour la terrasse, les architectes paysa-gers se sont inspirés de la géométrie et de l'exposition de cette maison d'habi-tation située à Bad Honnef. La pierre en béton sombre Umbriano donne l'impression de pro-longer la façade.

Metten Stein+Design

Overath | Germany

The family-owned company has been passionately dedicated to using concrete as a building material since 1938. | Das Familienunternehmen widmet sich seit 1938 mit Leidenschaft dem Baustoff Beton. | Cette entreprise familiale se consacre depuis 1938 avec passion au matériau béton.

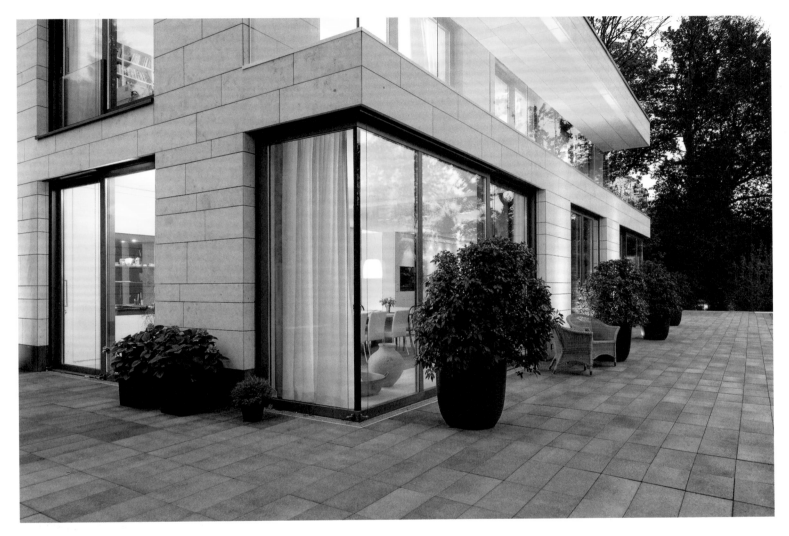

The building, designed by architect Kreyerhoff Koller, is surrounded by block-shaped stones with dimensions of 19,7 x 9,8 x 3,1 inches (50 x 25 x 8 centimeters) like a stone passe-partout.

Die riegelförmigen Steine in den Maßen 50 x 25 x 8 Zentimeter umgeben das Gebäude, entworfen von den Architekten Kreyerhoff Koller, wie ein steinernes Passepartout.

Comme un passe-partout en pierre Les pierres en forme de barre de 50 x 25 x 8 centimètres entourent le bâtiment dessiné par le cabinet d'architectes Kreyerhoff Koller.

155

Josef and Gertrud Metten received a wagon full of cement as a wedding gift in 1947, recounts the founder in 2013 on the 75th anniversary of the concrete workshop. Back then, everything began with a 12- by 12-inch (30- by 30-centimeter) concrete slab. Later came the invention of the grass paver—only one facet of today's extensive portfolio. This portfolio includes: The gray anthracite grained Umbriano, which imparts its elegant character to the courtyard and terrace of a private house in the Siebengebirge (Sieben Hills) near Bonn.

Zur Hochzeit 1947 bekamen Josef und Gertrud Metten einen Waggon Zement geschenkt, erzählte der Firmengründer anlässlich des 75-jährigen Jubiläums der Betonsteinwerke 2013. Alles fing damals mit einer Betonplatte in den Maßen 30 mal 30 Zentimeter an. Später folgte die Erfindung des Rasengittersteins – nur eine Facette aus dem heute umfangreichen Portfolio. Darunter auch: der grau-anthrazit gemaserte Stein Umbriano, der Hof und Terrasse eines Privathauses im Siebengebirge seinen eleganten Charakter verleiht.

Lorsqu'ils se marient en 1947, Josef et Gertrud Metten se voient offrir un wagon de ciment, comme le raconta le créateur de l'entreprise à l'occasion du 75e anniversaire de l'usine à béton en 2013. À l'époque, tout commence par une simple dalle de béton de 30 centimètres sur 30. Plus tard, l'entreprise invente la dalle de gazon en béton, qui n'est toutefois qu'un élément d'une gamme aujourd'hui très diverse. Citons par exemple la pierre Umbriano et sa veinure gris-anthracite, qui donne un aspect élégant à la cour et à la terrasse d'une maison du massif des Siebengebirge (Allemagne).

Terremoto

Los Angeles and San Francisco, California | USA

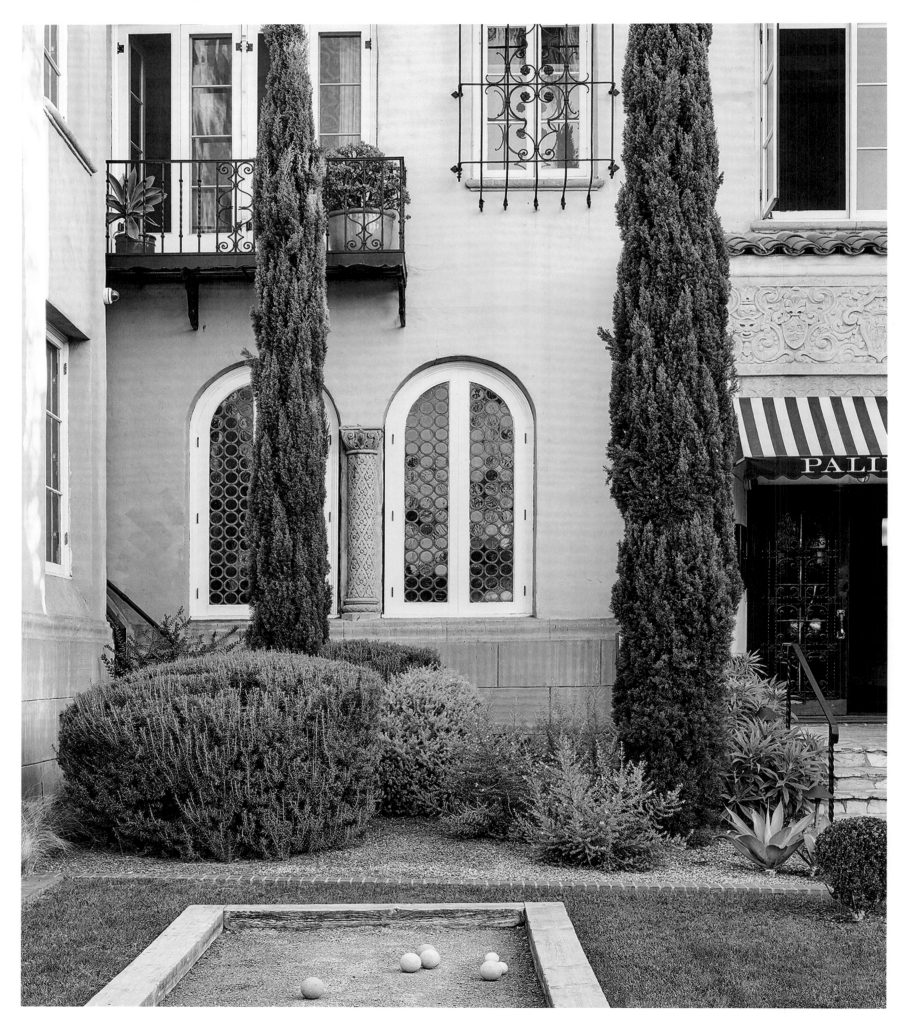

156

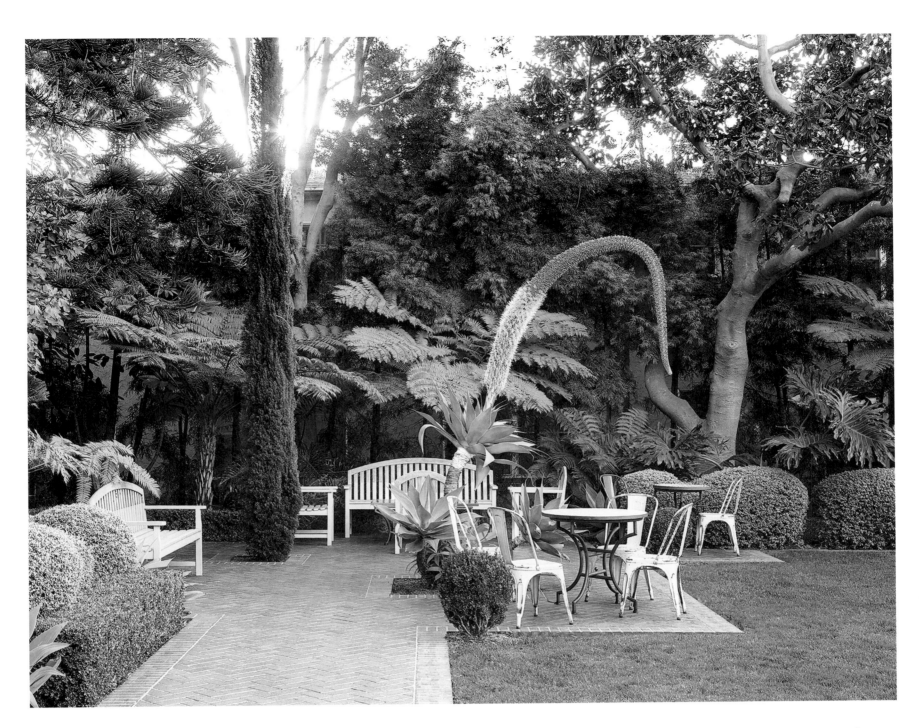

The Californian landscape architects of Terremoto say their kind of design is related to critical regionalism. | Kritisch-regional nennen die kalifornischen Landschaftsarchitekten von Terremoto ihre Art der Gestaltung. | Les paysagistes californiens de Terremoto qualifient de « régionale critique » leur façon d'aménager les jardins.

Terremoto is a landscape architecture office taking new paths in the interpretation of what exists and of further development of a style for which owner David Godshall gives this description: "Wrestle with the application of form to the physical world through materials." Founded in 2013, Terremoto seeks to figure out the philosophical subtext of a location before the musical anarchy of garden design, ecology and art inspires the design.

Terremoto ist ein Landschafts-gestaltungsstudio, das neue Wege geht in der Interpretation des Bestehenden und der Weiterentwicklung eines Stiles, den der Inhaber David Godshall so beschreibt: „Es ist ein Ringen, durch Materialien der physischen Welt eine Form zu geben." Gegründet 2013 möchte Terremoto nach eigenen Worten den philosophischen Subtext eines Ortes ergründen, bevor die musikalische Anarchie aus Gartenbau, Ökologie und Kunst die Gestaltung inspiriert.

Terremoto est un cabinet de création paysagère qui innove dans la manière d'interpréter l'existant et de le faire évoluer dans un style que le propriétaire David Godshall décrit ainsi : « C'est une lutte pour donner des formes avec des matériaux du monde physique. » Créé en 2013, Terremoto veut, selon ses propres mots, explorer le sous-texte philosophique d'un lieu, avant que le travail de création ne s'inspire de la musique anarchique composée par l'horticulture, l'écologie et l'art.

Palihouse, Santa Monica: In this garden, there is a meeting between elements of a linear Mediterranean garden, namely Italian cypresses (Cupressus sempervirens), and broad, striking tree ferns (Cyathea cooperi).

Palihouse, Santa Monica: Im Garten treffen sich Zitate eines linearen mediterranen Gartens, nämlich Italienische Zypressen (Cupressus sempervirens), mit breiten auffallenden Baumfarnen (Cyathea cooperi).

Palihouse, Santa Monica : Évocation du jardin méditerranéen linéaire, avec des cyprès italiens (Cupressus sempervirens) associés à de larges fougères de Cooper (Cyathea cooperi).

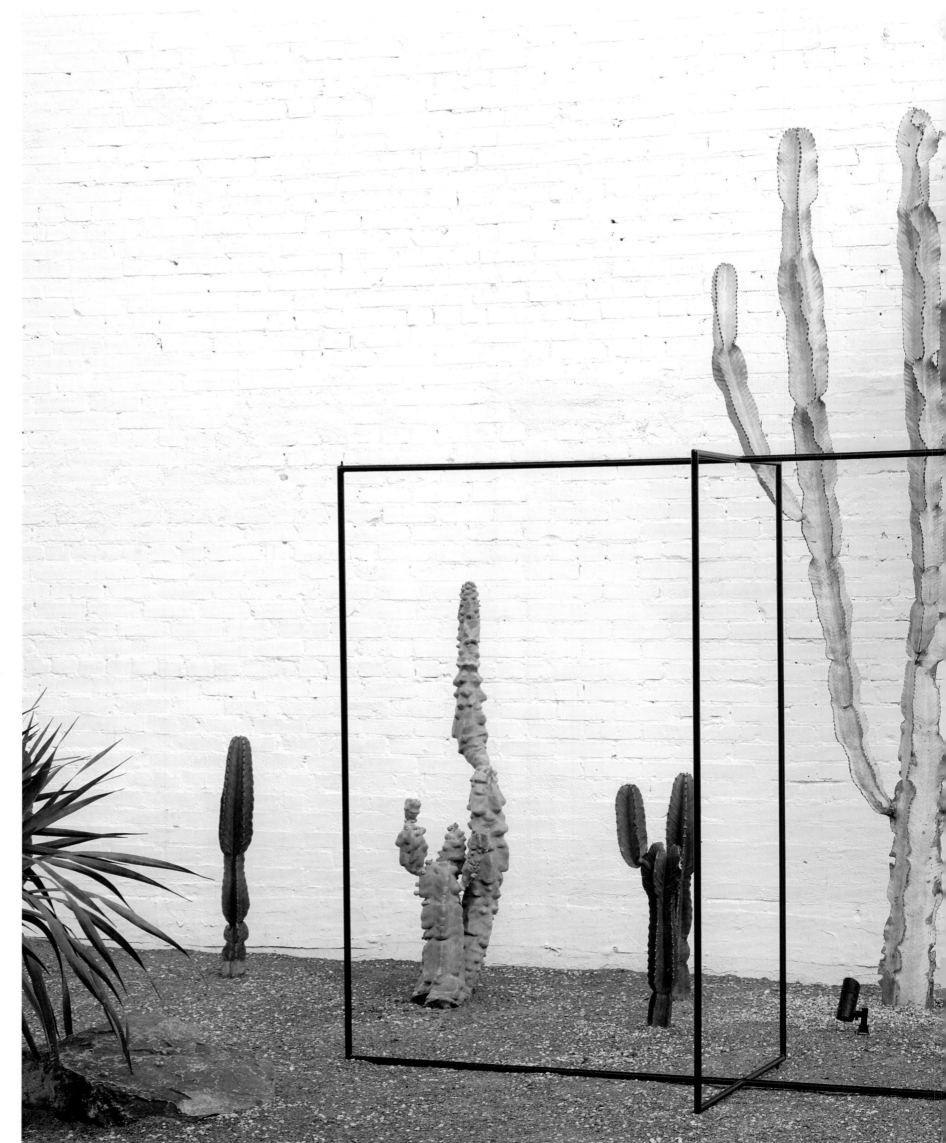

158

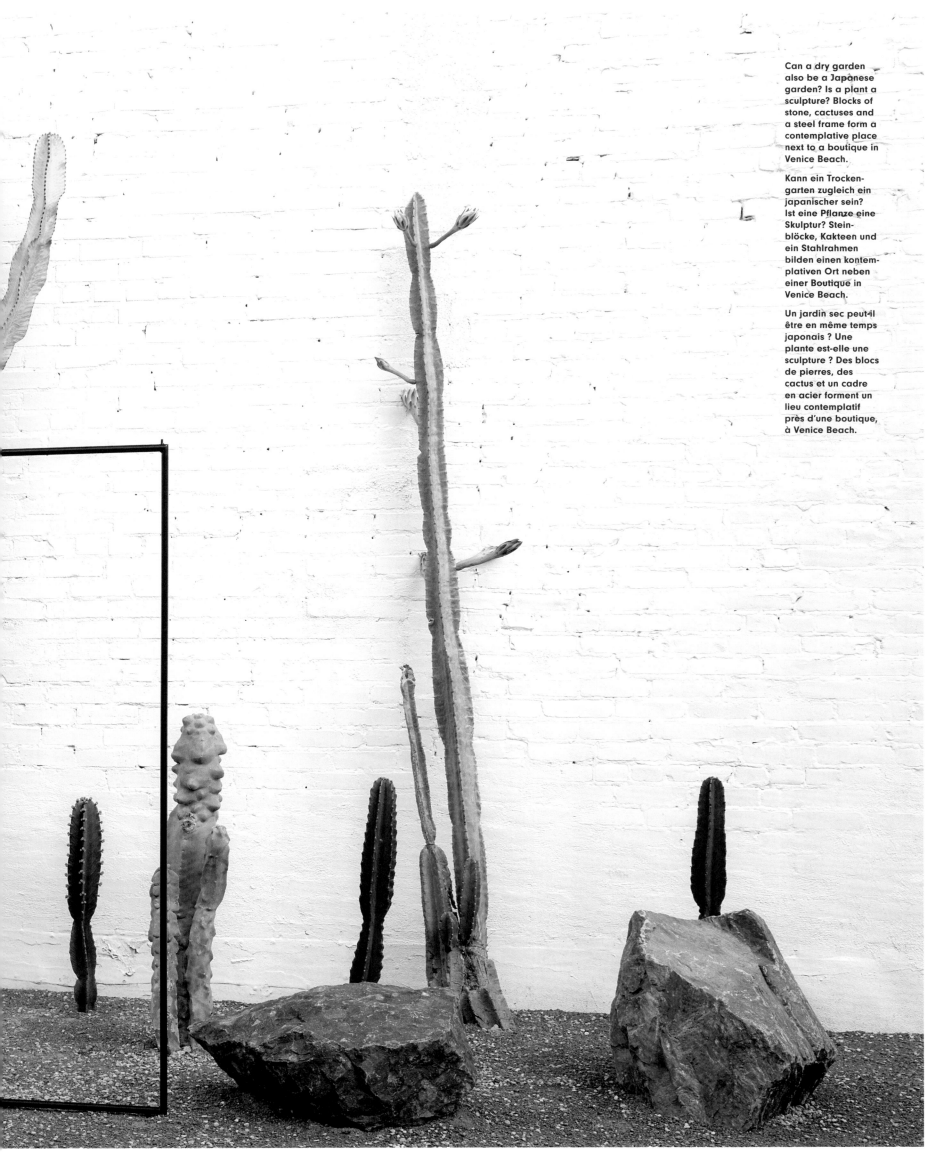

Can a dry garden also be a Japanese garden? Is a plant a sculpture? Blocks of stone, cactuses and a steel frame form a contemplative place next to a boutique in Venice Beach.

Kann ein Trockengarten zugleich ein japanischer sein? Ist eine Pflanze eine Skulptur? Steinblöcke, Kakteen und ein Stahlrahmen bilden einen kontemplativen Ort neben einer Boutique in Venice Beach.

Un jardin sec peut-il être en même temps japonais ? Une plante est-elle une sculpture ? Des blocs de pierres, des cactus et un cadre en acier forment un lieu contemplatif près d'une boutique, à Venice Beach.

159

Terremoto

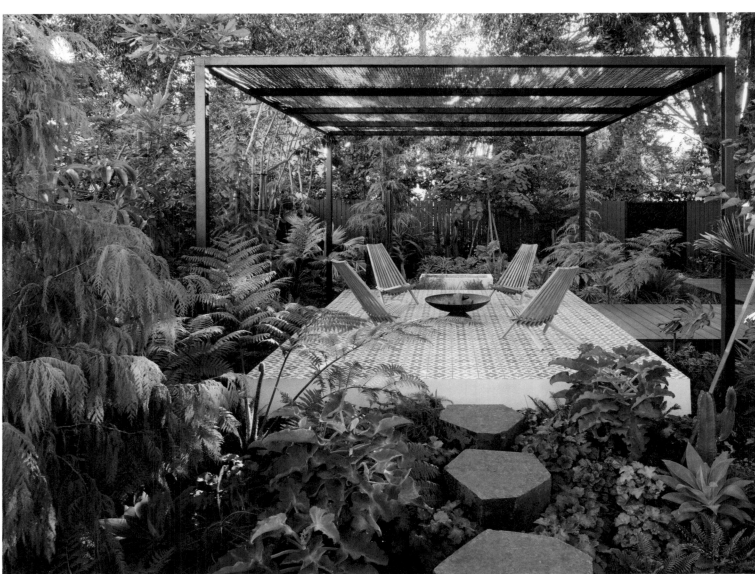

The Whitely Heights Garden is a meditation on the botanical world of Old Hollywood. It bears horticultural fancy and is suspended in a "surreality without origin," according to David Godshall.

Der Whitely Heights Garden ist eine Meditation über die botanische Welt von Alt Hollywood: Er trägt gärtnerische Phantasie und schwebt in einer „Surrealität ohne Herkunft", meint David Godshall.

Le Whitely Heights Garden est une méditation sur le monde végétal du vieil Hollywood : Pour David Godshall, il émane de ce lieu une fantaisie jardinière qui flotte dans une surréalité sans origine.

160

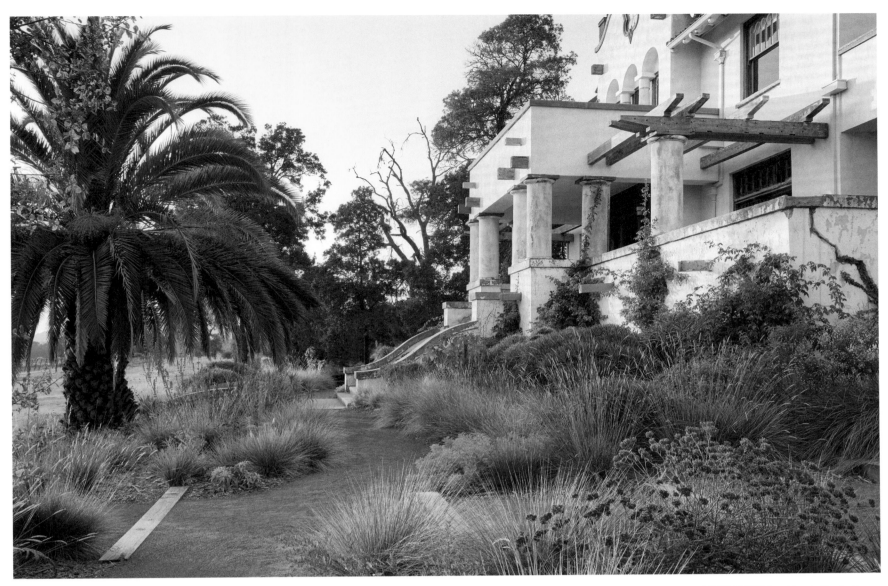

Top: In the Scribe Winery in Sonoma, historic ornamental plants meet native plants. Left: In this private garden in Los Angeles, Terremoto changed only what wasn't working right. The eyecatcher is a cypress full of character that is illuminated from inside.

Oben: In der Scribe Winery in Sonoma treffen historische Ornamentpflanzen auf einheimische Gewächse. Links: Bei diesem Privatgarten in Los Angeles veränderte Terremoto nur das, was nicht recht funktionierte. Den Blickfang bildet eine charaktervolle Zypresse, die von innen beleuchtet wird.

En haut : Dans la Scribe Winery de Sonoma, des plantes ornementales historiques poussent à côté de végétaux indigènes. À gauche : Dans ce jardin privé de Los Angeles, Terremoto n'a changé qui ce qui ne marchait pas vraiment. Le regard s'arrête sur des cyprès de caractère éclairés de l'intérieur.

Volker Weiss

Krefeld | Germany

162

Volker Weiss brings the sophistication of indoor furniture design outside with his outdoor furniture. | Mit seinen Möbeln für den Außenbereich bringt Volker Weiss das Design-Niveau anspruchsvoller Interieurs nach draußen. | Sur le plan du design, Volker Weiss conçoit ses meubles d'extérieur avec le même niveau de recherche et d'exigence que des meubles d'intérieur de haut de gamme.

Outdoor furniture by Volker Weiss has received international praise for more than 25 years. And for good reason: Uncompromising design is accompanied by technical innovations such as capillary-active, water vapor diffusion-open seat and back cushion cover material. This innovate seating furniture lineup, made from steel tubing with slots for arm or backrests, offers space for two to seven persons, while its design ensures optimal water runoff.

Seit mehr als 25 Jahren werden die Outdoor-Möbel von Volker Weiss international geschätzt. Aus gutem Grund: Kompromisslose Gestaltung geht hier einher mit technischen Neuerungen wie den kapillaraktiven, dampfdiffusionsoffenen Bezugsstoffen für die Sitz- und Rückenkissen der Outdoor-Sofas. Dieses innovative Sitzmöbelprogramm aus Stahlrohren mit Steckplätzen für Arm- oder Rückenlehnen bietet Platz für zwei bis sieben Personen und sorgt durch seine Konstruktion für optimalen Wasserabfluss.

Les meubles d'extérieur de Volker Weiss sont appréciés depuis plus de 25 ans partout dans le monde. Cela ne doit rien au hasard : l'absence de compromis esthétique est renforcée par des innovations techniques, comme les tissus capillaires actifs et perméables à la diffusion de vapeur pour les assises et les dossiers des canapés. Ces salons novateurs en tubes d'acier, dotés d'accoudoirs ou de dossiers emboîtables peuvent recevoir de deux à sept personnes et leur structure garantit le parfait écoulement de l'eau.

When it comes to the outdoor seat and back sofa cushions—color trumps all. Even the coffee tables are available in a spectrum of RAL colors.

Farbe ist Trumpf bei den Sitzkissen und Rückenpolstern der Outdoor-Sofas. Auch die Couchtische sind in vielen RAL-Farben erhältlich.

La couleur des assises et des dossiers est l'atout principal de ces canapés d'extérieur. Les tables de salon sont disponibles également dans de nombreux coloris RAL.

Volker Weiss

164

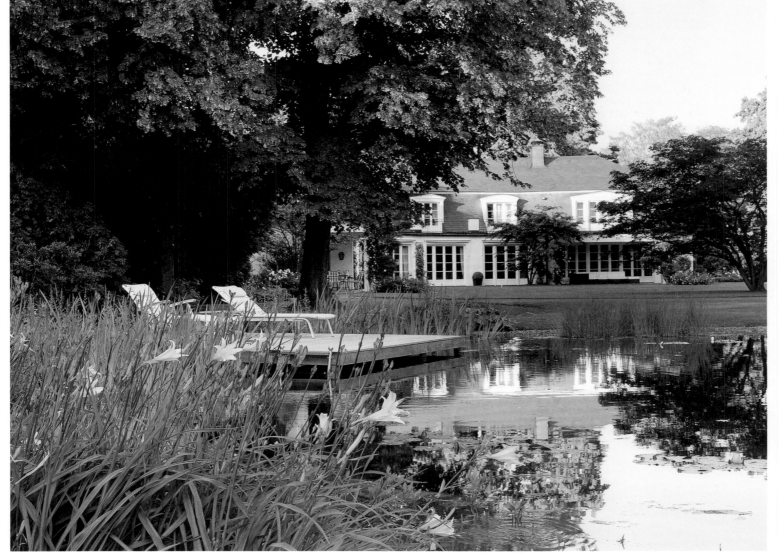

A scenic garden sur-
rounds this classic
villa in Meerbusch.
It is the interplay
between light and
shadow and the
work with width and
depth that make this
garden unique.

Ein landschaftlicher
Garten umgibt die
klassische Villa in
Meerbusch. Es sind
das Spiel mit Licht
und Schatten sowie
das Arbeiten mit
Weite und Tiefe,
die diesen Garten
ausmachen.

Un jardin paysager
entoure la villa clas-
sique de Meerbusch.
Un jardin qui se dis-
tingue par le jeu
d'ombres et de lu-
mières et le travail
sur la largeur et
la profondeur.

WKM Landschaftsarchitekten

Düsseldorf | Germany

WKM Landschaftsarchitekten designs ornate indoor and outdoor landscapes.
WKM Landschaftsarchitekten gestalten kunstvolle Landschaften für außen und innen.
Les paysagistes de WKM créent des paysages artistiques pour l'extérieur et l'intérieur.

The 'New Dawn' climbing rose spans the length of the villa's pillars and adorns them with its bright, pale pink blossoms. A large lawn stretches out in front of the building.

An den Säulen der Villa rankt die Kletterrose 'New Dawn' empor und umspielt diese mit ihren hellen, zartrosa Blüten. Großzügige Rasenflächen erstrecken sich vor dem Gebäude.

Un rosier grimpant 'New Dawn' s'agrippe aux colonnes de la villa, jouant autour d'elles de ses fleurs claires d'un rose tendre. De généreuses surfaces de pelouse s'étendent devant le bâtiment.

165

Roland Weber, the founder of the eponymous firm that spawned WKM Landschaftsarchitekten, designed well over 800 gardens in his 60-year career, which primarily consisted of gardens for single-family homes, administration buildings, and industrial buildings. Klaus Klein and Rolf Maas have carried on this tradition since Mr. Weber passed in 1987. These landscape architects have been awarded numerous prizes for their work in the past few years. Most recently, in 2016, they were honored with an award in the "Garden of the Year" competition for the villa garden in Meerbusch, Germany.

Roland Weber, der Gründer des gleichnamigen Büros, aus dem WKM Landschaftsarchitekten hervorging, hatte in seiner über 60-jährigen Tätigkeit weit über 800 Gärten entworfen, vor allem Anlagen für Einfamilienhäuser, Verwaltungs- und Industriebauten. Diese Tradition setzen seit seinem Tod 1987 Klaus Klein und Rolf Maas fort. Für ihre Arbeit erhielten die Landschaftsarchitekten in den vergangenen Jahren zahlreiche Preise, zuletzt 2016 eine Auszeichnung im Wettbewerb „Garten des Jahres" für den Villengarten in Meerbusch.

Dans ses plus de 60 ans d'activité, Roland Weber, créateur du cabinet éponyme qui donnera ensuite naissance à l'entreprise WKM, a dessiné plus de 800 jardins, essentiellement pour des maisons particulières et des bâtiments de bureaux ou industriels. Depuis sa disparition en 1987, la tradition a été reprise par Klaus Klein et Rolf Maas. Au cours des années passées, ils ont reçu de nombreux prix en reconnaissance de leur travail, le dernier obtenu en 2016 dans le cadre du concours du « Jardin de l'année », pour le jardin d'une villa de Meerbusch.

166

All the offices in the
Lufthansa AG admin-
istration building
in Frankfurt look
out at the garden
courtyards. These
courtyards provide
the building with
noise insulation, as
it is located in the
immediate vicinity
of the airport.

Im Verwaltungs-
gebäude der
Lufthansa AG in
Frankfurt sind alle
Büros auf die Gar-
tenhöfe ausgerich-
tet. Diese dienen
als Schallschutz, da
sich das Gebäude
in unmittelbarer
Nähe zum Flug-
hafen befindet.

Dans le bâtiment
administratif de la
Lufthansa situé à
Francfort, tous les
bureaux donnent
sur des jardins qui
jouent le rôle de
protection contre
le bruit puisque
le site se trouve à
proximité immédiate
de l'aéroport.

168

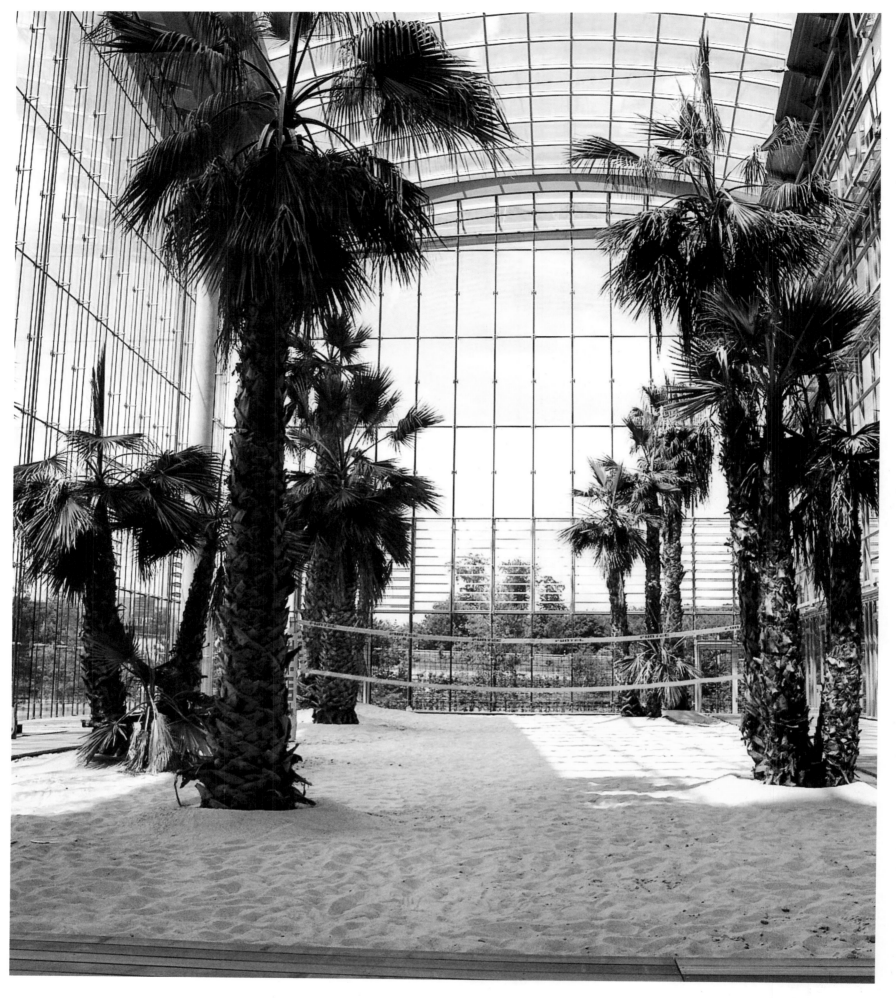

Plants from all five continents that Lufthansa planes fly to grow underneath glass. The Washingtonia robusta and sand represent Caribbean beaches and taking joy in leisure.

Unter Glas wachsen Pflanzen aus allen fünf Kontinenten, die die Lufthansa anfliegt. Die Washingtonia robusta und der Sand stehen für karibische Strände und Spielspaß.

Sous le toit en verre poussent des plantes provenant des cinq continents desservis par les avions de la Lufthansa. Le Washingtonia robusta, ou palmier du Mexique, et le sable évoquent les plages des Caraïbes et le plaisir du jeu.

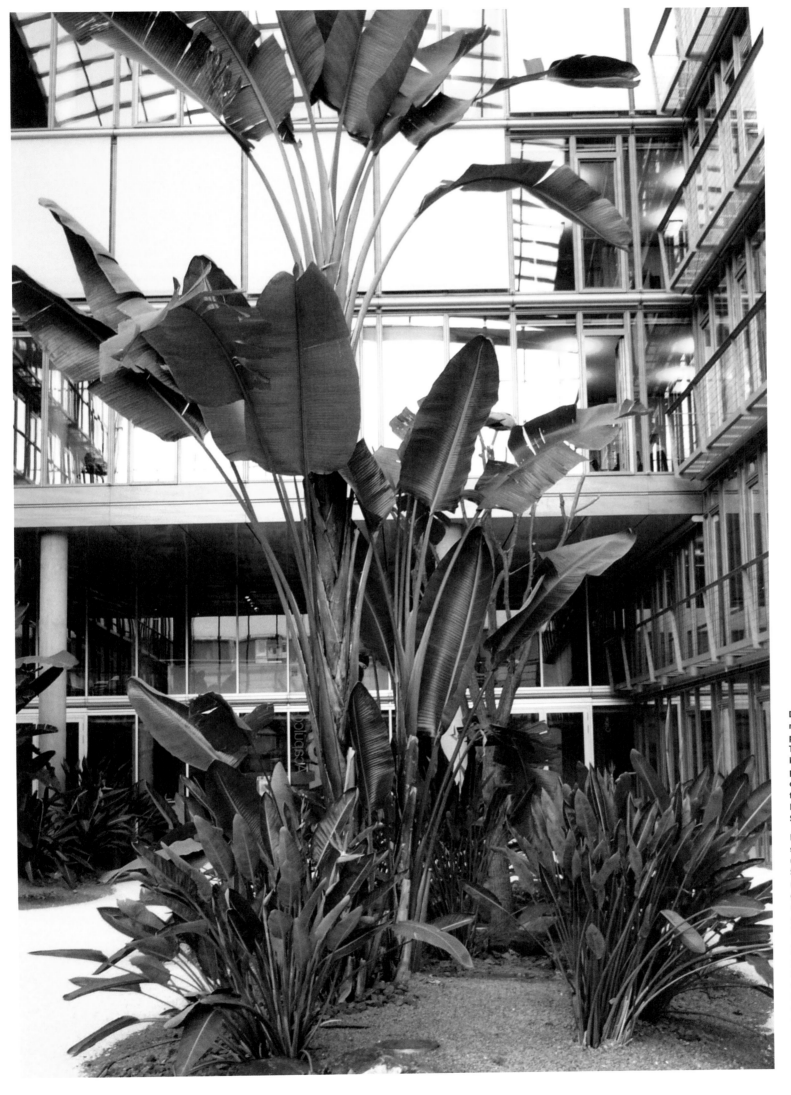

Date trees and myrrh grow in the palm tree courtyard. The strelitzia, also known as bird of paradise flowers, originate from the former Cape Province in South Africa.

Im Palmenhof wachsen Dattelpalmen und Myrrhe. Die Strelitzien, auch Paradiesvogelblumen genannt, stammen ursprünglich aus der Kappprovinz in Südafrika.

Dans la palmeraie poussent des palmiers dattiers et des arbres à myrrhe. Les strelitzias, appelés aussi fleurs d'oiseau de paradis, proviennent d'Afrique du Sud, précisément de la province du Cap.

Plants are Multi-functional

Green Air Conditioning Systems and Oases for Cities

Climate change is having a major effect on our cities. This effect is more extreme in these urban areas than it is in the surrounding regions. Smog, fog, cloud cover and precipitation all occur more frequently in cities. It is also warmer in these areas, partially because there is less evaporation than there is outside of the city, where more trees grow. This "heat island effect" rears its ugly head in summer and is especially prevalent during this time. This term refers to a scenario in which stone and concrete heat up during the day and do not sufficiently cool off at night. If the temperatures continue to rise as a result of climate change—at least two degrees Celsius by the year 2100 seems inevitable at this point—then the number of extremely hot days will continue to increase. On days such as this, a shady spot underneath a tree is very much a hot commodity.

Since many city residents do not have the luxury of having their own gardens, ideas are needed to help lower temperatures. In keeping with this ideal vision of a shady spot underneath a tree, green ideas are quickly becoming an area of focus. Plants are multi-functional. A tree, in addition to creating shade, absorbs water and then contributes to evaporation, which has a cooling effect. A 100-year old beech that is approximately 66 feet (20 meters) tall and has a 39-foot (twelve-meter) wide canopy consumes a whopping 106 gallon (400 liters) of water per day and then performs evaporation. This effect can be felt easily in a small park of approximately five acres (two hectares). It has its own cool microclimate that has definite effects on the surrounding environment. This cooling effect extends another 656 to 984 feet (200 to 300 meters) to the roads, where the heat is once again more prevalent. Therefore, the ideal approach would include many small parks that form a cooling network scattered throughout the concrete/stone districts of the city. A vision that will by no means always be realized,

as the influx of people into cities continues uninterrupted. Open areas are thus always coveted spaces for construction. The greenery must often make way for this construction, and be relocated to roofs or to building facades. These plants play a vital, effective role in these areas.

UP AND AWAY: GREEN DESIGNS
ARE TAKING OVER THE VERTICAL REALM.

For a long time, green facades were primarily viewed from ecological perspectives (example: as a habitat for insects). But they can do much more. They can act as natural air conditioning systems for buildings. Plants that cover the facades of old buildings help to insulate these buildings in the winter. On newer, well-insulated buildings, the focus is on the shade and cooling effect that occurs when the plants evaporate water (known as evaporation chill). So it's time to do away with the old ecological concept of green facades.

Botanist Patrick Blanc (see pages 176–181) has made art using greenery on facades. He created his first Mur Végétal above the entrance to the Fondation Cartier in Paris in 1998. It consists of a lush plant mural. He worked a long time at fine-tuning his design and even had it patented. From the irrigation system to the substrate, everything was coordinated to work flawlessly together. The design begins with a metal frame and

For a long time, green facades were primarily viewed from ecological perspectives (example: as a habitat for insects). But they can do much more. They can act as natural air conditioning systems for buildings.

irrigation pipes. The plants themselves are grown on acrylic felt and recycled acrylic fibers. Acrylic is used because, unlike natural fibers, it does not decompose. This thick network of fibers is great at retaining water, and it also acts as a culture medium for microorganisms such as mushrooms and mosses. Patrick Blanc drew inspiration for his

plant murals from his trips to tropical rain forests as a young man. He was fascinated by the plants growing almost everywhere he looked; not just on the ground, but also on rocks and roots. Plants, being frugal creatures, only need water, nutrients, and light. The Frenchman carefully selects the plant species that grow on his murals based on the climate zone. The Northern Hemisphere does not offer as many plants for the Mur Végétal as the Southern Hemisphere. The colder it is, the fewer prospective plants there are.

This plant specialist has found success with his idea. Since that time, he has created designs around the world and works with renowned architects such as Jean Nouvel. For Nouvel, he designed a green mural on the musée du quai Branly in Paris, the outer layer of a high-rise in Kuala Lumpur and, most recently, covered the facade of the One Central Park high-rise in Sydney in greenery. Like living carpets, the plants stick to the facades and breathe fresh, moist air out into the city. To be sure, Mr. Blanc's concept is not mainstream. The murals are difficult to maintain, particularly in harsh winter conditions when plants freeze. His murals are still works of art, but they are also beneficial to urban climates.

The same is true of the green high-rises designed by the architect Stefano Boeri in Milan, which he calls Bosco Verticale (meaning vertical forest). Over 700 trees and 20,000 bushes and shrubs grow on the balconies that jut way out from the two towers. This also requires a sophisticated irrigation system, and the plants were selected by a specialist with a deep knowledge of the subject area for this demanding, extremely difficult location. The purpose of the greenery in front of the apartments is not just to improve the air quality. They also provide insulation from the cold and heat.

The plant species on the terraces are expected to grow to a height of about 30 feet (nine meters). Extra-thick concrete slabs were installed in the

building to bear this extra weight. And Boeri's team traveled to Florida, which frequently experiences hurricanes, to research methods for planting trees that protect them from the wind. In the vases, which are over three feet (one meter) deep, there are wire racks that the roots of the tree species can cling onto.

Though the project entailed a significant workload—the trees had to be lifted onto the balconies with cranes, which took more than a year, and maintenance of the system is anything but simple—Boeri is already working on the next Bosco Verticale. The Mountain Forest Hotel in the Chinese province of Guizhou will also be covered with trees.

A PLUS FOR THE CLIMATE AND PEOPLE

Both of these examples represent the type of facade greening that is now garnering more interest in city centers. In the traditional approach, plants are grown in the ground and they eventually scale the building, but these newer systems do not require soil. The main challenge is to consider these systems during the design phase of the building because the goal is to incorporate the greenery into the architecture itself.

The same is true of roofs with greenery. They are also an investment in the future. They are another system for improving the climate in urban areas by cooling the environment through evaporation. And, like facade greening, they also create a more pleasant building climate. They achieve this by protecting and insulating roofs, storing rainwater and gradually evaporating this water. In any case, it will be increasingly important to collect as much water as possible in the future instead of guiding it directly to asphalt streets and sewer systems. The sewer systems in most cities are overstrained due to the extreme rain events associated with climate change. Another side effect can be observed. Green roofs provide new places of retreat in the city for bees, birds, bugs, and butterflies. People do not often visit rooftops with extensive greenery because these plants do

not require much care. As a result, they form their own habitat that is largely untouched. Full-scale roof greening is equally interesting in dense city centers that have few open areas. In this scenario, full-scale means nothing more than people being able to spend time on the roof and use it as one would a small park or garden. Their importance should not be overlooked because green areas serve as vital and pleasant oases for residents in city environments, which are all affected by the heat island effect.

PROJECTS TO CREATE MORE LIVABLE CITIES ON THE UPSWING

The great potential offered by green roofs is incentivizing many cities to develop strategies to promote these green roofs. For example, the Hanseatic City of Hamburg launched its green roof initiative in 2014. Since that time, the city has achieved considerable success. It now honors certain projects with the "Prize for Green Buildings," which is awarded to numerous innovative ideas involving green roofs. This includes a garden on the roof of a senior center where residents can take care of the various flowers as they would in a private garden.

A somewhat unusual example that, at first glance, has little to do with roofs is the High Line in New York. But ultimately, this park built on a former elevated railway line in Manhattan is a green roof in every sense of the term with the exception that it is not built on top of a building but on the steel design of the railway viaduct. The park walkway, designed by the landscape architect Field Operations, the architect Diller Scofidio + Renfro and the Dutch plant expert Piet Oudolf (see also pages 16–21 and 148–153) meanders for 1.5 miles (2.4 kilometers) through a sea of buildings in an area of southwestern Manhattan that was once run down. Most of the plants growing between the partially maintained tracks are native to the area. Goldenrod, birches, and grass give visitors the sense of being in the wild. But they are actually the result of a carefully coordinated

concept and, most importantly, regular care. This model of success has already spawned numerous imitations. In Chicago, there are plans to turn an abandoned railway line into a park, and in Atlanta, to create a green belt on a ring-shaped railway line around the city. There are similar ideas in Paris in the design of the Petite Ceinture, in Sydney for The Goods Line (see pages 182–185), and in Vienna for the High Line Park Vienna.

Together with the parks on the ground, these aerial gardens form a green network that makes cities livable. The denser the metropolitan areas are, the more varied the strategies have to be to design such a network. All green areas, both those on the ground and in the air, store rainwater and perform evaporation. In the future, the green mosaic of cities that acts as a refrigerator to create a pleasant climate (in the original sense of the word) within these cities will be become more diverse and will have to expand to all levels of the city.

171

Pflanzen als Alleskönner
Grüne Klimaanlagen und Oasen für Städte

Der Klimawandel trifft unsere Städte heftig. Denn dort geht es ohnehin deutlich extremer zu als im Umland: Es herrscht häufiger Smog, auch Nebel, Bewölkung und Niederschläge treten öfter auf. Und es ist wärmer, nicht zuletzt da die Verdunstung geringer ist als außerhalb der Stadt, wo mehr Bäume wachsen. Im Sommer macht sich dieser sogenannte Wärmeinseleffekt besonders unangenehm bemerkbar: wenn sich Steine und Beton tagsüber aufheizen und nachts nur wenig abkühlen. Steigen die Temperaturen im Zuge des Klimawandels weiter an – mindestens zwei Grad Celsius bis zum Jahr 2100 scheinen derzeit unausweichlich –, wird die Anzahl an Hitzetagen noch zunehmen. Ein schattiges Plätzchen unter einem Baum ist dann buchstäblich heiß begehrt.

Da längst nicht jeder Stadtbewohner den Luxus eines eigenen Gartens genießen kann, sind Ideen gefragt, die helfen, die Temperaturen zu senken. Und angesichts der Vision eines schattigen Plätzchens unter einem Baum rückt Grün schnell in den Fokus. Denn Pflanzen sind Alleskönner: Neben seiner Eigenschaft Schatten zu spenden, verdunstet ein Baum das Wasser, das er zuvor aufgenommen hat, und sorgt so zusätzlich für Abkühlung. Eine 100 Jahre alte Buche, etwa 20 Meter hoch und mit einer zwölf Meter breiten Krone verbraucht sage und schreibe 400 Liter Wasser am Tag – und verdunstet dieses auch wieder. Schon in einem kleinen Park von etwa zwei Hektar macht sich dies deutlich bemerkbar: Hier herrscht bereits ein eigenes, kühles Binnenklima – das durchaus auch Auswirkungen auf die Umgebung hat. Noch 200 bis 300 Meter weit reicht dieser erfrischende Effekt in die Straßen hinein, dann übernimmt wieder die Hitze. Ideal wären also viele kleine Parks, die sich wie ein kühlendes Netz durch die steinernen Stadtquartiere ziehen. Eine Vision, die sich jedoch längst nicht immer verwirklichen lassen wird, ist doch der Zuzug in die Städte ungebrochen. Freie Flächen sind daher immer auch begehrtes Bauland. Grün muss häufig weichen. Auf die Dächer. Oder aber auch an die Fassaden der Häuser. Dort ist es nicht minder wirkungsvoll.

HOCH HINAUS: DAS GRÜN EROBERT DIE VERTIKALE.

Lange Zeit wurden grüne Fassaden vor allem unter ökologischen Gesichtspunkten betrachtet, zum Beispiel als Lebensraum für Insekten. Doch sie können weit mehr: Sie funktionieren auch als Klimaanlagen für Gebäude. Bei Altbauten helfen Pflanzen, die die Fassaden bedecken, die Häuser im Winter zu isolieren. Bei gut gedämmten Neubauten stehen eher die Verschattung und die Kühle im Vordergrund, die entsteht, wenn die Pflanzen Wasser verdunsten, die sogenannte Verdunstungskälte. Zeit also, mit dem verstaubten Öko-Image von grünen Fassaden aufzuräumen.

Der Botaniker Patrick Blanc (siehe Seiten 176–181) hat aus Fassadengrün eine Kunst gemacht. Seine erste Mur Végétal schuf er 1998 über dem Eingang der Fondation Cartier in Paris: eine Pflanzenmauer aus üppigem Grün. An deren Aufbau hatte er lange gefeilt und ihn auch patentieren lassen. Von der Bewässerung bis hin zum Substrat wurde alles genau aufeinander abgestimmt: Die Konstruktion beginnt mit einem Metallgerüst und Bewässerungsrohren. Die Pflanzen selbst wachsen auf einem Filz aus Acryl und recycelten Acrylfasern. Acryl, da das Material im Gegensatz zu Naturfasern nicht verrottet. In dem dichten Fasernetz hält sich Wasser sehr gut, und es dient zugleich als Nährboden für Mikroorganismen wie Pilze und Moose. Inspiration für seine Pflanzenwände bekam Patrick Blanc durch seine Reisen als junger Mann in die tropischen Regenwälder. Dort faszinierten ihn die Pflanzen, die nahezu überall wuchsen, nicht nur auf dem Boden, sondern auch auf Felsen und Wurzeln. Genügsam wie sie sind, brauchen sie nur Wasser, Nährstoffe und Licht. Die Pflanzenarten, die auf seinen Wänden wachsen, wählt der Franzose sorgfältig aus, je nach Klimazone. Auf der Nordhalbkugel stehen daher nicht so viele Pflanzen für die Mur Végétal zur Verfügung wie auf der Südhalbkugel. Je kälter es ist, desto geringer ist die Auswahl.

Mit seiner Idee hat der Pflanzenspezialist Erfolg: Inzwischen ist er weltweit tätig und arbeitet mit renommierten Architekten wie Jean Nouvel zusammen, für den er eine grüne Wand am Museum Quai Branly in Paris gestaltete, die Außenhaut eines Hochhauses in Kuala Lumpur oder zuletzt die Außenseite des Hochhauses One Central Park in Sydney mit Grün überzog. Wie lebende Teppiche kleben die Pflanzen an den Fassaden und atmen frische, feuchte Luft in die Stadt. Massentauglich ist das Konzept von Blanc wohl nicht. Die Wände sind durchaus aufwendig im Unterhalt, wenn in strengen Wintern zum Beispiel Pflanzen erfrieren. Seine Wände bleiben eine Kunst. Aber eine, die dem Stadtklima zuträglich ist.

Gleiches gilt für das grüne Hochhausensemble des Architekten Stefano Boeri in Mailand, das er Bosco Verticale nennt, den senkrechten Wald. Über 700 Bäume und mehr als 20 000 Sträucher und Stauden wachsen an den Zwillingstürmen auf deren weit auskragenden Balkonen. Auch hier ist es ein ausgeklügeltes Bewässerungssystem nötig, und die Pflanzen wählte eine Spezialistin für den anspruchsvollen und extrem schwierigen Standort mit viel Fachkenntnis aus. Das Grün vor den Wohnungen soll nicht nur für eine bessere Luftqualität sorgen, sondern auch als Kältebeziehungsweise Wärmeschutz dienen.

Neun Meter hoch werden die Gehölze auf den Terrassen wachsen, so die Prognosen. Um diese Last tragen zu können, wurden extra dicke Betonplatten in das Gebäude eingezogen. Und

> **Lange Zeit wurden grüne Fassaden vor allem unter ökologischen Gesichtspunkten betrachtet, zum Beispiel als Lebensraum für Insekten. Doch sie können weit mehr: Sie funktionieren auch als Klimaanlagen für Gebäude.**

das Team von Stefano Boeri reiste ins hurrikan-erprobte Florida, um zu recherchieren, wie man Bäume windsicher pflanzt. Daher gibt es Roste in den über einen Meter tiefen Gefäßen, in denen sich die Wurzeln der Gehölze festkrallen sollen.

Auch wenn das Projekt hohen Aufwand erforderte – die Bäume mussten mit Kränen auf die Balkons gehievt werden, was insgesamt über ein Jahr dauerte, und auch die Unterhaltung der Anlage ist alles andere als einfach –, Boeri ist bereits mit dem nächsten Bosco Verticale beschäftigt: Auch das Mountain Forest Hotel in der chinesischen Provinz Guizhou soll mit Bäumen begrünt werden.

POSITIV FÜR DAS KLIMA UND DIE MENSCHEN

Die beiden Beispiele gehören zu dem Typ Fassadenbegrünung, der gerade in Innenstädten zunehmendes Interesse erfährt. Während bei der klassischen Variante die Pflanzen im Boden wachsen und die Fassade von dort aus erklimmen, sind diese neueren Systeme unabhängig vom Erdboden. Die große Herausforderung dabei ist es, sie schon in Entwurf für das Gebäude mitzudenken, denn das Grün wird hier zum Bestandteil der Architektur.

Gleiches gilt für begrünte Dachflächen: Auch sie sind eine Investition in die Zukunft. Denn sie verbessern ebenfalls das Klima im Stadtquartier, indem sie die Umgebung durch Verdunstung kühlen. Und sie helfen, ebenso wie die Fassadenbegrünung, ein angenehmeres Gebäudeklima zu schaffen: Indem sie die Dächer schützen und isolieren, aber auch, indem sie Regenwasser speichern und dieses Wasser dann sukzessive verdunsten. Ohnehin wird es künftig immer wichtiger sein, möglichst viel Wasser aufzufangen anstatt es direkt auf die asphaltierten Straßen und in die Kanalisation zu leiten. Denn mit den extremen Starkregenereignissen, die mit der Klimaerwärmung einhergehen, ist die Kanalisation der meisten Städte überfordert. Darüber hinaus lässt sich noch ein weiterer Nebeneffekt beobachten: Besonders auf naturnah gestalteten Dächern erobern Bienen, Vögel, Käfer

oder Schmetterlinge sich neue Rückzugsorte in der Stadt. Über extensiv begrünte Dachflächen gehen selten Menschen, da die Pflanzen dort wenig Pflege brauchen. Sie bilden so einen eigenen, weitgehend unberührten Lebensraum. Für die engen Innenstädte mit wenigen freien Arealen ist die sogenannte intensive Dachbegrünung nicht minder interessant. Intensiv bedeutet nichts anderes, als dass Menschen sich dort aufhalten und das Dach wie einen kleinen Park oder Garten nutzen können. Das ist nicht unwichtig, denn Grünflächen sind in den aufgeheizten Städten wichtige Wohlfühloasen für die Stadtbewohner.

PROJEKTE FÜR LEBENSWERTERE STÄDTE IM AUFSCHWUNG

Aufgrund dieser großen Potenziale von grünen Dächern erarbeiten bereits viele Städte eine Strategie, wie sich Grün auf Dachflächen fördern lässt. Zum Beispiel hat die Hansestadt Hamburg im Jahr 2014 ihre Gründachoffensive ins Leben gerufen. Seitdem erzielte sie beachtlichen Erfolg wie der ausgelobte Preis für Grünes Bauen der Stadt zeigt, mit dem zahlreiche innovative Ideen für Dächer ausgezeichnet wurden. Darunter ein Garten auf dem Dach eines Seniorenzentrums, auf dem die Bewohner sich wie im eigenen Garten zu Hause um die Blütenpracht kümmern können.

Ein etwas ausgefallenes Beispiel, das auf den ersten Blick mit einem Dach wenig zu tun hat, ist die High Line in New York. Und doch ist der Park auf der ehemaligen Hochbahntrasse auf in Manhattan letztendlich ein Gründach, nur dass darunter kein Haus steht, sondern die Stahlkonstruktion des Bahnviadukts. Auf 2,4 Kilometern schlängelt sich der Park-Laufsteg, entworfen von den Landschaftsarchitekten Field Operations, den Architekten Diller Scofidio + Renfro und dem niederländischen Pflanzenkenner Piet Oudolf (siehe auch Seiten 16–21 und 148–153) durch das Häusermeer in dem einst heruntergekommenen Viertel im Südwesten Manhattans. Zwischen den teilweise erhaltenen Gleisen wachsen vor allem einheimischen Arten: Goldrute, Birken und Gräser

sollen den Eindruck von Wildwuchs erwecken. Tatsächlich stecken dahinter aber ein fein abgestimmtes Konzept und vor allem auch regelmäßige Pflege. Das Erfolgsmodell hat bereits zahlreiche Nachahmer gefunden: In Chicago soll ebenfalls eine stillgelegte Eisenbahnlinie in einen Park verwandelt werden, in Atlanta ein Grüngürtel rings um die Innenstadt auf einem Bahn-Ring entstehen. Vergleichbare Ideen gibt es auch in Paris mit dem Petite Ceinture, in Sydney mit The Goods Line (siehe Seiten 182–185) und in Wien mit dem High Line Park Vienna.

173

Zusammen mit den Parks auf dem Boden bilden die luftigen Gärten ein grünes Netz, das die Städte lebenswert macht. Je dichter die Metropolen werden, desto variabler werden die Strategien sein müssen, um dieses zu gestalten. Grünflächen, egal ob unten oder oben, speichern Regenwasser und verdunsten es wieder. Das grüne Mosaik der Städte, das so als Kühlschrank fungiert, und daher so wichtig für ein – im ursprünglichen Sinne des Wortes – angenehmes Klima in den Städten ist, wird künftig vielfältiger werden und sich auf alle Etagen der Stadt ausweiten müssen.

Des plantes qui savent tout faire

Climatiseurs verts
et oasis pour les villes

Nos villes sont touchées de plein fouet par le changement climatique. Les extrêmes y sont de toute façon plus marqués que dans les campagnes environnantes : le smog est plus fréquent, de même que le brouillard, la couverture nuageuse et les précipitations. Il y fait aussi plus chaud, en particulier parce que l'évaporation est moindre qu'à l'extérieur des villes, là où poussent les arbres. En été, cet effet d'îlot de chaleur se faire sentir de manière plutôt désagréable, lorsque pierre et béton restituent la nuit la chaleur emmagasinée le jour. Si les températures continuent à croître à cause du changement climatique (au moins deux degrés Celsius semblent inévitables d'ici à 2100), le nombre de jours de canicule va encore augmenter. Et les places à l'ombre des arbres seront chères.

Chaque habitant ne pouvant pas se payer le luxe d'un jardin, il va falloir trouver des idées pour abaisser les températures. Et quoi de plus évident que de penser aux arbres et à la verdure quand on imagine des emplacements ombragés. Les végétaux savent tout faire : un arbre est capable de nous faire profiter de son ombre, mais il évapore aussi l'eau qu'il a absorbée au préalable, ce qui engendre un effet de rafraîchissement. Un hêtre centenaire mesurant environ 20 mètres et doté d'une couronne de douze mètres de large consomme pas moins de 400 litres d'eau par jour, puis la restitue sous forme d'évaporation. Imaginons un petit parc de deux hectares environ : il y règne un microclimat plus frais qui a sans aucun doute un impact sur les alentours. Il faut s'éloigner jusqu'à 200 à 300 mètres de la zone verte pour que l'effet de rafraîchissement diminue dans les rues et que la chaleur reprenne le dessus. L'idéal serait donc de créer de nombreux petits parcs qui constitueraient un réseau rafraîchissant à travers les quartiers minéralisés. Cette vision est toutefois bien loin d'être réalisable quand on voit à quel point la population

des villes ne cesse de croître. Les surfaces non occupées sont d'abord affectées aux constructions et la verdure doit céder la place. Restent les toits, ou même les façades des immeubles dont l'effet positif n'est pas moindre.

VERS LE CIEL : LE VERT À LA CONQUÊTE DE LA VERTICALITÉ.

On a longtemps vu les façades végétalisées uniquement dans une perspective écologique, par exemple comme espace de vie pour les insectes. Elles offrent pourtant bien plus que cela car elles jouent le rôle de climatiseurs pour les bâtiments. Sur les constructions anciennes, la végétation qui recouvre les façades contribue à l'isolation en hiver. Dans le cas des immeubles neufs bien isolés, on met plutôt l'accent sur l'ombrage et la fraîcheur qui apparait lorsque les plantes évaporent l'eau, pour donner ce qu'on appelle le froid d'évaporation. Il est donc temps de sortir de l'image ancienne purement écologique des façades végétalisées.

Le botaniste Patrick Blanc (voir les pages 176–181) en a fait un art. Il crée son premier mur végétal en 1998 au-dessus de l'entrée de la Fondation Cartier à Paris : une paroi de verdure luxuriante. Après avoir longtemps travaillé à sa conception, il l'a fait breveter. De l'irrigation au substrat, tout a été conçu avec précision : la structure est constituée d'une ossature en métal et de tuyaux d'irrigation. La végétation elle-même pousse sur un feutre en acrylique et des fibres d'acrylique recyclées. L'acrylique a été choisi parce qu'il ne pourrit pas, contrairement aux fibres na-

turelles. Ce dense réseau de fibres conserve très bien l'eau et sert en même temps de substrat nutritif pour les microorganismes tels que champignons et mousses. Pour concevoir ses murs végétaux, Patrick Blanc s'est inspiré de la forêt tropicale qu'il avait eu l'occasion de découvrir durant les voyages qu'il avait fait jeune. Il avait alors fasciné par les plantes qui poussaient presque partout, pas seulement sur le sol, mais aussi sur les rochers et les racines. Se satisfaisant de peu, ces végétaux n'ont besoin que d'eau, de substances nutritives et de lumière. Le botaniste français sélectionne soigneusement, en fonction des zones climatiques, les espèces qu'il implante dans ses murs. Dans l'hémisphère nord, on ne dispose donc pas d'autant de variétés pour les murs végétaux que dans l'hémisphère sud. Plus il fait froid, moins le choix est vaste. L'idée de Patrick Blanc a fait florès : aujourd'hui, il est demandé partout dans le monde et collabore avec des architectes de renom, tels Jean Nouvel pour lequel il a conçu un mur végétal pour le musée du Quai Branly, à Paris, réalisé la peau d'une tour à Kuala Lumpur, ou dernièrement revêtu de vert la façade de la tour One Central Park à Sydney. Comme des tapis vivants, les végétaux s'agrippent aux façades et respirent l'air frais et humide de la ville. Certes, le concept de Patrick Blanc n'est pas applicable en grande série. En effet, l'entretien des murs végétaux est coûteux, par exemple lorsque des plantes meurent de froid durant les hivers rigoureux. Mais ces murs sont un art, un art compatible avec le climat urbain.

Citons également l'ensemble de tours vertes réalisées par l'architecte Stefano Boeri à Milan, qu'il a baptisées bosco verticale, ou forêt verticale. Plus de 700 arbres et plus de 20 000 arbustes et buissons croissent sur les larges balcons des tours jumelles. Là encore, il faut un système d'irrigation très étudié, et les plantes ont été sélectionnées par une spécialiste pour s'adapter à un milieu

> On a longtemps vu les façades végétalisées uniquement dans une perspective écologique, par exemple comme espace de vie pour les insectes. Elles offrent pourtant bien plus que cela puisqu'elles jouent le rôle de climatiseurs pour les bâtiments.

174

exigeant et extrêmement difficile. La végétation qui enveloppe les logements est censée non seulement améliorer la qualité de l'air, mais servir aussi d'isolation contre le froid et la chaleur.

Selon les prévisions, les végétaux des terrasses devraient atteindre une hauteur de neuf mètres. Pour pouvoir porter cette charge, des dalles en béton d'épaisseur renforcée sont scellées dans la construction. Et l'équipe de Stefano Boeri s'est rendue en Floride pour étudier comment planter des arbres de façon qu'ils résistent au vent des ouragans de la région. Le principe consiste à intégrer des grilles dans des bacs de plus d'un mètre de profondeur, dans lesquelles viennent s'accrocher les racines des arbres et arbustes.

Même si le projet est très coûteux (il a fallu hisser les arbres sur les balcons avec des grues, ce qui a pris plus d'un an), et même si l'entretien est rien moins que simple, Boeri travaille déjà sur son prochain bosco verticale : situé dans la province chinoise de Guizhou, l'hôtel Mountain Forest doit également être revêtu d'une enveloppe de verdure.

UN EFFET POSITIF POUR LE CLIMAT ET LES PERSONNES

Ces deux exemples illustrent un type de végétalisation de façade qui suscite de plus en plus d'intérêt dans les centres-villes. Classiquement, les végétaux poussent dans la terre pour ensuite grimper le long des façades, alors que dans ces nouveaux systèmes, la croissance se fait sans lien avec le sol. Le grand défi consiste donc à intégrer la végétation dès le stade de la conception du bâtiment puisqu'elle fait partie intégrante de l'architecture.

Il en va de même pour les toits végétalisés : eux aussi sont un investissement dans l'avenir. En effet, ils améliorent également le climat des villes en rafraîchissant l'environnement par évaporation. Et ils contribuent à créer un climat intérieur plus agréable, de la même façon que les façades végétalisées : la végétation protège et isole les toits en stockant l'eau de pluie qui est ensuite restituée

progressivement par évaporation. De toute façon, il va être de plus en plus important de recueillir un maximum d'eau au lieu de la rejeter directement dans les rues goudronnées et dans les égouts. En effet, les épisodes pluvieux extrêmes devenant de plus en plus fréquents en raison du réchauffement climatique, il n'est pas rare que les égouts des villes soient surchargés. Par ailleurs, on peut observer un autre effet secondaire : sur les toits végétalisés, en particulier si leur réalisation les rapproche des espaces naturels, les abeilles, les oiseaux, les coléoptères et les papillons trouvent de nouveaux points de repli en ville. Les surfaces végétalisées de manière extensive sont très peu foulées par les personnes puisque les plantes qui y poussent demandent peu de soin. Il se forme de ce fait un espace naturel autonome et presque vierge. La végétalisation intensive des toitures n'est pas moins intéressante pour les centres urbains resserrés où les espaces dégagés sont rares. Ici, le caractère intensif signifie simplement que les personnes peuvent y séjourner et que les toits peuvent jouer le rôle d'un petit parc ou jardin. Cela n'est pas sans importance, car dans les villes chauffées, les surfaces vertes constituent d'importantes oasis de bien-être pour les citadins.

DES PROJETS POUR UNE MEILLEURE QUALITÉ DE VIE DANS LES VILLES

Ce potentiel des toits végétalisés amènent de nombreuses villes à mettre au point des stratégies pour favoriser la naturalisation des toitures. Un exemple : la ville hanséatique de Hambourg a lancé en 2014 une offensive pour des toits verts. Et la réussite est au rendez-vous comme le montre le prix de la construction verte décerné à la ville pour ses nombreuses innovations en faveur de la végétalisation des toits. On peut citer un jardin implanté sur le toit d'un centre pour personnes âgées, où les habitants peuvent s'occuper des fleurs comme dans leur propre jardin.

Un exemple un peu décalé, qui semble à première vue éloigné du sujet, est la High Line de New York. Et pourtant, le parc implanté sur

l'ancienne ligne de métro aérien à Manhattan est bien un toit vert, sous lequel ne se trouve pas un immeuble, mais la structure en acier du viaduc de chemin de fer. Serpentant sur 2,4 kilomètres, la passerelle conçue par les architectes paysagistes Field Operations, l'architecte Diller Scofidio + Renfro et le spécialiste hollandais des plantes Piet Oudolf (voir aussi les pages 16—21 et 148—153) traverse un océan de constructions d'un quartier autrefois délabré situé au sud-ouest de Manhattan. Entre les rails parfois conservés, les espèces présentes sont surtout indigènes : solidages, bouleaux et herbes donnent une impression de végétation sauvage. En réalité, tout cela est fait selon un concept très élaboré et bénéficie surtout d'un entretien régulier. Ce modèle est une réussite et a déjà suscité de nombreuses imitations : à Chicago, une ligne de chemin de fer réformée va aussi être transformée en parc, et à Atlanta, une ceinture verte va être créée autour du centre-ville sur une voie ferrée périphérique. Il existe des idées comparables à Paris, avec la Petite Ceinture, à Sydney, avec The Goods Line (voir les pages 182—185), et à Vienne, avec le High Line Park Vienna.

Associés aux parcs terrestres classiques, ces jardins aériens forment un réseau vert qui améliore la qualité de vie dans les villes. Plus les métropoles sont denses, plus les stratégies doivent être souples pour les aménager. Qu'ils soient au sol ou en hauteur, les espaces verts stockent l'eau de pluie qu'ils restituent sous forme d'évaporation. La mosaïque verte des villes, qui fonctionne alors comme un réfrigérateur et est donc si importante pour créer un climat agréable, au sens premier du terme, dans les villes, sera à l'avenir beaucoup plus diversifiée et devra s'étendre à tous les étages de la cité.

Patrick Blanc

Paris
France

The Parisian botanist helped provide over 300 buildings worldwide with a garden that grows on the façades.

Über 300 Gebäuden weltweit verhalf der Pariser Botaniker zu einem Garten, der an den Fassaden wächst.

Le botaniste parisien a déjà transformé en jardins les façades de plus de 300 bâtiments.

176

When people start talking about gardens that grow vertically, you'll immediately hear the name of the pioneer of this vegetation technique: Patrick Blanc. Since the 1970s he has been working with plants that grow in steep reaches without earth. Early on the French botanist discovered his love of tropical plants, especially those that fight their way upwards in extreme locations. All that matters is having enough water available. Even in temperate zones one finds these specialists that grow on cliffs, trees or walls. So Blanc experimented with vertical plantings to vegetate the walls of houses.

Of course, plants such as ivy and wisteria grew on houses, but they climbed directly on the masonry and were capable of damaging it. By contrast, the optimum foundation for vertical gardens that Blanc eventually developed is hung or placed in front of the wall. This is a metal frame with a 0.4-inch (one-centimeter) thick PVC sheet, upon which a polyamide felting is fastened that is prepared with pockets for holding plants, seeds or shoots, depending on the purpose and composition. Watering is done from above, with very little in the way of nutrient additives—the construction should never dry out.

Since debuting in 1986 with a green wall at the Cité des sciences et de l'industrie in Paris and attracting attention in 1994 with an object at the garden festival in Chaumont, Patrick Blanc has been in high demand among designers and architects. Today, his artistically planted walls are adding green to more than 300 buildings throughout the world. These are not gardens you can walk through, but they form biotopes and, as green installations, are pleasing to the eye.

Spricht man von Gärten, die in der Senkrechte wachsen, fällt sofort der Name des Pioniers dieser Vegetationstechnik: Patrick Blanc. Er beschäftigte sich seit den 1970er-Jahren mit Pflanzen, die an steilen Lagen ohne Erde wachsen. Früh entdeckte der französische Botaniker seine Liebe zu tropischen Pflanzen, besonders denjenigen, die sich an extremen Standorten nach oben kämpfen. Wichtig ist nur, dass ausreichend Wasser zur Verfügung steht. Auch in gemäßigten Zonen gibt es diese Spezialisten, die an Felsen, Bäumen oder Wänden wachsen. So experimentierte Blanc mit vertikalen Pflanzungen, um Hauswände zu begrünen.

Natürlich wuchsen Pflanzen wie Efeu oder Wisterien an Häusern, doch sie kletterten und klimmten direkt am Gemäuer und waren in der Lage, dieses zu beschädigen. Die optimale Grundlage für vertikale Gärten, die Blanc schließlich entwickelte, wird dagegen vor die Wand gehängt oder gestellt. Es handelt sich um einen Metallrahmen, darauf eine ein Zentimeter dicke PVC-Folie, auf der ein Filzstoff aus Polyamid befestigt wird, bereits mit Pflanztaschen zur Aufnahme von Pflanzen, Saatgut, Stecklingen, je nach Zweck und Komposition. Bewässert wird von oben, mit sehr wenig Nährstoffzugaben – austrocknen sollte die Konstruktion nie.

Seit Patrick Blanc 1986 mit einer grünen Wand am Pariser Museum für Wissenschaft und Technologie sein Debüt hatte und 1994 mit einem Objekt auf dem Gartenfestival in Chaumont Aufmerksamkeit erregte, war er bei Designern und Architekten sehr gefragt. Heute begrünen seine kunstvoll bepflanzten Wände mehr als 300 Gebäude in aller Welt. Betretbar sind diese Gärten nicht, aber sie bilden Biotope und sind als grüne Installationen eine Freude fürs Auge.

Lorsqu'on parle de jardins verticaux, on ne peut pas passer à côté du nom du pionnier de cette technique végétale : Patrick Blanc, l'homme qui travaille depuis les années soixante-dix sur les plantes capables de pousser sans terre sur des supports verticaux. Le botaniste français a découvert tôt son attrait pour les plantes tropicales, en particulier celles qui, bien que dans des sites difficiles, luttent pour se frayer un chemin vers le haut. Seul point important : l'eau doit être disponible en quantité suffisante. Mais ces plantes spécialistes des rochers, des arbres ou des murs, on en trouve aussi sous nos climats tempérés. C'est ainsi que Patrick Blanc expérimenta des plantations verticales afin de verdir les murs d'immeubles.

Dans la nature, des plantes comme le lierre ou la glycine poussent sur les maisons, mais elles y grimpent et se hissent en s'accrochant directement aux murs qu'elles endommagent. C'est pour cela que Patrick Blanc décide de concevoir un support pour jardins verticaux qui s'accroche ou se pose devant le mur. Il s'agit d'un cadre métallique sur lequel repose un film de PVC d'un centimètre d'épaisseur, auquel est fixé un feutre de polyamide portant des poches destinées à recevoir les plantes, les graines, les boutures, selon l'objectif et la composition recherchés. L'irrigation se fait par le haut, avec très peu d'apports nutritifs, l'essentiel étant que la structure ne se dessèche jamais.

En 1986, Patrick Blanc commence à végétaliser un mur de la Cité des sciences et de l'industrie à Paris, puis attire l'attention en 1994 en présentant une création au festival des jardins de Chaumont. Depuis, il est très demandé par les designers et les architectes et ses murs végétalisés de manière artistique embellissent plus de 300 bâtiments dans le monde. Même si on ne peut pas y flâner, ces jardins sont de véritables biotopes qui ne cessent de réjouir le regard.

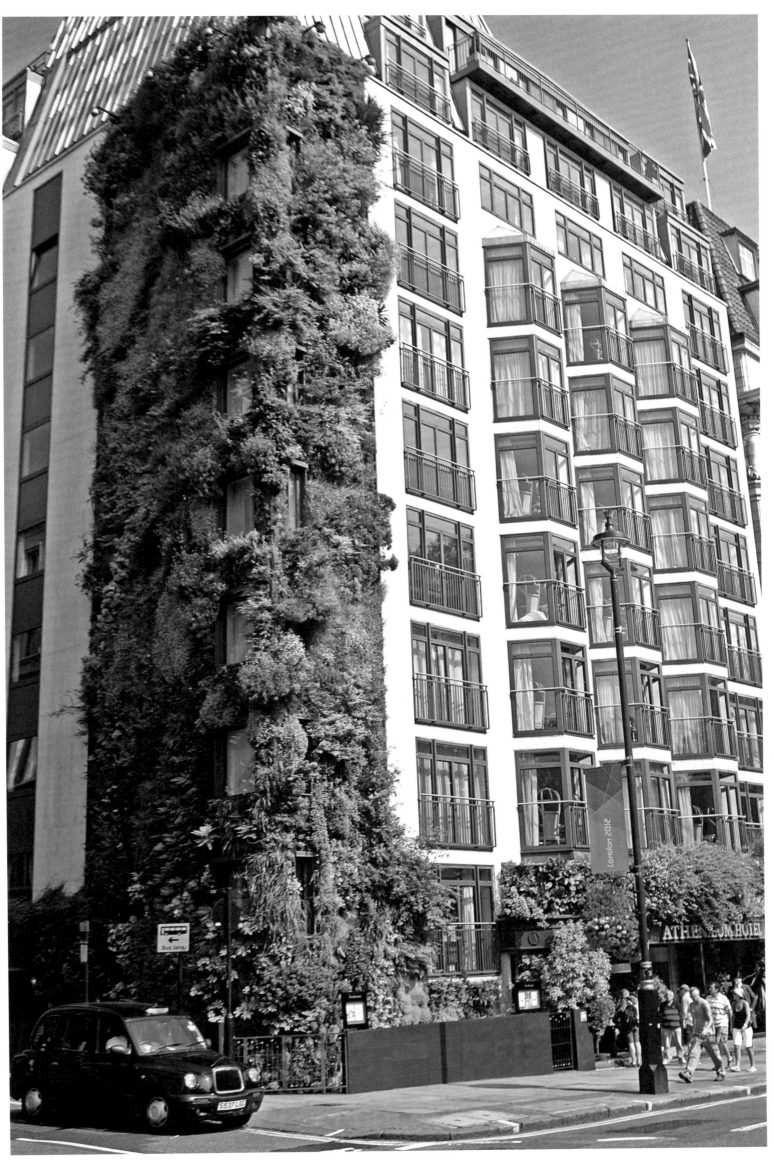

The Athenaeum
Hotel in London
obtained a vertical
garden from Patrick
Blanc in 2009,
which climbs all the
way to the top on its
corner.

Das Athenaeum
Hotel in London
wurde 2009 mit
einem vertikalen
Garten von Patrick
Blanc versehen, der
sich über die Ecke
ganz nach oben
hangelt.

L'hôtel Athenaeum
de Londres a été
pourvu en 2009 d'un
jardin vertical de
Patrick Blanc qui
se hisse vers le
haut en tournant
autour de l'angle.

Patrick Blanc

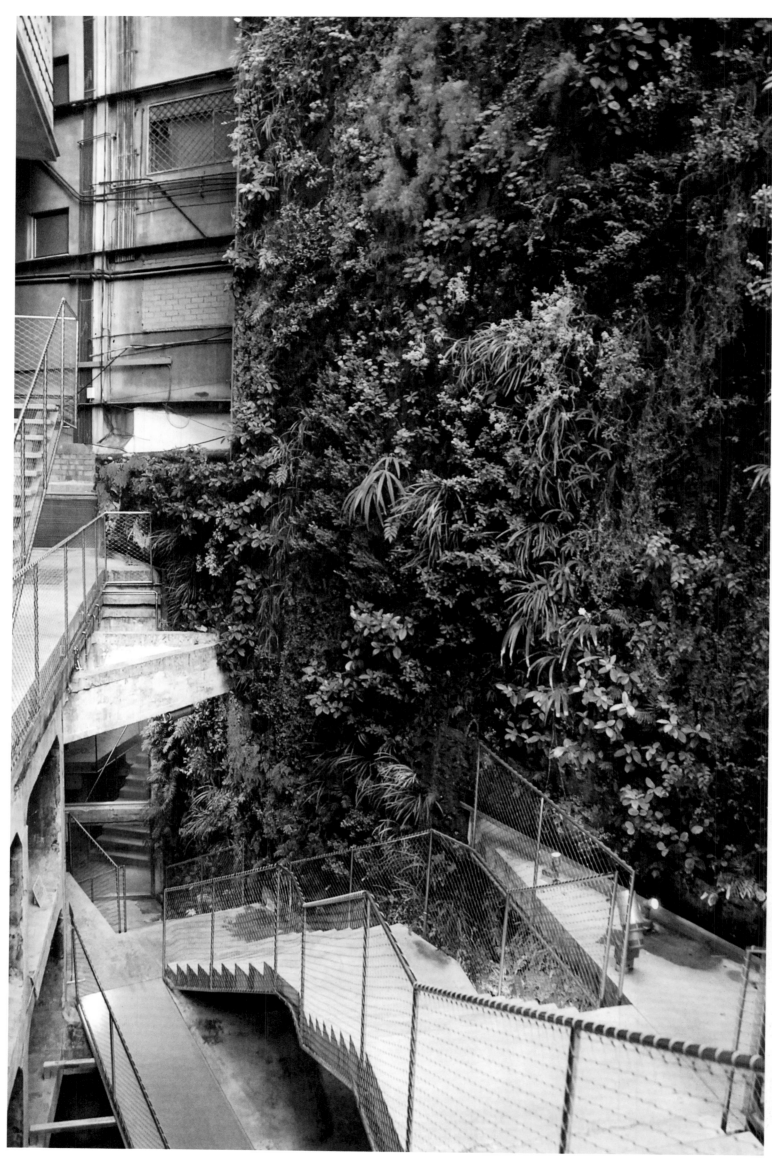

When the 19th-century building of the Moritz brewery in Barcelona was renovated by Jean Nouvel, the complex also received a vertical garden from Patrick Blanc.

Mit dem Umbau des aus dem 19. Jahrhundert stammenden Brauereigebäudes Moritz in Barcelona durch Jean Nouvel erhielt der Komplex auch einen vertikalen Garten von Patrick Blanc.

Lorsque Jean Nouvel transforme le bâtiment de la brasserie Moritz datant du 19e siècle, à Barcelone, le complexe bénéficie d'un jardin vertical conçu par Patrick Blanc.

178

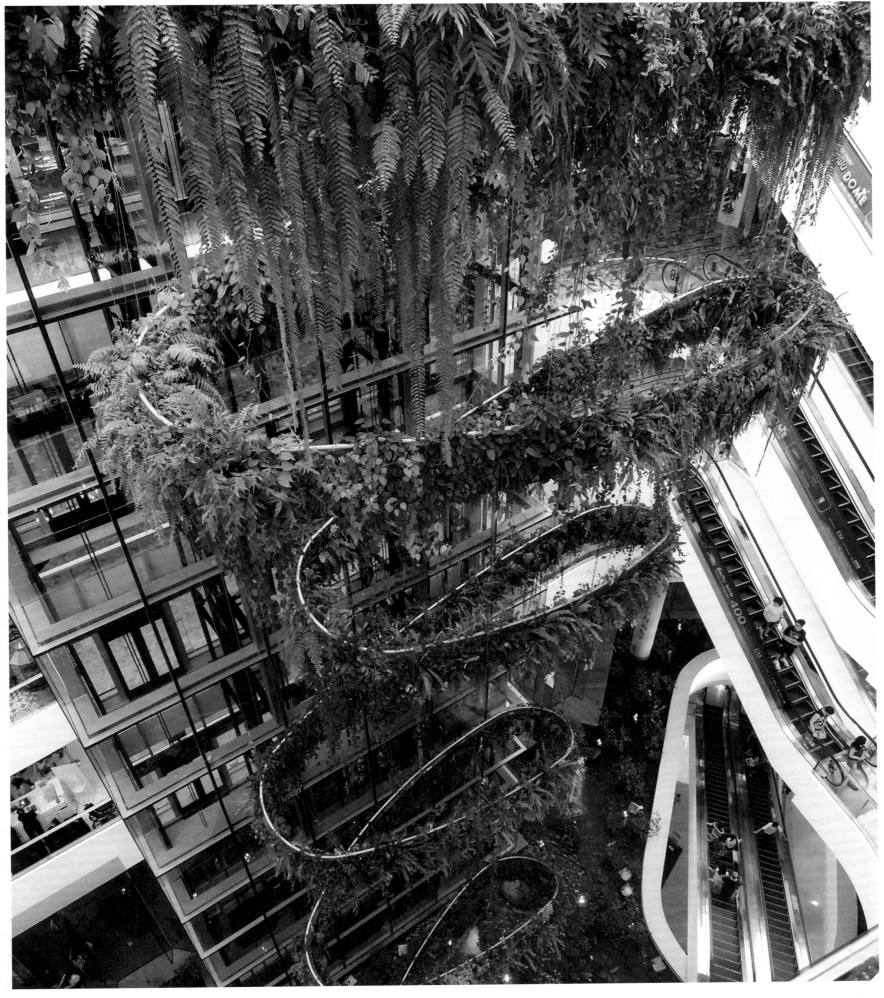

179

"Rain Forest Chandelier" is what Patrick Blanc calls this free-hanging plant-covered construction with a length of 338 feet (103 meters) in the EMQuartier, a shopping center in Sukhumvit, Bangkok (2015).

„Regenwald-Kronleuchter" nennt Patrick Blanc diese 103 Meter lange frei hängende bewachsene Konstruktion im EMQuartier, einem Einkaufszentrum in Sukhumvit, Bangkok (2015).

« Lustres de forêt équatoriale » : c'est ainsi que Patrick Blanc baptise cette structure végétalisée suspendue de 103 mètres de long qui se trouve dans l'EMQuartier, un centre commercial de Sukhumvit, à Bangkok (2015).

Patrick Blanc

Miramas, Mas de la Peronne: In Provence, an outlet center from McArthurGlen opened with an impressive green wall from Patrick Blanc that captivates your attention.

Miramas, Mas de la Peronne: In der Provence öffnete ein Outletcenter von McArthurGlen, das durch eine beeindruckende grüne Wand von Patrick Blanc besticht.

Miramas, Mas de la Péronne : en Provence, un magasin d'usines de McArthurGlen se distingue par une impressionnante paroi verte réalisée par Patrick Blanc.

180

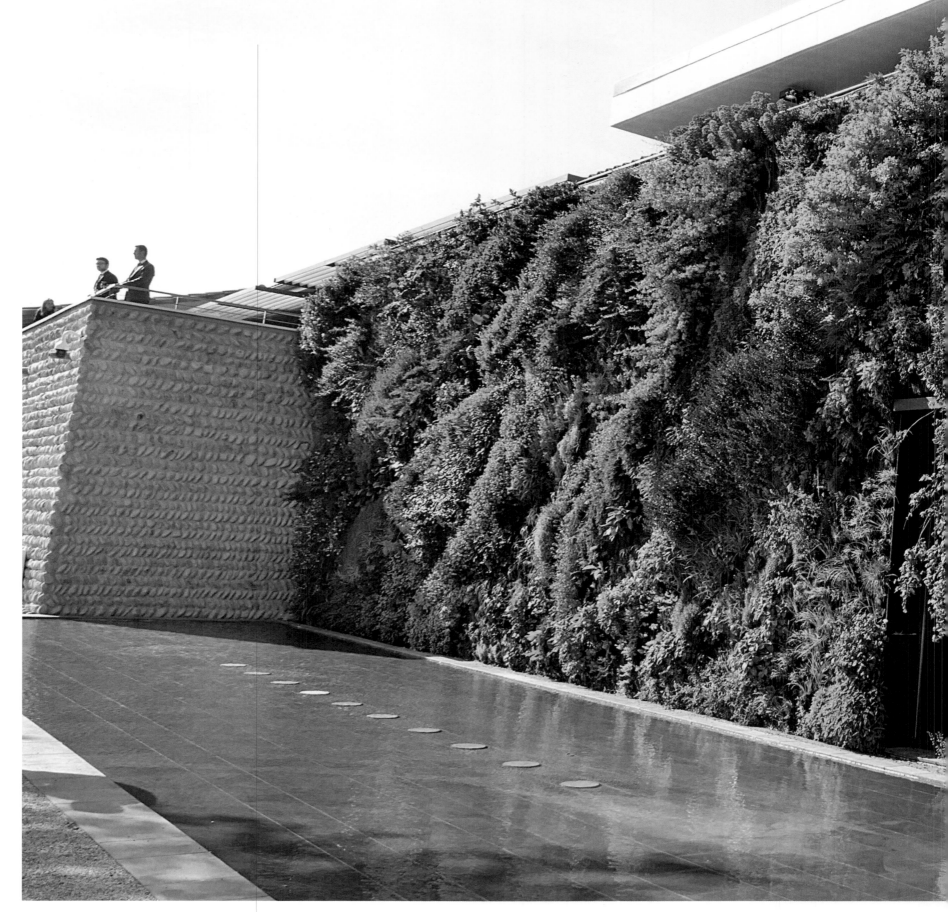

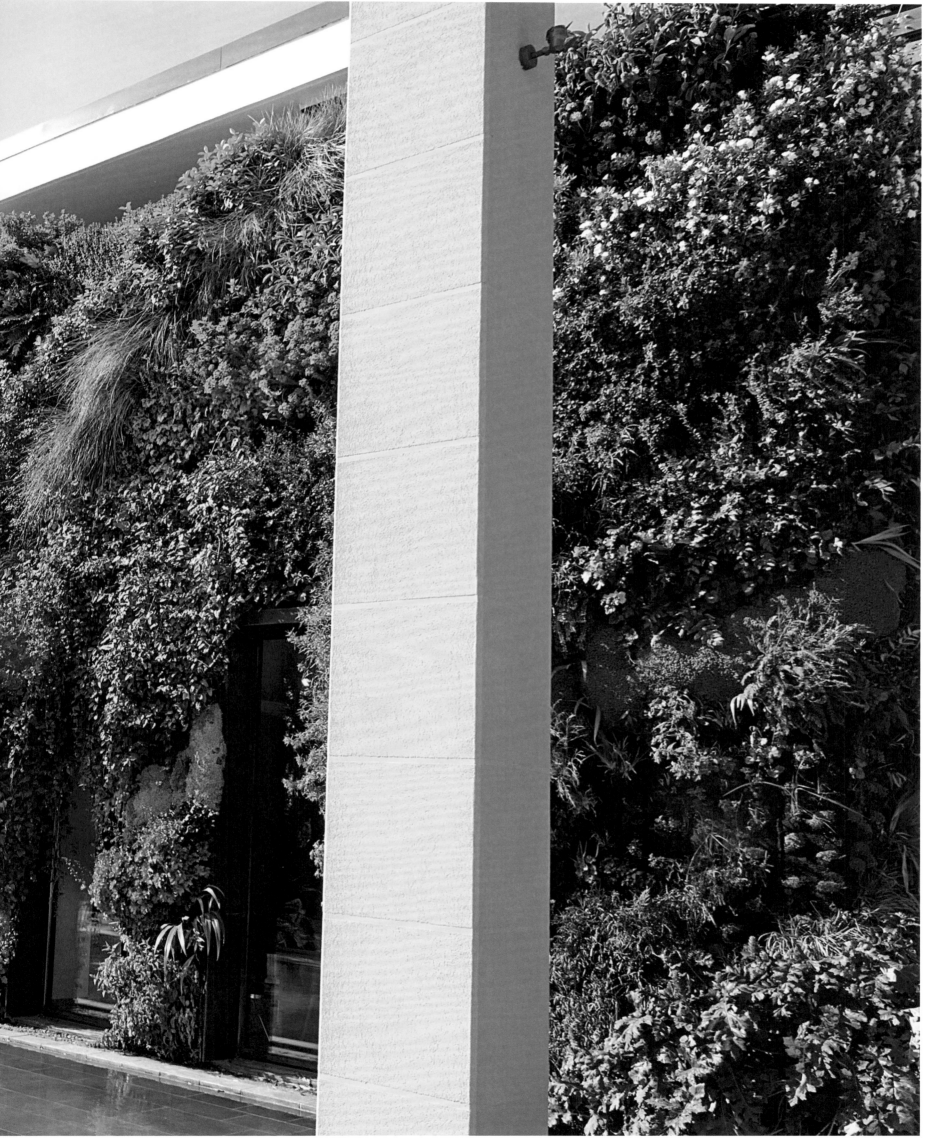

Patrick Blanc

Aspect Studios

Sydney | Australia

Aspect Studios designs spaces for social interaction, as attested to by an adventure playground and linear park. | Aspect Studios gestaltet Orte für soziale Interaktion – wie eine Spiellandschaft und ein linearer Park belegen. | Aspect Studios conçoit des lieux d'interaction sociale, ou comment aménager un paysage ludique et un parc linéaire.

The adventure playground consists of separate areas such as the bamboo forest, the jungle or the prehistoric area, featuring tree ferns, dracaena, and Ponytail Palm.

Die Spiellandschaft besteht aus verschiedenen Zonen wie dem Bambuswald, dem Dschungel oder der prähistorischen Zone mit Baumfarnen, Dracaenen und Elefantenfuß.

Le paysage ludique est composé de plusieurs zones, par exemple une forêt de bambous, une jungle ou encore une zone préhistorique où poussent des fougères arborescentes, des dragonniers et des nolines recourbées.

In the midst of a park in Sydney, the Ian Potter Children's Wild Play Garden playground captivates the imagination thanks to its thick vegetation of 13,000 plants and trees. Children can experience nature, have a little adventure and sharpen their senses—they play and learn without specified structures. The Goods Line (see following pages) is a linear park on an old railway line in a densely populated district of Sydney. Previously isolated areas have been reconnected and have become a popular gathering point for all groups of people.

Inmitten eines Parks in Sydney besticht der Spielplatz Ian Potter Children's Wild Play Garden durch seine dichte Vegetation aus 13 000 Pflanzen und Bäume. Hier können Kinder Natur erleben, auch etwas wagen und ihre Sinne schärfen – sie spielen und lernen ohne vorgegebene Strukturen. The Goods Line (nächste Doppelseite) ist ein linearer Park auf einer alten Bahntrasse in einem dicht besiedelten Stadtteil Sydneys. Ehemals isolierte Gebiete wurden wieder miteinander verbunden und so zum beliebten Treffpunkt für alle Bevölkerungsschichten.

Au cœur d'un parc de Sydney, le terrain de jeu appelé Ian Potter Children's Wild Play Garden séduit par la densité de sa végétation composée de 13 000 arbres et végétaux. Ici, les enfants peuvent ressentir la nature, mais aussi oser et aiguiser leurs sens, tout en jouant et en apprenant sans structures imposées. The Goods Line (double page suivante) est un parc linéaire situé sur une ancienne voie ferrée, dans un secteur très peuplé de Sydney. Il a permis de recréer un lien entre des quartiers autrefois isolés, devenant ainsi un lieu où toutes les couches de la population apprécient de se rencontrer.

183

The Artesian Water
Play tells the story
of Australia as the
driest continent on
the earth. Its great
artesian water basin
below brings life
to the landscape
demonstrating how
vital water is to the
ecosystem.

Das Artesian Water
Play erzählt die
Geschichte von
Australien als dem
trockensten Konti-
nent der Erde. Sein
großes artesisches
Wasserbecken,
das die Landschaft
belebt, zeigt, wie
wichtig Wasser für
das Ökosystem ist.

L'Artesian Water
Play raconte l'his-
toire de l'Australie,
continent le plus
sec de la terre. Le
paysage est animé
par un grand bassin
artésien conçu pour
démontrer l'impor-
tance de l'eau pour
les écosystèmes.

Aspect StudiosAspect Studios

184

The Goods Line—
a human centered
place offering a
range of social
experiences from
the individual to
collective and for
all demographics.
It is both a strategic
link and gathering
spaces. Several
design details re-
ference its former
industrial heritage.

The Goods Line ist
ein auf den Men-
schen ausgerichte-
ter Platz, der eine
Reihe von sozialen
Erfahrungen – vom
Individuum bis zum
Kollektiv – und für
alle Bevölkerungs-
schichten bietet. Er
ist sowohl strategi-
sches Bindeglied
als auch Treffpunkt.
Mehrere Details im
Design verweisen
auf sein früheres
industrielles Erbe.

The Goods Line est
un lieu conçu pour
l'Homme, offrant à
toutes les couches
de population un
ensemble d'expé-
riences sociales
allant de l'individu
au groupe, à la fois
lien stratégique et
point de rencontre.
Plusieurs détails
de conception font
référence à son
passé industriel.

Aspect Studios

Studio Jungles

Coconut Grove, Miami, Florida | USA

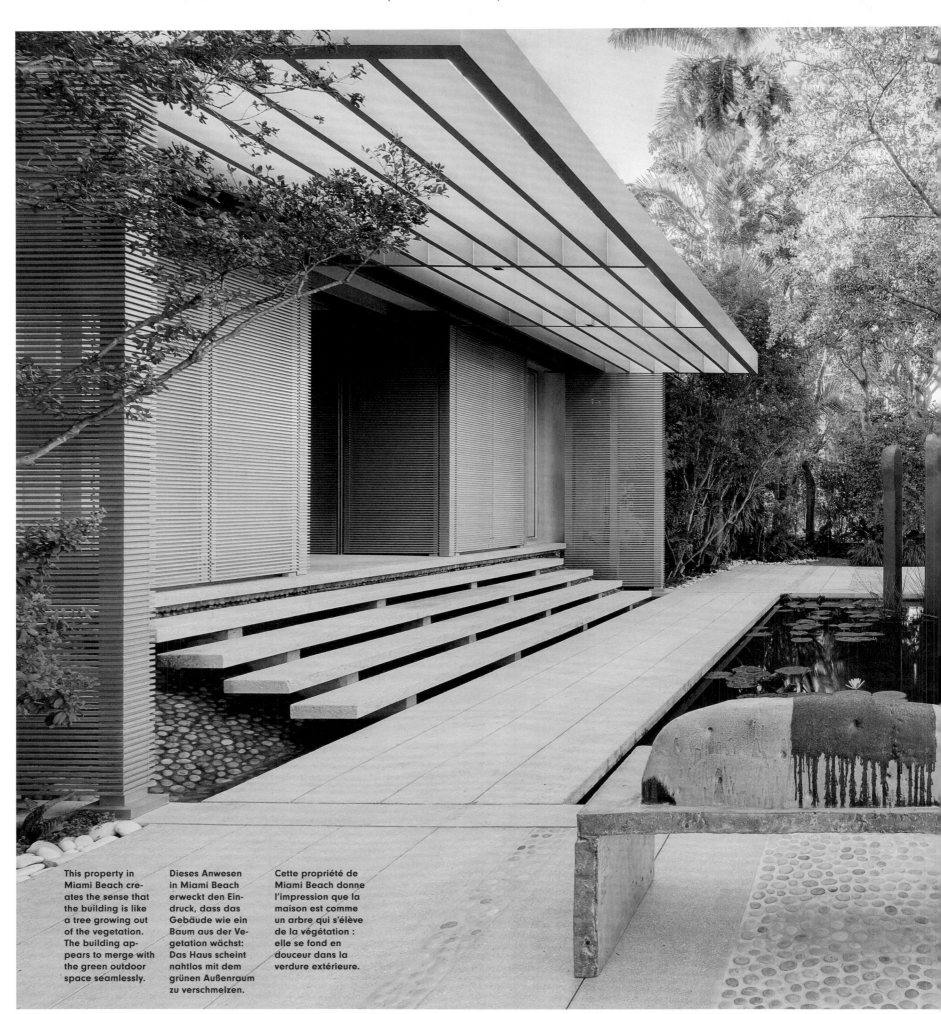

This property in Miami Beach creates the sense that the building is like a tree growing out of the vegetation. The building appears to merge with the green outdoor space seamlessly.

Dieses Anwesen in Miami Beach erweckt den Eindruck, dass das Gebäude wie ein Baum aus der Vegetation wächst: Das Haus scheint nahtlos mit dem grünen Außenraum zu verschmelzen.

Cette propriété de Miami Beach donne l'impression que la maison est comme un arbre qui s'élève de la végétation : elle se fond en douceur dans la verdure extérieure.

Raymond Jungles turned his passion for landscape architecture and design into his vocation.
Raymond Jungles machte die Leidenschaft für Landschaftsarchitektur und Design zu seiner Berufung.
De sa passion pour l'architecture paysagère et le design, Raymond Jungles a fait une vocation.

Just one year after graduating with honors from the University of Florida, Jungles founded his own landscape architecture agency— a long-standing dream. He has since worked with his team on countless projects, where he maintains constant awareness of his environmental responsibility. In his designs for gardens and parks, he breaks nature down to a smaller scale. His aspiration is to bring the timelessness and beauty of the natural environment as well as calming effects of nature into our cities.

Nur ein Jahr, nachdem Raymond Jungles an der Universität von Florida sein Studium mit Auszeichnung abschloss, gründete er sein eigenes Landschaftsarchitekturbüro – ein lang gehegter Traum. Seitdem arbeitete er mit seinem Team an unzähligen Projekten, wobei er sich stets seiner Verantwortung für die Umwelt bewusst ist. Die von ihm gestalteten Gärten und Parks brechen die Natur auf einen kleineren Maßstab herunter. Sein Anspruch: die Zeitlosigkeit und Schönheit der natürlichen Umgebung sowie die beruhigende Wirkung der Natur in unsere Städte zu holen.

Un an seulement après avoir terminé brillamment ses études à l'université de Floride, Raymond Jungles fonde son studio d'architecture paysagère, réalisant ainsi un vieux rêve. Depuis, lui et son équipe ont travaillé sur un très grand nombre de projets dans lesquels il a toujours su assumer sa responsabilité environnementale. Les jardins et parcs qu'il a créés sont un reflet de la nature à échelle réduite. Ce que recherche Raymond Jungles, c'est à faire entrer dans nos villes l'intemporalité et la beauté de l'environnement naturel ainsi que son effet apaisant.

187

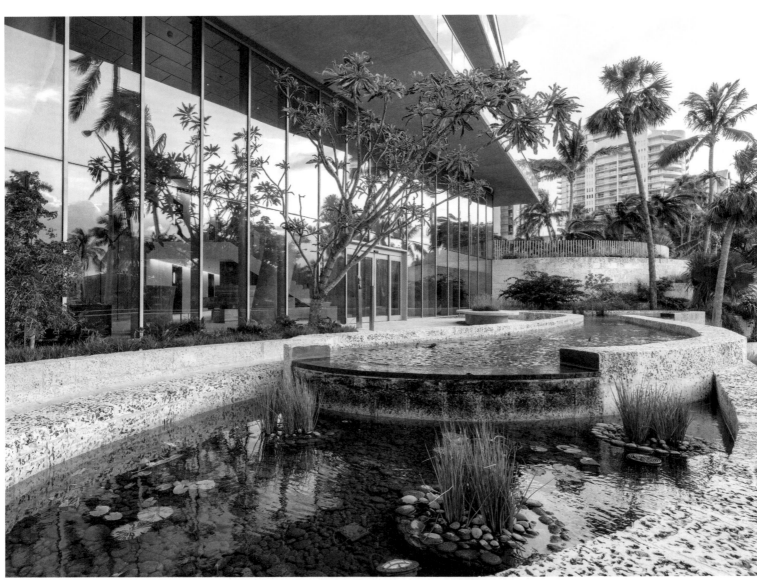

In Coconut Grove, Jungles stretched a web of gardens with curving forms, gracious ramps and twisting palm trees to complement the high-rise complex designed by the Bjarke Ingels Group.

Um den von Bjarke Ingels Group entworfenen Hochhauskomplex in Coconut Grove zu ergänzen, spannte Jungles ein Netz aus Gärten mit geschwungenen Formen, anmutigen Rampen und sich krümmenden Palmen.

Pour compléter le complexe de gratte-ciels de Coconut Grove conçu par le Bjarke Ingels Group, Jungles a créé un maillage de jardins aux formes sinueuses, aux rampes gracieuses et aux palmiers courbés.

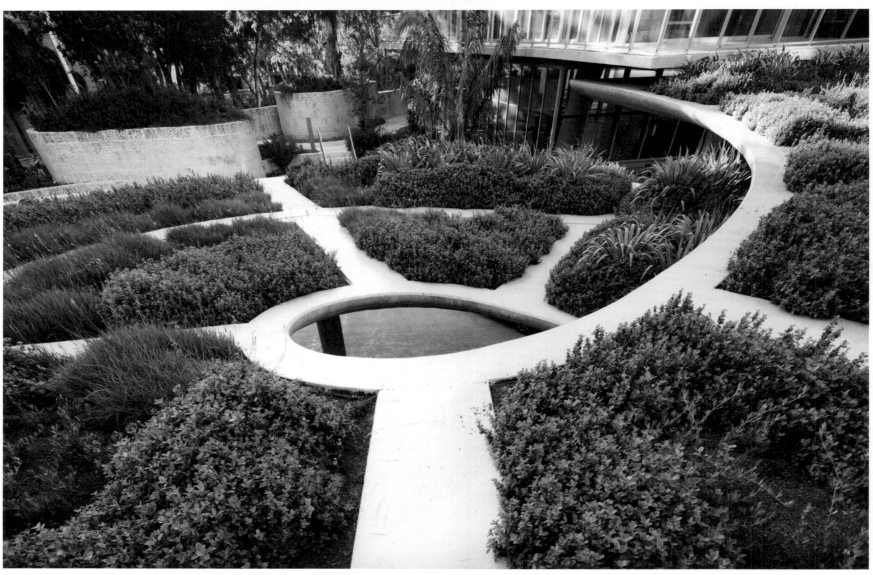

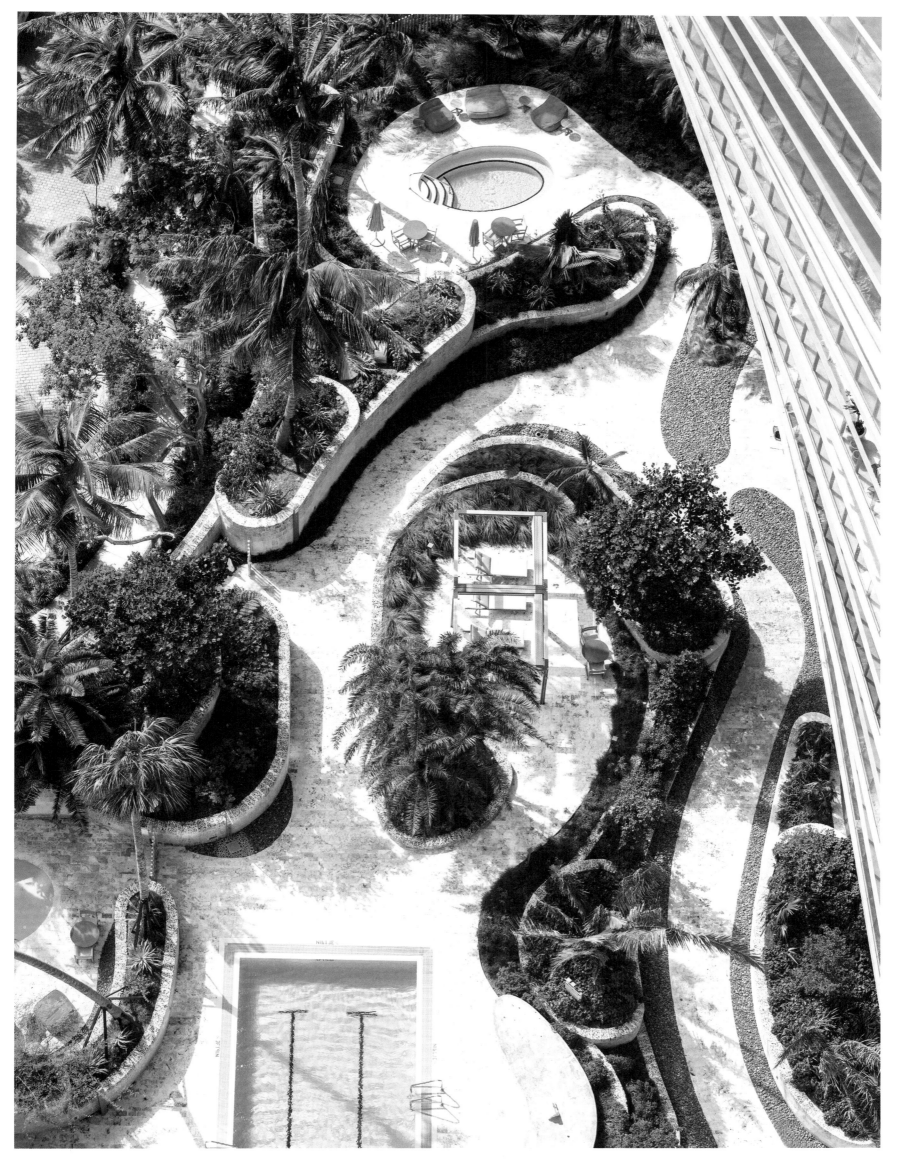

Studio Jungles

The Everglades are the inspiration for this piece of nature at the mall on Miami Beach's 1111 Lincoln Road (collaboration with Herzog & de Meuron).

Die Everglades standen Pate für dieses Stück Natur in der Mall an der Lincoln Road 1111 von Miami Beach (Zusammenarbeit mit Herzog & de Meuron).

Les Everglades ont inspiré ce morceau de nature implanté dans le centre commercial situé sur la Lincoln Road 1111 à Miami Beach (collaboration avec les architectes Herzog & de Meuron).

Urban Green Spaces
Significance of Gardens and Parks in Urban Areas

It is not the buildings that make a city unique. It is the people, their interactions and the open areas, especially the green gardens and parks.

Cities are not self-sustaining. Their success always relies on their connection to the rural areas that provide raw materials. Rome would not have existed without wheat from North Africa, and Hamburg would not be viable without food from the Altes Land (an adjacent area). It is deceptive to think all the buildings in densely built cities were always built right next to each other, made only of stone. The Babylonians created gardens, making them trendsetters of urban culture. This was not just for the purposes of representation or rituals—they were created to delight the senses and to provide a pleasant place to visit in everyday life. They were places of joy because, at the time, society did not believe in an afterlife and preferred to seek happiness in the here and now. The Hanging Gardens of Semiramis are among the ancient wonders of the world. They consist of a 98-foot (30-meter) high, terraced hanging garden landscape, supplied with water from the Euphrates.

Even Assyrians and Persians created sprawling irrigated landscape parks with animals and ponds in barren regions. They were initially created as enclosed palace gardens, which later gave the Greeks the name *Paradeisos* from Old Persian. This conception of the sensual garden as a paradise was incorporated into various religions and became a concrete concept of the good life in all cultures. However, water was the first requirement for flourishing. In Egypt, gardens soon stretched along the Nile—preferably near temples.

As inventors of the *polis* (city-state), the Greeks did not seem to have green thumbs, and there was no space for garden design in the densely built cities. Private life was confined to courtyards. Initially, this was also true of the Romans in their urban villas. It was only at their legendary country estates where they indulged in and advanced garden design, as can be seen in the preserved murals in Pompeii and the writings of Pliny the Younger. The rich Romans were farmers. Slaves were forced to work but, of course, their efforts are not recognized in the history of garden design. In the 2nd century BC, public gardens found their way into cities, as well as art, and created intimate green spaces in the courtyards through irrigation. It was these walled gardens with water and fragrant plants that became a model of success in the Arabian region. The art of designing shady, enclosed flower gardens was made its way from Morocco and Spain and across the Levant to medieval Europe, where the privileged classes reveled and indulged all their senses in castle and cloister gardens.

During antiquity and the Middle Ages, there were also undeveloped areas within city limits amidst houses made of clay, wood, and stone. However, these areas were rarely used for leisure. They were fruit or vegetable gardens or commons that were pastures. In the laws for Las Indias from the 16th century, the Spaniards stipulate that a common area should be defined within the city that is large enough to serve as a recreation area for people and a pasture for livestock despite the anticipated population growth.

It was still a long time until the common city dweller and his dog gained ownership of the city park and jogging became ubiquitous, replacing field work. Since time immemorial, even the private gardens of the noble or wealthy have been restricted and, at certain times, made accessible to the public (even in China during the Song Dynasty). Even in Rome, some private green spaces were accessible. In his will, Julius Caesar left his gardens in Trastevere to the public.

In the 17th century, access to the property of the crown became custom law in England. Hyde Park became a public park around 1630. The Tiergarten in Berlin, which is a royal hunting ground, has been open to the public for recreational walks since 1649. Even in pre-revolutionary France, the public was granted access to parks in Montpellier, Nîmes or Nancy, just for the purposes of strolling.

Ludwig XIV allowed ramparts that had become obsolete in Paris to be turned into promenades, which came to be known as boulevards. This was the first public green space in a city. Berlin, as well as cities such as Hanover and Graz, followed this example a hundred years later. The idea to rededicate useless military facilities as parks continued to be a model of success into the 19th century. Hamburg designed the park Planten un Blomen and Copenhagen designed the world-renowned amusement park Tivoli in 1843. This amusement park aided the absolutist king of Denmark, who was behind the times, in successfully ridding his people of thoughts of revolution. Before this time, accessible royal parks such as Regent's Park in London were only reserved for horsemen and carriages. The people were not taken into account; no footpaths were made.

The modern city park that was designed with commoners in mind was likely born in 1789, a year of revolution, when Friedrich Ludwig von Sckell designed the English Garden in Munich. The park, decreed by Elector Charles Theodore, was designed according to the German conception of the public garden to foster contact with the social classes and promote popular education. Another example is Birkenhead Park, built by Joseph Paxton in Liverpool, England in 1843. In this park, the paths for horsemen and pedestrians were separate. Around 1865, most districts of London had public parks. In Paris, a series of green spaces such as Parc Monceau and Buttes-Chaumont were designed as a part of Haussmann's renovation.

In their designs for Central Park in New York and Prospect Park in Brooklyn, Frederick Law Olmsted and Calvert Vaux were heavily influenced by Birkenhead and by the rural Mount Auburn Cemetery near Boston. To this day, Central Park is still the reference point for urban landscape architecture because Olmsted discovered that cities can be planned around parks. Life in the US metropolitan areas, with numerous immigrants, was not always placid. The Irish and Italians, for

example, formed their own neighborhoods. Olmsted's idea was to look past ethnic identities in order to make immigrant workers feel like true Americans. The purpose of the park was to improve the lifestyle of workers through contact with those of higher social ranking in a tranquil setting. He wanted to dissuade workers from the base amusements of sports!

In Germany, Peter Joseph Lenné's star rose. In 1824, he designed the first public garden, which was commissioned by a municipal city government. Starting in 1832, he fully renovated the Berlin Tiergarten, turning it into a recreational park. However, as cities grew and the number of residents increased drastically during the beginning of industrialization, the urban centers were not well equipped and living conditions were precarious. During this time, there were attempts made to prevent proletarian revolutions by designing public parks such as recreational, amusement and sports parks in order to keep things calm. In some cities, primarily in Berlin, Fritz Schumacher designed many public parks in the early 20th century, including in Hamburg in 1911.

It was Martin Wagner who wrote about "the sanitary green spaces of cities" in 1915, using a term that had been coined by city planner Camillo Sitte back in 1889. Wagner understood this as referring to "social green spaces" and defined per capita guidelines for open areas. After World War I, Berlin created nine additional public parks within ten years. This concept had been shown to be successful for the growing cities. The focus was on the need of city residents for recreational and walking areas that went beyond organized walking and the use of just a few recreational areas. The typical public park includes large, central, adjacent and walkable recreational and sports areas.

Many elements of the city park are now part of the standard repertoire for successful park design. But first, the cities and their residents had to suffer the consequences of city design during the era of modernity. Although extreme urban landscape ideas from Ludwig Hilberseimer and Le Corbusier were not implemented, many planners and politicians appreciated their ideas of the car-friendly city with Unité d'habitation housing design and separated life functions. We know what the results were, in both Europe and America.

The fight for a humane and human-focused city was revived in the 1960s: Sociologists, psychologists, and architects began to take an interest in people and their needs in urban environments. The state of modern planning, which includes public participation, is based on this work. Danish architect and city planner Jan Gehl focuses on the use of public space and city life between the buildings. For decades, he has been traveling around the world and advising municipalities on how to create livable city spaces. For a long time now, the focus has not been solely on creating large parks, but rather on creating open spaces in the vicinity of residential areas and taking back city space from motorized traffic.

The most interesting incentive to create parks was through new uses of industrial or traffic areas not currently in use. It started with Gas Works Park in Seattle and did not end with the spectacular High Line Park in New York, a city garden on an abandoned railway line. Other examples include the Westergasfabriek in Amsterdam and the Park at Gleisdreieck in Berlin, the Landschaftspark Duisburg and The Goods Line in Sydney (see pages 182–185): The sole focus is on people and their social interactions. And it gave landscape architects the opportunity to forge new paths in design, to create variety and to provide open areas for everyone. Together with plazas and streets, city parks and gardens are true democratic accomplishments that deserve to be defended once they are finally freed of the dominant vehicle traffic.

Parks were always an effective way to assuage the revolutionary ideas of the public. Perhaps this is because green spaces instill harmony and inspire confidence.

193

Stadtgrün
Bedeutung von Gärten und Parks im urbanen Raum

Es sind nicht die Häuser, die eine Stadt ausmachen, es sind die Menschen und deren Interaktion sowie die Freiräume, ganz besonders die grünen – Gärten und Parks.

Städte sind nicht autark. Ihr Erfolg beruht immer auf der Vernetzung mit dem Land, das die Rohstoffe liefert. Rom war undenkbar ohne Weizen aus Nordafrika, Hamburg nicht lebensfähig ohne Nahrung aus dem Alten Land. Denkt man nun, die dicht bebauten Städte wären immer nur steinern gewesen, Haus an Haus, so täuscht man sich. Schon die Babylonier als Trendsetter der urbanen Kultur legten Gärten an, nicht nur zur Repräsentation oder für kultische Handlungen, nein, zum sinnlichen Vergnügen und angenehmen Aufenthalt im Alltag. Sie waren Orte der Lebensfreude, weil die damalige Gesellschaft nicht an ein Leben nach dem Tod glaubte und es vorzog, im Diesseits ihr Glück zu finden. Die Hängenden Gärten der Semiramis zählten zu den Weltwundern der Antike, eine 30 Meter hohe terrassierte Dachgartenlandschaft, versorgt mit Wasser aus dem Euphrat.

Auch Assyrer und dann Perser legten in kargen Gegenden ausgedehnte bewässerte Landschaftsparks an, mit Tieren und Teichen, zunächst als umfriedete Palastgärten, denen dann später die Griechen aus dem Altpersischen den Namen *Paradeisos* gaben. Somit fand der sinnenfrohe Garten als Paradies Eingang in die Religionen und als konkrete Idee des guten Lebens Einzug in alle Kulturen. Wasser war allerdings erste Voraussetzung für das Gedeihen. In Ägypten ersteckten sich bald Gärten entlang des Nils, bevorzugt an Tempelanlagen.

Die Griechen als Erfinder der *Polis* (Stadtstaat) schienen keinen grünen Daumen gehabt zu haben, Gartenkunst fand keinen Platz in den eng gebauten Städten. Das private Leben zog sich zurück in die Innenhöfe. Das änderte sich zunächst auch nicht bei den Römern in ihren Stadtvillen.

Nur auf ihren legendären Landsitzen wurde dem Gartenbau gefrönt und die Gartenkunst vorangebracht, wie auf den erhaltenen Wandmalereien in Pompeji zu sehen und bei Plinius dem Jüngeren nachzulesen ist. Die reichen Römer waren Landwirte, arbeiten mussten die Sklaven, deren Verdienst natürlich in der Geschichte der Gartenkunst nicht gewürdigt wird. Im 2. Jahrhundert vor Christus hielten dann auch in den Städten öffentliche Gärten Einzug, ebenso wie die Kunst, in den Innenhöfen durch Bewässerung intime grüne Räume zu schaffen.

Gerade diese ummauerten Gärten mit Wasser und duftenden Pflanzen wurden zum Erfolgsmodell im arabischen Raum. Über Marokko und Spanien sowie über die Levante erreichte die Kunst, schattige umschlossene Ziergärten zu gestalten, auch das mittelalterliche Europa, wo sich die Privilegierten in Burg- und Klostergärten allerlei Lustbarkeiten und Sinnesfreuden hingaben.

Unbebaute Flächen innerhalb der Stadtgrenzen gab es auch in der Antike und im Mittelalter inmitten von Häusern aus Lehm, Holz und Stein. Diese dienten aber kaum dem Müßiggang, es waren Obst- oder Gemüsegärten sowie Allmenden, oder *commons* als Viehweiden. In den Gesetzen für Las Indias halten die Spanier für ihre eroberten Länder im 16. Jahrhundert fest, dass innerhalb der Stadt ein Gemeindeplatz abgesteckt werden soll, der groß genug ist, um trotz des zu erwartenden Bevölkerungswachstums den Menschen als Erholungsgebiet und dem Vieh als Weide dienen zu können.

Bis der gemeine Städter und sein Hund vom Rasen im Stadtpark Besitz ergreifen konnten und das ubiquitäre Joggen die Feldarbeit ersetzen sollte, war es noch ein langer Weg. Seit alters her wurden auch die privaten Gärten von Adligen oder Reichen eingeschränkt und zu bestimmten Zeiten öffentlich zugänglich gemacht, sogar im China der Sung-Dynastie. Auch in Rom waren einige private Grünanlagen zugänglich, Julius Caesar überließ dem Volk sogar per Testament seine Gärten in Trastevere.

In England hatte sich im 17. Jahrhundert der Zugang zum Besitz der Krone als Gewohnheitsrecht eingebürgert. So wurde der Hyde Park um 1630 öffentlich. Der Tiergarten in Berlin, ein königliches Jagdrevier, stand seit 1649 den Bürgern für „genußvolles Flanieren" offen. Auch im vorrevolutionären Frankreich gönnte man dem Volk Parks in Montpellier, Nîmes oder Nancy, alleine zum Zwecke des Promenierens.

Ludwig XIV. gestattete, in Paris obsolet gewordene Wallanlagen in Promenaden umzuwandeln – man nannte diese Boulevard, also Bollwerk. Damit verfügte die Stadt über die erste öffentliche Grünanlage. Berlin folgte diesem Beispiel hundert Jahre später, ebenso Städte wie Hannover oder Graz. Die Idee, unnütze militärische Anlagen zu Parks umzuwidmen, wurde zum Erfolgsmodell bis ins 19. Jahrhundert als Hamburg zu Planten un Plomen und schließlich 1843 Kopenhagen zu seinem weltberühmten Vergnügungspark Tivoli kam, mit dem der rückständig absolutistische Dänenkönig sein Volk erfolgreich von revolutionären Gedanken abhalten konnte. Bis dahin waren offene königliche Parks wie der Londoner Regent's Park nur Reitern oder Kutschen vorbehalten, das gemeine Volk war nicht vorgesehen, es gab keine Fußwege.

Die Geburtsstunde des modernen Stadtparks auch für das gemeine Volk schlug wohl im Revolutionsjahr 1789 mit dem Entwurf des Englischen Gartens in München von Friedrich Ludwig von Sckell. Die Anlage sollte nach der deutschen Volksgartenidee der Begegnung der sozialen Klassen und der Volkserziehung dienen – per Dekret des Kurfürsten Karl Theodor. Oder dann 1843 in England mit dem Birkenhead Park bei Liverpool von Joseph Paxton – hier verliefen die Wege für Reiter und Fußgänger getrennt. Um 1865 besaßen die meisten Londoner Stadtteile öffentliche Parks, auch in Paris entstanden als Teil von Haußmanns Plänen eine Reihe von Grünflächen wie Parc Monceau oder Buttes-Chaumont.

Frederick Law Olmsted und Calvert Vaux wurden für die Gestaltung des Central Park in New York sowie des Prospect Park in Brooklyn maßgeblich von Birkenhead und vom landschaftlich angelegten Mount Auburn Friedhof bei Boston inspiriert. Noch heute ist dieser Park der Bezugspunkt für die urbane Landschaftsarchitektur, denn Olmsted hatte erfasst, dass man Städte um Parks herum planen kann. Das Leben in den amerikanischen Metropolen mit den zahllosen Einwanderern aus aller Herren Länder war nicht immer friedlich, Iren oder Italiener beispielsweise schlossen sich in Nachbarschaften zusammen. Ein Ansinnen Olmsteds war, ethnische Identitäten zu brechen, aus den zugezogenen Arbeitern Amerikaner zu machen. Im Park sollten sich die Lebensgewohnheiten der Arbeiter durch die Begegnung mit gesellschaftlich Höhergestellten in einer beschaulichen Umgebung verbessern. Er wollte die Arbeiter abbringen vom rauen Vergnügen des Sports!

In Deutschland ging der Stern von Peter Joseph Lenné auf, der 1824 in Magdeburg den ersten Volksgarten im Auftrag einer kommunalen Stadtverwaltung entwarf. Ab 1832 baute er den Berliner Tiergarten komplett zum Erholungspark um. Als dann allerdings die Städte wuchsen, die Einwohnerzahlen im Zuge der beginnenden Industrialisierung drastisch zunahmen, waren die urbanen Zentren schlecht gerüstet, die Lebensbedingungen waren prekär. Um proletarischen Revolutionen vorzubeugen, wurde nun versucht, mit der Idee der Volksparks die Arbeiter ruhigzustellen, ihnen Erholungs-, Vergnügungs- und Sportparks zu bieten. Vor allem in Berlin entstanden Anfang des 20. Jahrhunderts in rascher Folge Volksparks wie auch in Hamburg durch Fritz Schumacher im Jahr 1911.

Es war Martin Wagner, der 1915 über „Das sanitäre Grün der Stadt" schrieb und damit einen Begriff aufnahm, der vom Stadtplaner Camillo Sitte bereits 1889 geprägt worden war. Wagner verstand darunter „soziales Grün" und legte erstmals Freiflächen-Richtwerte pro Kopf fest. Nach dem Ersten Weltkrieg schuf Berlin in zehn Jahren weitere neun Volksparks, deren Idee sich als erfolgreich für die wachsenden Städte erwiesen hatte. Die Bedürfnisse der städtischen Bevölkerung

Parks waren stets probate Mittel, den Bürgern revolutionäre Gedanken auszutreiben. Vielleicht liegt es daran, dass Grün harmonisiert und Zuversicht verleiht.

nach Spiel- und Bewegungsraum, nicht nur zum gesitteten Spazierengehen und Benutzen einiger weniger vorgesehener Vergnügungsplätze, stand im Vordergrund. Typisch für Volksparks sind zentrale, große und zusammenhängende, betretbare Spiel- und Sportflächen.

Viele Elemente der Stadtparks gehören bis heute zum Standardrepertoire erfolgreicher Parkgestaltung. Doch zunächst hatten die Städte und ihre Bewohner unter den Folgen der Moderne im Städtebau zu leiden. Auch wenn extreme Vorstellungen einer Stadtlandschaft von Ludwig Hilberseimer oder Le Corbusier nicht umgesetzt wurden, so verfielen doch viele Planer und Politiker deren Ideen von der autogerechten Stadt mit Wohnmaschinen und getrennten Lebensfunktionen. Die Ergebnisse kennen wir, in Europa wie in Amerika.

Der Kampf für eine humane Stadt erwachte in den 1960er-Jahren: Soziologen, Psychologen und Architekten begannen, sich für die Menschen und deren Bedürfnisse in ihrer städtischen Umwelt zu interessieren. Unsere heutige Planungswirklichkeit mit Partizipation der Bürger fußt auf diesen Arbeiten. So legt beispielsweise der dänische Architekt und Stadtplaner Jan Gehl den Schwerpunkt auf die Nutzung des öffentlichen Raums, auf das Leben zwischen den Häusern. Seit Jahrzehnten reist er durch die Welt und berät Kommunen, wie sie lebenswerte Stadträume schaffen können.

Längst geht es nicht alleine darum, große Parks anzulegen, sondern wohnungsnahe Freiräume zu schaffen und sich den Stadtraum vom motorisierten Verkehr zurückzuerobern.

Parks erhielten den interessantesten Schub durch die Neunutzung brachgefallener Industrie- oder Verkehrsflächen. Es begann mit dem Gas Works Park in Seattle und endete nicht mit dem spektakulären High Line Park in New York, einem Stadtgarten auf einer stillgelegten Bahnstrecke. Ob Westergasfabriek in Amsterdam oder der Park am Gleisdreieck in Berlin, der Landschaftspark Duisburg oder The Goods Line in Sydney (siehe Seiten 182–185): Es dreht sich alles um die Menschen und deren soziale Interaktivität. Und es bescherte den Landschaftsarchitekten die Chance, in der Gestaltung neue Wege zu gehen, Vielfalt zu schaffen, Freiraum für alle anzubieten. Somit sind Parks und Gärten in der Stadt zusammen mit Plätzen und Straßen, wenn diese endlich vom dominanten Autoverkehr befreit sind, echte demokratische Errungenschaften, die zu verteidigen sich lohnt.

Villes vertes
De l'importance des jardins et des parcs dans l'espace urbain

Ce ne sont pas les maisons qui font la ville, mais ses habitants et leurs interactions ainsi que les espaces dégagés, en particulier lorsqu'ils sont verts – parcs ou jardins.

Une ville ne vit jamais en autarcie. Sa viabilité dépend toujours des liens qu'elle noue avec la terre qui l'approvisionne en matières premières. Sans le blé d'Afrique du Nord, Rome n'aurait pas pu exister, et Hambourg n'aurait pas été viable sans les produits alimentaires de l'Altes Land proche. Penser que nos villes et leurs constructions denses ont toujours été exclusivement de pierre, maison contre maison, c'est se tromper. Pionniers de la culture urbaine, les Babyloniens aménageaient déjà des jardins, pas seulement pour le prestige ou l'exercice de leurs cultes, non, ils le faisaient aussi pour le plaisir des sens et le bonheur d'y séjourner chaque jour. C'étaient des lieux conçus pour la joie de vivre parce que la société de l'époque ne croyait pas à une vie après la mort et préférait trouver son bonheur dans l'ici-bas. Merveille du monde antique, les Jardins suspendus de Sémiramis formaient en fait un paysage de terrasses aménagées à 30 mètres de hauteur et alimentées par l'eau de l'Euphrate.

De même, les Assyriens, puis les Perses des régions arides aménageaient de vastes parcs paysagers irrigués, avec des animaux et des pièces d'eau, d'abord dans les enceintes de leurs palais ; les Grecs leur donnèrent le nom de *paradeisos,* un mot venu du persan. C'est ainsi que le jardin conçu pour le plaisir des sens fit son apparition sous le nom de paradis dans les religions, puis dans toutes les cultures, concrétisant l'idée qu'on se faisait d'une vie bonne. Toutefois, rien n'était possible sans un élément indispensable : l'eau. En Égypte, des jardins s'étirèrent bientôt le long du Nil, de préférence près des temples.

Inventeurs de la *polis* (cité-État), les Grecs ne semblent pas avoir eu la main verte, et l'art du jardin ne trouva pas sa place dans leurs villes aux constructions denses. La vie privée se retire alors dans les cours intérieures et rien ne change non plus chez les Romains qui privilégient leurs maisons de ville. Le jardinage est alors réservé aux légendaires domaines campagnards des villas, où les Romains cultivèrent l'art du jardin comme on peut le voir sur les fresques de Pompéi et le lire chez Pline le Jeune. Les Romains riches étaient des agriculteurs qui faisaient travailler des esclaves dont le mérite n'a pas été salué avec suffisamment de dignité dans l'histoire du jardinage. Au 2e siècle avant Jésus-Christ, les jardins publics finissent par pénétrer dans les villes, de même que l'art de créer des espaces verts intimes dans les cours intérieures, grâce à l'irrigation.

Ce sont précisément ces jardins entourés de mur et associant l'eau aux plantes exhalant des odeurs agréables qui connurent un grand succès dans le monde arabe. Passant par le Maroc, l'Espagne et le Levant, l'art de créer des jardins d'ornement fermés et ombragés atteint l'Europe médiévale où les privilégiés s'adonnent alors à toutes sortes de réjouissances et de plaisirs sensuels dans les jardins des châteaux-forts et des couvents.

Dans l'Antiquité et au Moyen-Âge, il existait des surfaces non bâties dans l'enceinte des villes, au milieu des maisons en terre, en bois ou en pierre. Mais ces espaces n'étaient pas conçus pour l'oisiveté et servaient de jardins fruitiers ou potagers, ou encore de pâtures communautaires.

Dans les lois édictées pour Las Indias, les Espagnols exigent pour les terres conquises au 16e siècle qu'une place communautaire soit jalonnée, suffisamment grande pour pouvoir servir d'espace de repos aux habitants et de pâture pour le bétail, malgré la croissance attendue de la population.

Le chemin sera encore long avant que le citadin moyen et son chien ne prennent possession des pelouses des parcs urbains et que l'omniprésence des joggers ne se substitue au travail des champs. Depuis des temps immémoriaux, les jardins privés des nobles ou des riches étaient fermés et leur accès au grand nombre n'était possible qu'à certains moments, y compris dans la Chine de la dynastie Sung. À Rome, certains espaces verts privés étaient également accessibles, et Jules César céda même au peuple par testament ses jardins du Trastevere.

En Angleterre, l'accès aux biens de la couronne devient une coutume au 17e siècle et c'est ainsi que Hyde Park devint public vers 1630. À Berlin, le Tiergarten, un territoire de chasse royal, fut ouvert aux habitants dès 1649 pour le « plaisir de la flânerie ». Et même dans la France pré-révolutionnaire, on accorde au peuple des parcs à Montpellier, Nîmes ou Nancy dans le seul but de s'y promener.

À Paris, Louis XIV autorise la transformation en promenade de fortifications devenues inutiles, marquant ainsi la naissance des boulevards, terme qui nous vient du mot néerlandais bolwerc signifiant fortifications. C'est ainsi que la ville disposa de son premier espace vert public. Berlin suivra cet exemple cent ans plus tard, de même que des villes comme Hanovre ou Graz. L'idée de transformer en parc des sites militaires obsolètes remporta un grand succès jusqu'au 19e siècle lorsque Hambourg crée le parc Planten un Plomen et qu'en 1843, Copenhague aménage le parc de loisirs mondialement célèbre de Tivoli. C'est grâce à ce dernier que le roi du Danemark, qui se distingue alors par un absolutisme rétrograde, parvint à persuader son peuple de renoncer aux idées révolutionnaires. Jusque-là, les parcs royaux ouverts au public, tels Regent's Park à Londres, étaient réservés aux seuls cavaliers et calèches, et rien n'était prévu pour le bas peuple puisqu'il n'y avait pas d'allées de promenade.

Mais c'est sans doute 1789, l'année de la Révolution, qui marque la naissance du parc urbain moderne, avec le projet de jardin anglais de Munich conçu par Friedrich Ludwig von Sckell. Conformément à un décret du prince-électeur Charles-Théodore, l'idée est alors de créer un jardin populaire allemand censé faciliter la

rencontre entre les classes sociales et favoriser l'éducation du peuple. On peut mentionner aussi l'année 1843 en Angleterre, avec le parc Birkenhead, près de Liverpool, dessiné par Joseph Paxton et se caractérisant par des allées séparées pour les cavaliers et les promoneurs. Autour de 1865, la plupart des quartiers de Londres avaient leur parc public, et à Paris, une série d'espaces verts naissent dans le contexte des travaux du baron Haussmann, comme le parc Monceau ou celui des Buttes-Chaumont.

Frederick Law Olmsted et Calvert Vaux ont créé Central Park à New York et le Prospect Park de Brooklyn en s'inspirant largement de Birkenhead et du cimetière paysagé du Mont Auburn, près de Boston. Aujourd'hui encore, ce parc est une référence pour l'architecture paysagère urbaine, car Olmsted avait compris qu'il était possible de planifier des villes autour des parcs. Dans les métropoles américaines peuplées d'innombrables immigrants de tous les pays du monde, la vie n'était pas toujours paisible, et les Irlandais ou les Italiens, par exemple, avaient tendance à vivre entre eux. Un des objectifs d'Olmsted était de casser les identités ethniques afin de faire de travailleurs venus d'ailleurs des Américains. Le parc devait être le cadre dans lequel les habitudes de vie des ouvriers pouvaient s'améliorer grâce à la rencontre avec des membres des couches supérieures dans un environnement paisible. Il voulait dissuader les ouvriers de s'adonner aux rudes plaisirs de la pratique des sports !

En Allemagne, Peter Joseph Lenné dessine en 1824 à Magdebourg le premier jardin populaire pour le compte de la municipalité. À partir de 1832, il transforme complètement en parc de loisirs le Tiergarten de Berlin. Toutefois, dans un contexte de croissance des villes et en raison de la forte augmentation du nombre d'habitants induite par l'industrialisation naissante, les centres urbains sont mal adaptés et les conditions de vie sont précaires. Pour prévenir les révolutions prolétariennes, on tente alors de calmer la classe ouvrière grâce à l'idée des parcs populaires, et on propose des parcs de loisirs, de plaisance et de sport. En particulier à Berlin, on voit apparaître rapidement au début du 20e siècle plusieurs parcs populaires, de même qu'à Hambourg, avec le parc créé par Fritz Schumacher en 1911.

En 1915, Martin Wagner évoque par écrit la « saine verdure de la ville », reprenant ainsi une terminologie déjà utilisée en 1889 par l'urbaniste Camillo Sitte. Wagner veut en fait parler de « verdure sociale » et fixe même pour la première fois une valeur indicative de surface non bâtie par habitant. Après la Grande Guerre, Berlin crée en dix ans neuf nouveaux parcs populaires dont l'idée

Les parcs ont toujours été de bons moyens pour chasser les pensées révolutionnaires des habitants. Et si cela était dû à l'harmonie et à la confiance que nous donne la verdure ?

rencontre un grand succès dans les villes en forte croissance. L'accent est mis sur les besoins d'espaces de loisirs et de mouvement pour la population urbaine, au-delà donc du seul usage de promenade pour les gens de bonne éducation et de la création d'un petit nombre de parcs de plaisance. Ces parcs populaires se caractérisent par de grandes aires centrales de jeu et de sport ouvertes à tous.

De nombreux éléments des parcs urbains font toujours partie du répertoire standard d'un aménagement réussi. Mais dans un premier temps, les villes et leurs habitants souffrent des conséquences de l'urbanisme moderne. Même si les idées extrêmes d'un Ludwig Hilberseimer ou d'un Le Corbusier ne seront pas appliquées, de nombreux urbanistes et élus vont tomber dans le piège de la ville conçue pour l'automobile et composée d'unités d'habitation avec des fonctions de vie séparées. Nous en subissons toujours les conséquences, en Europe comme en Amérique.

Le combat en faveur d'une ville à taille humaine reprendra dans les années soixante : les sociologues, les psychologues et les architectes commencent alors à s'intéresser à l'être humain et à ses besoins en milieu urbain. En matière d'urbanisme, notre réalité d'aujourd'hui, qui recherche la participation des citoyens, s'appuie sur ces travaux. Ainsi, l'architecte et urbaniste danois Jan Gehl met l'accent sur l'utilisation de l'espace public, sur la vie entre les immeubles. Depuis des décennies, il voyage à travers le monde et conseille les communes sur la façon de créer des espaces urbains où il ferait bon vivre. Depuis longtemps, il ne s'agit plus de créer de grands parcs, mais d'aménager des espaces proches des logements et de reconquérir l'espace urbain sur la circulation motorisée.

L'impulsion la plus intéressante qui a été donnée aux parcs vient du recyclage de friches industrielles ou de voies de circulation abandonnées. On a vu cette tendance naître avec le parc Gas Works de Seattle et se poursuivre avec le spectaculaire parc High Line de New York, un jardin urbain aménagé sur une ligne de train désaffectée. Citons encore le Westergasfabriek, à Amsterdam, ou le parc du Gleisdreieck de Berlin, le parc paysager de Duisburg ou le parc The Goods Line à Sydney (voir les pages 182–185) : ici, tout tourne autour de l'humain et de l'interactivité sociale. Et cela offre aux paysagistes la possibilité de se lancer dans des voies nouvelles, de créer de la diversité, d'offrir des espaces à tous. Ainsi, les parcs et jardins des villes, avec les rues et les places une fois que celles-ci sont débarrassées de la domination de la circulation automobile, deviennent d'authentiques conquêtes démocratiques qu'il vaut la peine de défendre.

Topiaries from the Bruns Pflanzen assortment; left: Boxwood balls and yew with columnar emerald green arborvitae in the background as well as pine bonsai and hornbeam forms. Below: Yew flattened spheres with a background of columnar hornbeams trimmed into square spires.

Formgehölze aus dem Sortiment von Bruns Pflanzen; links: Buchs-Kugeln und Eiben, im Hintergrund zur Toskanaform geschnittene Thuja Smaragd sowie Pinus Bonsai und Hainbuchen-Formen. Unten: Eiben-Flachkugeln, im Hintergrund Säulenhainbuchen als quadratische Säulen gezogen.

Arbres et arbustes topiaires au catalogue de Bruns Pflanzen ; à gauche : buis et ifs taillés en boules, thuyas occidentaux taillés comme en Toscane ainsi que pins en bonsaï et charmes de différentes formes en arrière-plan. Ci-dessous : ifs en boules plates et charmes communs en colonnes carrées en arrière-plan.

198

Bruns Pflanzen

Bad Zwischenahn | Germany

The Bruns tree nursery has been passionately dedicated to plant life for more than 140 years.
Die Baumschule Bruns widmet sich seit mehr als 140 Jahren mit großer Leidenschaft den Pflanzen.
La pépinière Bruns cultive une véritable passion pour les plantes depuis plus de 140 ans.

199

The Bruns tree nursery in Bad Zwischenahn is already on its fourth generation of ownership. Gardener Diedrich-Gerhard Bruns established a plant nursery with a small variety of goods in 1876. His son Johann took over the company in 1900 and converted it into a tree nursery that has grown continuously ever since. Jan-Dieter Bruns took the helm of the international enterprise in 1990. It now cultivates more than 4,000 plant species on more than 1,236 acres (500 hectares) through the efforts of 350 employees.

Es ist bereits die vierte Generation, die die Baumschule Bruns in Bad Zwischenahn führt. Im Jahr 1876 gründete der Gärtner Diedrich-Gerhard Bruns einen Gartenbaubetrieb mit kleinem Sortiment. Sein Sohn Johann, der 1900 die Firma übernahm, baute sie zur Baumschule um, die seitdem kontinuierlich gewachsen ist. Seit 1990 leitet Jan-Dieter Bruns die Geschicke des international tätigen Unternehmens, das heute mit 350 Mitarbeiterinnen und Mitarbeitern auf über 500 Hektar Fläche mehr als 4 000 Pflanzenarten und -sorten kultiviert.

La pépinière Bruns de Bad Zwischenahn est aujourd'hui dirigée par la quatrième génération de la famille Bruns. En 1876, Diedrich-Gerhard Bruns, jardinier de son état, a créé son exploitation horticole avec une petite gamme de produits. Son fils Johann, qui a repris l'entreprise en 1900, l'a transformée en pépinière dont la croissance ne s'est depuis jamais démentie. Depuis 1990, c'est Jan-Dieter Bruns qui a en main le destin de cette entreprise internationale dont les effectifs atteignent aujourd'hui 350 personnes. Plus de 4 000 espèces et variétés de plantes y sont cultivées sur plus de 500 hectares.

These specimen maple trees are cultivated in SpringRing planters. This makes it possible to plant in summer as well because the roots are not damaged during removal.

Diese Ahorn-Solitäre werden im Springring kultiviert. Das macht es möglich, auch im Sommer zu pflanzen, da die Wurzeln beim Herausnehmen nicht beschädigt werden.

Ces érables solitaires sont cultivés en conteneurs SpringRing. Ils pourront être plantés même en été, les racines n'étant pas endommagées lors du retrait de ces conteneurs.

Impressions from private gardens: Pinus sylvestris trimmed into a pine shape with boxwood (top) and individual boxwood specimens with a Taxus cuspidata bonsai in the background.

Impressionen aus Privatgärten: pinienförmig gezogene Pinus sylvestris mit Buchs (ganz oben) und Buchs-Solitäre mit einem Taxus cuspidata Bonsai im Hintergrund.

Incursion dans des jardins privés : pins sylvestres taillés en forme de parasol avec buis (image du haut) et buis solitaires avec if du Japon en arrière-plan.

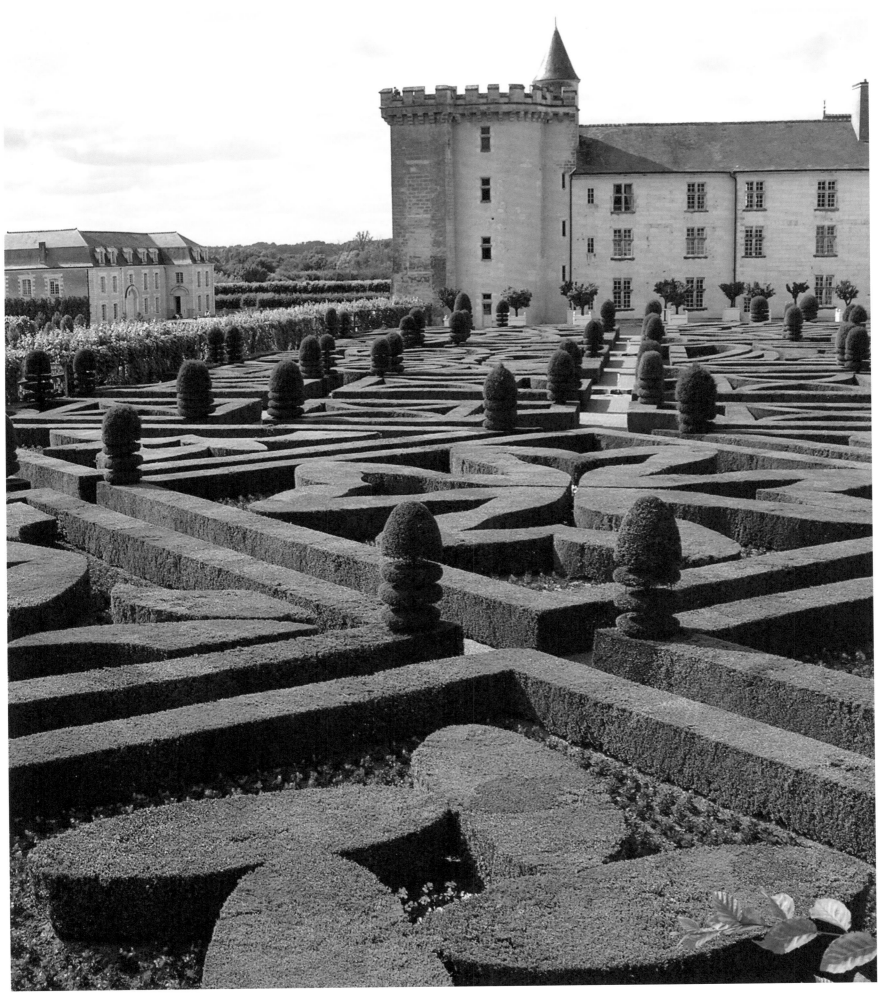

201

For the Château de Villandry park in France, specially trimmed yews and box-shaped linden trees were tended at Bad Zwischenahn over a five-year period.

Für den Park des Château de Villandry in Frankreich wurden speziell geformte Eiben und kastenförmig gezogene Linden über fünf Jahre in Bad Zwischenahn vorkultiviert.

Les ifs topiaires et les tilleuls taillés en rideaux du parc du château de Villandry en France ont été pré-cultivés pendant cinq ans à Bad Zwischenahn.

202

Box hedges adorn the Bundesrat grounds in Berlin. Hydrangeas grow in the terracotta pots in spring and summer, replaced by Japanese Azaleas in fall and winter.

Buchshecken schmücken den Bundesrat in Berlin. Im Frühjahr und Sommer wachsen Hortensien in den Terrakotta-Gefäßen, im Herbst und Winter Japanische Azaleen.

Des haies de buis décorent le Bundesrat à Berlin. Dans les pots en terre cuite poussent des hortensias au printemps et en été, puis des azalées japonaises en automne et en hiver.

Yew hemispheres accentuate the restored Pariser Platz near the Brandenburg Gate (top right).
Right: Picea excelsa at the Peterhof in St. Petersburg.

Eiben-Halbkugeln setzen Akzente auf dem restaurierten Pariser Platz am Brandenburger Tor (oben rechts).
Rechts: Picea excelsa am Peterhof in Sankt Petersburg.

Des ifs en demi-boules décorent la Pariser Platz restaurée, près de la Porte de Brandebourg (en haut à droite).
À droite : épicéas devant le palais de Peterhof à Saint-Pétersbourg.

Jan-Dieter Bruns

Greenery as a life calling
Gehölze als Lebensaufgabe
Une vie consacrée aux plantes

Jan-Dieter Bruns is devoted to sustainability. He reduced the use of manure, pesticides, and water to a minimum, and replaced service buildings with new constructions featuring solar panels and better energy efficiency.

Jan-Dieter Bruns führt das Familienunternehmen in eine nachhaltige Zukunft: Er reduzierte den Einsatz von Dünger, Pflanzenschutzmitteln und Wasser auf ein Minimum, ersetzte die Betriebsgebäude durch neue, deutlich energieeffizientere Neubauten. Solaranlagen auf den Hallen erzeugen Strom.

Jan-Dieter Bruns mise sur la durabilité : n'utilisant que le strict minimum d'engrais, de produits phytosanitaires et d'eau, il a également fait construire de nouveaux bâtiments de production énergétiquement efficaces avec des panneaux solaires.

Mr. Bruns, you grew into being part of a family-owned company.

Yes, you could say that. My parents never pressured me into it. Maybe that is why taking up the mantle just seemed like the natural path for me. I learned how to be a gardener at a tree nursery and then studied horticulture at the Osnabrück University of Applied Sciences. After some very formative years gathering practical experience in Europe and North America, I joined the company in 1977 at the age of 25. Now the fifth generation is waiting in the wings. Two of our four children have opted for the green path.

Herr Bruns, Sie sind in ein Familienunternehmen hineingewachsen.

Ja, das kann man so sagen. Meine Eltern haben nie Druck ausgeübt. Vielleicht war für mich die Betriebsnachfolge gerade deshalb selbstverständlich. Ich habe Baumschulgärtner gelernt und dann Gartenbau an der Fachhochschule Osnabrück studiert. Nach sehr prägenden Praxisjahren in Europa und Nordamerika stieg ich 1977 mit 25 Jahren ins Unternehmen ein. Inzwischen steht die fünfte Generation bereit. Zwei unserer vier Kinder haben sich für die grüne Branche entschieden.

Monsieur Bruns, l'entreprise familiale, c'était une voie toute tracée pour vous ?

Oui, on peut le dire. Mes parents ne m'y ont jamais forcé. C'est peut-être pour cette raison qu'il m'a paru naturel de reprendre le flambeau. J'ai suivi une formation de pépiniériste avant d'étudier l'horticulture à l'institut universitaire de technologie d'Osnabrück. Après des années de pratique très enrichissantes en Europe et en Amérique du Nord, j'ai rejoint l'entreprise en 1977 à l'âge de 25 ans. Aujourd'hui, la cinquième génération est prête. Deux de nos quatre enfants ont choisi de travailler dans l'industrie verte.

Trees grow slowly. You have to predict what demand might look like in ten or twenty years.

A tree nursery—especially a specimen tree nursery like ours—is based on a generational commitment. The huge 50-year-old oaks that we deliver today were planted by my father. We constantly need to re-examine our ideas and actions to

A tree nursery rooted in a multi-generational commitment.

allow us to react much more quickly. Currently, we are generally facing challenges relating to the phytosanitary, meaning topics related to plant health, and to urban climates becoming more extreme. This is evident in the species in demand for urban use. In years past the predominant species included maple, ash, and linden, but now they are joined by Sophora, Gleditsia, Koelreuteria paniculata and Quercus cerris. On our end, this means we have to keep a wider variety in stock.

What do you see becoming the big things in the coming years?

Hand-sculpted bonsai plants have been very popular in recent years. This desire for the exotic is currently being replaced with a yearning to bring nature back into the urban and back to personal gardens. This idea is captured by picture-perfect, natural-looking stand-alone plants with notable features such as flowers, fruit or fall coloration. We're not fortune-tellers, but I'm confident the next generation will also have impatient customers looking to plant an impressive stand-alone centerpiece in their garden, like a 50-year-old oak, a tall little-leaf linden or a 40-foot (12-meter) Scotch pine.

Bäume wachsen langsam. Sie müssen vorhersehen, wie der Bedarf in zehn, 20 Jahren aussehen könnte.

Eine Baumschule – und insbesondere eine Solitär-Baumschule wie die unsere – basiert auf einem Vertrag der Generationen. Die großen 50-jährigen Eichen, die wir heute liefern, hat noch mein Vater gepflanzt. Wir müssen unser Denken und Handeln immer wieder hinterfragen, um auch deutlich kurzfristiger reagieren zu können. Aktuelle Herausforderungen sind etwa phytosanitäre, also die Pflanzengesundheit betreffende Themen oder das extremer werdende Stadtklima. Das merkt man an den Gehölzen, die für die Stadt nachgefragt werden. Waren es vor Jahren Leitbaumarten wie Ahorn, Esche

Eine Baumschule basiert auf einem Generationenvertrag.

oder Linde, so sind es heute auch Sophora, Gleditsia, Koelreuteria paniculata oder Quercus cerris. Für uns bedeutet das, ein vielfältigeres Sortiment vorzuhalten.

Welche Schwerpunkte setzen Sie in den kommenden Jahren?

In den letzten Jahren waren handgeformte Bonsai-Pflanzen sehr beliebt. Dieser Wunsch nach Exotischem wird aktuell abgelöst von der Sehnsucht, die Natur in die Stadt und den eigenen Garten zurückzuholen. Malerisch gewachsene, natürlich anmutende Solitärpflanzen mit besonderen Aspekten wie Blüte, Frucht oder Herbstfärbung sind dabei Thema. Wir sind keine Hellseher, aber ich bin überzeugt, dass es auch in der nächsten Generation ungeduldige Kunden geben wird, die ausdrucksvolle Solitäre wie eine 50-jährige Eiche, eine große Winter-Linde oder eine zwölf Meter hohe Waldkiefer in ihren Garten pflanzen möchten.

Les arbres poussent lentement. Il vous faut anticiper la demande des clients dans dix ou vingt ans.

Une pépinière – notamment une pépinière de solitaires comme la nôtre – repose sur un contrat intergénérationnel. Les grands chênes de 50 ans que nous livrons aujourd'hui ont été plantés par mon père. Nous devons sans cesse nous

Une pépinière repose sur un contrat intergénérationnel.

remettre en question pour pouvoir satisfaire plus rapidement les demandes de nos clients. Nos défis actuels sont par exemple les produits phytosanitaires, c'est-à-dire tout ce qui touche à la santé des plantes, ou encore le réchauffement climatique local. On le constate avec les arbres qui nous sont demandés pour la ville. Si l'érable, le frêne ou le tilleul étaient autrefois les espèces dominantes, ils sont aujourd'hui rejoints par le sophora, le févier d'Amérique, le savonnier ou le chêne chevelu. Il nous faut donc sans cesse diversifier notre gamme de produits.

Quelles sont vos priorités pour les années à venir ?

Ces dernières années, les plantes en bonsaï taillées à la main étaient très populaires. Cette recherche d'exotisme est actuellement remplacée par l'envie de ramener la nature au cœur de la ville et des jardins privés. Les gens préfèrent désormais les plantes solitaires au charme pittoresque et naturel avec des critères de floraison, fruitiers ou de coloration automnale. Nous ne pouvons pas prédire l'avenir, mais il est certain que la prochaine génération aura également affaire à des clients impatients qui souhaiteront planter dans leur jardin de grands arbres solitaires comme un chêne de 50 ans, un grand tilleul à petites feuilles ou un pin sylvestre de douze mètres de haut.

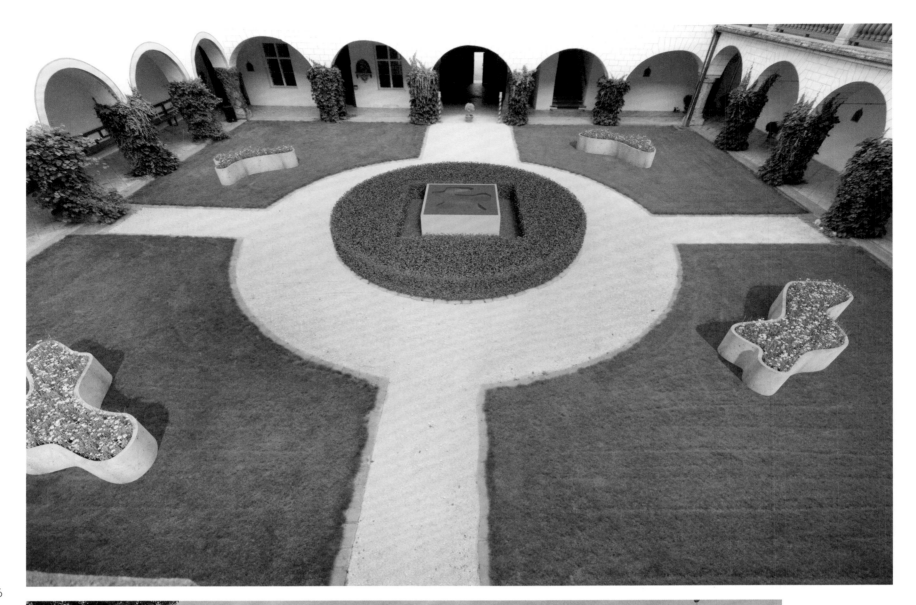

Next to the
St. Georg Market
Church, mourning
willow and organi-
cally manicured yew
hedges lead toward
the castle. The court-
yard is charming
with its minimalist
water basin (above).

Neben der Markt-
kirche St. Georg
führen Hängewei-
den und organisch
geschnittene Eiben-
hecken zum Schloss.
Dort präsentiert
sich der Innenhof
mit einem minima-
listischen Was-
serbecken (oben).

À côté de l'église
Saint-Georges, les
prés en pente et
les haies d'ifs à
taille douce mènent
vers le château où
la cour intérieure
séduit par son
bassin minimaliste
(en haut).

Schloss Tüßling

Schloss Tüßling

Markt Tüßling | Germany

The castle near the Upper Bavarian city of Altötting will be receiving a modern palace park, for which the planning is now complete. | Das Schloss nahe des oberbayerischen Altötting erhält einen modernen Schlosspark, dessen Planung nun abgeschlossen ist. | Ce château situé près de Altötting, en Haute-Bavière, va s'embellir d'un parc moderne dont l'étude est maintenant achevée.

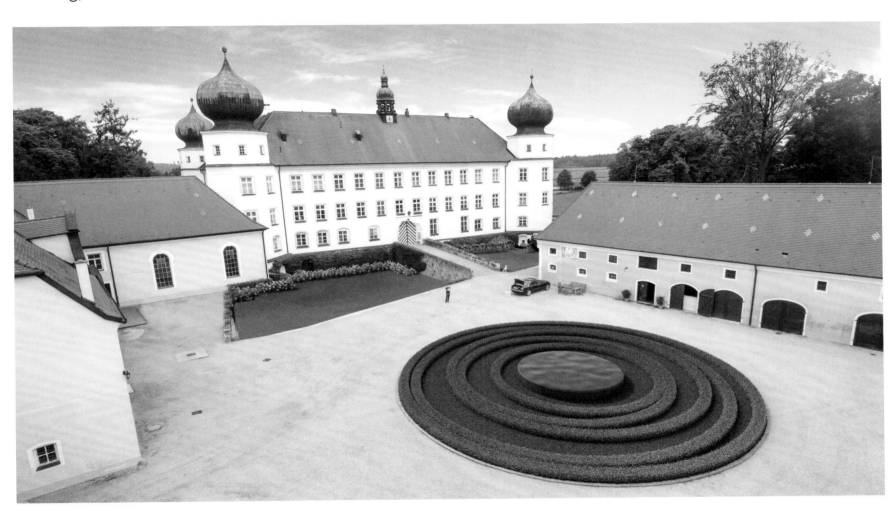

207

Tüßling Castle near Altötting is a pearl of the Renaissance. Built between 1581 and 1583 at the behest of Count Johann Veit von Toerring, the eye-catching construction with its bulbous spires captivates today thanks to its meticulous restoration. The facades and the courtyard shine in new splendor. Since the 1990s, owner Countess Stephanie Bruges-von Pfuel has been dedicating herself to the redevelopment. Now, together with garden designer Ralf Knoflach, she is devoting herself to the park of the formerly moated castle.

Schloss Tüßling bei Altötting gilt als Perle der Renaissance. Erbaut zwischen 1581 und 1583 im Auftrag von Johann Veit Graf von Toerring, besticht der prägnante Bau mit seinen Zwiebeltürmen heute durch seine sorgfältige Restaurierung. Die Fassaden und der Innenhof erstrahlen in neuer Pracht. Bereits seit den 1990ern engagiert sich die Besitzerin Stephanie Gräfin Bruges-von Pfuel für die Sanierung. Jetzt widmet sie sich zusammen mit dem Gartengestalter Ralf Knoflach dem Park des einstigen Wasserschlosses.

Le château de Tüßling, situé à proximité de Altötting, est considéré comme un joyau de la Renaissance. Construit entre 1581 et 1583 pour Johann Veit, comte de Toerring, cette bâtisse impressionnante dotée de tours à bulbe a profité d'une restauration très soignée grâce à laquelle les façades et la cour intérieure rayonnent d'une splendeur renouvelée. La propriétaire des lieux, la comtesse Stephanie Bruges-von Pfuel, avait commencé à œuvrer pour la restauration dès les années quatre-vingt-dix. Aujourd'hui, avec le soutien du paysagiste Ralf Knoflach, elle se consacre au parc de cet ancien château à douves.

A round fountain stone adorns the castle square and is framed by a hedge sculpture. In order to showcase the building, English hydrangeas grow at its base.

Den Schlossplatz schmückt ein runder Brunnenstein, gerahmt von einer Heckenskulptur. Um das Gebäude gut zur Geltung kommen zu lassen, wachsen an dessen Sockel große englische Hortensien.

La place du château s'orne d'une fontaine ronde entourée d'une haie sculptée. Pour bien mettre le bâtiment en valeur, de grands hortensias anglais sont plantés sur son socle.

Schloss Tüßling

209

Classic stone figures
from the entire park
are getting a new
home between
manicured hedges,
resembling pixels.

Klassische Steinfigu-
ren aus dem gesam-
ten Park bekommen
ein neues Zuhause
zwischen geschnitte-
nen Heckenkörpern,
die Pixeln gleichen.

Les statues clas-
siques en pierre
ont trouvé un nouvel
écrin entre les haies
taillées dont la
forme évoque
des pixels.

210

The main artery
of the park is
accompanied by
manicured copper
beeches and yews
that alternate in a
way that is reminis-
cent of a camou-
flage pattern.

Die Hauptachse
des Parks wird
von geschnittenen
Blutbuchen und
Eiben begleitet, die
sich so abwech-
seln, dass sie im
Zusammenspiel an
ein Camouflage-
Muster erinnern.

Sur l'axe principal
du parc s'aligne une
alternance de hêtres
pourpres et d'ifs
taillés, dont l'im-
pression d'ensemble
évoque le dessin
d'un camouflage.

In reminiscence of its history as a moated castle, a wide strip of high reeds grows in the former moat of the Renaissance building.

Als Reminiszenz an die Geschichte als Wasserschloss wächst im einstigen Schlossgraben des Renaissancegebäudes ein breites Band aus hohem Schilf.

Comme une réminiscence de l'histoire du château, les anciennes douves du bâtiment Renaissance abritent un large ruban de roseaux hauts.

Stephanie Gräfin Bruges-von Pfuel

The Path to a Modern Future
Der Weg in eine moderne Zukunft
Vers un avenir moderne

Countess Stephanie Bruges-von Pfuel has been redeveloping and designing the Tüßling Castle and its park since 1991. The current lady of the house grew up as part of the third generation on this gorgeous property.

Stephanie Gräfin Bruges-von Pfuel saniert und gestaltet seit 1991 Schloss Tüßling und seinen Park. Die heutige Hausherrin wuchs in dritter Generation auf dem wunderschönen Besitz auf.

La comtesse Stephanie Bruges-von Pfuel restaure et embellit depuis 1991 le château de Tüßling et son parc. Représentant la troisième génération de la famille propriétaire, l'actuelle maîtresse de maison a grandi dans ce magnifique domaine.

When you took over this property, it was not in good condition. Since then you have accomplished a lot.

The castle has been in our family since 1905. After my father's passing, I inherited it in late 1991. At that time it was in fact in a disastrous state: The roofs were leaky, the grout was crumbling from the facades. The work on and in the castle and on the operational buildings has now been completed.

And now you are dedicating yourself to the garden.

I have continually taken care of cleared, and planted the neglected park over the years. We have also arranged events as we go along, such as a garden fair, a Christmas market and the

Als Sie Schloss Tüßling übernahmen, war es in keinem guten Zustand. Seitdem haben Sie viel bewirkt.

Das Schloss ist seit 1905 im Besitz unserer Familie, nach dem Tod meines Vaters habe ich es Ende 1991 geerbt. Damals war der Zustand tatsächlich desaströs: Die Dächer waren undicht, der Putz bröckelte von den Fassaden. Die Arbeiten am und im Schloss sowie an den Betriebsgebäuden sind inzwischen aber abgeschlossen.

Und jetzt widmen Sie sich dem Garten.

Ich habe mich in den vergangenen Jahren immer wieder um den vernachlässigten Park gekümmert, gerodet und gepflanzt. Wir haben nach und nach Veranstaltungen

Lorsque vous avez pris en mains le château de Tüßling, il n'était pas en bon état. Depuis, vous avez beaucoup travaillé.

Notre famille est propriétaire du château depuis 1905, et j'en ai hérité après la mort de mon père fin 1991. À l'époque, il était effectivement en très mauvais état : les toits fuyaient, le crépi des façades se fissurait. Aujourd'hui, les travaux sont terminés, autant à l'extérieur qu'à l'intérieur du château, ainsi que dans les communs.

Et vous vous attaquez maintenant au jardin.

Ces dernières années, je n'ai pas cessé de m'occuper du jardin qui était négligé, j'ai arraché et planté. Peu à peu, nous avons organisé

212

Raiffeisen-Kultursommer, a popular annual concert event. These public events take place in the operation buildings, but also primarily in the park. To accommodate all of this, there will now be an overarching design concept for the park.

Gardens are my passion. It is a personal ambition of mine to redesign the park using new, contemporary ideas.

What motif are you going for here?

Because of around 100,000 visitors come to the events every year, the park has to serve this purpose to a certain extent. This means that the requirements, such as open space for events, play a role. However, the main idea is to connect the concepts of modern art in the garden to the historical buildings, which I find to be quite enthralling.

What does a garden mean to you, personally?

As a graduate engineer in forestry, I have a very close connection with nature and gardens are one of my passions. As such, it is a highly personal ambition of mine to redesign the park with new, contemporary ideas. We are getting started this year and will work our way forward bit by bit.

And what do you think will be your favorite area?

I can't quite say just yet. That depends on the nuances: How the light shines and what happens to be blooming at the moment. I am eagerly awaiting it!

wie eine Gartenmesse, einen Weihnachtsmarkt und den Raiffeisen-Kultursommer etabliert. Diese öffentlichen Events finden in den Betriebsgebäuden, aber eben auch vor allem im Park statt. Nicht zuletzt, um dem Rechnung zu tragen, wird es jetzt ein Gesamtkonzept für den Park geben.

Welchem Leitgedanken folgen Sie hier?

Da jedes Jahr etwa 100 000 Besucher zu den Veranstaltungen kommen, muss der Park sich dem bis zu einem gewissen Grad unterordnen. Das bedeutet, Vorgaben wie freie Flächen für die Events spielen eine Rolle. Doch die Hauptidee ist es, den Gedanken von moderner Kunst im Garten mit den historischen Gebäuden zu verbinden, was ich sehr spannend finde.

Gärten sind meine Leidenschaft. Daher ist es mir ein persönliches Anliegen, den Park mit neuen, zeitgemäßen Ideen umzugestalten.

Was bedeutet ein Garten für Sie persönlich?

Ich bin als Diplomingenieurin der Forstwissenschaft eng mit der Natur verbunden, und Gärten sind eine meiner Leidenschaften. Daher ist es mir ein ganz persönliches Anliegen, den Park mit neuen, zeitgemäßen Ideen umzugestalten. Wir beginnen in diesem Jahr und arbeiten uns dann Abschnitt für Abschnitt vor.

Und was denken Sie, wird Ihr Lieblingsplatz?

Das kann ich noch nicht sagen. Da kommt es ja auch auf Nuancen an: Wie das Licht fällt oder was gerade blüht. Ich bin gespannt!

des manifestations récurrentes, par exemple un salon des jardins, un marché de Noël ainsi qu'un festival de musiques, « l'été culturel Raiffeisen ». Ces événements publics ont lieu dans les communs, mais aussi et surtout dans le parc. Et c'est aussi pour en tenir compte que nous souhaitons un projet global de refonte du parc.

Quelle est l'idée qui préside à votre projet ?

Chaque année, nous recevons environ 100 000 visiteurs pour ces manifestations, et il faut donc que jusqu'à un certain point, le parc soit

Les jardins sont ma passion. C'est donc un souhait personnel de vouloir transformer le parc sur la base d'idées nouvelles de notre époque.

adapté aux contraintes que cela engendre. Par exemple, nous devons faire en sorte de disposer d'aires dégagées pour ces événements. Mais l'idée principale est de faire le lien entre l'art moderne du jardin et les bâtiments historiques, et c'est pour moi quelque chose de très intéressant.

À titre personnel, que représente pour vous le jardin ?

J'ai une formation d'ingénieur forestier et à ce titre, je suis très attachée à la nature et les jardins sont une de mes passions. C'est donc une volonté très personnelle de ma part de vouloir transformer le parc sur la base d'idées nouvelles de notre époque. Nous commençons cette année et nous allons avancer secteur par secteur.

Et selon vous, quel sera votre endroit préféré du jardin ?

Je ne sais pas encore. Cela tiendra certainement à des nuances : la lumière ou ce qui fleurit à un moment donné. Je suis impatiente de voir le résultat !

213

Stephanie Gräfin Bruges-von Pfuel

Acres Wild

Horsham | England

Connecting the house to the garden and the garden to the landscape, the customer's wish was executed perfectly. | Das Haus mit dem Garten und den Garten mit der Landschaft verbinden – der Wunsch der Kunden wurde perfekt umgesetzt. | Relier la maison au jardin et le jardin au paysage, ou comment respecter parfaitement le souhait du client.

214

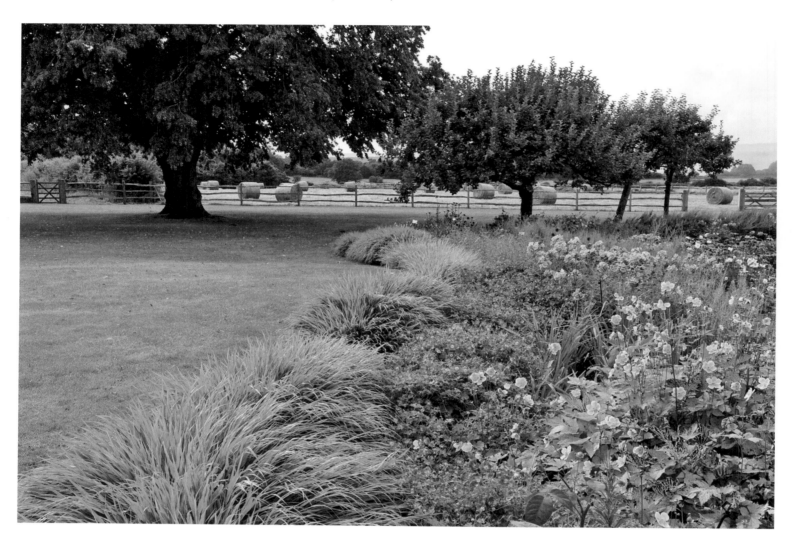

Geranium, Phlox and other perennials are gently surrounded by Hakonechloa macra, a Japanese forest grass. The adjoining lawn merges into the surrounding meadow landscape.

Geranium, Phlox und andere Stauden werden sanft eingefasst vom Japanischen Berggras Hakonechloa macra. Der anschließende Rasen leitet zur umgebenden Wiesenlandschaft über.

Les géraniums, les phlox et autres plantes vivaces sont entourés d'un doux cadre d'herbes japonaises de montagne Hakonechloa macra. La pelouse qui prend le relais fait la transition avec le paysage de prairies des alentours.

Jon and Sue Olsen grew up in South Africa and longed for an open view of the landscape. For this reason, landscape designers Debbie Roberts and Ian Smith from Acres Wild removed all visual obstructions, such as walls and fences, and arranged the Victorian house's expansive garden in the Surrey Hills with geometric elements, combined with generous amounts of planting beds. The view now flows unobstructed from the house into the garden and then onto the landscape beyond, which the family and their invited guests can enjoy.

Jon und Sue Olsen wuchsen in Südafrika auf und sehnten sich nach freier Sicht in die Landschaft. Die Gartengestalter Debbie Roberts und Ian Smith von Acres Wild ließen daher Hindernisse wie Mauern verschwinden und gliederten den weitläufigen Garten des viktorianischen Hauses in den Surrey Hills mit geometrische Elementen, kombiniert mit großzügigen Pflanzbeeten. Der Blick schweift nun ungehindert vom Haus in den Garten und in die Landschaft, was die Familie und ihre Gäste bei gesellschaftlichen Anlässen genießen können.

Ayant grandi en Afrique du Sud, Jon et Sue Olsen rêvaient d'une vue dégagée sur le paysage. Les paysagistes Debbie Roberts et Ian Smith, de la société Acres Wild, ont donc fait disparaître les obstacles visuels, comme les murs, et structuré le vaste jardin de cette maison victorienne de la région des collines du Surrey en recourant à des éléments géométriques associés à de généreux massifs. Aujourd'hui, la famille et les invités peuvent laisser le regard flotter librement de la maison vers le jardin, puis vers le paysage alentour.

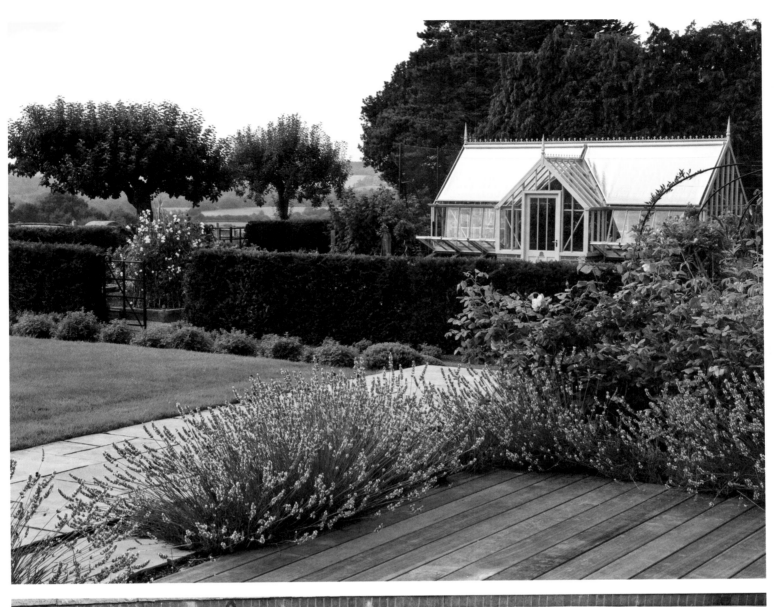

Top: A vegetable garden lies in front of the Victorian-style greenhouse and behind the hedgerow. The deck is surrounded by white lavender, roses, and catmint. Left: Curved stone steps lead through a row of spherically trimmed Box (Buxus sempervivens) to the newly designed pool area with a wooden deck.

Oben: Vor dem Gewächshaus im viktorianischen Stil liegt der Gemüsegarten hinter Hecken. Die Terrasse ist eingefasst von weißem Lavendel, Rosen und Katzenminze. Links: Geschwungene Steinstufen führen durch eine Reihe von kugelig geschnittenem Buchs (Buxus sempervivens) zum neu gestalteten Poolbereich mit Holzbelag.

Ci-dessus : Devant la serre au style victorien, le potager se cache derrière des haies. La terrasse est entourée de lavande blanche, de rosiers et de cataires (qu'on appelle aussi menthe aux chats). À gauche : Les marches courbées en pierre traversent une rangée de buis taillés en boule (Buxus sempervivens) avant d'arriver à la nouvelle piscine revêtue de bois.

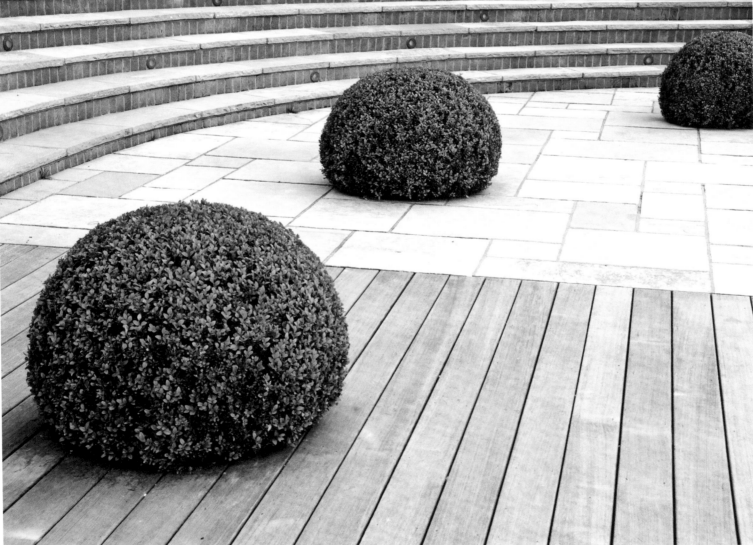

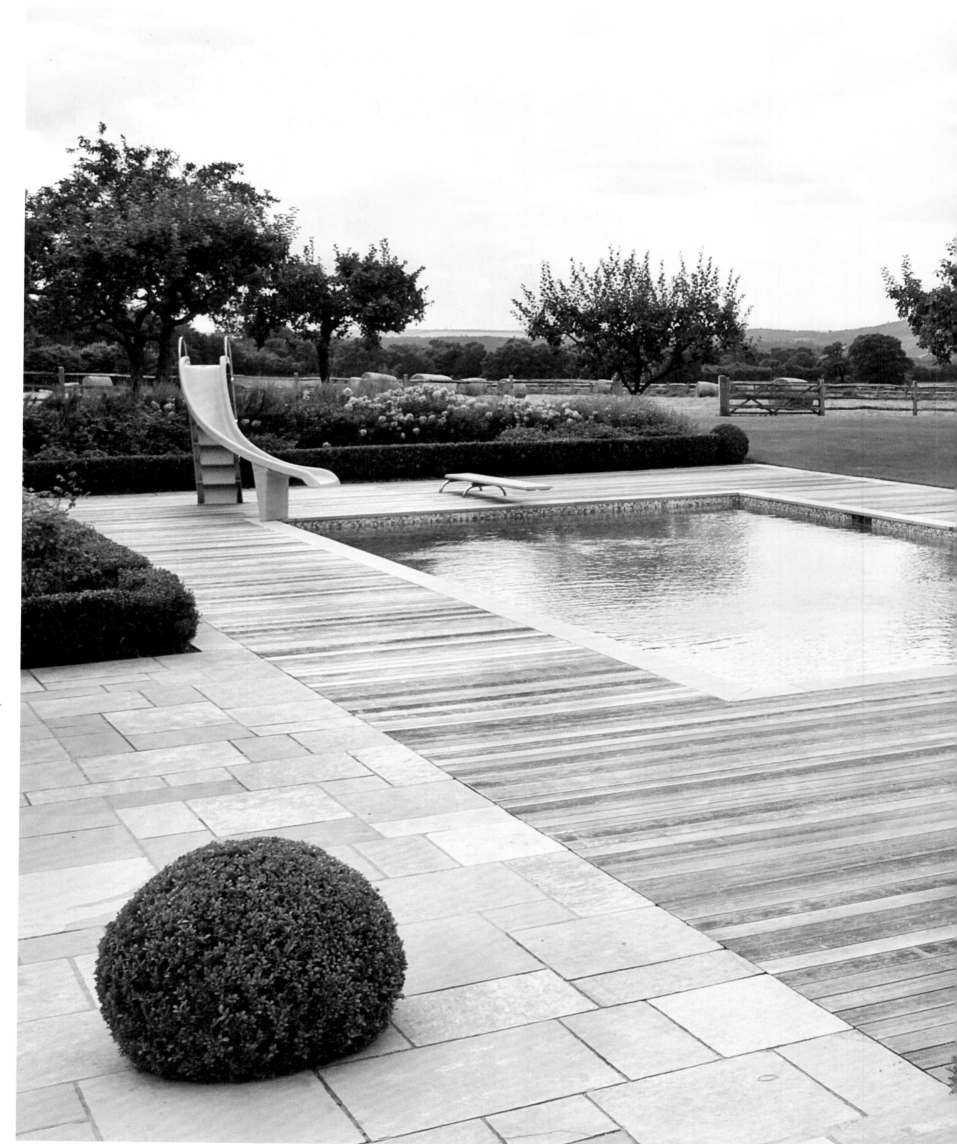

216

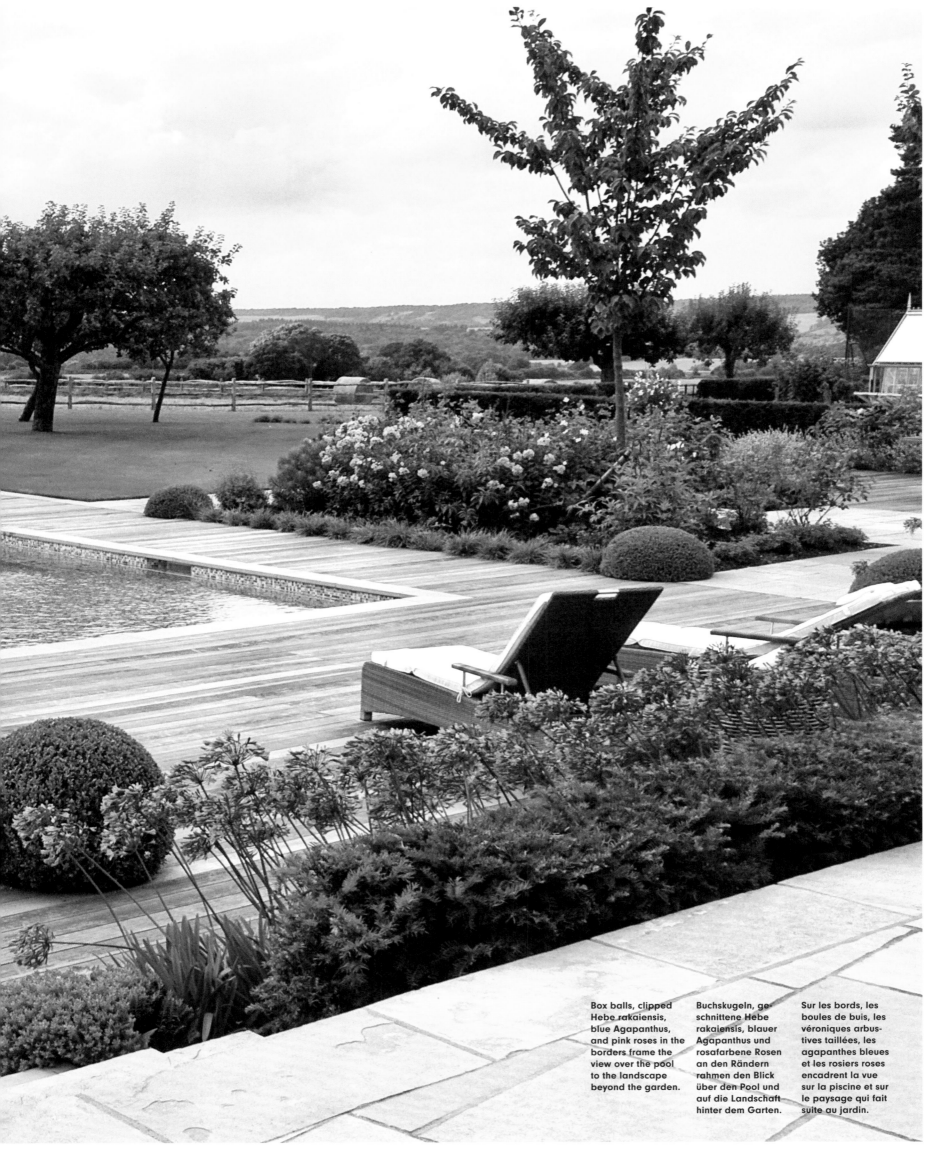

217

Box balls, clipped Hebe rakaiensis, blue Agapanthus, and pink roses in the borders frame the view over the pool to the landscape beyond the garden.

Buchskugeln, geschnittene Hebe rakaiensis, blauer Agapanthus und rosafarbene Rosen an den Rändern rahmen den Blick über den Pool und auf die Landschaft hinter dem Garten.

Sur les bords, les boules de buis, les véroniques arbustives taillées, les agapanthes bleues et les rosiers roses encadrent la vue sur la piscine et sur le paysage qui fait suite au jardin.

Niagara and Villa L

Ramatuelle
France

The Bay of St. Tropez contains a gardening jewel with an impressive pool landscape.

In der Bucht von St. Tropez liegt ein Schmuckstück von Garten mit eindrucksvoller Pool-Landschaft.

La baie de Saint-Tropez abrite un jardin de rêve avec piscine dans un décor naturel impressionnant.

218

The two villas overlooking the Bay of Pampelonne are protected from the mistral, a strong wind that gusts through Provence about 100 days out of the year and is capable of blowing for seven days straight at times. The property is owned by a famous artist and designer whose multidisciplinary work provides ample evidence of a passion for the experimental and inventive in terms of using materials, processes, and items from our everyday lives. His villa garden at the Bay of St. Tropez offers generosity and an unobstructed view of the Mediterranean.

The father of the current owner began developing the plot in the 1960s, at a time when it was adorned solely by a single fishing hut. Two villas were built: The Niagara, a cozy private hideaway for the family, and the adjoining Villa L, a spacious guest house. The exterior landscaping follows a similar pattern. While Villa L's garden tackles a theme of vastness and opens out to the coastline, the Niagara's surroundings have been kept in a more organic form and offer countless enchanted private nooks and retreats.

Over the years, the garden has become neater and more open, with immense swaths of grass and terraces along with borders with a wild, more natural appearance. That is where long-time gardener Aidon Harrington planted each of his new finds. This garden consciously avoids colorful beds of perennials or ostentatious flowering shrubs.

Geschützt vor dem Mistral, der die Provence an etwa 100 Tagen im Jahr zerzaust, und durchaus auch sieben Tage am Stück wehen kann, liegen die beiden Villen in der Bucht von Pampelonne. Der Hausherr ist ein renommierter Künstler und Designer, dessen multidisziplinäre Arbeit von einer Leidenschaft für Experimente und Erfindungen zeugt, was die Anwendbarkeit von Materialien, Prozessen und Alltagsgegenständen betrifft. Sein Villengarten in der Bucht von St. Tropez besticht durch Großzügigkeit und den freien Blick auf das Mittelmeer.

Der Vater des heutigen Besitzers begann das Areal, auf dem einst nur ein Fischerhäuschen stand, in den 1960er-Jahren zu entwickeln. Zwei Villen entstanden: Niagara als verstecktes und gemütliches Privathaus der Familie und die benachbarte Villa L als großzügiges Gästehaus. Entsprechend sind auch die Außenanlagen gestaltet. Während im Garten der Villa L Weite das Thema ist und dieser sich zur Küste öffnet, bietet die in organischen Formen gehaltene Umgebung der Niagara zahlreiche verwunschene private Nischen und Rückzugsorte.

Im Lauf der Jahre wurde der Garten immer aufgeräumter und übersichtlicher, mit großen Rasenflächen und Terrassen, wild und natürlicher im Aussehen an den Rändern. Dort pflanzte der langjährige Gärtner Aidon Harrington immer wieder neue Fundstücke. Auf bunte Staudenbeete oder auffällig blühende Sträucher hat man in dieser Gartenanlage bewusst verzichtet.

Protégées du mistral qui souffle près de 100 jours par an en Provence et parfois même pendant sept jours d'affilée, les deux villas sont situées dans la baie de Pampelonne. Le maître des lieux est un artiste et designer célèbre dont le travail multidisciplinaire témoigne d'une véritable passion pour les expérimentations et les inventions en matière d'utilisation de matières première, de processus et d'objets du quotidien. Le jardin de sa villa dans la baie de Saint-Tropez impressionne par ses grandes étendues et par la vue imprenable sur la Méditerranée.

L'extension du terrain, où se tenait autrefois uniquement une maison de pêcheurs, a été entreprise par le père de l'actuel propriétaire dans les années 1960. Deux villas y ont vu le jour : la Niagara, confortable résidence privée de la famille, à l'abri des regards, et la Villa L voisine, spacieuse maison d'hôtes. Les espaces extérieurs sont aménagés à l'image de celles-ci. Si dans le jardin de la Villa L, les grandes étendues dominent et s'ouvrent sur la côte, le paysage naturel conservé de la Niagara offre de nombreux recoins privés et havres de paix enchanteurs.

Au fil des années, le jardin a été de plus en plus aménagé et ordonné, avec de grandes pelouses et terrasses, conservant un aspect plus sauvage et naturel en lisière. C'est là qu'Aidon Harrington, jardinier de longue date sur la propriété, a planté ses nombreuses trouvailles. Les habituels massifs multicolores de plantes vivaces ou buissons fleuris n'y ont volontairement pas leur place.

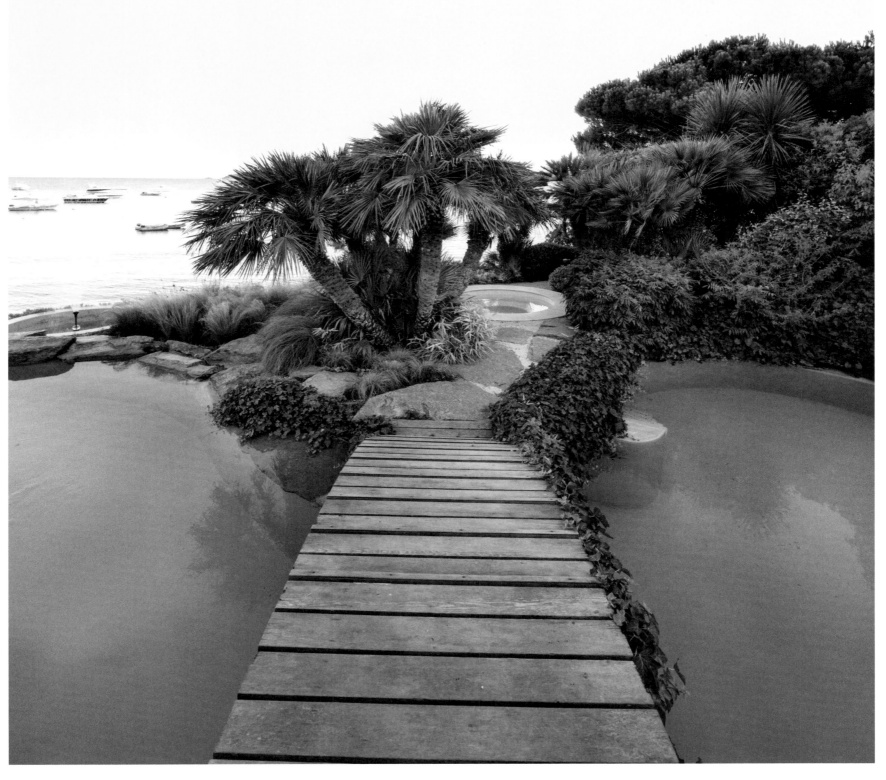

A wooden arched bridge leads over the natural flowing shape of the pool on the Niagara property. Morning glories and ivy entwine at the bridge with a backdrop of dwarf fan palms, pines, cinnamon and dragon trees bordered by grasses and bamboo.

Eine hölzerne Bogenbrücke führt über den natürlich geschwungenen Pool des Anwesens Niagara. An der Brücke ranken Prunkwinden und Efeu, den Hintergrund bilden von Gräsern und Bambus gesäumte Zwergpalmen, Pinien sowie Drachen- und Zimtbäume.

Un pont en arc en bois enjambe la piscine aux courbes naturelles de la Niagara. Le long du pont grimpent des ipomées et du lierre tandis que l'arrière-plan est formé par des palmiers nains, pins, dragonniers et canneliers bordés d'herbes et de bambous.

219

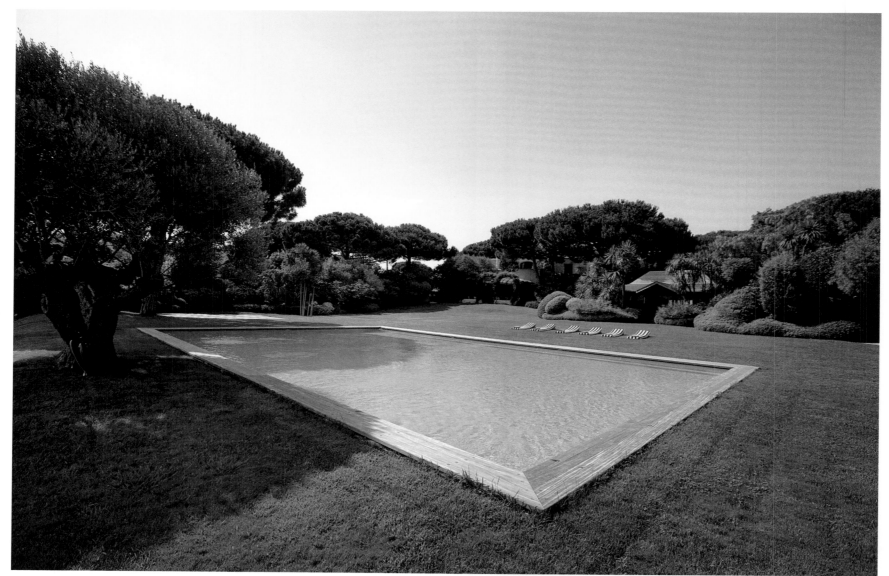

220

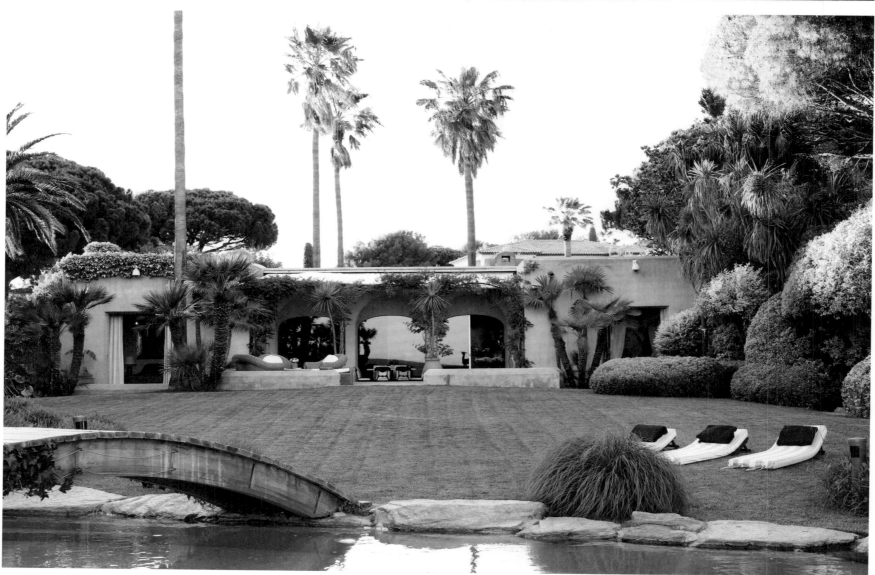

Under wind-swept pines, magnificent cordyline specimens thrive at the edges of the lawns together with trimmed photinias, pittosporums, and oleander, while tall Washingtonia fan palms—a hallmark of the French Riviera—reach into the sky behind the house.

Unter windgebeugten Pinien gedeihen am Rande der Rasenflächen prächtige Exemplare von Keulenlilien sowie in Form geschnittene Glanzmispeln, Klebsamen und Oleander, während hinter dem Haus hohe Washingtonia-Palmen – ein Wahrzeichen der Côte d'Azur – in den Himmel ragen.

Sous les pins courbés par le vent prolifèrent en bordure des pelouses de magnifiques spécimens de cordylines et de photinias, pittosporums et autres lauriers roses taillés en topiaire, tandis que de hauts palmiers Washingtonia – devenus l'emblème de la Côte d'Azur – se dressent derrière la maison.

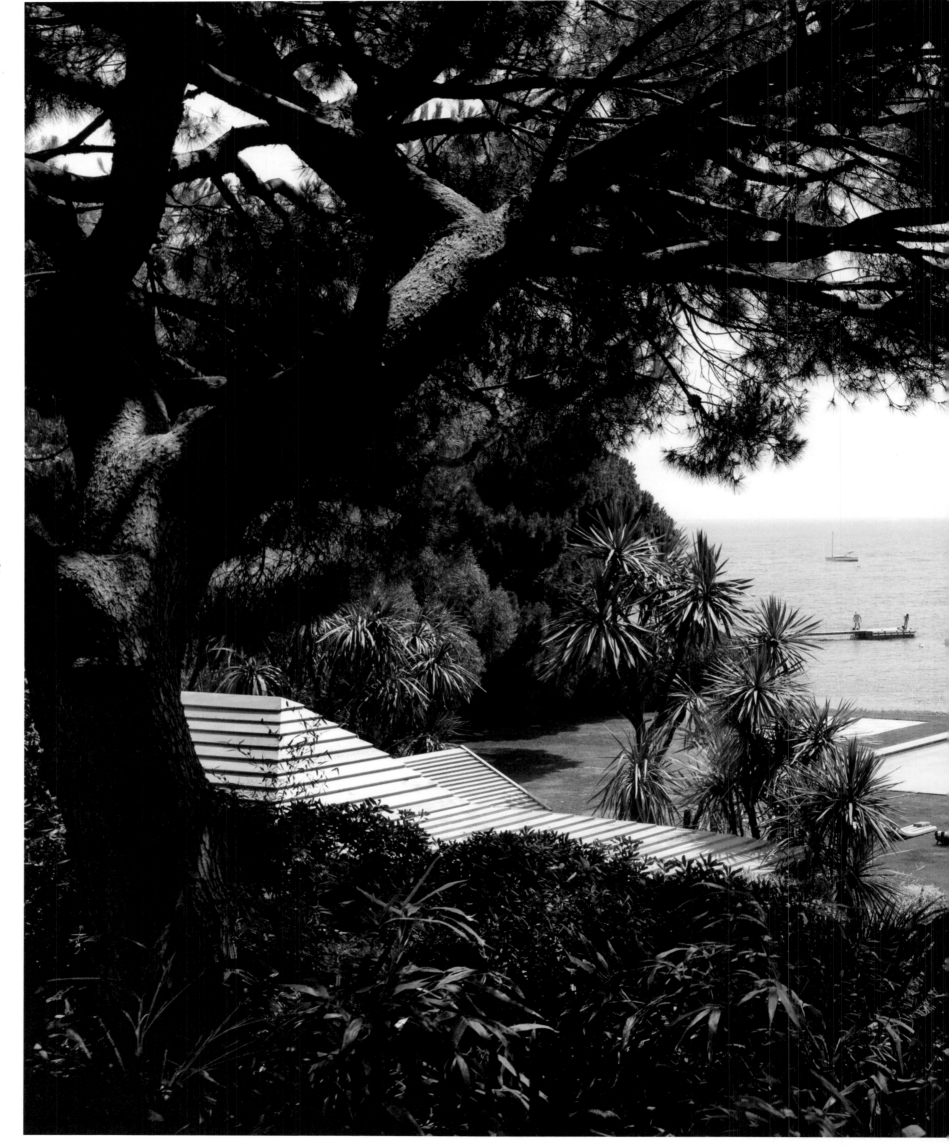

222

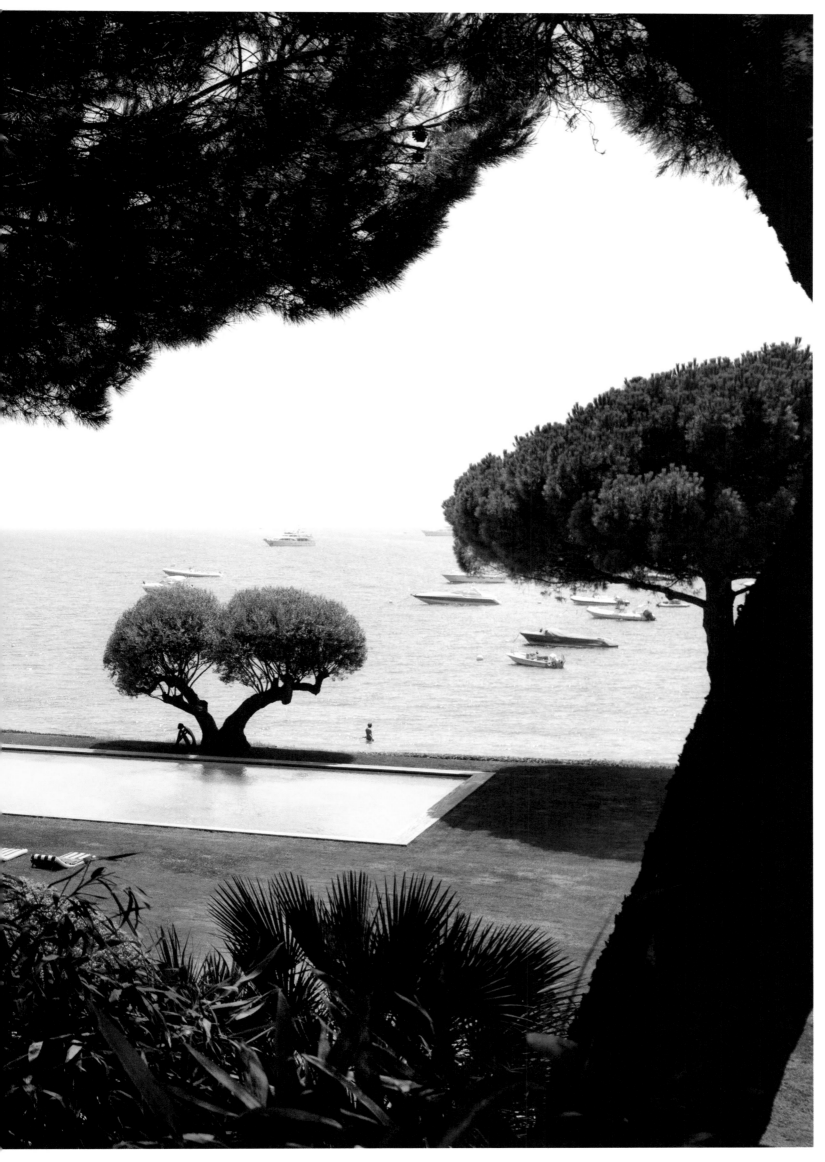

While the Niagara's pool takes on the appearance of a lake, the Villa L pool juts right into the lawn. Mediterranean plant life trimmed into organic shapes stands under wind-swept pines to form a living framework for both villas.

Während der Pool der Niagara fast die Anmutung eines Sees hat, schneidet sich der Pool der Villa L geradlinig in die Rasenfläche. Unter windgebeugten Pinien bilden zu organischen Formen geschnittene mediterrane Gehölze einen lebendigen Rahmen für die beiden Villen.

Si la piscine de la Niagara a presque des airs de lac, celle de la Villa L affiche une forme rectangulaire parfaite sur la pelouse. Sous les pins courbés par le vent, les arbres méditerranéens taillés aux formes naturelles forment le décor vivant des deux villas.

Sun- Square

Tulln
Austria

Whether for courtyards, terraces, sitting areas in the garden or by the pool, sun sails by SunSquare provide customized solutions.

Ob für Höfe, Terrassen, Sitzecken im Garten oder am Pool, Sonnensegel von SunSquare bieten maßgefertigte Lösungen.

Les voiles d'ombrage SunSquare offrent des solutions sur mesure pour tous les besoins : cours, terrasses, salons de jardin, bords de piscine.

224

Sun sails are the specialty of SunSquare Kautzy GmbH, founded in 1993 in Vienna. Their aesthetically sophisticated and custom-made motor-operated shading solutions provide refreshing shade and protection from UV-rays in the Zürich Botanical Garden, in the Lower Austria Museum in St. Pölten and Melk Abbey, in the Palm House in Vienna, at the Mori-Building in Tokyo and on the Caribbean Island of Aruba.

The first prototype was brought to fruition almost 20 years ago, having been adapted from an idea by designer Gerald Wurz. Today, they are produced in the city of Tulln in Lower Austria; 21 employees along with more than 50 partner companies worldwide manufacture the architectural sun shades.

The structure, consisting of a drive and shaft, control system, sail and supports requires four or six attachment points depending on the system: The shaft must be installed on both sides using ground supports or supports attached to the exterior wall of a house, while the ends of the sail are attached at one or two points. This is where the greatest load is borne—up to a maximum of 154 pounds (70 kilograms) tension on each end of the sail. Wind forces are absorbed by an elaborate suspension system that also keeps the sail stable in the rain. The angle of the sail is also designed to allow for rainwater runoff.

Featuring triangular and rectangular shading, rooftop gardens, terraces, sitting areas in the garden or by the pool, courtyards, playgrounds or parking lots can all be covered. Each sail is made from coated acrylic fabric or PVC netted fabric and is crafted according to the customer's requirements up to a maximum size of 753 square feet (70 square meters).

Sonnensegel sind die Spezialität der 1993 in Wien gegründeten SunSquare Kautzy GmbH. Deren ästhetisch anspruchsvolle und maßgefertigte motorbetriebene Beschattungslösungen bieten unter anderem im Botanischen Garten in Zürich, im Landesmuseum St. Pölten sowie im Stift Melk, im Palmenhaus in Wien, am Mori-Building Tokyo oder auf der Karibikinsel Aruba wohltuenden Schatten und Schutz vor UV-Strahlung.

Vor knapp 20 Jahren entstand der erste Prototyp des Sonnensegels nach einer Idee des Designers Gerald Wurz. Heute wird im niederösterreichischen Tulln produziert; 21 Mitarbeiter stellen mit über 50 weltweiten Partnerfirmen den architektonischen Sonnenschutz her.

Die Konstruktion aus Antrieb mit Welle, Steuerung, Segel und Stützen benötigt vier oder sechs Befestigungspunkte, je nach System: Die Welle muss beiderseits mittels Stützen am Boden oder an der Hauswand montiert werden, die Segelenden werden an einem oder an zwei Punkten fixiert. Dort treten auch die größten Lasten auf, bis maximal 70 Kilogramm Zug an jedem Segelende. Windkräfte werden über ein ausgeklügeltes Federungssystem abgefangen, das das Segel auch bei Regen stabil hält. Die Neigung des Segels ist zudem so konzipiert, dass Regenwasser abrinnen kann.

Mit den drei- sowie viereckigen Beschattungen können etwa Dachgärten, Terrassen, Sitzecken im Garten oder am Pool, Hofflächen, Spiel- oder Parkplätze überdacht werden. Jedes Segel besteht aus beschichtetem Acrylgewebe oder PVC-Netzgeweben und wird mit einer Größe von maximal 70 Quadratmetern nach den individuellen Bedürfnissen des Kunden angefertigt.

Les voiles d'ombrage sont la spécialité de la société SunSquare Kautzy GmbH, créée en 1993 à Vienne. Très recherchées sur le plan esthétique, ses solutions motorisées sont fabriquées sur mesure : on les trouve en particulier au jardin botanique de Zurich, au musée de Sankt-Pölten (Basse-Autriche), ainsi qu'à l'abbaye de Melk (Basse-Autriche), dans la serre aux palmiers de Vienne, dans la tour Mori de Tokyo ou encore sur l'île caribéenne d'Aruba, où elles dispensent leur ombre bienfaisante et protègent des rayons ultraviolets.

Le premier prototype de voile d'ombrage est né il y a près de 20 ans sur une idée du designer Gerald Wurz. Aujourd'hui, la production a lieu à Tulln, en Basse-Autriche, où 21 personnes fabriquent les protections solaires d'architecture, en collaboration avec plus de 50 partenaires internationaux.

Constituée d'un moteur et d'un arbre, d'une commande, de la voile proprement dite et de poteaux, la structure requiert quatre ou six points de fixation, selon le système : l'arbre doit être monté des deux côtés sur des poteaux reposant au sol ou bien sur le mur, tandis que les extrémités de la voile viennent se fixer en un ou deux points. C'est là que les charges sont les plus fortes, avec un maximum de 70 kilos sur chaque extrémité. Les forces dues au vent sont absorbées grâce un système très étudié d'amortissement qui assure la stabilité de la voile même en cas de pluie. De plus, l'inclinaison de la voile est calculée de façon à permettre l'écoulement de l'eau de pluie.

De forme triangulaire ou quadrangulaire, les voiles peuvent abriter, par exemple, les jardins de toitures, les terrasses, les salons de jardin ou de piscine, les cours, les aires de jeu ou encore les parkings. Chaque voile est composée d'une toile acrylique enduite ou de tissus en PVC à mailles, et est confectionnée selon les besoins spécifiques du client, pour une surface maximale de 70 mètres carrés.

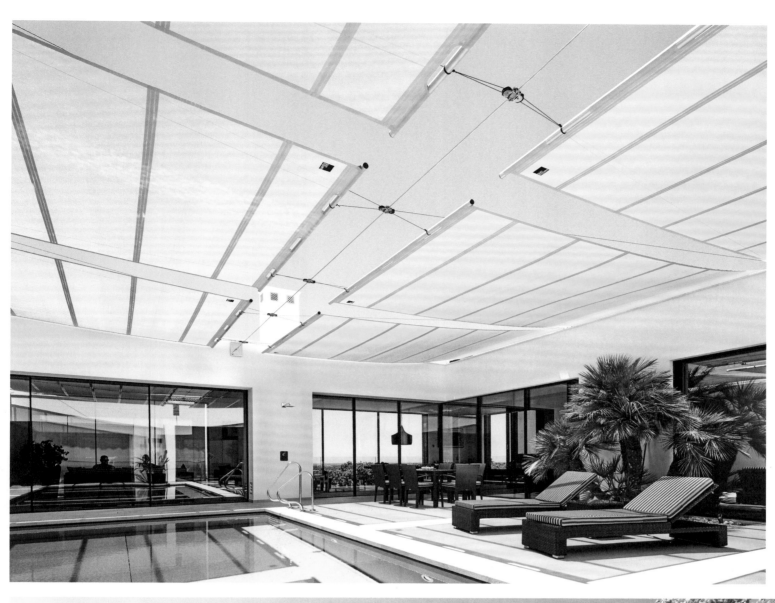

The sun sails are installed on the house and in the garden harmoniously. Amidst all the technology, whether triangular or rectangular, attached to supports or on walls, not only is optimal protection brought to the fore—but also aesthetic enjoyment.

Die Sonnensegel können harmonisch am Haus und im Garten angebracht werden. Ob drei- oder viereckig, an Stützen oder Mauern befestigt – bei aller Technik nicht nur optimaler Schutz, sondern auch ästhetischer Genuss.

Des voiles d'ombrage qui s'harmonisent avec les bâtiments et les jardins. Voiles triangulaires ou quadrangulaires, fixées sur des poteaux ou au mur : une technique qui associe protection optimale et esthétique.

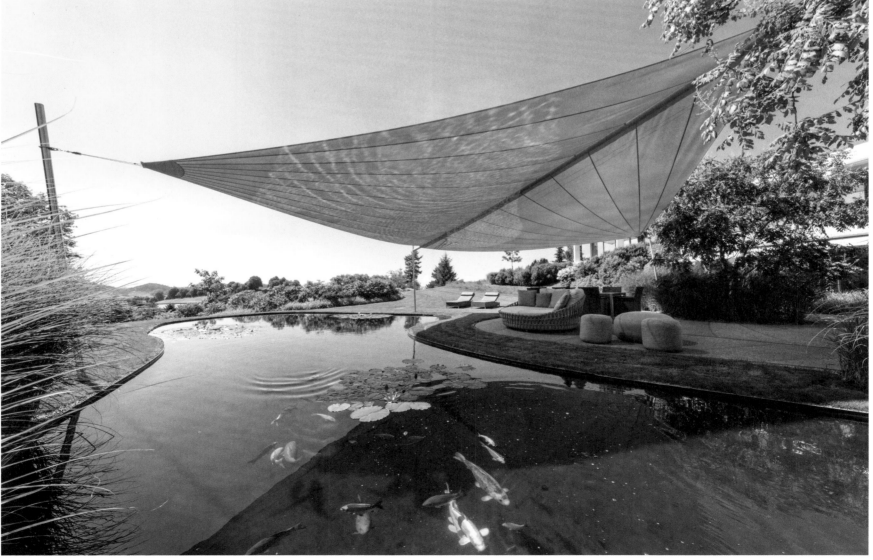

Cothay Manor

Nr Wellington | England

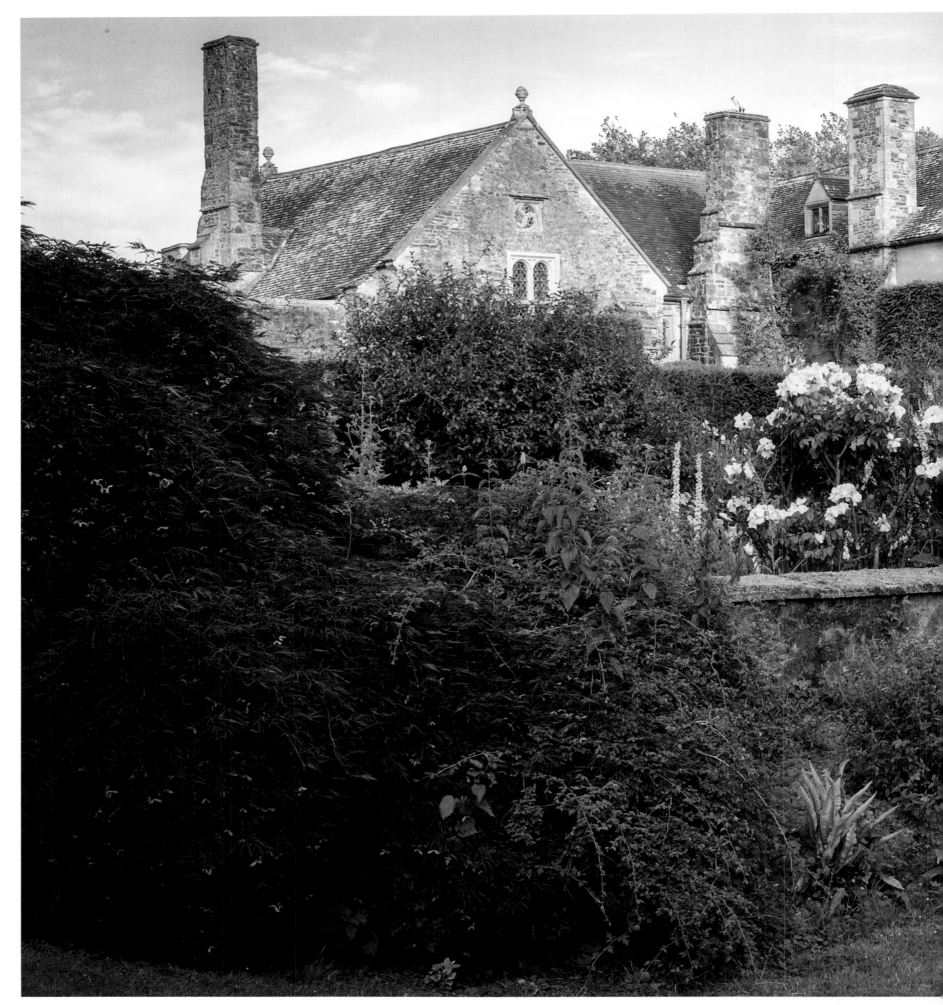

The traditional and the modern come together in garden spaces individually designed by an ambitious gardener. | Tradition und Moderne treffen sich in individuell gestalteten Gartenräumen einer ambitionierten Gärtnerin. | Tradition et modernité se rencontrent dans les espaces paysagers personnalisés d'une jardinière pleine d'ambition.

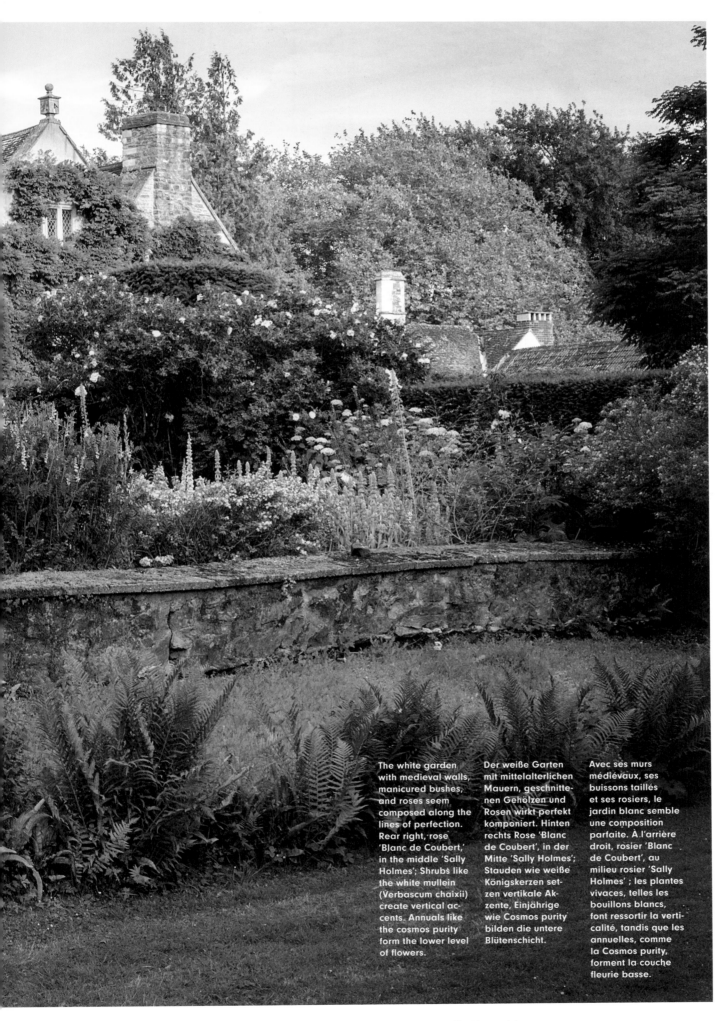

The white garden with medieval walls, manicured bushes, and roses seem composed along the lines of perfection. Rear right, rose 'Blanc de Coubert,' in the middle 'Sally Holmes'; Shrubs like the white mullein (Verbascum chaixii) create vertical accents. Annuals like the cosmos purity form the lower level of flowers.

Der weiße Garten mit mittelalterlichen Mauern, geschnittenen Gehölzen und Rosen wirkt perfekt komponiert. Hinten rechts Rose 'Blanc de Coubert', in der Mitte 'Sally Holmes'; Stauden wie weiße Königskerzen setzen vertikale Akzente, Einjährige wie Cosmos purity bilden die untere Blütenschicht.

Avec ses murs médiévaux, ses buissons taillés et ses rosiers, le jardin blanc semble une composition parfaite. À l'arrière droit, rosier 'Blanc de Coubert', au milieu rosier 'Sally Holmes' ; les plantes vivaces, telles les bouillons blancs, font ressortir la verticalité, tandis que les annuelles, comme la Cosmos purity, forment la couche fleurie basse.

Cothay Manor, built around 1480, is among the best preserved medieval houses in England and enjoys the highest level of protection in the National Heritage List. Colonel Reginald Cooper laid out the gardens in the Arts & Crafts style in 1920. When Alastair and Mary-Anne Robb acquired Cothay in 1993, they left a majority of the garden structure, such as the yew hedges, trees, and shrubs. In the spaces in between they planted gardens, each in a restrained color. Thanks to new ideas, the garden is continually changing.

Cothay Manor, um 1480 erbaut, zählt zu den am besten erhaltenen mittelalterlichen Häuser Englands und genießt höchsten Schutz in der National Heritage List. Die Gärten legte Colonel Reginald Cooper 1920 im Arts & Crafts-Stil an. Als Alastair und Mary-Anne Robb 1993 Cothay übernahmen, beließen sie den Großteil der Gartenstruktur: die Eibenhecken, Bäume und Sträucher. Die Räume dazwischen bepflanzten sie in je einer zurückhaltenden Farbe. Dank neuer Ideen verändert sich der Garten stetig.

Construit vers 1480, Cothay Manor une des maisons médiévales anglaises les mieux conservées, protégée à ce titre par son classement dans la National Heritage List. Les jardins avaient été aménagés par le colonel Reginald Cooper en 1920 dans le style Arts & Crafts. Lorsque Mary-Anne Robb et son mari Alastair prennent possession de Cothay en 1993, ils conservent la plus grande partie de la structure des jardins : les haies d'ifs, les arbres, les arbustes. Pour chacun des espaces intermédiaires ils choisissent des couleurs discrètes. Grâce à leurs idées nouvelles, le jardin change en permanence.

227

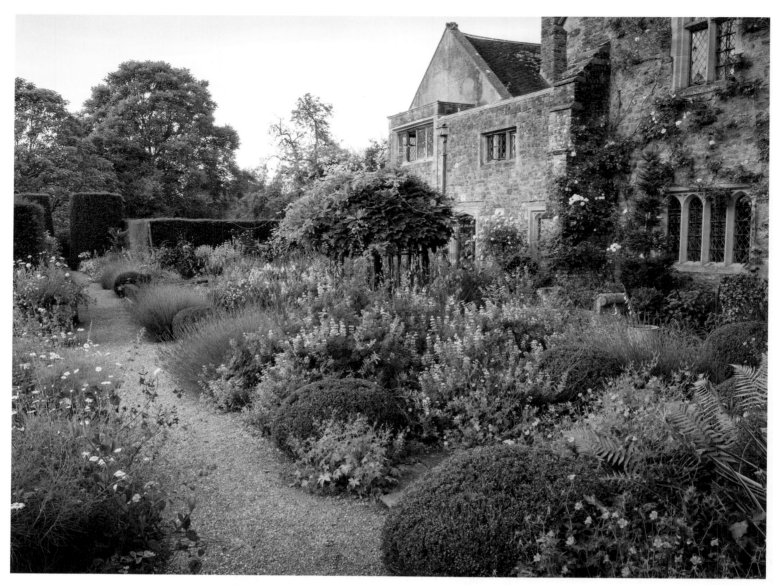

Self-reproducing plants such as Spanish daisies (Erigeron karvinskianus), Dierama and Potentilla nepalensis grow in the flagstone gaps on the terrace. Manicured box balls and yews as well.

Auf der Terrasse wachsen in den Pflasterfugen selbstvermehrende Pflanzen wie Spanisches Gänseblümchen (Erigeron karvinskianus), Trichterschwertel (Dierama) und Fingerkraut (Potentilla nepalensis). Dazu geschnittene Buchskugeln und Eiben.

Dans les joints des pavés de la terrasse poussent des plantes qui se multiplient spontanément, comme les vergerettes de Karvinski (Erigeron karvinskianus), les cannes à pêche des anges (Dierama pendulum) et la potentille vivace du Népal (Potentilla nepalensis). Et n'oublions pas les boules de buis et les ifs taillés.

228

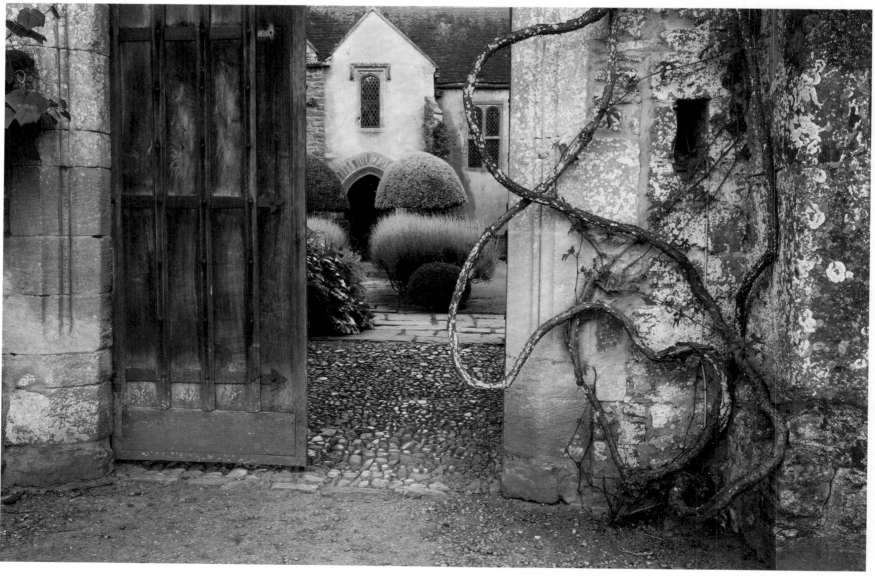

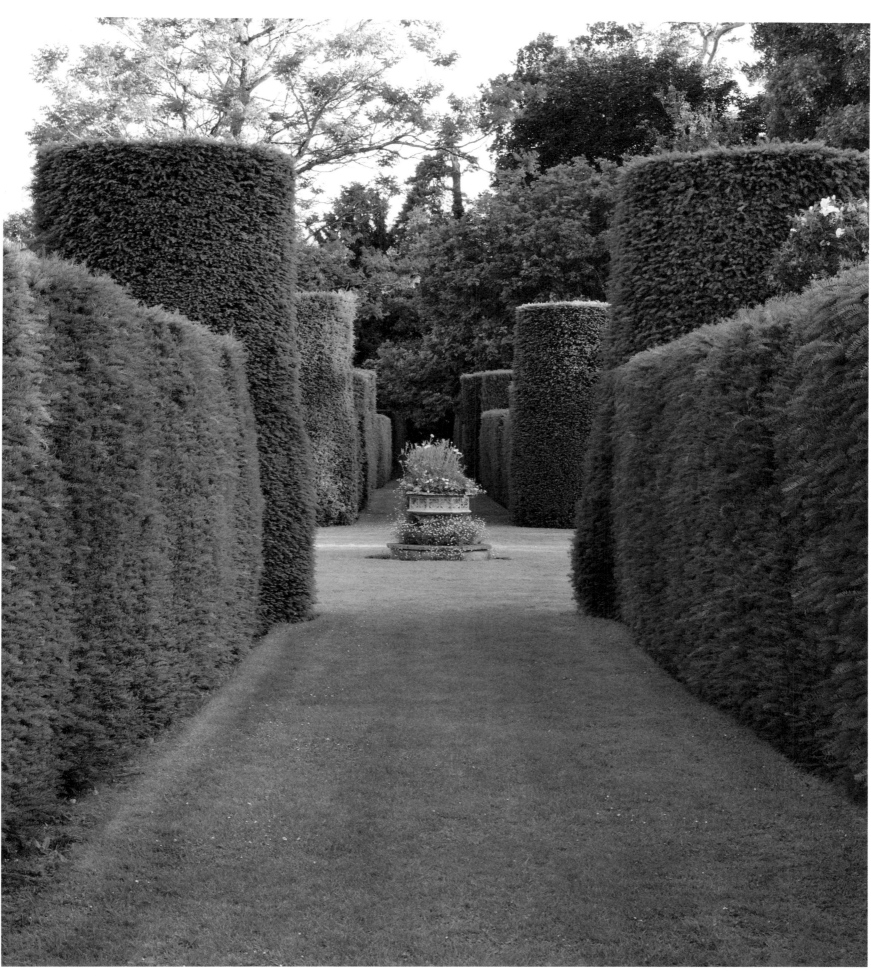

Left page: Looking through the gatehouse, the eye is drawn to the Oratory, one of the earliest parts of the house. The vine to the right of the gatehouse is 'Ampelopsis var. brevipedunculata' which has an abundance of turquoise and purple berries in the autumn.

Linke Seite: Durch das Torhaus blickt man auf das Oratorium, einen der ältesten Teile des Hauses. Die Weinrebe rechts des Torhauses ist eine 'Ampelopsis var. brevipedunculata', die im Herbst eine Fülle von türkis- und violettfarbenen Beeren aufweist.

Page gauche : À travers la porterie, on aperçoit l'oratoire, une des parties les plus anciennes de la maison. La vigne qui se trouve à droite de la porterie est une 'Ampelopsis var. brevipedunculata', qui porte en automne une multitude de raisins turquoise et violets.

Meticulously manicured yew hedges form the Yew Walk which is 984 feet (300 meters) long, off which are smaller individual gardens within the main. Harold Nicholson used many of his friend Reginald Cooper's ideas at Sissinghurst Palace.

Auf 300 Meter Länge säumen akkurat geschnittene Hecken den Eibenweg, von dem kleinere Einzelgärten innerhalb des Hauptgartens abzweigen. Harold Nicholson verwendete viele Ideen seines Freundes Reginald Cooper im Sissinghurst Palace.

Sur 300 mètres de long, des haies taillées avec grand soin ornent le chemin des ifs d'où partent des petits jardins séparés à l'intérieur du grand jardin. Harold Nicholson s'est servi des nombreuses idées que son ami Reginald Cooper avait réalisées à Sissinghurst Palace.

230

The impressive "Walk of the Unicorn" is 656 feet (200 meters) long. The eponymous unicorn was sculpted at the owners' request by a local sculptor. Covered with moss, it rests in the middle of The Walk. The path is lined with an avenue of Robinia pseudoacacia 'Umbraculifera.' Underplanted with the summer-long flowering cat mint nepetas 'Six Hills Giant' which in turn are underplanted with over 2,000 white triumphanter tulips for added spring glory.

Der beeindruckende „Weg des Einhorns" ist 200 Meter lang. Namensgebend ist eine Einhorn-Skulptur, die die Besitzer bei einem lokalen Bildhauer fertigen ließen. Mit Moos bewachsen, ruht sie in der Mitte der Anlage. Der Weg ist gesäumt von einer Allee aus Kugelrobinien (Robinia pseudoacacia 'Umbraculifera'). Darunter erstrahlt den ganzen Sommer die Katzenminze Nepeta 'Six Hills Giant', die wiederum mit 2 000 weißen, im Frühjahr prächtig blühenden Triumphtulpen unterpflanzt wurde.

L'impressionnant chemin de la licorne mesure 200 mètres. Il doit son nom à la licorne sculptée que les propriétaires ont commandée à un artiste local. Revêtue de mousse, elle repose au milieu du site. Le chemin est bordé d'un alignement d'acacias boules (Robinia pseudoacacia 'Umbraculifera') sous lesquels rayonne tout l'été la cataire Nepeta 'Six Hills Giant', elle-même surmontant 2 000 tulipes triomphe blanches au magnifique fleurissement printanier.

231

Cothay Manor

Mary-Anne Robb

232

Mary-Anne Robb and her husband, Alastair, are blessed with a green thumb. When they acquired the heritage-protected Cothay Manor in 1993, they breathed new life into the romantic gardens.

Mary-Anne Robb ist wie ihr Mann Alastair mit einem grünen Daumen gesegnet. Als sie 1993 das denkmalgeschützte Cothay Manor übernahmen, hauchten sie der romantischen Gartenanlage neues Leben ein.

Comme son mari Alastair, Mary-Anne Robb a la main verte. Lorsqu'en 1993, ils rachètent le manoir classé de Cothay, ils redonnent vie au jardin romantique.

The Garden is Ever on the Move.
Der Garten ist immer in Bewegung.
Le jardin est toujours en mouvement.

The garden is in a constant state of evolution. Where do you get your ideas from?

My ideas come from my imagination, other gardens I admire, from discussions with my family and the people who come and visit. A garden is a continually changing thing and like a partner in need, it requires enduring attention, love, and care.

A garden is like a partner in need of nurturing – it needs a lot of affection, care, and love.

Do roses have a special meaning to you?

I love the single-flowered rose. Their delicate beauty is timeless. We are fortunate to have perfect soil for them and grow many different varieties.

Is there any favorite plant you like best?

My favorite plants are from the family Leguminosae, plants with pea-like flowers. Apart from those, the Angels Fishing Rods and the Dioramas which we have interspersed throughout the terrace, dangling their marvelous fronds.

Perennials, potted plants, and topiaries require a lot of maintenance. How many gardeners are working with you?

All the gardeners are part-time, roughly amounting to the equivalent of one full-time worker plus a student three days per week. I also have a part-time groundsman three mornings per week. As you can imagine, there is a plenty of garden work that remains for me and my husband to do.

Sie verändern Ihren Garten regelmäßig. Woher nehmen Sie all diese Ideen?

Sie entspringen meiner Vorstellungskraft, sie kommen aus anderen Gärten, die ich schätze, resultieren aus Diskussionen mit Familienmitgliedern oder von Bekannten, die uns besuchen kommen. Jeder Garten ist stets im Wandel, und wie ein pflegebedürftiger Partner verlangt er beständige Zuwendung, Liebe und Fürsorge.

Haben Sie eine besondere Liebe zu Rosen?

Ich mag die einblütigen Rosen – ihre ätherische Schönheit ist zeitlos. Wir haben das Glück, diesen Rosen den perfekten Boden zu bieten zu können, so dass wir viele Sorten anpflanzen.

Ein Garten ist wie ein pflegebedürftiger Partner: Er verlangt viel Zuneigung, Liebe und Fürsorge.

Haben Sie eine Lieblingspflanze?

Meine Lieblingspflanzen gehören zur Familie der Leguminosen, Pflanzen mit Blättern wie die Erbsen. Aber auch das Trichterschwert Dierama 'Angel's Fishing Rod', das bei uns überall auf der Terrasse wächst mit seinen eindrucksvollen Wedeln.

Stauden, Kübelpflanzen und die Formgehölze verlangen sehr viel Pflege. Wie viele Gärtner unterstützen Sie dabei?

Alle Gärtner arbeiten Teilzeit, das macht zusammen nur eine volle Stelle aus. Dazu kommen an drei Tagen in der Woche ein Student und an drei Vormittagen noch jemand, der auf dem Gelände nach dem Rechten sieht. Wie man sich also denken kann, bleibt für mich und meinen Mann genügend Arbeit im Garten übrig.

Vous changez régulièrement votre jardin. D'où vous viennent toutes ces idées ?

Elles sortent de mon imagination, ou viennent d'autres jardins que j'apprécie, elles sont aussi le fruit de discussions avec des gens de ma famille ou des connaissances qui viennent nous voir. Chaque jardin est en mutation permanente,

Un jardin est comme un compagnon devenu dépendant : il a besoin d'attention, de soins et d'amour.

c'est comme un compagnon dépendant, il requiert une attention de tous les instants, des soins et de l'amour.

Ressentez-vous une affection particulière pour les roses ?

J'aime les rosiers à une fleur, leur beauté éthérée est intemporelle. Nous avons le bonheur de pouvoir offrir à ces rosiers un sol parfait et nous en plantons donc de nombreuses variétés.

Avez-vous une plante préférée ?

Mes plantes préférée sont des légumineuses, des plantes à feuilles tels que les petits pois. Mais j'aime aussi le Dierama pendulum, appelé aussi 'canne à pêche des anges', qui pousse partout sur la terrasse, avec ses palmes impressionnantes.

Plantes vivaces, plantes en jardinières et arbustes taillés demandent énormément d'entretien. Combien de jardiniers vous aident-ils ?

Tous les jardiniers travaillent à temps partiel, si bien qu'au total, cela fait un temps complet. De plus, j'ai un étudiant trois jours par semaine, et puis trois matinées une personne qui vient voir si tout va bien. Comme on le voit, il nous reste donc suffisamment de travail à moi et à mon mari.

Mary-Anne Robb

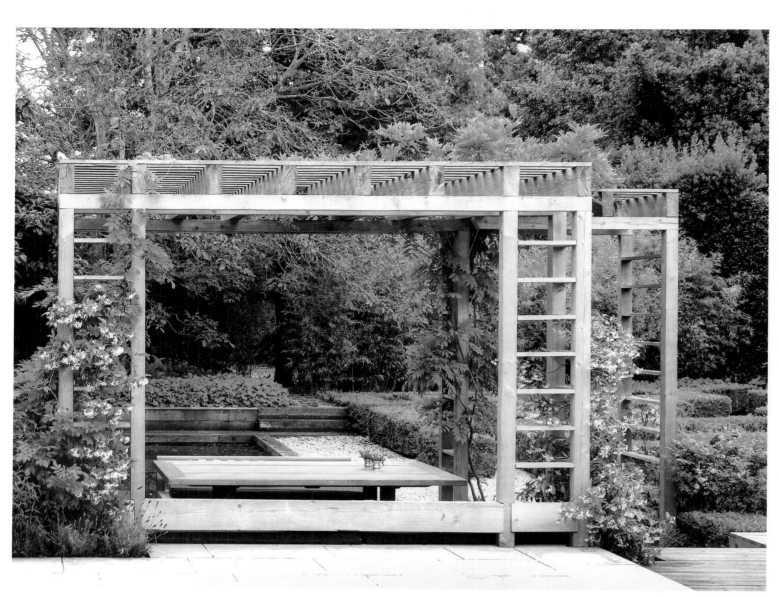

Left: Designed to echo a contemporary glass extension, the clean-lined pergola provides support for wisteria and jasmine to scramble over. Below: The high banks of the moat were stepped down to give greater visibility to the water.

Links: Entworfen, um einen modernen Glasanbau zu spiegeln, bietet die geradlinige Pergola Glyzinien und Jasmin Halt. Unten: Die steilen Ufer des Grabens wurden abgetragen, um das Wasser besser sichtbar zu machen.

À gauche : Conçue pour refléter une extension moderne vitrée, la pergola droite sert de soutien à des glycines et des jasmins. Ci-dessous : Les rives escarpées du fossé ont été érodées pour que l'eau soit mieux visible.

234

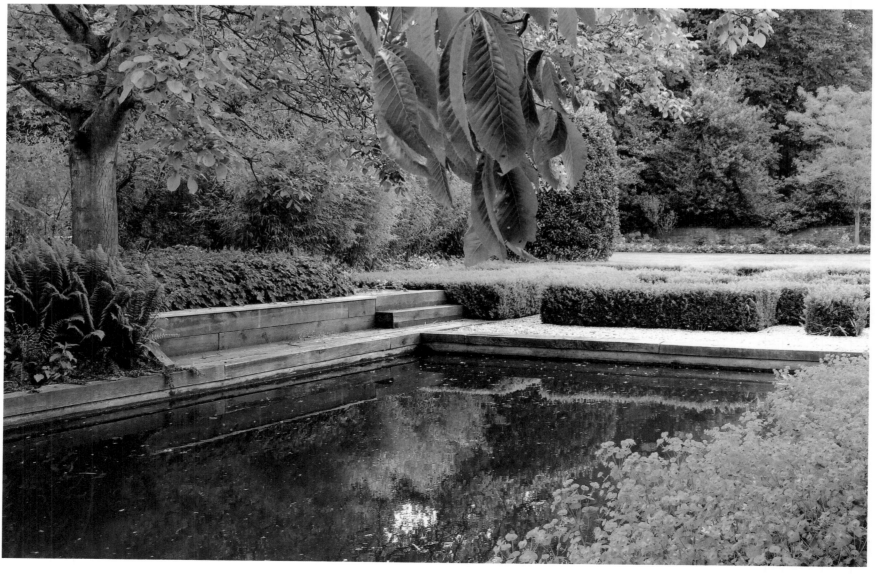

Alexis McNally

West Sussex | England

Landscape designer Alexis McNally has used the element of water to bring the garden of a West Sussex manor back to life. | Landschaftsarchitekt Alexis McNally nutzte das Element Wasser, um den Garten eines Herrenhauses in West Sussex wieder zum Leben zu erwecken. Cet architecte paysagiste s'est servi de l'eau pour redonner vie au jardin d'une maison de maître située dans le Sussex de l'Ouest.

Catching the light, a serpentine rill snakes its way between two trees.

Zwischen den Bäumen schlängelt sich eine Wasserrille, die das Licht einfängt.

Ondulant entres les arbres, un serpent d'eau semble capter la lumière.

235

Surrounding an enchanting country manor house, extensive lawns stretch idyllically beneath stately trees. The key feature however—a stream-fed watercourse flowing through the garden—ran through a pipe under the access drive, or was obscured by high banks and overgrown vegetation. So in order to revive the spirit of the place a new wide channel was excavated, spanned by a bridge. Elsewhere the water was brought into view by lowering the ground level, and a shady pergola now forms a focal point overhanging the water's edge.

Rund um ein bezauberndes Landhaus erstrecken sich weite, idyllische Rasenflächen unter stattlichen Bäumen. Doch das Schlüsselelement, ein den Garten durchquerender Wasserlauf, floss durch ein Rohr unter der Zufahrtstraße oder war durch hohe Ufer und Vegetation verdeckt. Um den Geist des Ortes wiederzubeleben, wurde ein neuer, breiter Kanal gegraben, überspannt von einer Brücke. Anderswo wurde das Wasser durch Absenken des Bodens in Sicht gebracht, und eine schattige Pergola bildet nun einen Blickfang, der über den Rand des Wassers ragt.

Entourant une ravissante maison de campagne, de vastes pelouses idylliques s'étalent sous d'imposants arbres. Mais l'élément clé du domaine, un cours d'eau traversant le jardin, passait dans une canalisation sous la route d'accès ou était masqué par une rive haute et de la végétation. Pour retrouver l'esprit originel du lieu, on a creusé un large canal qu'enjambe un pont. Ailleurs, le niveau du sol a été abaissé pour que l'eau redevienne visible et une pergola dispense désormais son ombre, attirant le regard au-dessus du bord du cours d'eau.

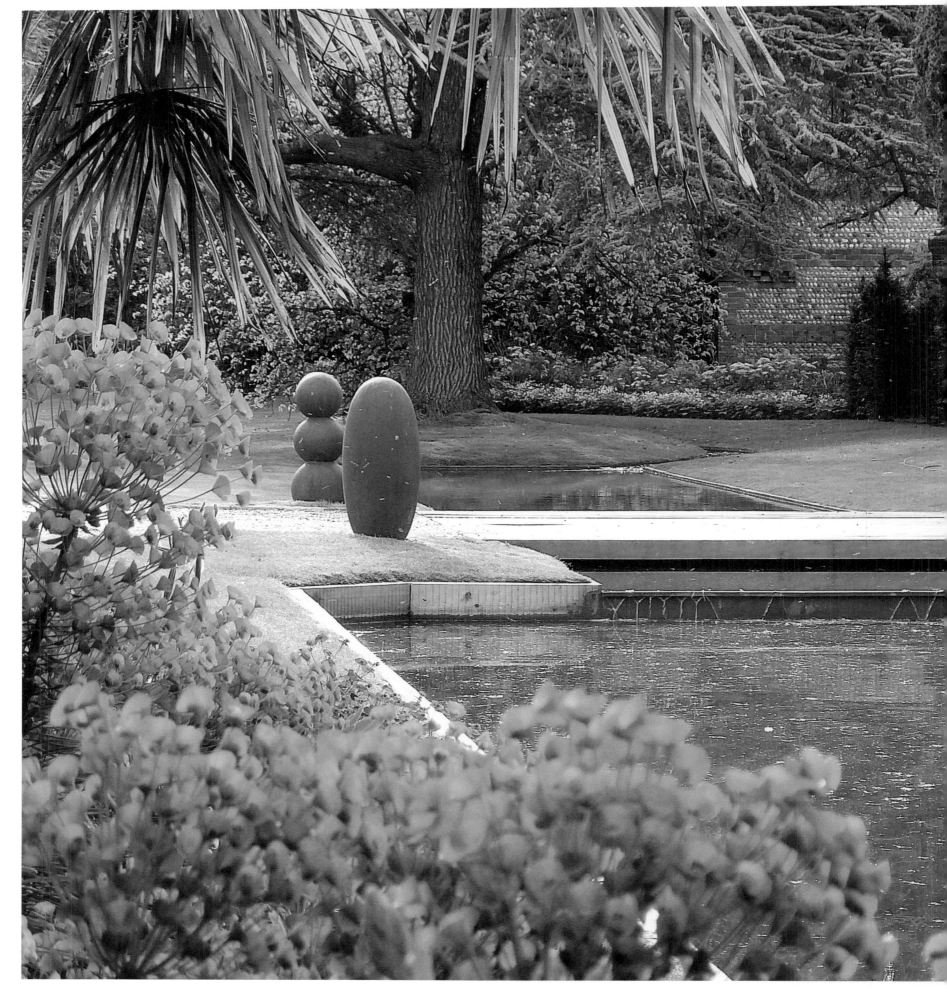

236

A sleek oak bridge appears to float over the new water channel. Four bollards by sculptor Antony Gormley mark the corners.

Eine schlanke Eichenbrücke scheint über dem neuen Wasserkanal zu schweben. Vier Poller von Bildhauer Antony Gormley markieren die Ecken.

Un mince pont en chêne semble flotter au-dessus du nouveau canal. Quatre poteaux créés par le sculpteur Antony Gormley en marquent les angles.

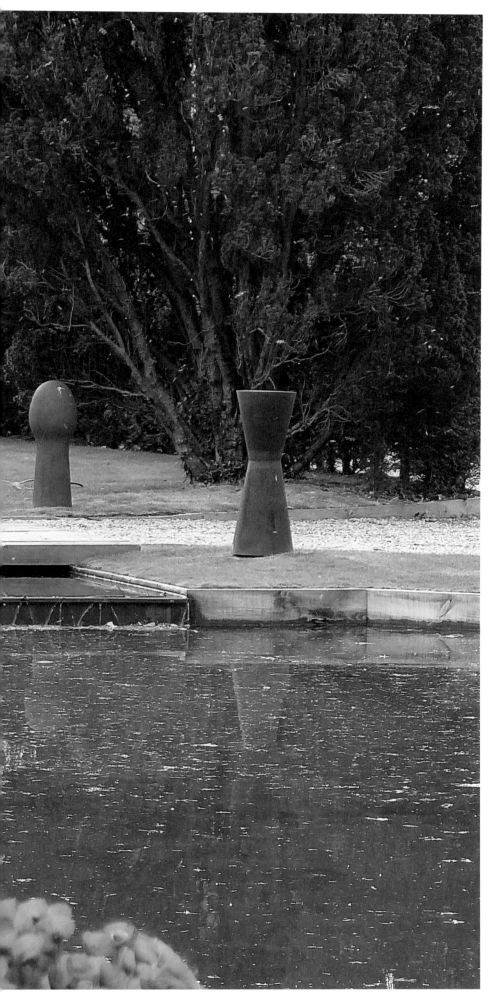

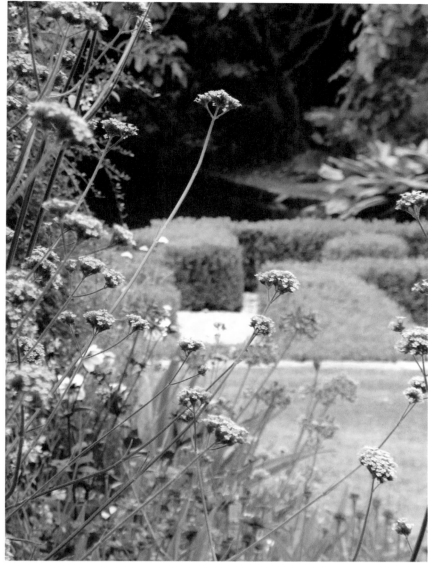

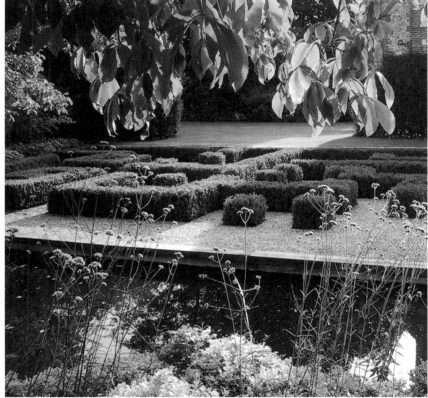

The geometric shapes of a box parterre create an intricate play of light and shadow, forming the back-drop for an informal planting of verbena, dahlia, agapanthus, and coneflower.

Die geometrischen Formen eines Buchs-parterres erzeugen ein komplexes Spiel von Licht und Schatten und bilden den Hintergrund für eine informelle Pflanzung von Eisenkraut, Dahlie, Agapanthus und Sonnenhut.

Les formes géo-métriques d'un parterre de buis engendrent un jeu complexe d'ombre et de lumière et for-ment l'arrière-plan d'une plantation informelle de ver-veines, de dahlias, d'agapanthes et d'échinacées.

Alexis McNally

Museum Insel Hombroich

Kulturraum Hombroich, Neuss | Germany

238

"Art in parallel to nature" is the motto of an impressive garden landscape on the Erft River. | „Kunst parallel zur Natur" lautet das Motto einer beeindruckenden Gartenlandschaft an der Erft. | « L'art est une harmonie parallèle à la nature » : l'impressionnant parc des bords de l'Erft fait écho à la phrase de Cézanne.

Karl-Heinrich Müller was struck with the idea to exhibit his collected works of art, in equitable fashion, in a natural environment—an idea which developed from a landscape park on the Erft river flood plain. Various artists as well as landscape architect Bernhard Korte were involved in building "a network of people, ideas and work." For the grounds of such an exhibition space come to fruition, Korte uncovered the structures of the overgrown garden and supplemented the varied 23-hectare (56-acre) large museum grounds with both native and exotic species of plants.

Karl-Heinrich Müller hatte die Idee, die von ihm gesammelten Kunstwerke gleichberechtigt in einem Naturraum auszustellen, der sich aus einem Landschaftspark in der Erftaue entwickelte. Diverse Künstler und der Landschaftsplaner Bernhard Korte wurden eingebunden, „um ein Netz von Menschen, Vorstellungen und Arbeit" zu knüpfen. Korte legte dazu die Strukturen des verwilderten Gartens frei und ergänzte die Pflanzungen aus einheimischen wie exotischen Arten auf dem 23 Hektar großen vielgestaltigen Museumsgelände.

C'est Karl-Heinrich Müller qui eut l'idée d'exposer les œuvres de sa collection dans un espace naturel créé à partir d'un parc situé dans les prairies humides des bords de la rivière Erft. Il fit pour cela appel à divers artistes ainsi qu'au designer paysagiste Bernhard Korte « afin de constituer un réseau de personnes, d'idées et de travail ». Bernhard Korte va commencer par dégager la structure du parc à l'abandon, puis complètera les plantations par des espèces locales et exotiques sur les 23 hectares de ce terrain très varié du musée.

Hombroich is a lushly vegetated park, intermingled with buildings and works of art. Those places where visitors see wilderness is where the horticulturist had scrupulously been at work.

Hombroich ist ein üppig bewachsener Park mit eingesprengten Gebäuden und Kunstwerken. Wo Besucher Wildnis sehen, war der Gärtner behutsam am Werk.

Hombroich est un parc à la végétation luxuriante, parsemé de bâtiments et d'œuvres d'art. Les visiteurs ont l'impression de contempler des espaces sauvages, alors que le jardinier a œuvré avec le plus grand soin possible.

The sculptor, Erwin Heerich, created ten museum structures as walkable sculptures. Top: the Graubner Pavilion, 1984. Below: A group of sculptures by Anatol Hertzfeld—the artist works in an atelier in the museum.

Der Bildhauer Erwin Heerich schuf für Hombroich zehn Museumsbauten als begehbare Skulpturen, oben der Graubner-Pavillon, 1984. Unten: Skulpturengruppe von Anatol Hertzfeld – der Künstler arbeitet in einem Atelier im Museum.

Pour Hombroich, le sculpteur Erwin Heerich a réalisé dix bâtiments sous forme de sculptures accessibles à pied, ci-dessus le pavillon Graubner, 1984. Ci-dessous : Groupe de sculptures d'Anatol Hertzfeld ; l'artiste travaille dans un atelier qui se trouve dans le musée.

Museum Insel Hombroich

Heerich created an impressive pavilion on the Raketenstation Hombroich, featuring a ceramic relief of Lucio Fontana. The Gästehaus Kloster (guest house Kloster) (below), also by Heerich, can be booked for overnight stays.

Der Bildhauer Erwin Heerich schuf für ein Keramikrelief von Lucio Fontana einen eindrucksvollen Pavillon auf der Raketenstation Hombroich. Das Gästehaus Kloster (unten), ebenfalls von Erwin Heerich, kann für Übernachtungen gebucht werden.

Le sculpteur Erwin Heerich a créé pour un relief en céramique de Lucio Fontana un superbe pavillon sur la Raketenstation Hombroich. La Gästehaus Kloster (maison d'hôtes Kloster) (ci-dessous), également œuvre d'Erwin Heerich, sert d'hébergement (sur réservation).

240

Raketenstation Hombroich

Raketenstation Hombroich

Kulturraum Hombroich, Neuss | Germany

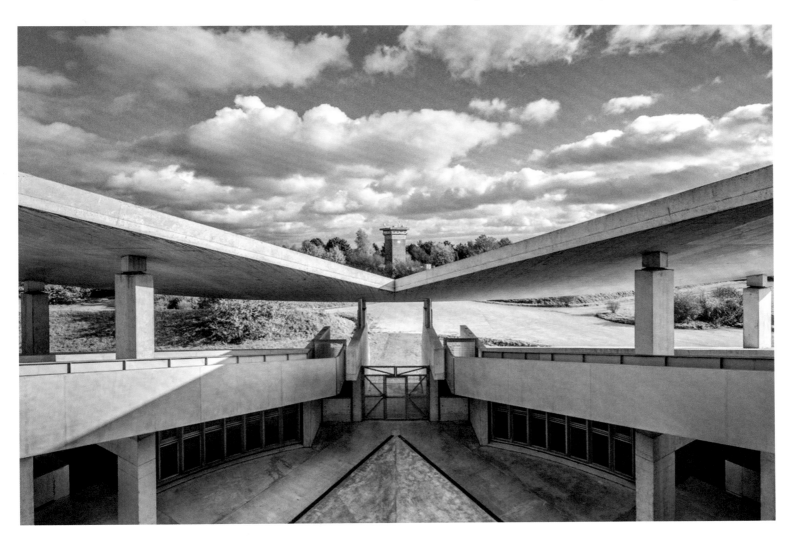

The Haus für Musiker (House for Musicians) is a community center that is less functional than sculptural and having been the last project of the late American architect Raimund Abraham. Planned in 2006, it was only finished after eleven years of construction.

Das Haus für Musiker, als Begegnungsstätte weniger funktional als skulptural, ist das letzte Projekt des verstorbenen US-Architekten Raimund Abraham. 2006 geplant, konnte es erst nach elf Jahren Bauzeit fertiggestellt werden.

Lieu de rencontre moins fonctionnel que sculptural, la Haus für Musiker (maison des musiciens), est le dernier projet de l'architecte américain Raimund Abraham, aujourd'hui disparu. Conçue en 2006, elle n'a pu être achevée qu'après onze ans de travaux.

241

Halls, hangars, bunker systems—a part of German history and the Kulturraum Hombroich (Hombroich Arts and Culture Site) all at once. | Hallen, Hangars, Bunkersysteme – Teil der bundesdeutschen Geschichte und des Kulturraums Hombroich zugleich. | Halls, hangars, complexes de bunkers : à la fois témoignage de l'histoire de l'Allemagne fédérale et symbole du Kulturraum Hombroich (l'espace culturel de Hombroich).

The former NATO missile base has been used complementary to the Museum Insel Hombroich since 1994 as a site for the development of art and architecture and as a living and work space for artists from the domains of art, literature and music. Participating in the redesign and reconstruction were the artists and architects Raimund Abraham, Tadao Ando, Dietmar Hofmann, Erwin Heerich, Oliver Kruse, Katsuhito Nishikawa, Claudio Silvestrin and Álvaro Siza. A new field for experimentation came into being—a place for culture, science and nature.

Die ehemalige Nato-Raketenstation wird seit 1994 komplementär zum Museum Insel Hombroich als Ort der Entwicklung von Kunst und Architektur und als Lebens- und Arbeitsraum für Künstler aus den Bereichen Kunst, Literatur und Musik genutzt. An ihrer Umgestaltung und Neubebauung beteiligten sich die Künstler und Architekten Raimund Abraham, Tadao Ando, Dietmar Hofmann, Erwin Heerich, Oliver Kruse, Katsuhito Nishikawa, Claudio Silvestrin und Álvaro Siza. Es entstand ein neues Experimentierfeld – ein Ort der Kultur, Wissenschaft und Natur.

L'ancienne base de lancement de missiles de l'OTAN est utilisée depuis 1994 en complément du Museum Insel Hombroich : elle sert en même temps de lieu de création artistique et architecturale et de lieu de vie et de travail pour des artistes, écrivains et compositeurs. La transformation du site et sa reconstruction sont l'œuvre des artistes et architectes Raimund Abraham, Tadao Ando, Dietmar Hofmann, Erwin Heerich, Oliver Kruse, Katsuhito Nishikawa, Claudio Silvestrin et Álvaro Siza. C'est ainsi qu'est né un nouveau champ d'expérimentation, lieu consacré à la culture, aux sciences et à la nature.

Kirkeby-Feld

Kulturraum Hombroich, Neuss | Germany

An ensemble of architectural brick sculptures serve as a figurative bridge between the Museum Insel Hombroich and the Raketenstation Hombroich. | Als Brücke zwischen dem Museum Insel Hombroich und der Raketenstation Hombroich liegt das Ensemble architektonischer Backsteinskulpturen. | L'ensemble des sculptures architecturales en briques fait office de pont entre le Museum Insel Hombroich et la Raketenstation Hombroich.

242

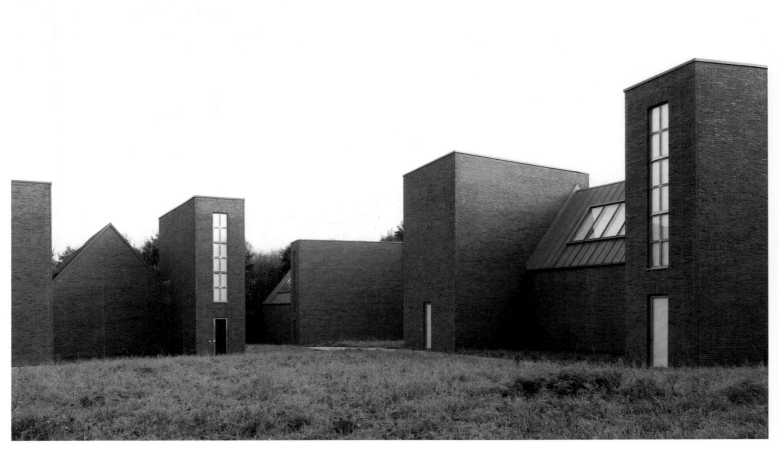

Kirkeby's work has found expression in many artistic media, including film and painting. In 1972, the trained geologist found himself creating open space brick sculptures. The Drei Kapellen (Three Chapels) in Hombroich constitute his impressive later work.

Per Kirkeby drückte sich in vielen künstlerischen Medien aus, darunter Film und Malerei. Der studierte Geologe fand 1972 zu Freiraumskulpturen aus Backstein. Die Drei Kapellen in Hombroich bilden sein eindrucksvolles Spätwerk.

Per Kirkeby s'est exprimé dans de nombreuses formes artistiques, dont le cinéma et la peinture. Géologue de formation, il s'est consacré en 1972 aux sculptures d'extérieur en briques. Les Drei Kapellen (trois chapelles) de Hombroich sont son œuvre tardive la plus impressionnante.

The area, named after Per Kirkeby, is made up of five brick structures by the Danish artist and is surrounded by a small forest. Kirkeby also designed the Bushaltestelle (bus stop) at the Museum Insel Hombroich. The walkable sculptures were not planned according to the rules of conventional architecture. Despite this, they radiate with classic precision and tranquility. The Stiftung Insel Hombroich (Hombroich Insel Foundation) and their partners use the buildings for temporary exhibitions and other artistic formats.

Das nach Per Kirkeby benannte Areal umfasst fünf von einem kleinen Wald umgebene Backsteinbauten des dänischen Künstlers. Zudem entwarf Per Kirkeby die Bushaltestelle am Museum Insel Hombroich. Die begehbaren Skulpturen wurden nicht nach den Regeln konventioneller Architektur geplant und strahlen dennoch eine klassische Genauigkeit und Ruhe aus. Die Stiftung Insel Hombroich und ihre Partner nutzen die Gebäude für wechselnde Ausstellungen und andere künstlerische Formate.

La zone à laquelle a été donné le nom de son créateur, l'artiste danois Per Kirkeby, comprend cinq ouvrages en briques entourés d'une forêt. Per Kirkeby a aussi conçu le Bushaltestelle (l'arrêt de bus) du Museum Insel Hombroich. Les sculptures accessibles à pied n'ont pas été créées selon les règles de l'architecture conventionnelle, mais il en émane pourtant une précision et un calme classiques. La Stiftung Insel Hombroich (fondation Insel Hombroich) et ses partenaires utilisent les bâtiments pour des expositions temporaires et d'autres formats artistiques.

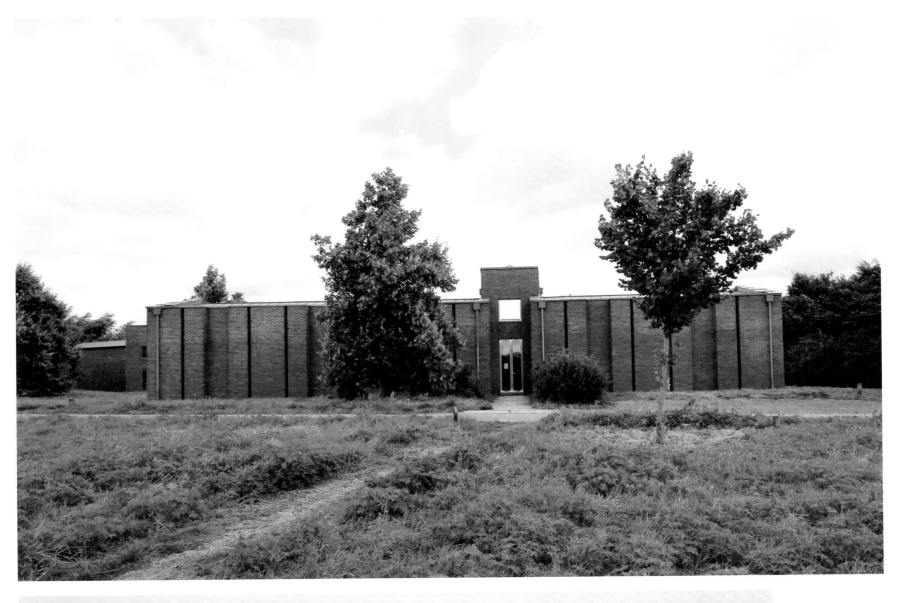

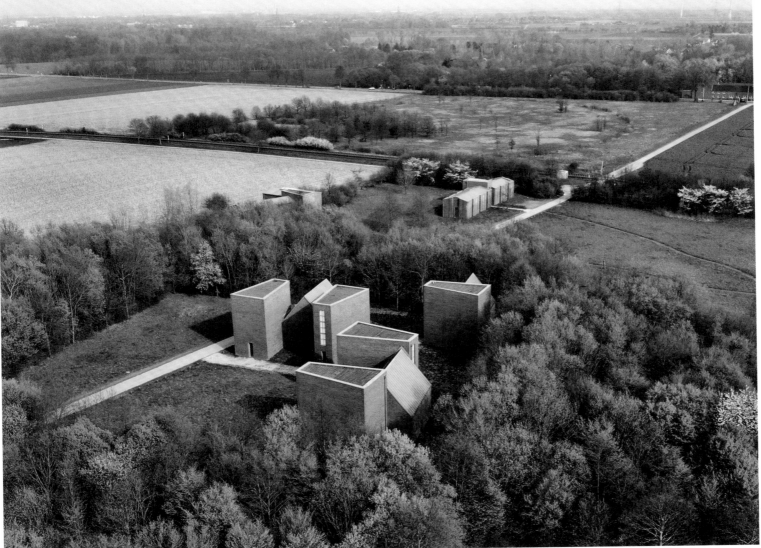

The brick structures by Kirkeby are used for exhibitions and are therefore accessible to visitors only on a short, temporary basis.

Die Backstein-Bauten von Per Kirkeby werden für Ausstellungen genutzt und sind so temporär für Besucher zugänglich.

Les ouvrages en briques de Per Kirkeby sont utilisés pour des expositions qui les rendent temporairement accessibles aux visiteurs.

Kirkeby-Feld

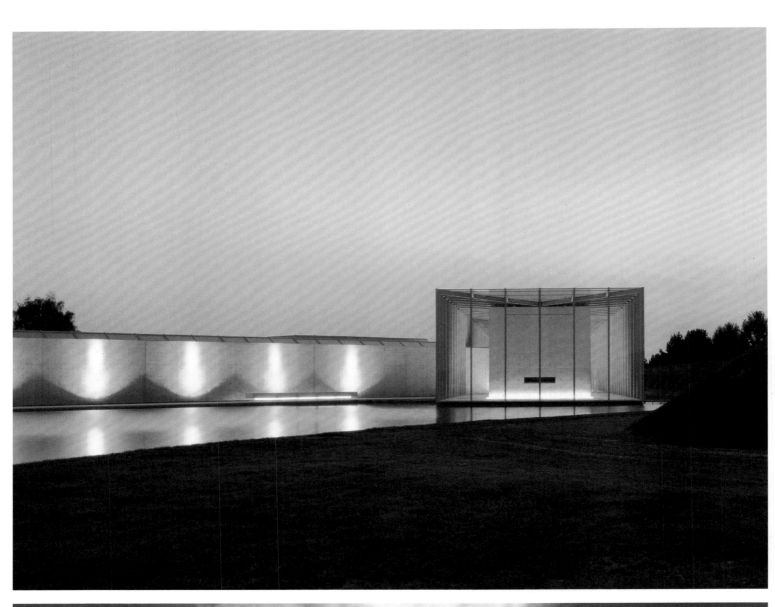

There is a long, narrow gallery located in the ground-level concrete slab that Ando specially designed for the Japanese part of the Langen collection as the "Room of Silence."

Im ebenerdigen Betonriegel befindet sich eine lange und schmale Galerie, die Tadao Ando als Raum der Stille speziell für den japanischen Teil der Sammlung Langen konzipiert hat.

Dans la barre en béton qui affleure au sol se trouve une longue et étroite galerie que Tadao Ando a voulu être « espace de silence » pour la partie japonaise de la collection Langen.

244

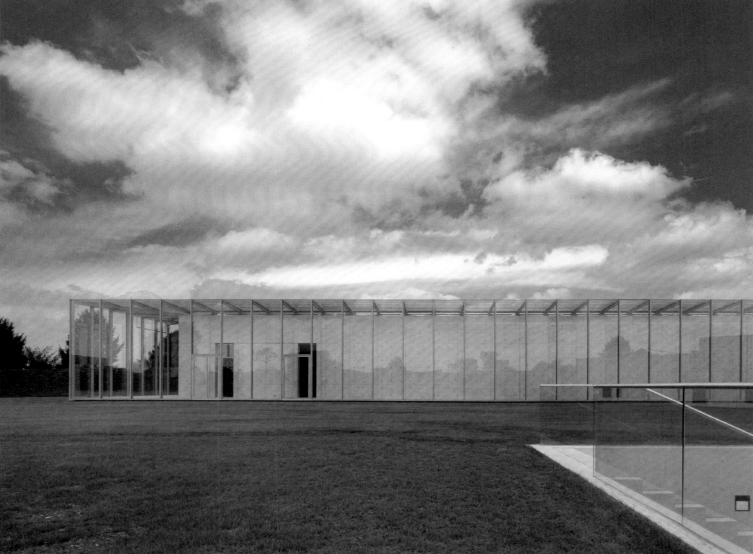

The landscape around the building is designed not to intrude upon Ando's introverted architecture.

Der introvertierten Architektur Tadao Andos angepasst, wurde die Landschaft um das Gebäude unauffällig gestaltet.

Le paysage qui entoure le bâtiment se veut discret pour s'harmoniser avec l'architecture introvertie de Tadao Ando.

Langen Foundation

Kulturraum Hombroich, Neuss | Germany

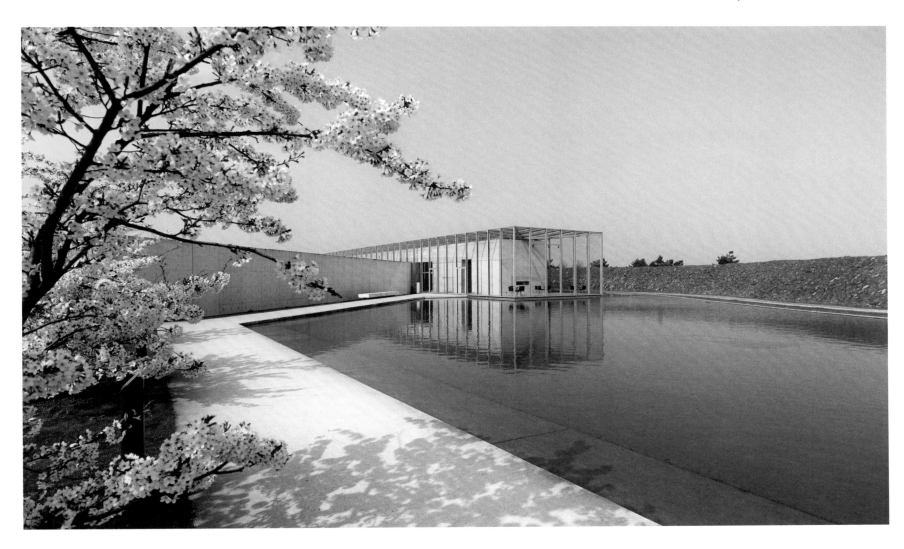

245

A private art collection found a new home inside modern Japanese architecture on the Raketenstation Hombroich in 2004. | Eine private Kunstsammlung fand 2004 in moderner japanischer Architektur auf der Raketenstation Hombroich eine neue Heimat. Une collection privée a élu domicile en 2004 sur la Raketenstation Hombroich, dans un bâtiment d'architecture japonaise moderne.

In the surrounding 1,300-square meter (14,000 square foot) exhibition building of the Langen Foundation, traditional Japanese art from the Langen family's collection is presented alongside current temporary exhibitions of contemporary art. Architect Tadao Ando secreted the concrete, glass and steel-made complex away, digging it in deeply behind earthen walls. The view from there that falls upon the museum is first directed through a concrete arch along a pond, the museum is composed of two architecturally differing yet intertwining buildings.

Im 1 300 Quadratmeter umfassenden Ausstellungsgebäude der Langen Foundation wird neben aktuellen Wechselausstellungen zur zeitgenössischen Kunst die traditionelle japanische Kunst aus der Sammlung der Familie Langen präsentiert. Der Architekt Tadao Ando verbarg den Komplex aus Beton, Glas und Stahl tief eingegraben hinter Erdwällen. Durch einen Betonbogen entlang eines Teichs fällt der Blick auf das Museum, das sich aus zwei architektonisch unterschiedlichen und miteinander verbundenen Gebäuden zusammensetzt.

Dans les 1 300 mètres carrés du bâtiment d'exposition de la Langen Foundation, on peut admirer, outre les expositions temporaires d'art contemporain, l'art japonais traditionnel de la collection de la famille Langen. L'architecte Tadao Ando a enterré profondément derrière des murs de terre le complexe de béton, de verre et d'acier. Le long d'une pièce d'eau, une arche en béton porte le regard vers le musée qui se compose de deux bâtiments d'architecture différente reliés l'un à l'autre.

The exhibition building is reflected in the garden pond behind earthen walls. A row of cherry trees flanks the basin as an allusion to Japanese garden design.

Hinter Erdwällen spiegelt sich das Ausstellungsgebäude im Wasserbecken. Als Andeutung japanischer Gartenkunst flankiert eine Reihe Kirschbäume das Becken.

Le bâtiment d'exposition se reflète dans le bassin, derrière des murs de terre. Évocation de l'art japonais du jardin, une rangée de cerisiers flanque le bassin.

Burkhard Damm

I make decisions with emotion.
Ich entscheide mit Gefühl.
Je décide selon mon intuition.

Burkhard Damm has been the landscape architect responsible for the 63-hectare (155-acre) landscape area surrounding the Stiftung Insel Hombroich since 2001. He is happiest when he can work horticulturally and make decisions directly on site.

Seit 2001 ist Burkhard Damm als Landschaftsarchitekt zuständig für die 63 Hektar umfassenden Landschaftsräume der Stiftung Insel Hombroich. Am glücklichsten ist er, wenn er direkt vor Ort gärtnern und entscheiden kann.

Burkhard Damm est depuis 2001 l'architecte paysagiste responsable des 63 hectares de la Stiftung Insel Hombroich. C'est lorsqu'il peut jardiner et décider sur place qu'il vit ses moments les plus heureux.

Do you have a horticultural guideline for the so varying areas in Hombroich?

The overarching approach for my horticultural work is that we are designing a living space for plants, animals and humans. The horticulturalist designs. Sometimes more, sometimes less. There is no wild nature here. The three spaces are cared for as required by their respective concept. My job is to find a responsible balance. Refraining from intervening is also designing! The "Meadow," "Old Park" and "Terrace" areas of the museum have different concepts and the approach is differentiated accordingly. The Raketenstation Hombroich,

Haben Sie eine gärtnerische Leitlinie für die so unterschiedlichen Bereiche in Hombroich?

Die Klammer für meine gärtnerische Arbeit ist die Haltung, dass wir hier einen Lebensraum für Pflanze, Tier und Mensch gestalten. Der Gärtner gestaltet, mal mehr, mal weniger. Es gibt hier keine wilde Natur. Pflege an den drei Orten erfolgt so, wie es die jeweilige Konzeption erfordert. Es ist meine Aufgabe, verantwortungsvoll eine Balance zu finden. Auch Unterlassen eines Eingriffs ist Gestaltung! Die Bereiche des Museums „Aue", „Alter Park" und „Terrasse" haben unterschiedliche

Avez-vous une ligne directrice pour les zones tellement diverses des jardins de Hombroich ?

Ce qui structure mon travail de jardinier, c'est l'idée que nous modelons ici un espace de vie pour des plantes, des animaux et l'Homme. Le jardinier façonne, tantôt plus, tantôt moins. Ici, il n'y a pas de nature sauvage. Sur les trois sites, l'entretien se fait selon ce qu'exige la conception. Mon travail consiste à trouver un équilibre responsable. Façonner, cela peut aussi vouloir dire ne rien faire ! Les zones « Aue » (prairie), « Alter Park » (parc ancien) et « Terrasse » répondent à des

the Kirkeby field, the Libeskind field and a twelve-hectare (30-acre) area for year-long livestock grazing are further building blocks in the Kulturraum Hombroich, which is developed and advanced using various methods.

"There's a lot that you can't just learn from a book."

How do you see the natural elements in competition with the architectural and artistic objects?

I don't think that there is a competition. I see it more as mutual fertilization, a strengthening. You can call it yin and yang, inhaling and exhaling, tension and relaxation, or nature and culture. You can't have one without the other.

What do you love the most about your work in Hombroich?

Working directly on site. Working among the population isn't happening in an office. Just by standing on location, you can tell by what you see as to if it was developed on-site or as somebody's pure "brainchild." There's a lot that you can't just learn from a book. This includes the wealth of experience caring for and observing a location. The changes provoked during the course of a day, a year, or during extremes in weather can quickly throw many presumptions into array! The real-world conflict indoctrinates the senses, the understanding of space, the sense for proportion and growth, and so on and so forth.

Konzepte, entsprechend differenziert ist die Herangehensweise. Die Raketenstation Hombroich, das Kirkeby-Feld, das Libeskind-Feld sowie eine zwölf Hektar große Fläche für eine Ganzjahresbeweidung mit Heckrindern sind weitere Bausteine im Kulturraum Hombroich, die auf unterschiedliche Art und Weise entwickelt werden.

Wie sehen Sie die natürlichen Elemente in Konkurrenz zu den architektonischen und künstlerischen Objekten?

Ich denke nicht, dass es eine Konkurrenz gibt, ich sehe es eher als gegenseitige Befruchtung, ein sich Bestärken. Nennen Sie es Yin und Yang, Ein- und Ausatmen, Anspannung und Entspannung, oder auch Natur und Kultur. Das eine kann nicht ohne das andere.

Was lieben Sie am meisten an Ihrer Arbeit in Hombroich?

Die unmittelbare Arbeit vor Ort. Arbeiten im Bestand geht nicht vom Büro aus. Man sieht es dem Ergebnis an, ob es aus dem Ort entwickelt wurde oder eine reine „Kopfgeburt" ist. Es gibt vieles, was man nicht aus Büchern lernen kann. Dazu kommt die

„Es gibt vieles, was man nicht aus Büchern lernen kann."

lange Erfahrung, das Begleiten und Beobachten eines Ortes. Die Veränderungen, hervorgerufen durch Tageszeit, Jahreszeit oder Wetterextreme, können sehr schnell viele Annahmen über den Haufen werfen. Die konkrete Auseinandersetzung schult die Sinne, das Raumverständnis, das Gefühl für Proportion, das Wachstum …

conceptions différentes si bien que l'approche elle-même est différente. La Raketenstation Hombroich, la zone Kirkeby et la zone Libeskind ainsi qu'un espace de douze hectares sur lequel paissent toute l'année des aurochs de Heck sont d'autres facettes du Kulturraum Hombroich, conçues et réalisées de façon différente.

Comment voyez-vous les éléments naturels en concurrence avec les objets architecturaux et artistiques ?

Je ne pense pas qu'il y ait concurrence, je vois plutôt une fécondation,

« Il y a beaucoup de choses qu'on n'apprend pas dans les livres. »

un renforcement mutuels. Appelez-ça yin et yang, inspiration et expiration, tension et détente, ou encore nature et culture. Chaque élément ne peut pas se passer de l'autre.

Qu'est-ce que vous préférez dans le travail que vous avez fait à Hombroich ?

C'est le fait de travailler directement sur le site. On ne peut pas travailler sur de l'existant dans un bureau. Quand on voit le résultat, on sait s'il a été obtenu à partir du lieu ou bien s'il s'agit purement d'une « naissance intellectuelle ». Il y a beaucoup de choses qu'on n'apprend pas dans les livres. Et puis bien sûr, il y a une grande expérience, l'accompagnement d'un lieu, sa contemplation. Les variations engendrées par l'heure du jour, la saison ou les événements météorologiques extrêmes peuvent rapidement amener à jeter des hypothèses à la poubelle. C'est la confrontation réelle qui forme les sens, la compréhension de l'espace, le sens des proportions, la croissance des végétaux...

Ingrao Inc.

New York City | USA

248

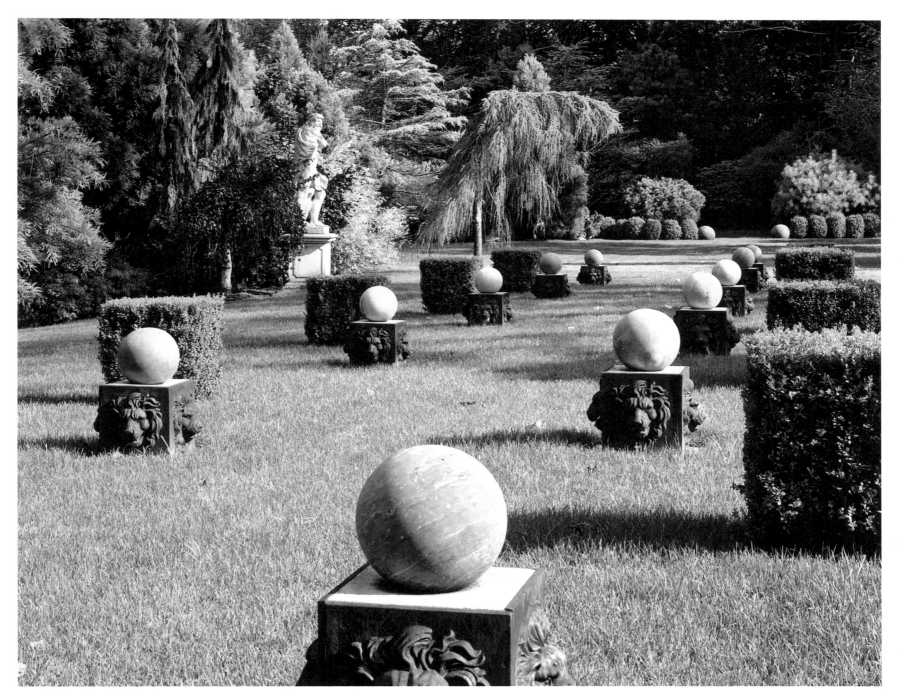

Anthony Ingrao and his partner Randy Kemper have been setting standards in the world of luxury for more than 40 years. | Anthony Ingrao und sein Partner Randy Kemper setzen seit über 40 Jahren Maßstäbe in der Welt des Luxus. | Depuis plus de 40 ans, Anthony Ingrao et son associé Randy Kemper sont la référence de l'univers du luxe.

Ingrao and Kemper have worked on projects around the world through their architecture and design agency since 1982. In their work, they have been supported by 36 other designers and architects. Their name epitomizes ingenuity, quality, and an inimitable style that has captivated actors and global players in finance and business. Some of their projects include the Ward Village in Hawaii with architect Richard Meier and the Baccarat Residences in New York.

Mit ihrem Architektur- und Designbüro arbeiten Anthony Ingrao und Randy Kemper seit 1982 an Projekten weltweit. Unterstützt werden sie dabei von 36 weiteren Designern und Architekten. Ihr Name steht für Raffinesse, Qualität und einen unnachahmlichen Stil, der auch Schauspieler und Global Player aus Finanzwesen und Wirtschaft in ihren Bann zieht. Zu ihren Projekten gehören unter anderem die Ward Village auf Hawaii mit dem Architekten Richard Meier und die Baccarat Residences in New York.

Avec son cabinet d'architecture et de design, Anthony Ingrao and Randy Kemper réalisent des projets partout dans le monde depuis 1982. Ils sont assistés par 36 designers et architectes. Leur travail se distingue par le raffinement, la qualité et un style inimitable qui attire en particulier des acteurs ou des personnalités du monde de la finance internationale et des entreprises. Parmi leurs projets, on peut citer entre autres le Ward Village d'Hawaï, réalisé avec l'architecte Richard Meier, et les Baccarat Residences de New York.

Ingrao Inc. primarily focuses on interior architecture. However, Ingrao and Kemper are also dedicated to designing gardens.

Der Schwerpunkt von Ingrao Inc. liegt auf der Innenarchitektur. Doch Anthony Ingrao und Randy Kemper widmen sich auch dem Entwerfen von Gärten.

Ingrao Inc. se consacre essentiellement à l'architecture d'intérieur, mais Anthony Ingraoet Randy Kemper s'adonnent aussi à la création de jardins.

250

251

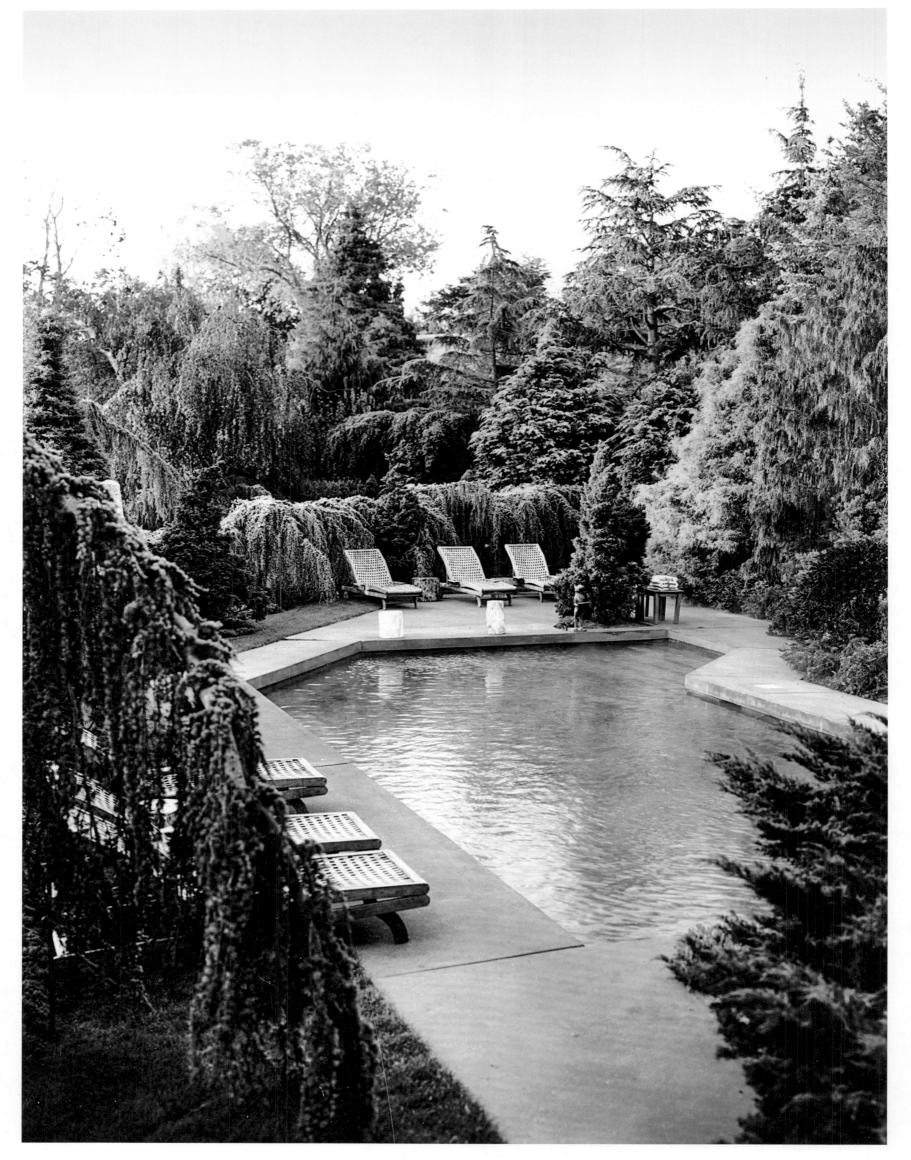

252

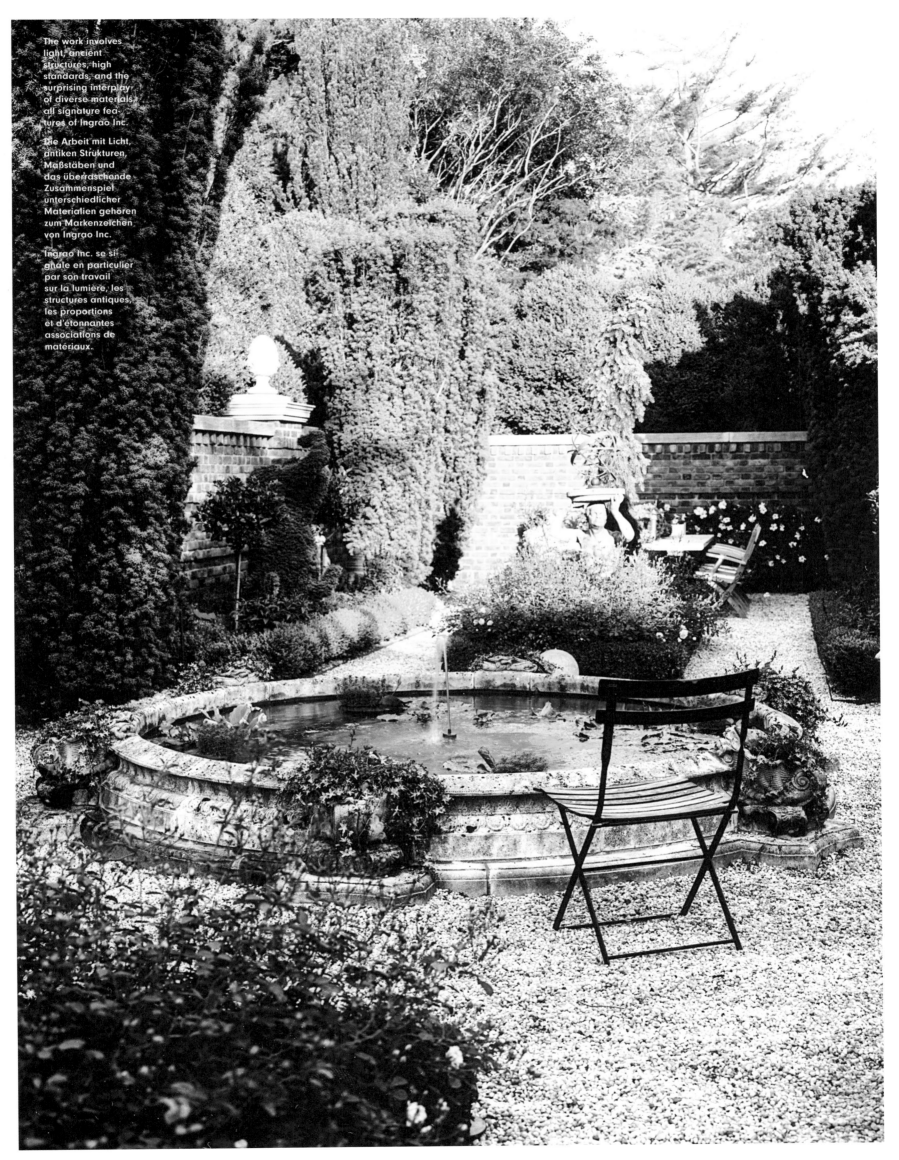

The work involves light, ancient structures, high standards, and the surprising interplay of diverse materials, all signature features of Ingrao Inc.

Die Arbeit mit Licht, antiken Strukturen, Maßstäben und das überraschende Zusammenspiel unterschiedlicher Materialien gehören zum Markenzeichen von Ingrao Inc.

Ingrao Inc. se signale en particulier par son travail sur la lumière, les structures antiques, les proportions et d'étonnantes associations de matériaux.

253

Ingrao Inc.

Son Muda Gardens

Mallorca | Spain

"Gardens are a wonderful opportunity to make people happy." With this credo, Hélène Lindgens began designing gardens on Mallorca in 2011. This started with her own, the Son Muda garden, which she quite literally extracted from the bare landscape. Today, it is the calling card and foundation for all of the team's projects at Son Muda Gardens, also owned by landscape architect Hans Achilles since 2015. Juan Ramon Puigserver and Esteban Vaquero Benito are responsible for implementation and maintenance.

„Gärten sind eine wunderbare Möglichkeit, Menschen glücklich zu machen." Mit diesem Credo begann Hélène Lindgens bereits 2011 auf Mallorca, Gärten zu gestalten. Zuerst einmal ihren eigenen, den Garten Son Muda, den sie im wahrsten Sinne des Wortes der kargen Landschaft abrang. Er ist heute Visitenkarte und Basis für alle Projekte des Teams von Son Muda Gardens, zu dem seit 2015 auch der Landschaftsarchitekt Hans Achilles gehört. Für Umsetzung und Pflege sind Juan Ramon Puigserver und Esteban Vaquero Benito zuständig.

« Les jardins sont une merveilleuse façon de rendre les gens heureux. » C'est ce credo qui a amené Hélène Lindgens à créer des jardins dès 2011 à Majorque, en commençant par le sien, le Son Muda, qu'elle a arraché de haute lutte à une terre ingrate. Aujourd'hui, il est la carte de visite et la base de tous les projets de l'équipe de Son Muda Gardens, dont fait partie depuis 2015 l'architecte paysagiste Hans Achilles. Juan Ramon Puigserver et Esteban Vaquero Benito se chargent de la réalisation et de l'entretien.

254

Son Muda Gardens—the Art of Gardening | Son Muda Gardens – die Kunst des Gärtnerns | Son Muda Gardens – l'art du jardinage

255

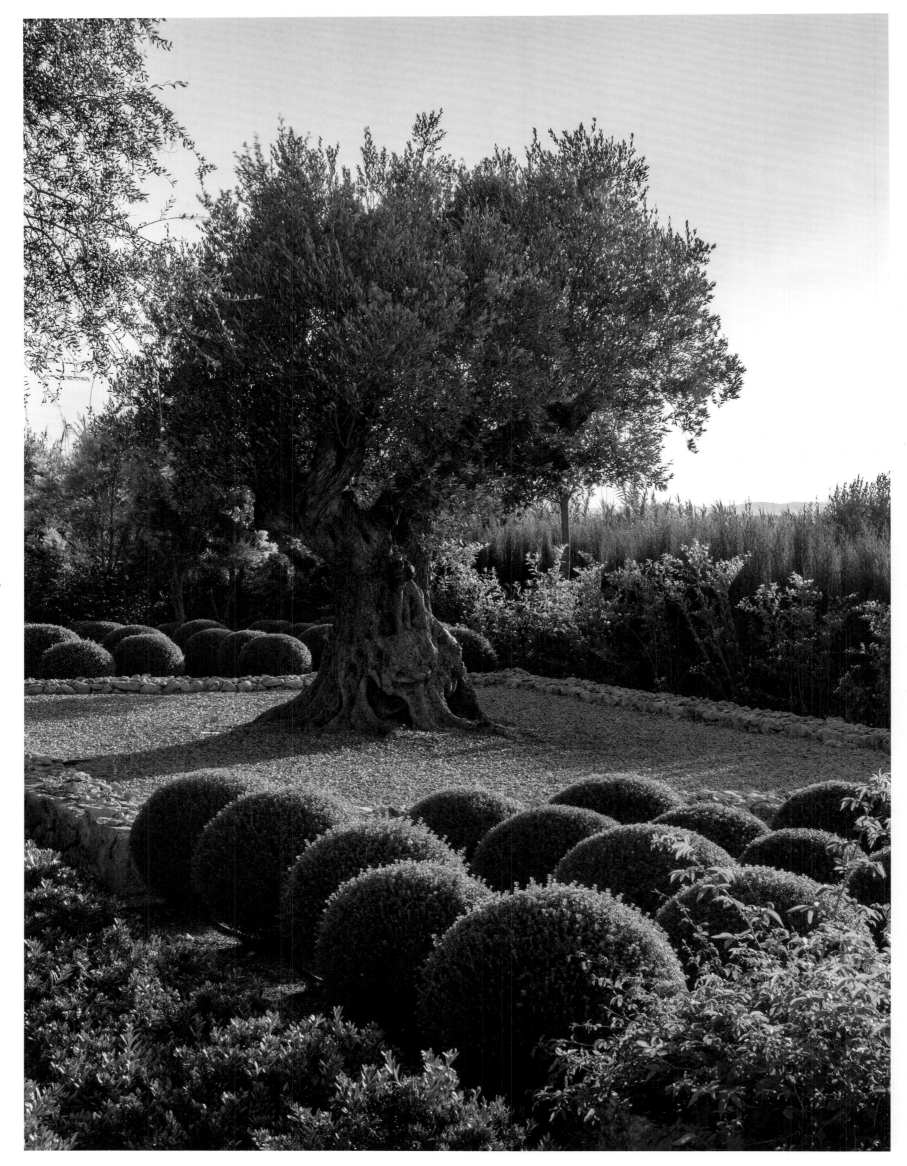

256

The work on the Finca's (estate) garden, purchased on Mallorca by the Swiss Hélène Lindgens and her family, began at the same time as the re-development of the Son Muda estate. Their vision for the 3.7-acre (15,000-square meter) property: a garden featuring only white blossoms. Varied forms underscore the atmosphere of the individual garden spaces.

Die Arbeit an dem Garten der Finca, die die Schweizerin Hélène Lindgens und ihre Familie auf Mallorca kauften, begann zeitgleich mit der Sanierung des Anwesens Son Muda. Ihre Vision für das 15 000 Quadrat-meter große Grund-stück: ein Garten, in dem alle Blüten weiß sind. Abwechs-lungsreiche Formen unterstreichen die Atmosphäre der einzelnen Gartenräume.

L'aménagement du jardin de la finca que la Suissesse Hélène Lindgens et sa famille avaient acquise à Majorque avait commencé en même temps que la remise en état du domaine de Son Muda. Sa vision pour les 15 000 mètres carrés de terrain : un jardin peuplé exclusi-vement de fleurs blanches, mais avec des formes variées pour souligner l'atmosphère de chaque espace.

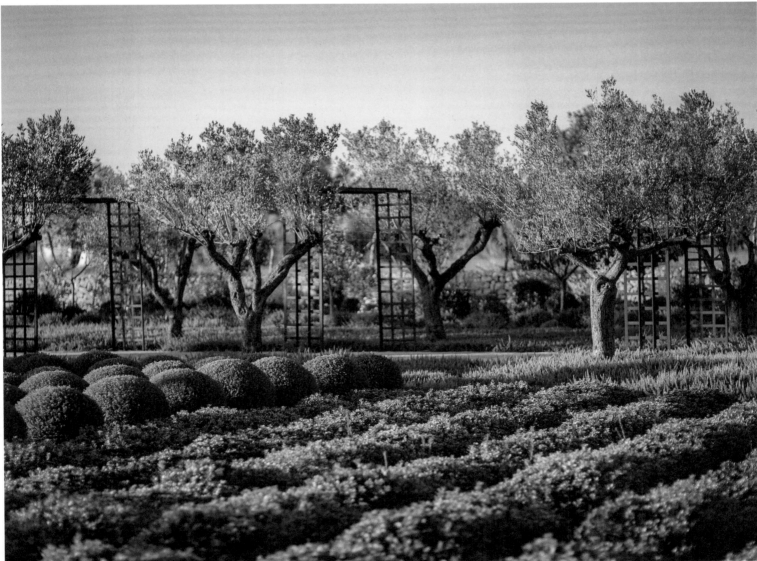

Son Muda Gardens

258

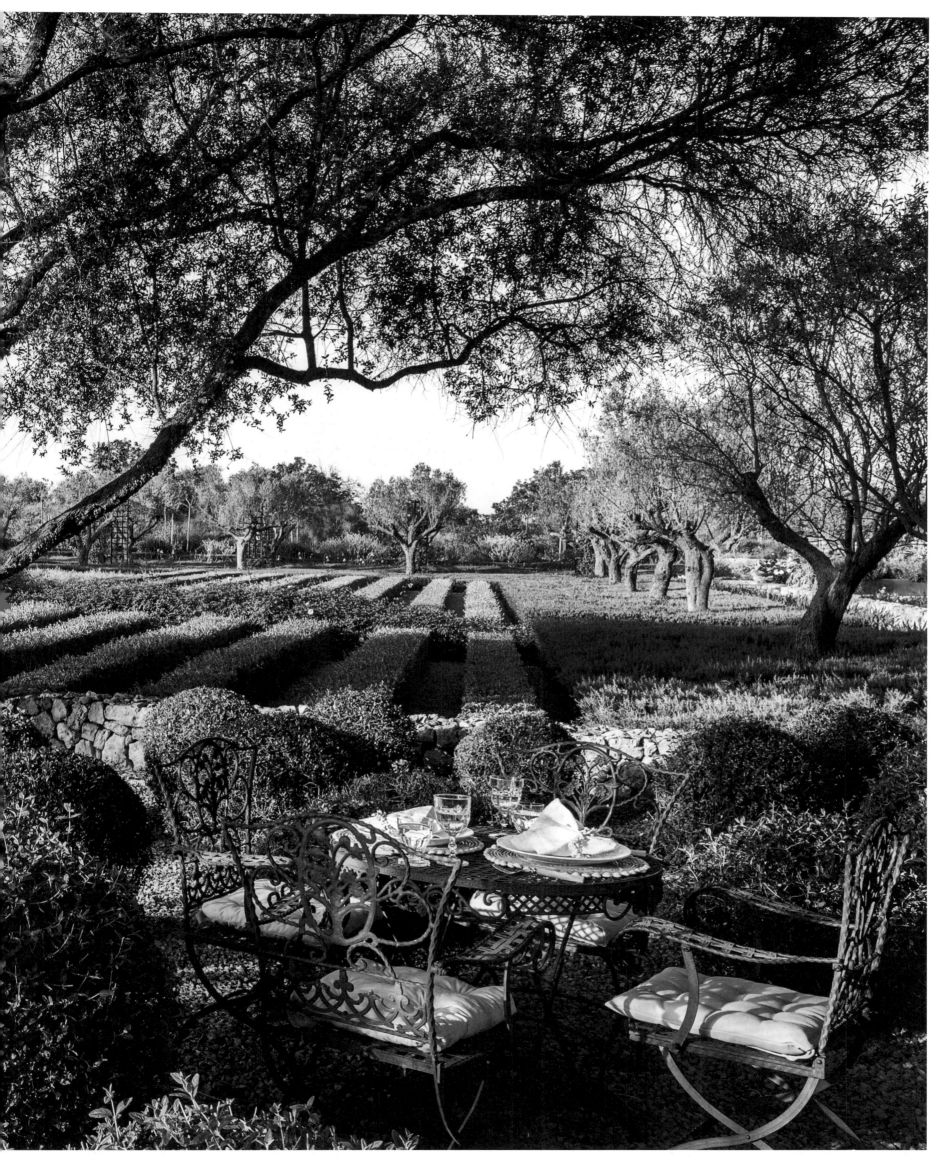

Son Muda Gardens

261

White roses bloom
between topiaries,
bright field grasses
wave along below
olive trees. The Son
Muda Garden is
the eponym for the
Lindgens' company,
which has also taken
on construction and
care for the planned
gardens since 2015,
permanently ensur-
ing their quality. Just
like Son Muda, the
company has come
into being step by
step. Today, the
team consists of 36
people who work on
more than 40 gar-
dens on Mallorca—
even working on
one in Marrakesh,
Morocco.

Zwischen Formgehöl-
zen wachsen weiß
blühende Rosen,
unter Olivenbäu-
men wogen helle
Gräserfelder. Der
Garten Son Muda
ist Namensgeber für
Lindgens' Firma, die
seit 2015 auch den
Bau und die Pflege
der geplanten
Gärten übernimmt,
um die Qualität
dauerhaft zu ge-
währleisten. Wie
Son Muda selbst
entstand sie Schritt
für Schritt. Heute
umfasst das Team
36 Personen, die
an über 40 Gärten
auf Mallorca und
sogar einem
in Marrakesch
arbeiten.

Entre les arbustes
taillés poussent
les rosiers à fleurs
blanches et des
champs d'herbes
clairs ondoient
sous les oliviers. Le
jardin de Son Muda
a donné son nom à
l'entreprise d'Hélène
Lindgens qui pro-
pose aussi depuis
2015 la réalisation
et l'entretien des
jardins qu'elle crée
afin d'en garantir
durablement la
qualité. Comme Son
Muda, l'entreprise
a évolué pas à
pas. Aujourd'hui,
l'équipe comprend
36 personnes travail-
lant dans plus de 40
jardins majorquins
et même dans un
jardin situé
à Marrakech.

Feuerring

Immensee | Switzerland

262

The Feuerring arose from a love for fire, for a healthy grilling culture, and through an artistic formative principle. | Der Feuerring entstand aus Liebe zum Feuer, für eine gesunde Grillkultur und aus einem künstlerischen Formprinzip. | Le Feuerring (« anneau de feu ») est né de l'amour du feu et de l'envie de déguster des grillades saines avec un matériel aux formes artistiques.

Fire was the nucleus of community life for centuries. As such, sociability and enjoyment are also the most important facets of the Feuerring by steel sculptor Andreas Reichlin. This outdoor object is a fireplace, grill and gathering spot in one. Grilling is done on the inward-slanting steel ring that is connected seamlessly to a stylish bowl in which flames blaze. For this design, the Feuerring was awarded the Red Dot best of the best in 2016.

Feuer war über Jahrhunderte der Mittelpunkt des Zusammenlebens. Und so sind Geselligkeit und Genuss auch die wesentlichen Aspekte des Feuerrings des Stahlplastikers Andreas Reichlin. Das Outdoor-Objekt ist Feuerstelle, Grill und Ort des Miteinanders zugleich. Gegrillt wird dabei auf nach innen geneigten Stahlringen, die mit einer formschönen Schale fest verbunden sind, worin die Flammen lodern. Dafür wurde der Feuerring 2016 mit dem Red Dot best of the best 2016 ausgezeichnet.

Pendant des siècles, le feu a été le centre de la vie en société. Pour le plasticien Andreas Reichlin, la convivialité et le plaisir demeurent les principaux éléments qui ont présidé à la création du Feuerring. Conçu pour une utilisation en extérieur, il est en même temps foyer, gril et lieu de rencontre où l'on se sent bien. La cuisson des aliments se fait sur des anneaux en acier inclinés vers l'intérieur et reliés par une vasque esthétique dans laquelle dansent les flammes. Le Feuerring a reçu en 2016 le prix du design « Red Dot best of the best ».

The Feuerring reduces style to the pure basics: Material, shape, and function come together. The sculptured steel combines aesthetics and culinary art.

Der Feuerring reduziert sich auf das Wesentliche: Material, Form und Funktion sind aufeinander abgestimmt. Die skulpturale Stahlplastik verbindet Ästhetik und Kulinarik.

Le Feuerring se réduit à l'essentiel : matériau, forme et fonction sont en totale harmonie. La sculpture en acier associe esthétique et plaisir culinaire.

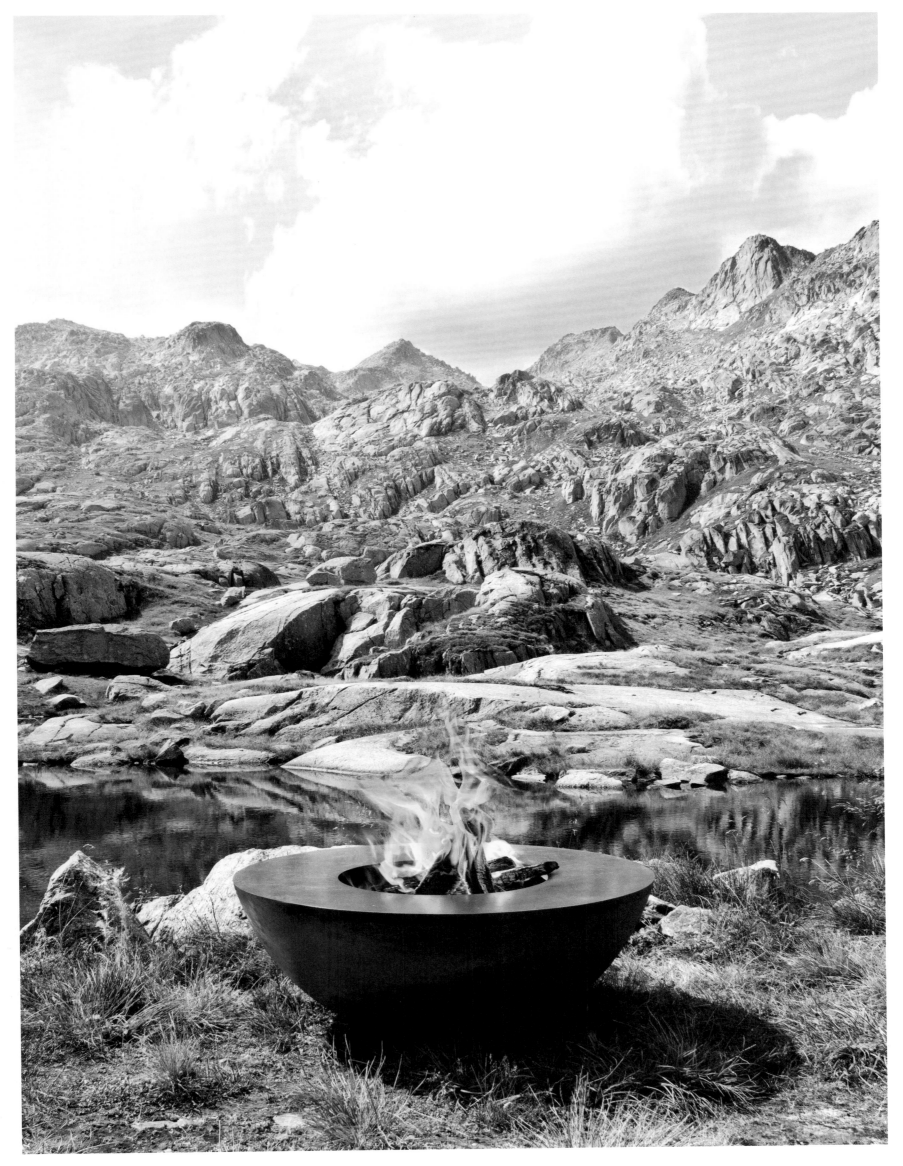

Feuerring

264

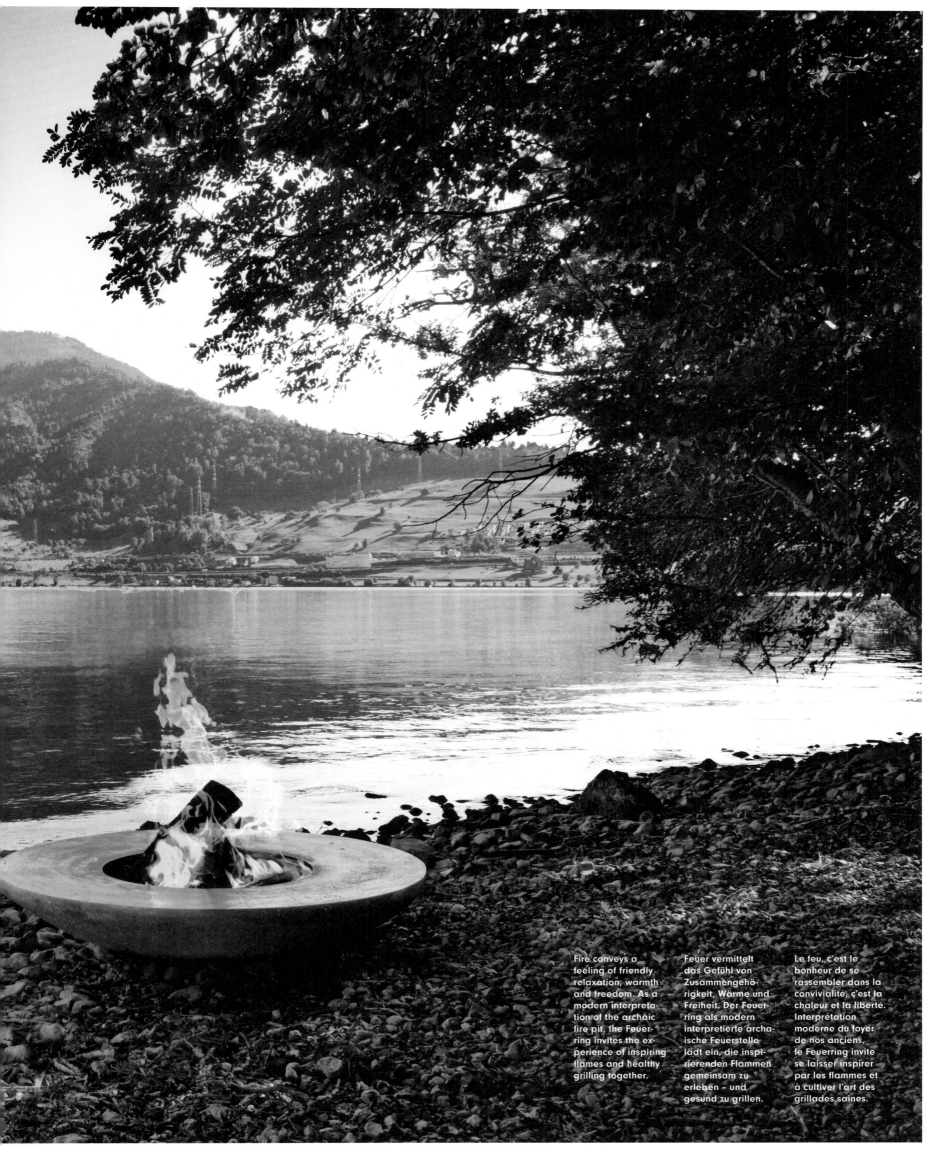

Fire conveys a feeling of friendly relaxation, warmth and freedom. As a modern interpretation of the archaic fire pit, the Feuerring invites the experience of inspiring flames and healthy grilling together.

Feuer vermittelt das Gefühl von Zusammengehörigkeit, Wärme und Freiheit. Der Feuerring als modern interpretierte archaische Feuerstelle lädt ein, die inspirierenden Flammen gemeinsam zu erleben – und gesund zu grillen.

Le feu, c'est le bonheur de se rassembler dans la convivialité, c'est la chaleur et la liberté. Interprétation moderne du foyer de nos anciens, le Feuerring invite se laisser inspirer par les flammes et à cultiver l'art des grillades saines.

Unlimited Earth Care

Bridgehampton, New York | USA

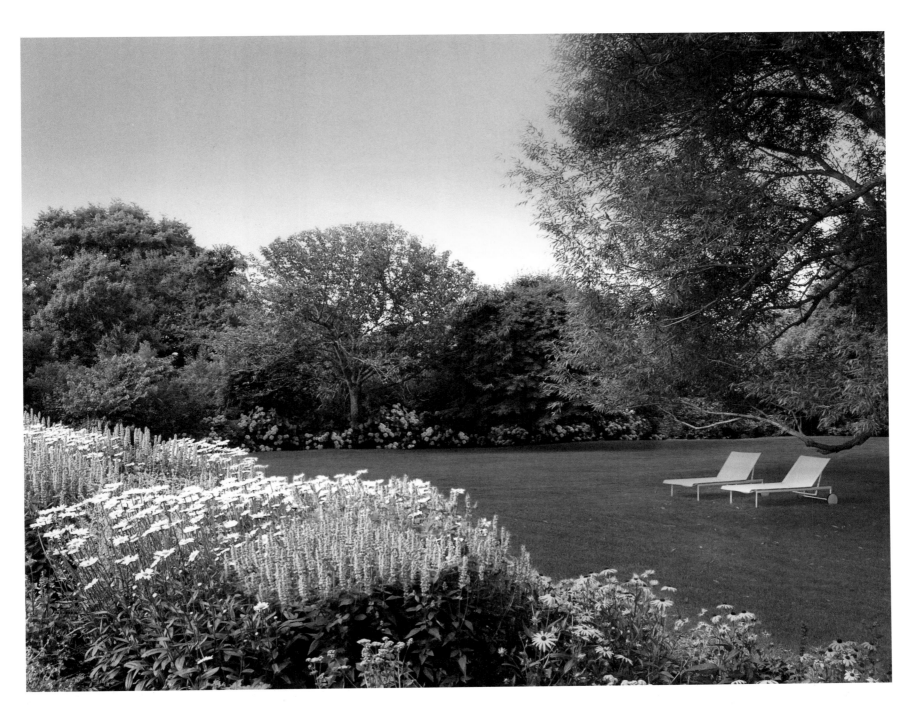

The gardens of the award-winning landscape designer Frederico Azevedo radiate perfect harmony. | Die Gärten des preisgekrönten Landschaftsarchitekten Frederico Azevedo strahlen vollendete Harmonie aus. | Une harmonie parfaite émane des jardins de l'architecte paysagiste Frederico Azevedo.

The core of Azevedo's garden design shines in the Hamptons. Here, in landscapes shaped by wind and weather, he creates paradises that demonstrate the full extent of his skill. Here you can marvel at his eclectic planting style, which can be described as seemingly chaotic and impulsive while also being poetic and ordered. In order to be able to fit the location, Unlimited Earth Care works together with specialists such as ecologists and arborists. This comprehensive approach makes the gardens memorable.

Das Herz des Gartendesigns von Frederico Azevedo schlägt in den Hamptons. Hier, in der von Wind und Wetter geformten Landschaft erschafft er Paradiese, die sein ganzes Können unter Beweis stellen. Hier lässt sich auch sein eklektischer Pflanzstil bewundern, der sich als scheinbar chaotisch und spontan und doch zugleich als poetisch und geordnet beschreiben lässt. Um auf den Ort eingehen zu können, arbeitet Unlimited Earth Care mit Spezialisten wie Ökologen und Baumpflegern zusammen. Dieser ganzheitliche Ansatz macht die Gärten unvergesslich.

Détenteur de plusieurs prix, Frederico Azevedo conçoit ses créations en s'inspirant de sa région des Hamptons. Ici, dans un paysage modelé par le vent et les intempéries, il crée des paradis qui témoignent de la totalité de son savoir-faire. C'est là que l'on peut admirer son style végétal éclectique, apparemment chaotique et spontané, mais aussi et paradoxalement, poétique et ordonné. Pour pouvoir s'adapter à un lieu, Unlimited Earth Care travaille avec des experts, tels des écologues ou des spécialistes de l'entretien des arbres. C'est cette approche globale qui rend ces jardins inoubliables.

At the headquarters of Unlimited Earth Care in Bridgehampton, New York, Azevedo's landscape art greets visitors like in a showroom.

Am Hauptsitz von Unlimited Earth Care in Bridgehampton präsentiert sich die Landschaftskunst von Frederico Azevedo den Besuchern wie in einem Showroom.

Au siège social de Unlimited Earth Care, à Bridgehampton, l'art paysager de Frederico Azevedo se révèle aux visiteurs comme dans un show room.

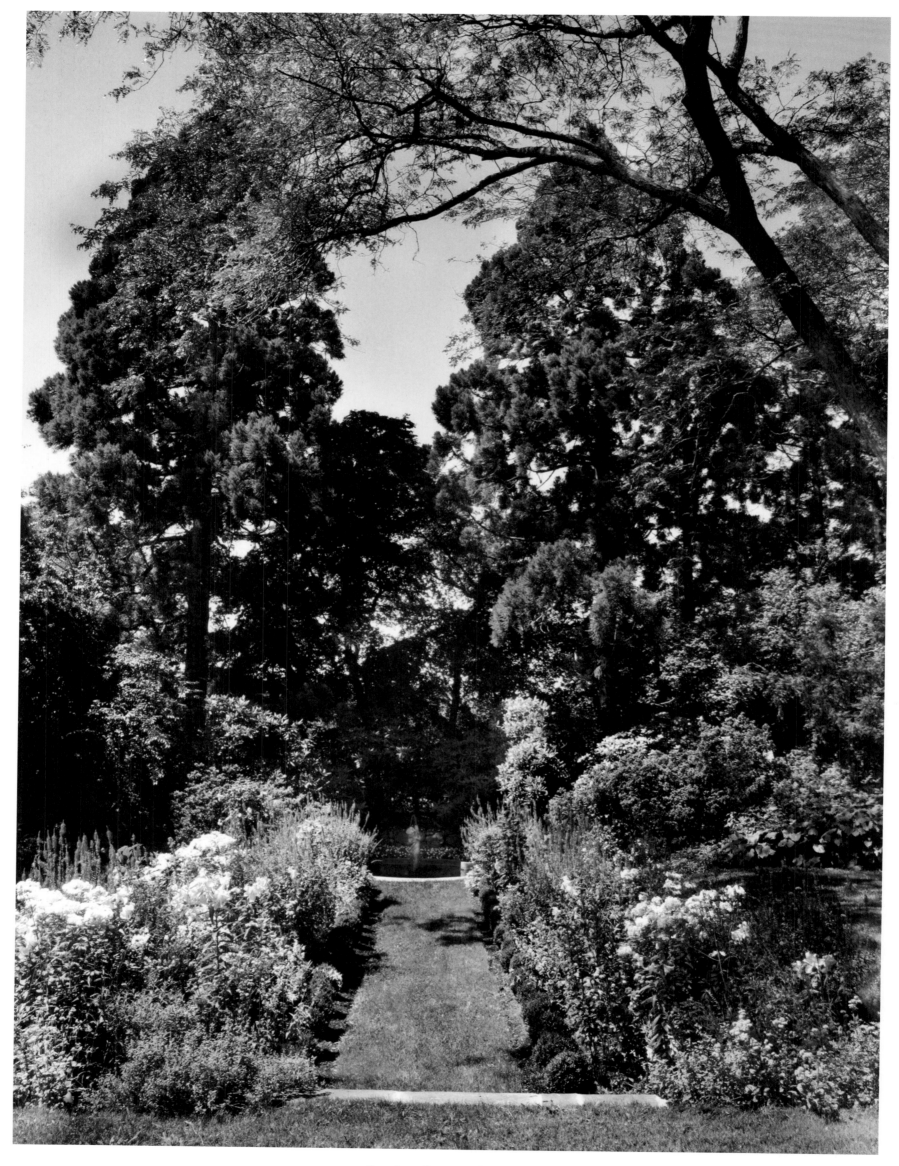

268

Through the contrast
to the clean lines
and wide spaces
in the garden, the
exuberant colors of
the plants and the
abundance of spe-
cies and patterns
combine to create a
harmonious whole.

Die überbordenden
Farben der Pflan-
zungen, die Fülle
an Arten und Struk-
turen fügen sich
durch den Kontrast
zu den klaren
Linien und weiten
Flächen im Garten
zu einem harmoni-
schen Ganzen.

Les couleurs
débordantes des vé-
gétaux, la multitude
des variétés et des
structures se fondent
en un tout harmo-
nieux suscité par le
contraste entre les
lignes claires et les
vastes étendues.

Marders

Brigdehampton, New York | USA

Exceptional rare and unusual trees and plants, specially grown or collected, are a trademark of Charles and Kathleen Marder. | Außergewöhnlich seltene und ungewöhnliche Bäume und Pflanzen, eigens herangezogen oder gesammelt, sind ein Markenzeichen von Charles und Kathleen Marder. | Charles et Kathleen Marder se distinguent en élevant ou en sélectionnant des arbres et des plantes extrêmement rares et très peu connus.

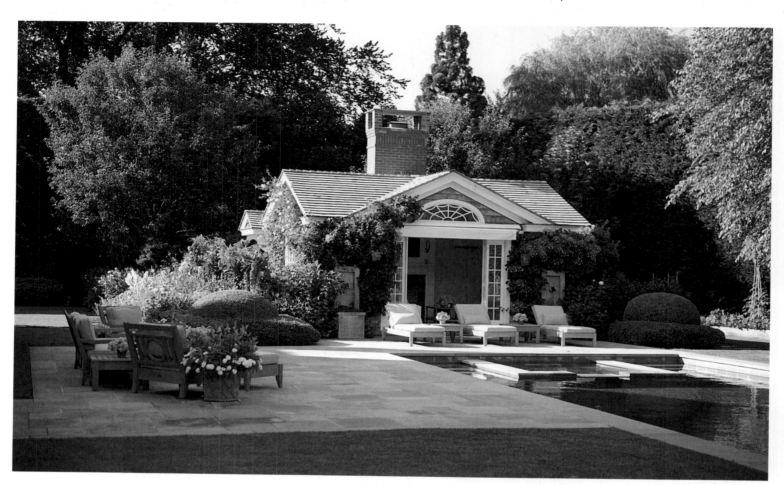

Charles has been able to fulfill the client's objective— a "been there forever" look, using selections from their over 5-million US Dollar (4.3-million Euro) inventory.

Charles war in der Lage, die Zielsetzung des Kunden zu erfüllen: eine Anmutung, als sei der Garten schon immer so gewesen – unter Verwendung einer Pflanzenauswahl aus seinem über 4,3 Millionen Euro umfassenden Warenbestand.

Charles a su répondre à la demande du client : en sélectionnant des végétaux dans un assortiment dont la valeur s'élève à plus de 4,3 millions d'euros, il est parvenu à donner l'impression que le jardin a toujours été là.

270

Charles Marder and his wife Kathleen began their work in Charles' mother's living room more than 40 years ago. They were pioneers in transplanting large trees back then. Today they are old hands when it comes to planting trees that are over 100 feet (30 meters) tall. From the beginning, their focus has been on bioproduction. Now they employ more than 300 people at their company. Through their experience, they provide support to garden designers throughout the world as well as private clients. The garden in East Hampton displays their skill.

Charles Marder und seine Frau Kathleen begannen ihre Tätigkeit vor über 40 Jahren im Wohnzimmer von Charles Mutter. Sie waren damals Pioniere auf dem Feld der Großbaumverpflanzung, heute sind sie Routiniers, wenn es darum geht bis zu über 30 Meter hohe Bäume zu pflanzen. Von Anfang an setzten sie auf Bioproduktion. Inzwischen beschäftigen sie über 300 Mitarbeiter in ihrem Unternehmen. Sie unterstützen mit ihrer Erfahrung Gartendesigner auf der ganzen Welt sowie auch Privatkunden. Der Garten in East Hampton zeugt von ihrem Können.

Charles Marder et sa femme Kathleen ont débuté il y a plus de 40 ans dans la salle de séjour de la mère de Charles. À l'époque, ils innovent en se lançant dans la plantation d'arbres de grande taille ; aujourd'hui, grâce au savoir-faire accumulé, ils n'hésitent pas à transplanter des arbres pouvant atteindre une hauteur de 30 mètres. Dès le début, ils misent sur la culture biologique. Aujourd'hui, leur entreprise compte plus de 300 personnes qui mettent leur expérience à la disposition de paysagistes du monde entier et de clients particuliers. Ce jardin situé à East Hampton témoigne de leur expertise.

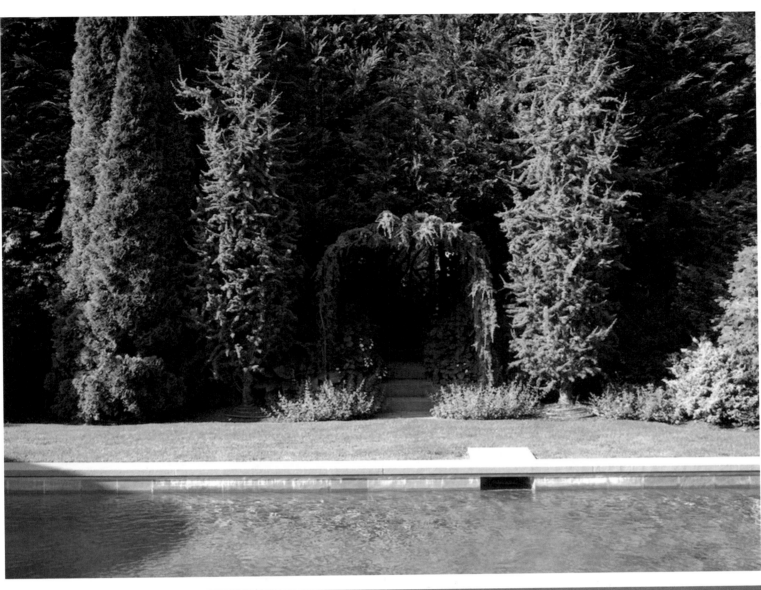

Merging newly acquired gardens as for this client is a specialty of Charles' as clients expand and create family compounds in the Hamptons.

Das Zusammenlegen von neu erworbenen Gärten ist eine Spezialität von Charles, da viele Kunden in den Hamptons ihre Grundstücke erweitern, um eine größere Anlage für ihre ganze Familie zu schaffen.

Le regroupement de jardins voisins est une spécialité de Charles, car dans les Hamptons, beaucoup de clients souhaitent disposer de jardins plus étendus pour recevoir leurs grandes familles.

Marders

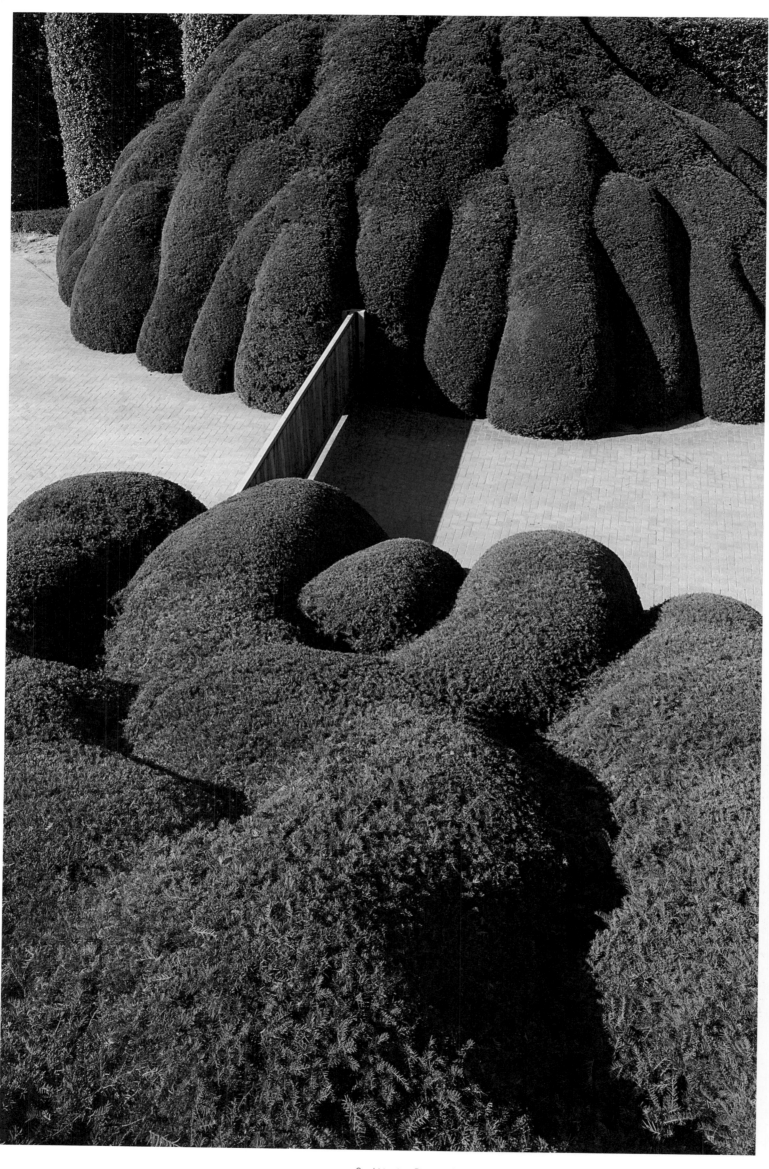

272

A highly accurately shaped 23-foot (7-meter) high yew sculpture forms the entrance to the tree nursery. Like other individual groups, it awaits new owners and will be sold as a set.

Den Eingang zur Baumschule bildet eine sieben Meter hohe akkurat geformte Eibenskulptur, die, wie andere individuelle Gruppen, auf neue Besitzer wartet und als Ensemble verkauft wird.

L'entrée de la pépinière est formée d'une sculpture de sept mètres de haut composée d'ifs taillés avec une grande précision, qui n'attend plus que d'être vendue complète à un nouveau propriétaire, comme d'ailleurs d'autres groupes originaux de végétaux.

Solitair Boomkwekerij

Loenhout | Belgium

The Belgian tree nursery Solitair presents characterful multi-stem and standard trees, classical and experimental trimmed shapes and large-sized evergreen screening. | Die belgische Baumschule Solitair präsentiert charaktervolle mehr- und einstämmige Bäume, klassische und experimentelle Schnittformen sowie großflächige, immergrüne Sichtschutzpflanzen. | La pépinière belge propose des arbres de caractère à une ou plusieurs tiges, des plantes taillées de manière classique ou expérimentale ainsi que des haies brise-vue de grande dimension et toujours vertes.

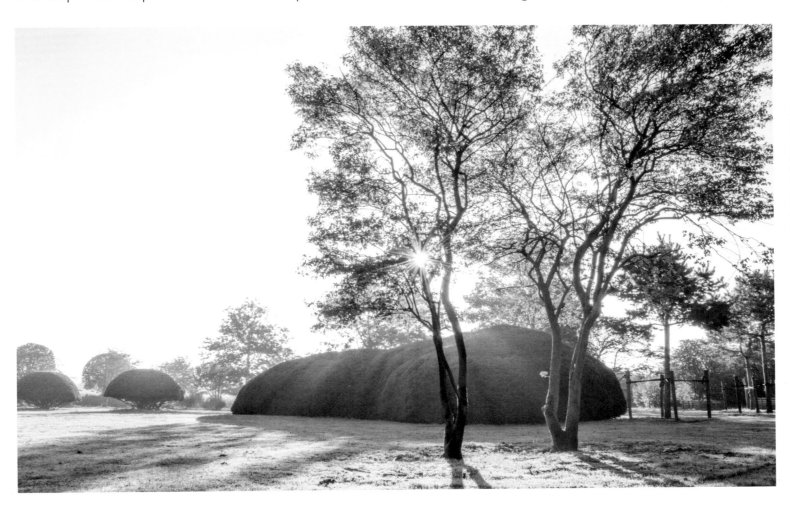

Large individual plants stand freely in the tree nursery as if they were already in a park, such as these two serviceberry plants (Amelanchier lamarckii) in front of a large, cloud-shaped group of yews.

Frei wie in einem Park stehen die großen Individuen in der Baumschule, wie diese beiden Kupfer-Felsenbirnen Amelanchier lamarckii vor einer großen wolkenförmig geschnittenen Eibengruppe.

Les grands solitaires poussent librement dans la pépinière, comme ces deux amélanchiers de Lamarck implantés devant un grand groupe d'ifs taillés en forme de nuage.

273

For over 30 years, Solitair specialises in unique stand-alone trees that find their way to all styles of gardens. In the 297-acre (120-hectare) tree nursery you find a combination of their own production and a selection of individual trees that are sourced throughout Europe. Garden- and landscape architects come here together with their clients to find the one-of-a-kind specimen that will change the character of their garden or project. During winter, various trees form an inspiring indoor garden in a 43-foot (13-meter) high greenhouse.

Seit mehr als 30 Jahren ist Solitair auf einzigartige Solitärbäume spezialisiert, die ihren Weg in alle Arten von Gärten finden. In der 120 Hektar großen Baumschule findet sich eine Kombination aus eigener Produktion und einer Auswahl an Einzelbäumen, die aus ganz Europa stammen. Garten- und Landschaftsarchitekten kommen mit ihren Kunden dorthin, um das einzigartige Exemplar zu finden, das den Charakter ihres Gartens oder Projekts verändern wird. Im Winter bilden verschiedene Bäume einen inspirierenden Indoor-Garten in einem 13 Meter hohen Gewächshaus.

Depuis plus de 30 ans, Solitair est le spécialiste des arbres solitaires de caractère que l'on retrouve dans toutes sortes de jardins. Sur 120 hectares, la pépinière offre un choix de végétaux de sa production associés à une sélection d'arbres uniques provenant de toute l'Europe. Les jardiniers et paysagistes y viennent avec leurs clients pour trouver l'exemplaire qui donnera à leur jardin ou à leur projet le caractère qui en fera quelque chose d'unique. En hiver, à l'intérieur d'une serre de 13 mètres de haut, divers arbres forment un jardin intérieur inspirant.

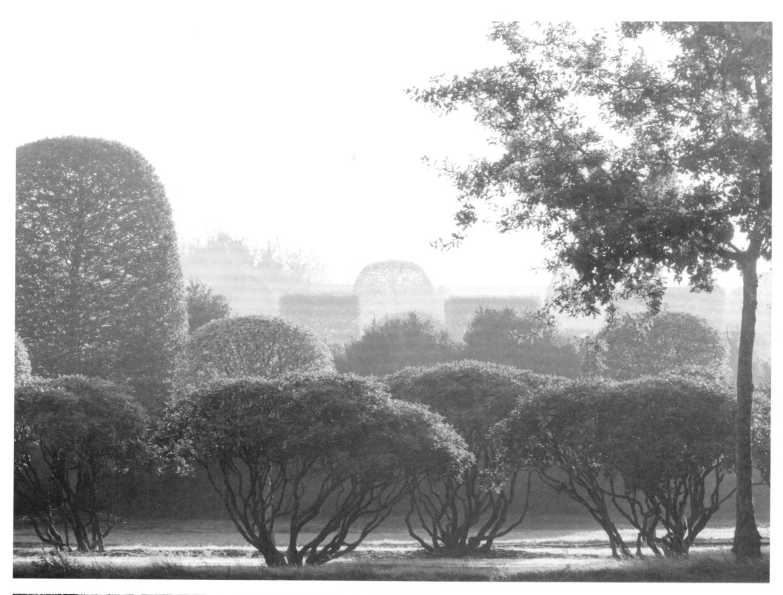

Multi-stemmed
'Cunningham's White'
rhododendrons
grow in front of a
hornbeam trimmed
in the shape of
a dome. Solitair
specializes in yews
of all shapes and
designs (here, a
detailed image of
the bark is shown).

Mehrstämmige
Rhododendren
'Cunningham's
White' wachsen vor
einer in Kuppelform
geschnittenen Hain-
buche. Eiben, hier
die Detailaufnahme
der Rinde, gehören
in jeder Form
und Gestalt zu den
Spezialitäten
von Solitair.

Des rhododen-
drons multitiges
'Cunningham's White'
poussent devant
un charme commun
taillé en coupole.
Taillés dans toutes
les formes imagi-
nables, les ifs, dont
on voit ici l'écorce
de près, sont une
des spécialités
de Solitair.

274

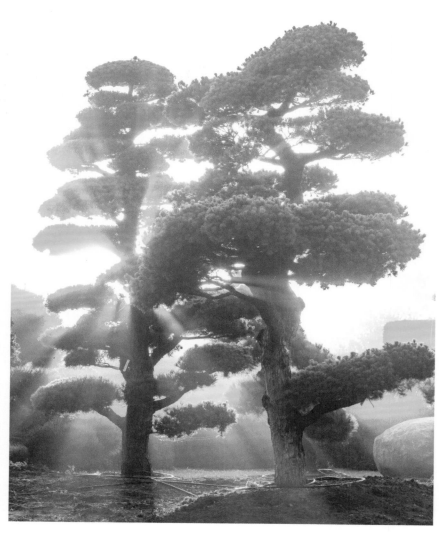

275

Even exotic plants, such as five-needle pines (Pinus parviflora) and individual plants such as Japanese maple (Acer palmatum 'Dissectum Nigrum') (above), are grown skillfully here.

Auch Exoten wie die im japanischen Stil geschnittenen Kiefern Pinus parviflora oder Individuen wie der Ahorn Acer palmatum 'Dissectum Nigrum' (oben) werden hier sachkundig herangezogen.

La pépinière s'y connaît aussi en arbres exotiques, comme avec ces pins Pinus parviflora taillés à la japonaise ou des pièces uniques comme l'érable Acer palmatum 'Dissectum Nigrum' (ci-dessus).

Schlosspark Türnich

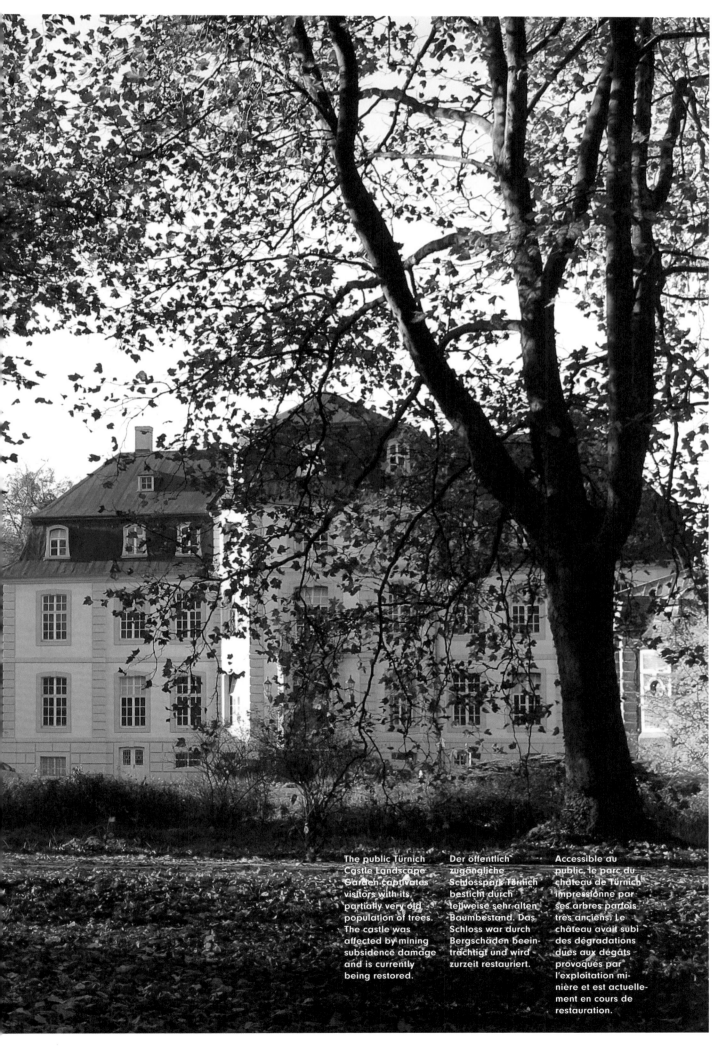

A landscape garden on the Erft River with baroque origins, stone settings, and ecological agriculture | Ein Landschaftspark an der Erft – mit barocken Ursprüngen, Steinsetzungen und ökologischer Landwirtschaft | Un parc paysager au bord de l'Erft – origines baroques, alignements de pierres et agriculture écologique

The Türnich Castle Landscape Garden was created in 1873, bringing together older plantations of a once smaller park from the 1790s and the French garden originating from the 18th century. The castle and the park suffered damage from nearby mining, but the family of count von und zu Hoensbroech is venturing "to create a sensual landscape that aligns itself to natural cycles." This includes geomantic stone settings by the Slovenian artist Marko Pogacnik.

Der Landschaftspark Schloss Türnich wurde im Jahre 1873 angelegt, unter Einbeziehung von älteren Pflanzungen eines ersten kleineren Parks aus den 1790er-Jahren sowie des Französischen Gartens, der aus dem frühen 18. Jahrhundert stammt. Schloss und Park wurden durch den Bergbau in Mitleidenschaft gezogen, doch die Familie der Grafen von und zu Hoensbroech ist bestrebt, „eine lustvolle Landschaft zu schaffen, die sich an natürlichen Kreisläufen orientiert". Dazu gehören auch geomantische Steinsetzungen des slowenischen Künstlers Marko Pogacnik.

Intégrant les plantes anciennes d'un petit parc remontant aux années 1790 ainsi que le jardin français datant du début du 18e siècle, le parc du château de Türnich a été créé en 1873. Le château et le parc avaient subi des dégradations dues aux dégâts provoqués par l'exploitation minière, mais la famille des comtes von und zu Hoensbroech exprime alors le désir de « créer un paysage plein de volupté et s'inspirant des cycles de la nature », en y incluant en particulier les alignements géomantiques de pierres de l'artiste slovène Marko Pogacnik.

277

The public Türnich Castle Landscape Garden captivates visitors with its partially very old population of trees. The castle was affected by mining subsidence damage and is currently being restored.

Der öffentlich zugängliche Schlosspark Türnich besticht durch teilweise sehr alten Baumbestand. Das Schloss war durch Bergschäden beeinträchtigt und wird zurzeit restauriert.

Accessible au public, le parc du château de Türnich impressionne par ses arbres parfois très anciens. Le château avait subi des dégradations dues aux dégâts provoqués par l'exploitation minière et est actuellement en cours de restauration.

The 984-foot (300-meter) long allée with 111 linden trees was designed in 1873 and is the most striking design element of the English landscape garden surrounding the Türnich Castle.

Die bereits 1873 angelegte 300 Meter lange Allee mit 111 Linden ist das bemerkenswerteste Gestaltungselement des englischen Landschaftsparks, der Schloss Türnich umgibt.

L'élément le plus remarquable du parc paysager anglais qui entoure le château de Türnich est l'allée de 300 mètres réalisée dès 1873 et constituée de 111 tilleuls alignés.

278

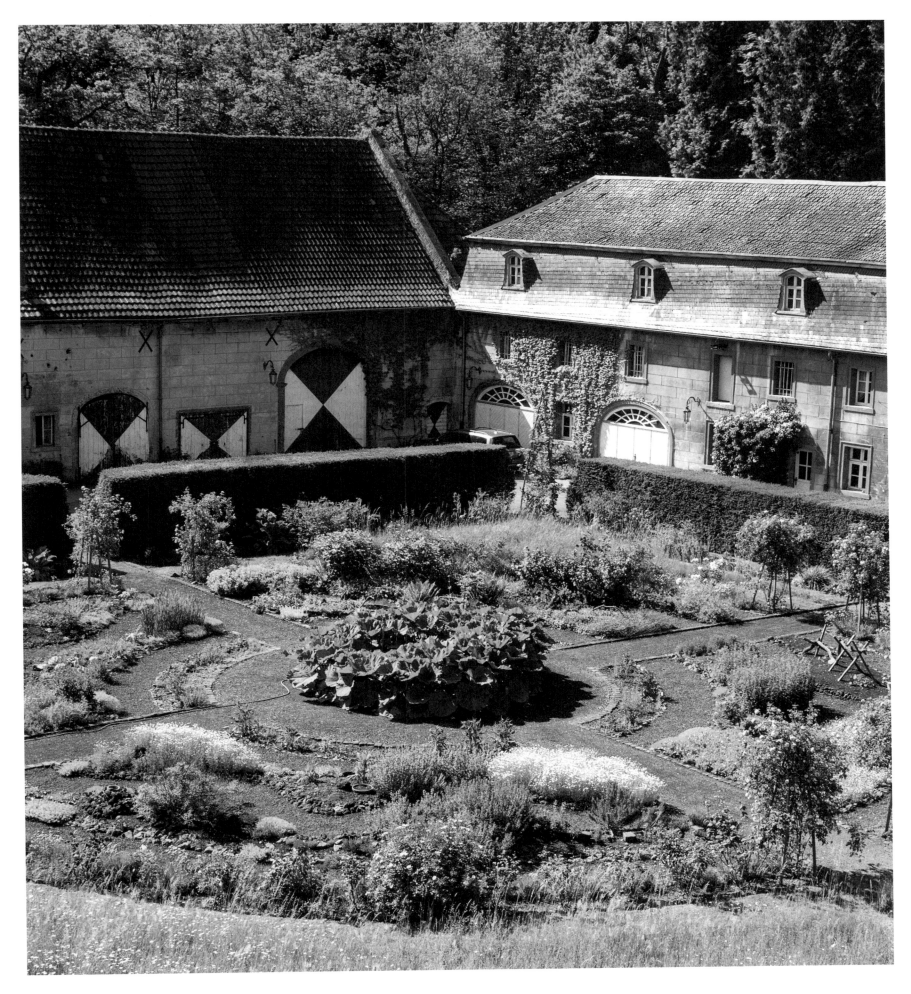

The castle's court-
yard is nestled with
roses from the Ceres
Heilmittel GmbH's
medicinal herb dis-
play garden, which
produces and mar-
kets herbal, homeo-
pathic medicines.

Im Innenhof des
Schlosses liegt in
Rosen eingebet-
tet der Heilkräuter-
Schaugarten der
Ceres Heilmittel
GmbH, die pflanz-
lich-homöopathi-
sche Arznei-
mittel herstellt
und vertreibt.

Dans la cour inté-
rieure du château,
on peut admirer,
entouré de rosiers,
le jardin d'herbes
médicinales de
la société Ceres
Heilmittel GmbH qui
fabrique et distribue
des médicaments
homéopathiques à
base de plantes.

Schlosspark Türnich

In 2011, the artist, Ati von Gallwitz, designed a new oval labyrinth out of 750 hollies (Ilex crenata 'convexa') below a hundred-year-old pine tree.

2011 gestaltete die Künstlerin Ati von Gallwitz ein neues ovales Labyrinth aus 750 Stechpalmen (Ilex crenata 'convexa') unter einer hundertjährigen Kiefer.

En 2011, l'artiste Ati von Gallwitz conçoit sous un pin centenaire un nouveau labyrinthe ovale de 750 houx crénelés (Ilex crenata 'convexa').

Art and nature coming together in harmony is a main objective of the Türnich Castle grounds. Meadows are left to bloom for the entire blooming period and tree stumps serve as a hotel for insects. It is in this way that the landscape garden has become a diverse and species-rich biotope.

Kunst und Natur in harmonischer Weise miteinander zu verbinden, ist ein zentrales Anliegen im Schlosspark Türnich. Wiesen bleiben bis zum Ende der Blühzeit stehen, Baumstümpfe dienen als Hotel für Insekten. So wurde der Landschaftspark ein vielfältiges und artenreiches Biotop.

Dans le parc du château de Türnich, la motivation principale est de parvenir à associer art et nature de manière harmonieuse. Les prairies ne sont pas fauchées tant que la floraison n'est pas terminée et les souches d'arbre servent d'hôtels à insectes. Le parc paysager se transforme ainsi en biotope où règnent la variété et la biodiversité.

Schlosspark Türnich

Schlotfeldt Licht

Hamburg | Germany

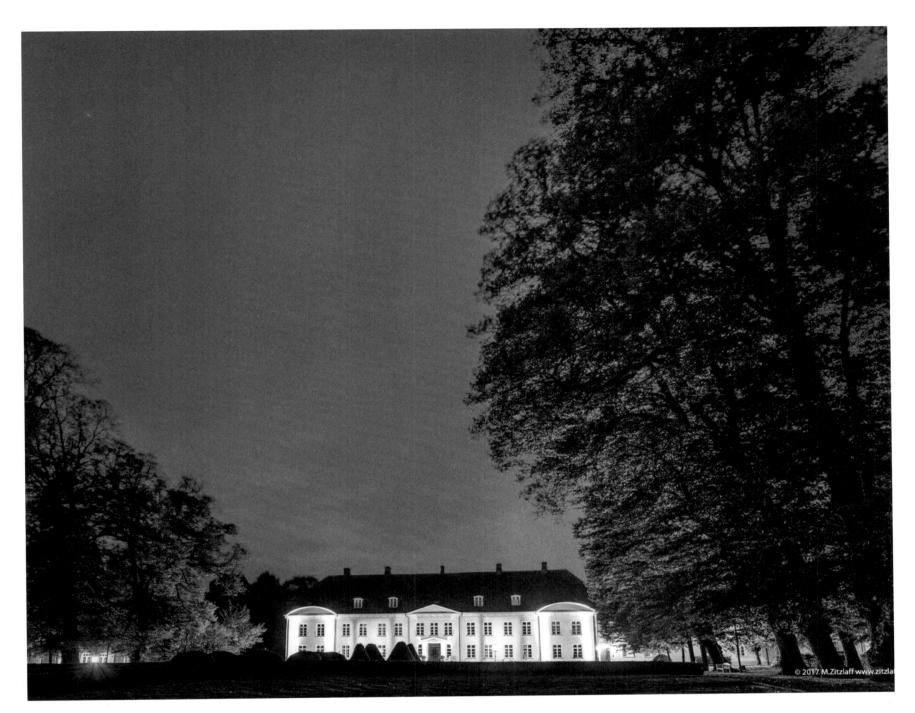

© 2017 M.Zitzlaff www.zitzla...

A team made up of architects and designers develops creative light visions all around the globe. | Ein Team aus Architekten und Designern entwickelt kreative Licht-Visionen rund um den Globus. | Une équipe d'architectes et de designers réalise des éclairages créatifs à travers le monde.

Light is the foundation of life. Schlotfeldt Licht has made working with light its mission, using the most modern technology to turn creative visions into reality. The focus is on people and their needs at all times. Light also plays an especially important role in the outdoors: It provides support to the concept of garden and landscape design and is critical for atmosphere in the gloom. The resulting light architecture is based on an ecological approach.

Licht ist Grundlage des Lebens. Mit Licht zu arbeiten, mit bester Technik kreative Visionen Realität werden zu lassen, das hat sich Schlotfeldt Licht zur Aufgabe gemacht. Der Fokus liegt stets auf dem Menschen und seinen Bedürfnissen. Auch im Outdoor-Bereich spielt Licht eine besonders wichtige Rolle: Es unterstützt das Konzept der Garten- und Landschaftsgestaltung und ist entscheidend für die Atmosphäre in der Dunkelheit. Die so entstehende Lichtarchitektur basiert auf einem ökologischen Denkansatz.

De la lumière naît la vie. Travailler avec la lumière, donner vie à des éclairages créatifs grâce à des technologies de pointe, voilà la mission de Schlotfeldt Licht. L'agence de design adapte chaque projet au client et à ses besoins. L'éclairage des extérieurs joue également un rôle essentiel : partie intégrante de l'aménagement des paysages et des jardins, il détermine aussi l'atmosphère de la nuit. L'architecture lumineuse ainsi obtenue repose sur une approche écologique.

For the boarding school in the Louisenlund Castle in Schleswig-Holstein in northern Germany, the light team developed façade illumination that provides support to the architecture of the early-classical building construction.

Für das Internat und Ganztagesgymnasium im Schloss Louisenlund in Schleswig-Holstein entwickelte das Licht-Team eine Fassadenbeleuchtung, die die Architektur des frühklassizistischen Baus unterstützt.

Conçu par l'équipe de Schlotfeldt Licht, l'éclairage de la façade du lycée et internat du château Louisenlund au Schleswig-Holstein souligne l'architecture de cet édifice qui date des débuts du néo-classicisme.

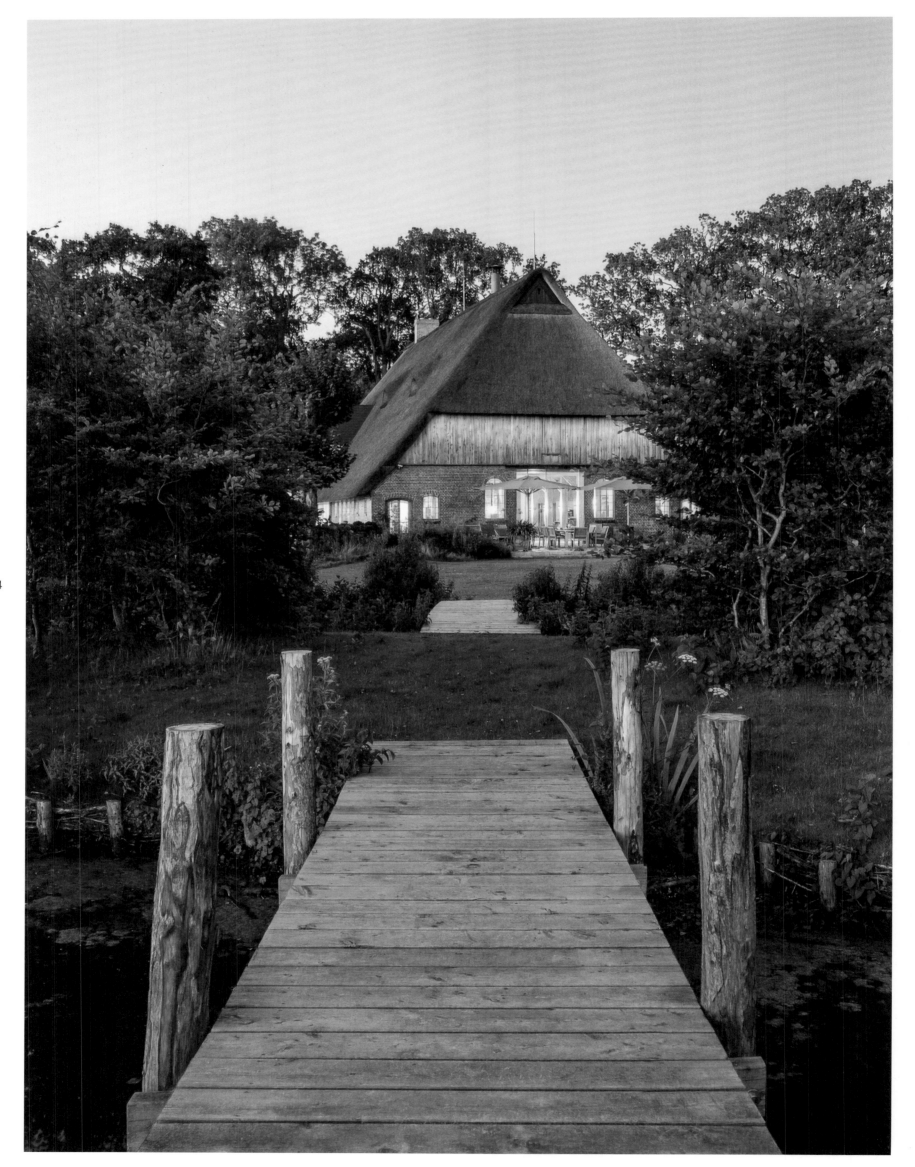

284

The Ostermühlen estate in the heart of Schleswig-Holstein, with its landmarked building structure, has been meticulously restored over the last few years. Owing to its private use, the lighting design is conceptualized to be quite restrained, most notably accentuating the large tree population of the property.

Das Gut Ostermühlen im Herzen Schleswig-Holsteins mit seiner denkmalgeschützten Bausubstanz wurde in den vergangenen Jahren sorgfältig restauriert. Die Lichtplanung ist aufgrund der privaten Nutzung sehr zurückhaltend konzipiert und betont vor allem den großen Baumbestand des Anwesens.

Les bâtiments classés monuments historiques de la propriété d'Ostermühlen, au cœur du Schleswig-Holstein, ont été restaurés avec soin ces dernières années. Tout en retenue en raison du caractère privé des lieux, la conception des éclairages met surtout en valeur les nombreux arbres de la propriété.

Schlotfeldt Licht

Index

286

About the Editor

RALF KNOFLACH, born in Meerbusch, Germany, completed apprenticeships as a Horticulturist in the USA, France, and Italy. He completed his commercial training and gained professional experience at various tree nurseries. For more than 10 years, Knoflach has been independent with green | Gartenkultur and is a tree broker and gardener of entries, terraces, roof gardens, and courtyards all over Europe.

Credits

Imprint

© 2018 teNeues Media GmbH & Co. KG, Kempen
All rights reserved.

Preface by Ralf Knoflach
Texts by Gesa Loschwitz-Himmel, Robert Schäfer
Editor: Ralf Knoflach
Contributing Editors: Cindi Cook, Rosa von Fürstenberg,
Marc Steinhauer
Translations by STAR Software, Translation, Artwork,
Recording GmbH, Munich
Copyediting by Sabine Egetemeir
Proofreading by Sabine Egetemeir
Creative Director: Martin Graf
Design & Layout: Robin John Berwing, Stefan Gress
Editorial coordination by Sabine Egetemeir
Production by Nele Jansen
Color separation by Jens Grundei

Cover photograpy: Koiteiche und exklusive Gärten Reinhold Borsch,
© Photographer: Jürgen Becker
Back Cover photography: Tectona, © Photographer: Matthieu Gafsou

ISBN 978-3-96171-103-1

Library of Congress Number: 2017958248

Printed in Italy

Bibliographic information published by
the Deutsche Nationalbibliothek
The Deutsche Nationalbibliothek lists this publication in the
Deutsche Nationalbibliografie; detailed bibliographic data are
available on the Internet at http://dnb.dnb.de.

Published by teNeues Publishing Group

teNeues Media GmbH & Co. KG
Am Selder 37, 47906 Kempen, Germany
Phone: +49–(0)2152–916–0
Fax: +49–(0)2152–916–111
e–mail: books@teneues.com

Press department: Andrea Rehn
Phone: +49–(0)2152–916–202
e–mail: arehn@teneues.com

Munich Office
Pilotystraße 4, 80538 Munich, Germany
Phone: +49–(0)89–443–8889–62
e–mail: bkellner@teneues.com

Berlin Office
Kohlfurter Straße 41–43, 10999 Berlin, Germany
Phone: +49–(0)30–4195–3526–23
e–mail: ajasper@teneues.com

teNeues Publishing Company
350 7th Avenue, Suite 301, New York, NY 10001, USA
Phone: +1–212–627–9090
Fax: +1–212–627–9511

teNeues Publishing UK Ltd.
12 Ferndene Road, London SE24 0AQ, UK
Phone: +44–(0)20–3542–8997

teNeues France S.A.R.L.
39, rue des Billets, 18250 Henrichemont, France
Phone: +33–(0)2–4826–9348
Fax: +33–(0)1–7072–3482

www.teneues.com

FSC
www.fsc.org

MIX
Paper from
responsible sources
FSC® C015829

teNeues Publishing Group
Kempen
Berlin
London
Munich
New York
Paris

teNeues